Women artists and modernism

MANCHESTER
UNIVERSITY PRESS

EDITED BY KATY DEEPWELL

# Women artists and modernism

UCD WOMEN'S CENTER

MANCHESTER UNIVERSITY PRESS

MANCHESTER AND NEW YORK

*distributed exclusively in the USA by St. Martin's Press*

*Published by* Manchester University Press
Oxford Road, Manchester M13 9NR, UK
*and* Room 400, 175 Fifth Avenue, New York, NY 10010, USA

*Distributed exclusively in the USA by*
St. Martin's Press, Inc., 175 Fifth Avenue, New York,
NY 10010, USA

*Distributed exclusively in Canada by*
UBC Press, University of British Columbia, 6344 Memorial Road,
Vancouver, BC, Canada V6T 1Z2

*British Library Cataloguing-in-Publication Data*
A catalogue record for this book is available from the British Library

*Library of Congress Cataloging-in-Publication Data applied for*

ISBN 0 7190 5081 2 *hardback*
     0 7190 5082 0 *paperback*

First published 1998

05 04 03 02 01 00 99 98   10 9 8 7 6 5 4 3 2 1

Typeset in Centaur
by Servis Filmsetting Ltd

Printed in Great Britain
by Bell & Bain Ltd, Glasgow

# Contents

# Figures

# Contributors

RENEE BAERT is an independent curator and critic from Canada. She teaches at Concordia University, Montreal. Her Ph.D. was on poetics of the body in feminist art (McGill University, 1997). Her recent exhibitions include *Fetish* (Art Gallery of Windsor, 1997–98); *Trames de Mémoire* (Galerie Expression and Canadian tour, 1996–98); and *Objects in Advance of the Concept* (Burnaby Art Gallery, 1995). Her publications include (ed.) *Territories of Difference* (Banff: Walter Phillips, 1993); and *The Video Issue/Propos Vidéo* (Canada: Intermagazine, 1993). She is currently a postdoctoral fellow at the Center for Visual and Cultural Studies, University of Rochester, New York.

JANE BECKETT teaches history of art and visual culture at the University of East Anglia, Norwich. She has written extensively on modernism and its histories. Her publications include *Henri Gaudier-Breska* (1983), *British Sculpture in the Twentieth Century* (1986) and, with Deborah Cherry, *The Edwardian Era* (1987). She is currently preparing an urban history of Amsterdam in the early twentieth century and working on a study of the relations between modernity and urban culture with Deborah Cherry, with whom she co-contributed '"Jenseits des Sichtbaren": Frauen, Großstadtkultur, Vortizismus' to *Blast! Vortizismus: die erste Avantgarde in England, 1914–1918* (1996).

ROSEMARY BETTERTON is Reader in Art History at Sheffield Hallam University. Her publications include *An Intimate Distance: Women, Artists and the Body* (1996); 'Mother Figures: The Maternal Nude in the Work of Käthe Kollwitz and Paula Modersohn-Becker', in Griselda Pollock (ed.) *Generations and Geographies in the Visual Arts: Feminist Readings* (1996); and (ed.) *Looking On: Images of Femininity in the Visual Arts and Media* (1987) as well as journal articles and essays on women in the visual arts.

DEBORAH CHERRY teaches history of art at the University of Sussex, Brighton. Her publications include *Painting Women: Victorian Women Artists* (1993). Her study of the relations between feminism and visual culture in Britain before 1900 will be published in 1998. She is working on a study of the relations between women, modernity and culture with Jane Beckett, with whom she co-contributed '"Jenseits des Sichtbaren": Frauen, Großstadtkultur, Vortizismus' to *Blast! Vortizismus: die erste Avantgarde in England, 1914–1918* (1996).

KATY DEEPWELL is founder and editor of *n.paradoxa*, a quarterly international feminist online magazine (http//web.ukonline.co.uk/n.paradoxa/index.htm). She is a freelance critic and President of AICA, British Section (1997–2000). Recent articles have appeared in *Contemporary Visual Arts* (UK), *Nka: Journal of Contemporary African Art* (USA) and *Siksi: Nordic Art Review* (Finland). She has taught art theory at several colleges, including Oxford–Brookes, Goldsmiths' and KIAD. She is editor of *New Feminist Art Criticism: Critical Strategies* (1995) and *Art Criticism and Africa* (1997).

BRIDGET ELLIOTT is Associate Professor of Visual Arts at the University of Western Ontario, where she teaches in the areas of history, theory and criticism. With Jo-Ann Wallace she is author of *Women Artists and Writers: Modernist (Im)positionings* (1994) and, most recently, with Anthony Purdy, *Peter Greenaway: Architecture and Allegory* (1997). She is currently completing a study of visual and discursive representations of late-Victorian music-hall entertainment.

JOANNA FRUEH is Professor of Art History at the University of Nevada, Reno. Her most recent book is *Erotic Faculties* (1996), a collection of her critical and performance art writings. She is author

of *Hannah Wilke: A Retrospective* (1989) and co-editor of *New Feminist Criticism: Art, Identity, Action* (1994) and *Feminist Art Criticism: An Anthology* (1991).

SUSAN PLATT is a visiting professor at the University of Washington, Seattle. Her Ph.D. thesis was published as *Modernism in the 1920s* (1985). She is currently completing a book, *Art and Politics in the 1930s*. She is Seattle Regional Editor for *Art Papers*.

HILARY ROBINSON lectures in the history and theory of art at the School of Fine and Applied Arts, University of Ulster, Belfast. Her M.A. (RCA, 1987) researched body image and sexuality in feminist art and her Ph.D. research explores the implications of Luce Irigaray's writing for contemporary art. She has published widely in art and academic journals, exhibition catalogues and books. She edited *Visibly Female* (1987, 1988) and is currently working on a book, *Feminist Art Theory, 1970–1999*.

MOIRA ROTH is Trefethen Professor of Art History at Mills College, California. She has written extensively in art journals, catalogues and anthologies. Her new publications include two volumes of her own writings, *Difference / Indifference: Musings on Postmodernism, Marcel Duchamp and John Cage* (1998) and a second volume of her writings on women artists, feminism and cultural diversity. She recently edited *We Flew Over the Bridge: Memoirs of Faith Ringgold* (1995) and *Rachel Rosenthal* (1997).

PAULINE DE SOUZA teaches at Cheltenham and Gloucester College of Higher Education and the University of Derby. She is currently co-editing a collection of essays from the *Rhapsodies in Black: Art, Literature and Music of the Harlem Renaissance* conference (Hayward Gallery, 1997).

NEDIRA YAKIR lectures part-time at Falmouth College of Arts and the University of Exeter. Her publications include 'Interview with Orlan' in *Women's Art Magazine* (1996) and a catalogue of Shuli Nchshon (Ein-Hod, Israel: dada-Janko Museum, 1996). Her current research project is on gender in the construction of the St Ives School.

# Introduction

KATY DEEPWELL

This anthology has been compiled with a view to demonstrating how different methodologies and approaches can be used to reveal the woman artist as a 'subject' in histories of twentieth-century art. Feminist art history has studied many different areas and produced work using a number of methods of analysis since the early 1970s, but the idea of the discrete study and of feminist readings as interventions which challenge existing orthodoxies about modernism continues to predominate. This book does not provide a comprehensive overview of modernist art in the twentieth century, nor does it seek to address all the places, moments and spaces women have occupied in Western art history in relation to the canon of modernism. Instead these essays offer specific case-studies of historical narratives, of artworks or individuals' artistic projects which lie within and offer opportunities to question ideas about modernism. Each essay introduces divergent possibilities and strategies for productive and different feminist readings of women's art practices, their lives and position in twentieth-century culture.

The writers work in Britain, Ireland, Canada and the United States. They address primarily work by artists and critics undertaken in these countries at different historical moments in order to raise questions about the asymmetry of gender relations and sexual difference. The questions they ask, the subjects they address and the theoretical frameworks offered vary from essay to essay.

Over the last three decades, feminist art historians in their recovery and rediscovery of women artists have written numerous critiques of the ideologies of modernism in the history of art, the debates on conceptions of modernity as opposed to modernism, and constructions of femininity/-ies and the figure of Woman. The essays included here continue that work in an attempt both to critique and to reimagine the pre-existing classifications under which much of the writing about women artists in the twentieth century is still offered. In this introduction, I will try to situate their work within this expanding field.

## Women and modernism

One of the central questions for feminist enquiry is how history has produced and reproduced the continued marginalisation of women artists[1] when, particularly in the twentieth century, the numbers of women artists have been steadily increasing as formal education became available to large numbers of women, and artists' clubs, groups and societies slowly admitted women artists as professional members. As the battles of the late nineteenth century for access to formal training ended, the arguments in art criticism and art history about women artists became centred around two critical questions: what are the qualities of women artists' work (qualities frequently juxtaposed to or read against a normative 'male' model), and what is the relationship of women's work to contemporary concepts of femininity?

As twentieth-century museums and art history textbooks have defined and revised our ideas of modernism, the work of women artists has rarely occupied more than 10–20 per cent of illustrations in modern art books or of works in exhibitions of modern movements and in installations of permanent collections. This level of presentation, which is also reproduced in university curricula, reinforces the idea that women artists who worked in or around the modernist movements of the twentieth century were at best marginal or occasional presences in the art world, and therefore only of marginal interest in relation to defining avant-garde practice or its politics.

With the development of different forms of feminist art history since the 1970s asking questions about the work of women artists and the representation of women as subjects in art, the illusion is frequently created that prior to the 1970s women artists were an isolated and rare phenomenon, and it is only since then that one can trace a sudden explosion of activity and visibility. The substantial presence of women artists throughout the course of the twentieth century can, however, readily be traced, identified and mapped through material available in library archives, museum collections, specialist publications, magazines and newspaper articles. Indeed, the collection and collation of data on women artists, the art-historical detective work of finding archival material, works, books, manuscripts and letters of women artists, has been central to feminist art-historical projects (see the select bibliography) and the building of feminist archives since the early 1970s. A large number of collections of 'great women artists', biographical and bibliographical dictionaries and exhibition catalogues have been published since then which attest to women artists' presence, outline their work and offer data for further research. Biographical and bibliographical data on women artists can be found on the internet through many research projects and library and museum collections, and most libraries now possess very extensive databases of books, theses, articles and reviews on artists which facilitate research and access to detailed studies on the work of women artists. With such research tools at hand, why is it that women artists in the twentieth century continue to appear as rare beings and that to write about women artists is still seen as a highly specialised, even esoteric, occupation or an irrelevance to the 'main' agenda?

Any research about women artists quickly brings one to the question of value, to questions about how frameworks for interpretation in art history define 'major' and 'minor' artists and validate particular research areas and topics, and how ideology works to construct some subjects as 'appropriate' for research while excluding others. While there are many instances in which women artists are repeatedly mentioned in modernist histories and one piece of their work is reproduced, this has not, of itself, prompted further studies or exhibitions or monographs or *catalogues raisonnés* to be produced. Women artists' writings on their own work, for example, of which many exist, are rarely republished as a guide to teaching about their ideas and practice or as a demonstration of the positions they adopted as artists or theorists. Mara Witzling's two recent feminist anthologies of women artists' writings, for example, stand in direct contrast to Charles Harrison and Paul Wood's *Art in Theory, 1900–1990*, published as a definitive textbook for teaching, where of the 319 texts only 14 are by

women, and of these only three, Hepworth, Rosanova and Popova, predate the 1970s.[2] Analysing the value placed on women's work is one factor in explaining the processes by which women artists are routinely marginalised.

Two lines of enquiry, given this situation, become possible: the first looks again at the conditions of artistic production, the dominant models of artistic practice and how these have been slowly transformed in the twentieth century; the second looks at how modernism constructs a model of art history which produces the marginalisation of most women practitioners because it privileges and is centred upon discussion of only male examples. When the attention shifts to female subjects, the defining topos requires redefinition and new layers of complexity are added to the arguments. The field itself becomes redefined.

Modernism is most commonly identified with the succession of modernist movements in Western art history which emerged in the early twentieth century and which, to take a prominent example, A. J. Barr presented in his book *Cubism and Abstract Art*.[3] The chronology from 1900 to 1935 presented by Barr has been the subject of extensive critique, for its limited explanations of change in terms of novelty, reaction and causality,[4] and for its biases and exclusions not only with respect to women but in the formation of a particularly exclusive Euro-American model of internationalism across a Paris–New York axis.[5] Barr's account has also been criticised for its privileging of appreciation and sensibility in its aesthetics in a manner which emphasises only the 'purely visual' qualities of autonomous art objects.[6]

These essays bridge the common formalist periodisation of modernism which developed as a result of Barr's chronology into 'classic' modernism (1890–1939), leading to the work of the American abstract expressionists, 'high' modernism (1940–65) and 'late' modernisms (1965 to the present (1998)). For when the centre of international trade in contemporary art moved in 1940 from Paris to New York, the story of modernism as 'high modernism' continued in the post-war institutionalisation of that culture in the work of museums of modern art and art publishing houses in both Europe and America.[7] Post-war culture developed the 'normative' model whereby competing members of avant-garde art movements are categorised chronologically in terms of international developments with national/regional variations, major and minor artists, and hierarchies of innovators and followers within the avant-garde. Modernism, understood as this art-historical and curatorial model, a 'corporate system',[8] is not *the* history of twentieth-century culture, it is a selection from all the forms of visual culture produced at any one moment. As Raymond Williams has indicated about how a selective tradition survives (how, for example, modernism becomes synonymous with all 'modern art'), 'an effective dominant culture is always passed off as "*the* tradition", "*the* significant past"'.[9] Williams's model of culture, developed through attention to Gramsci's concept of hegemony, highlights how what can be described as a corporate system in culture arose as the result of struggle and negotiation for power between dominant, residual and emergent formations in a society.[10] Recognising the operations of a selective tradition at work as a process, not a fixed incontestable framework, usefully enables reconsideration of the role of institutions in maintaining and mediating that tradition and opens a space for analysis

of the criteria, values and interests represented in the selection. Subscribing to the view that because a woman artist has not been consecrated by a major exhibition or a book, she cannot be a worthy object of study, is to subscribe to the values determined by the existing model of culture and to leave unquestioned its value system or its ability to perpetually reinvent itself.

Understanding modernism as a selective tradition enables a shift in focus towards examination of the ideologies at work – and their relation to sexism, racism, nationalism – which have defined modernist canons, defined what counts as significant art practice, and formed both the implicit and explicit biases of much art criticism and history. Modernism can then productively begin to be studied in Williams's terms as a 'signifying system', or set of ideologies, within culture which are constitutive of that culture.[11] What values are in operation when the same key examples are repeatedly used to 'explain' modernism? Why, as Carol Duncan has asked about the Museum of Modern Art's display, are the definitive moments in modernism represented by the creative male artist/passive female model dualism?[12]

If one adopts Michel Foucault's terms to analyse the relationship between modernism and modernity, one could extend this argument by attention to the complex interrelations between institutions, practices and discourses.[13] This might enable art practices, studio procedures or modes of criticism as forms of knowledge (in terms of the construction of 'disciplines', 'statements' and 'discursive formations') which generate, categorise and produce subjects, artists, masterpieces, œuvres. This framework analyses the production of knowledge as always situated/located in both time and place and pays attention to the discontinuities in our invented traditions, disrupting the notion of teleology or continuity implicit in most modernist histories – the 'golden torch' theory of male inheritance and exchange. Such attention to the power and operation of discourse, the use of language terms (and the authority to name) manifest in specific historical events, may enable different types of analysis of the formation of institutions, the emergence of ideas around an exhibition, methods of classification and teaching, systems of control, teaching and surveillance, limitations in thought and the 'interest' generated by 'new' discoveries in a discipline. In Foucauldian terms, an archaeology/genealogy of knowledge may also enable a means to reconsider those on the margins as offering resistance against dominant institutions, practices or discourses. By 'freezing' or 'jamming' the constant repetition of definitive evaluation in relation to the canon, questions about how such value judgements are arrived at can be asked, and also, what are the mechanisms which underlie the reproduction of modernist ideas and practices as normative or 'the only way to proceed'.

For feminists, attention to the processes by which women artists have been marginalised in the selective tradition of modernism has only been the first step in recovering a history of women artists. Analysis of institutions and 'male-dominated' canons, of the work of intellectuals through the theories and practices they inherit, maintain, produce and challenge, must necessarily consider what stake this knowledge has in relation to investments in and articulations of social, economic and cultural power. What appears as a consensus arrived at through mediation or a dialogue

between competing accounts or insights brought by fresh empirical enquiry cannot be divorced from the knowledge-interests of those who have the power to fund, publish, promote and package their particular views of the world. If one wants to account for the processes through which women artists are rendered invisible, one must look not only to the 'exceptional' case, the magnificent exception, but also to the trivialisation of women's work through stereotyping or the exclusion or devaluation of areas where women artists worked in large numbers.

In most histories of modernism women artists' rare occurrences frequently place them in a separate category designated by their gender. Women artists often appear defined exclusively as the embodiment of the 'feminine', but this mode of presentation positions women as singular isolated followers of male examples, never innovators, in modern movements.[14] Innovation and a relation to all-male genealogies are often the key to how a progressive avant-garde artist is described and positioned. The question of women's position has always initially been defined in relation to a better-known all-male circle of friends; in fact, it is almost a definition of the avant-gardes of the twentieth century that they consist of a self-defined (male) group against whom, no matter how strong the evidence is of women's participation, women remain a marginalised 'Other': a strategic absence.[15] The most visible women artists in these modern movements remain those who were the ex-pupils, wives, lovers, mothers, patrons or colleagues of male artists in avant-garde groups. Women's relationship to each other is frequently ignored, designated a non-subject.

Kuhn's paradigm theory, developed from studies of how communities of scientists produce scientific knowledge, has been used as one model to analyse art history as a discipline, which, although it may encourage a diversity of explanations within an agreed framework, nevertheless privileges certain paradigmatic examples of study and methods.[16] Paradigm shifts are possible: witness the protracted debates between modernism and postmodernism concerning where different boundaries may be drawn and which theoretical stances are regarded as persuasive. Nevertheless, there are clearly defined axes in this exchange which continue to privilege certain types of work and certain artists as 'paradigmatic' of dominant trends. Bourdieu's analysis of a field in which individuals and institutions operate in a market to acquire both economic and cultural capital by making distinctions between cultural objects and judgements of taste both individually and as part of social groups represents another persuasive analytical model.[17]

These ideas are important in comprehending how even feminist work on women artists may repeat, challenge and resist already existing assumptions in accounting for the emergence of modern movements in the twentieth century while forming new perspectives and practices. Feminist art history has its own history of emergence within the academy and art school system since the 1970s and its own struggles about interdisciplinary methods within cultural studies, women's studies and art school curricula.[18] These have been fuelled by an external focus upon feminism as a politics, not just a methodology, with its injunction towards activism and demands for social change both within and outside the academy; a focus produced by substantial critiques of the closures within feminism in its address to all women,

particularly in respect of its analyses of class, race and sexual orientation. Feminism's tenuous hold within the academy and its increasingly academic debates as well as divergent methodologies are also the product of its own histories of negotiation of disciplinary boundaries for recognition and alliances with different programmes for social and political change. The surety of a 'correct' type of practice for feminist art history does not exist – in contrast, perhaps, to the certainties of method associated with different kinds of formalist analysis in modernism. Today it is necessary to speak of feminist art histories in the plural, but the aim of this work is not to canonise a few more token women as great artists, nor is it to 'taxonomise the women's movement to make one's own political tendencies appear to be the telos of the whole' since this, as Donna Haraway warns, may produce more 'epistemologies to police deviation from official women's experience'.[19] While trying to encourage a broadening of research into the work of women artists within the academy, the stake for feminism lies in developing perspectives adequate for an exploration of women as subjects.

## Women and modernity

Following Mary Kelly's suggestion in 'Reviewing Modernism',[20] opening up a distinction between modernism and modernity is one way in which the materiality, sociality and sexuality of the field called modernism can be reconsidered and the vested knowledge-interests articulated there can be critiqued. Thinking about women's position within modernity may enable us to articulate more clearly both women's social, political and cultural experience of the world and the specific positions, viewpoint and perspectives embodied, in the sense of articulated rather than reflected, in their theories and practices as modernists. Modernity remains a complex notion, whether it is understood as the transformation of everyday life through the accelerated pace of changes brought about by (1) transformations within capitalism/industrialisation, by changing patterns of work/leisure, production/consumption;[21] (2) a redefinition of space and time brought about by advances in and the potential uses of technologies of energy/transport/mass communications/visual media;[22] or (3) definitions of what it means to be modern in the sense of being 'à la mode' or belonging to the zeitgeist, alongside (4) the effects of social change offered by varieties of political and intellectual avant-gardism.[23] Defining themes in modernity or modern social and political thought is further problematised by the relationship of modernity to the Enlightenment project and to both colonial and imperialist enterprises and anti-/postcolonial struggles which draw on larger histories and developments stretching from the eighteenth century to the present.[24] The woman's movement itself has its own particular genealogy in relation to Enlightenment thought and colonial and postcolonial struggles. As Barbara Marshall suggests:

> Engendering modernity reveals that gender is not absent from the discourse of modernity – it was there all along but was not recognised, it has remained largely 'unthought'. But silence constitutes a special type of treatment – a strategic absence, or presence by absence. We need to historicise some of our basic concepts (such as the public/private distinction) to undermine some of the reified abstractions which

have excluded women from analysis, to correct the one-sided story which misin-forms social theory's self-understanding.[25]

Following Marshall's analysis, feminist art history needs both to break the monolithic placing of women as 'Other' and to address the historical critique of the public/private distinction, given the changing life, experiences and work of twentieth-century women. New feminist readings of women's lives addressing the changes in women's attitudes and experiences are emerging in sociology, social history and cul-tural studies, which challenge the models of analysis previously used. The late-nineteenth-century Victorian ideology of 'separate spheres'[26] – whereby women are allied with the private world of hearth and home and men with the public world of business, culture and politics – may have remained visible at the level of public rhetoric, particularly given its reincarnation in 1950s ideologies of the nuclear family,[27] but its bases in social, political and economic life have shifted dramatically in the course of the twentieth century.[28] For behind the 'ideology' of the nineteenth-century images of the 'angel at the hearth', the bourgeois woman of leisure who amateurishly dabbled in the arts and in philanthropic good causes, lie other images of the women who built schools, founded colleges, campaigned in a variety of social and political movements, including anti-slavery and temperance movements, formed women's com-munities and challenged the system of training and recognition by demanding entry to the professions; who published novels and political tracts, and sold their artwork to earn a living for themselves and their families.[29] In North America and Europe, new forms of academic knowledge, coupled with the increase in the number of uni-versity-educated women and the campaigns for suffrage, increasingly emphasised cul-tural and educational factors in women's development, challenging the 'biological' basis for most arguments underpinning the ideology of separate spheres.[30] By the 1890s women had gained access to the academic art school system and were travelling to major cities in ever-increasing numbers to train in academies, private artists' ateli-ers or small schools for modern art.[31] In Britain, Virginia Woolf's choice of 1910 as the year when things changed is significant on many levels, both as the year of the first Post-Impressionist exhibition in London, and the beginnings of increasingly militant suffrage campaigns. That year also represents historically the moment of decline for Liberal patriarchal imperialist England[32] and the emergence of the figure of the 'New Woman': a different identity for modern women. Focusing on these changes, both empirically and qualitatively (through oral history, anecdotal and attitudinal research), and in terms of how we understand or conceive of these, may enable us to reconsider the work of women from a different perspective and highlight the sense of negotiation of a 'public' and 'private' self in women as professional artists. Such redefinition or refocusing is indicative in historical analysis of a means of coming to terms with a central feminist phrase, 'the personal is political'.

### Feminism and modernism

At the level of ideology, the male artists of many avant-garde movements who have been mythologised in terms of their asocial, decadent or self-abusive behaviour, in

different libertarian, romantic or revolutionary forms, are often represented as a radical social challenge to the Victorian (bourgeois) ideology of separate spheres.[33] If the figure of the *flâneur* in late-nineteenth-century Paris encapsulates the perspective of modernity from the point of view of a bourgeois, detached, even disinterested, vision dependent upon a masculine freedom within the city,[34] why should women look for a *flâneuse*, a female equivalent? The women who were partners and colleagues of male avant-garde artists are frequently stereotyped as the loyal, if emotionally unstable, models, muses and mistresses of these charismatic figures.[35] Women artists' mythological status as outcasts from the norms of bourgeois ideology has often been measured against the norm of 'ideal' wife and mother through attention to their sexual mores or behaviour, frequently arriving at a characterisation of the woman-in-question as someone who blindly follows and supports the revolutionary convictions of her partner. This characterisation routinely ignores the kind of partnership established and the fact that some of these women also became mothers. The Victorian ideology of 'separate spheres' was frequently repeated to women through family members, teachers and partners in terms of a clear choice; one must be an artist or a wife and mother. Such an ideology treated as incomprehensible or a contradiction in terms the idea of the woman artist as a mother. Coupled with the isolation of the rare woman achiever and the erasure from collective knowledge of large numbers of women who remained artists, some of whom had children, this 'ideology' perpetuated the idea that having a partner or children was an impossibility if one sought a creative life as an artist. One form of productive enquiry using the private/public distinction for framing an analysis of representations in terms of both signifying spaces and significant differences in social/cultural experiences has been Griselda Pollock's analysis of the depiction of social spaces in the work of male and female Impressionists.[36] Another dimension to this question can be found in Linda Nochlin's analysis of Berthe Morisot's depiction of a wet-nurse feeding Morisot's child, which draws on an analysis of historically specific and class-bound social customs which 'denaturalises' the bond between mother and child and offers another means to reassess Morisot's dismissal because of her position as a 'feminine' painter.[37] Alicia Foster's approach, which draws on feminist research into women's experiences of modernity in sociology, highlights the significance of shopping in the metropolis as a means to discuss Gwen John's life and work in a way which counters the 'nun'-like qualities which have previously stereotyped her.[38]

The notion of 'separate spheres' continued to be echoed in the ideology of the post-war nuclear family, in so far as it segregated tasks and responsibilities within and outside the home (albeit with the connotation of complementarity and the translation of skill into 'domestic science'). It has also frequently been 'naturalised' by society as 'the way things should be' and worse still as 'the way things have always been'. The institutionalisation of culture particularly in museums and publishing frequently markets and repeats such stereotyping.[39] The 1950s denial of women's creativity and labour in the face of 'keeping up appearances' of routine femininity was again at odds with the actual changing experience of women in the labour market since the Second World War and with the influx of women who joined the waged labour

market, especially women working after marriage, which continues to increase.[40] The image of the 'ideal wife and mother' continued to provide a problematic access to social acceptability for women artists, who either appeared as the silent self-effacing girlfriend who quietly made work in the kitchen[41] or like Lee Krasner became the artist–wife who made jam on the day when reporters came to visit her husband, the 'legendary' painter Jackson Pollock.[42]

As Bridget Elliott and Jo-Ann Wallace have argued, feminism has initiated new frameworks to consider the positionings of women artists – (im)positionings which are against the grain.[43] Whitney Chadwick's work on how the Surrealists' image of Woman as the elusive muse or 'femme–enfant' framed the reception of the women Surrealists is but one example.[44] Briony Fer's work on women constructivists takes a different line of enquiry, arguing that while gender differentiation can be discerned, the grounds and content of such an analysis vary considerably depending on which historical moment is studied.[45] In another study, Deborah Cherry and Jane Beckett have argued that our understanding of femininities in 1920s Paris should be broadened to consider the differences between women in relation to definitions of the modern woman's identity, subjectivity and sexuality, exemplified by the figures of 'les midinettes, les avatrices, les garçonnes'.[46]

In order to reconceive the lives, experiences and work of women as artists during the twentieth century, we need to recognise the social, political and cultural differences bound up with and in relation to theories of race, class, sexual preference and ethnic and religious difference. Women, and women artists among them, are not and have never been a homogeneous group. Gayatri Spivak has argued with regard to criticism, feminism and the institution, that rather than constantly positioning the woman as inhabiting the spaces of absence in a universalising discourse, it is necessary to pursue questions about 'the heterogeneous production of sexed subjects',[47] a subject-constitution based not only on psychoanalytic models (and their counter-arguments), but also with a view to the international division of labour. Such questions as these are critical in developing different synchronic accounts of women's activities working within the same historical moment; but as with diachronic studies which focus on trends/movements through historical time, the generalised assumptions which underpin such work equally require careful scrutiny.

Class and economic privilege has been a strong factor in determining who became and continued as artists among the large numbers of educated middle- and upper-class women artists in Britain, America and Canada, and who gained access to extended periods of art education and had sufficient independent means to establish both a studio and a reputation. Among women artists in the first half of the twentieth century, many did have private incomes or financial support from their parental family or husbands,[48] but this is not the whole story, as access to formal education through scholarships and increasing diversity in the job market meant that many women artists earned a living working as designers, illustrators and occasionally writers.[49] Closer examination is also needed of their relationships with their male peers: stories of women as perpetual pupils abound in the mythologies about women artists in the twentieth century, because no credence is given to developing a picture

of a woman artist as an independent subject, and so far little attention has been paid to the impact of women artists as teachers on generations of art students.

### The essays

What nominally unites these essays is their consistent focus upon how gender operates in relation to class, race, sexual orientation and social and political belief systems and values through a close historical reading or symptomatic rereading of women's lives and art practices. However, the analysis shifts in each essay from attention to individual artworks to broader analysis of representations in visual culture and politics; from interpretations of events based on significant liaisons or personal connections to the examination of how women's work has been stereotyped or positioned negatively within the value systems used in curation and art criticism. Each essay takes as its point of departure common definitions of key modernist tropes or characterisations and through analysis explores their limitations in respect of women artists, for example, the idea of the autonomy of art guaranteed by the separation of art from politics or modernism as centred in a modern relationship to contemporary metropolitan experience, or the marginalisation of women in discussions of a modern movement. These essays also engage with theoretical work from literary criticism, philosophy, sociology and psychoanalytic theory.

Jane Beckett and Deborah Cherry's essay analyses the representation of four women artists in relation to their involvement within Vorticism's manifestation in Britain in the Rebel Art Centre and its magazine, *Blast*. They examine the coverage in the press in terms of how the women are represented and raise the notion of 'street-haunting' to analyse again conceptions of space and time in the modern metropolis, which were so central to questions of the New Woman and modernity. Their focus on the first British avant-garde movement, which is usually regarded as a poor relation of Cubism in France and Futurism in Italy, is significant, as it was itself marginalised until its enthusiastic 'recovery' in the 1970s as a precedent for modernism in Britain. Nedira Yakir takes another moment in the creation of modernism in Britain, the Tate Gallery's exhibition of the history of St Ives from 1939 to 1964. She reviews how the exhibition marginalised the women who were included, placing them as witnesses to events, rather than active participants. Having the opportunity to interview both Margaret Mellis and Winifred Barns-Graham provided her with another means to review this misleading interpretation: an oral history which places women's perspectives as central.

Two other essays in this volume question the bias implicit when historical understanding is focused exclusively on (male) authority figures. Pauline de Souza's essay on gender and representation in the Harlem Renaissance focuses on the work of Meta Warrick Fuller as a position of difference with respect to other representations of Afro-American womanhood — women in the labour market and as mothers — in the developing debates on the 'New Negro' of William E. B. Dubois and Alain Locke between 1914 and 1934. Moira Roth's essay — the text of a lecture given as a performance — sends imaginary letters to Duchamp in order to consider her own role

among other dutiful daughters, turned irreverent sisters, through the challenge to Duchamp represented by the work of Lynn Hershmann, Shigeko Kubota and Faith Ringgold. Her essay raises the question of how the legacy of a 'major' artist continues to determine the scholar's field of study and the significance of imaginary identification with the object of study. Repeated homages paid in both artworks and criticism continue to rearticulate their position across modernism/postmodernism and enable continued maintenance of their authority. Moira Roth's scepticism arises because the questions which most concern her now as a feminist are moving off in a different direction.

Once we start to move away from women defined principally through their relationships to men, women's lived experience of one another, their own relationship as women to other women, starts to come into view; in friendships, in lesbian relationships and in family relationships as sisters, mothers and daughters. As sexed subjects, women do not necessarily share the same attitudes, perspectives or values about marriage, social status, love, children, sexuality or ageing. Identifications between women – actual, real and imaginary – as valued or ambivalent role models or competitors[50] are as significant as the exchanges between women and men, and need to become a greater part of our understanding of women's lives and experiences in the twentieth century. One area which has emerged from comparisons with women's role in literary modernism is the small lesbian subculture centred on the figures of Gertrude Stein, Natalie Barney and Romaine Brookes in both Paris and London.[51] The history of lesbianism (and homosexuality) itself undergoes dramatic changes in the course of the twentieth century. Any brief consideration of the spectrum of positions across the century leads one from (male) homosexuality's criminalisation as an underground status to repeal of legislation, Gay Pride and campaigns for policies against discrimination. In this respect, it is necessary to consider the wide variety of covert and overt forms of persecution, and alternately celebration, of lesbian identities in politics and in cultural life. 'Lesbianism' undergoes considerable shifts in the twentieth century in terms of how it is defined, experienced or thought: from medical classifications, as a pyschological and psychoanalytic problem needing a cure; to theories of passive and active 'inverts'; to acknowledgement of 'lesbianism' as an 'innate condition', a form of sexual behaviour or a lifestyle choice.[52] Bridget Elliott's essay explores a highly ambivalent moment of exchange between two artists, Romaine Brooks and Gluck, in 1923, when they paint portraits of each other. Elliott stages their reactions to each other against the background of representations of lesbian identities, reconsidering both the question of *les garçonnes* and ideas of the *flâneur* and the dandy.

Women's relationship to their mothers and women's experiences of being mothers in the twentieth century are similarly neither uniform nor subject to a singular categorisation, given, for example, the ways in which the institutions of medicine, social policy, political rhetoric, psychoanalytic theory (either in popular media representations or clinical practices) have changed the way in which 'mothering' has been thought.[53] Renee Baert attends to the specificities of how mother–daughter relationships can be figured through absence and presence in her discussion of the work

of two contemporary women film-makers and by utilising the shifting possibilities offered through a range of psychoanalytic models. In Hilary Robinson's essay a different model again is offered, which draws on Irigaray's ideas of how women may create their own concept of 'beauty' (a standard defined in opposition to the singular (male) ideal of beauty), and highlights Irigaray's attention to depictions of the biblical Anne–Mary relationship as a bond between women of different generations. Hilary Robinson discusses two examples of contemporary Irish women artists' work and how each has represented women in terms of mother–daughter and mother/ Other/udder relations with respect to the social, political, religious and cultural specificity of Ireland.

Women's identifications with a politics for and on behalf of women and the changing political forms and institutional struggles for representation have also changed dramatically during the course of the twentieth century. The level of political and social identifications made in different countries at different historical moments and manifest in different social and aesthetic strategies has varied from Marxist, Fabian, conservative or liberal definitions of 'the woman question' to the 1970s politics of the women's liberation movement.[54] Politics and critique include the conflicts between the suffragettes' militancy and the constitutional and social work of the National Union of Women's Suffrage Societies (NUWSS);[55] between popular mythologies of the 'war between the sexes', or, later, Simone de Beauvoir's existentialism, and the development of feminism itself as a term in both popular and academic debate;[57] from Betty Friedan's 'problem with no name'[58] to academic feminist psychoanalytic critiques of the Phallic Symbolic.[59] Contemporary forms of feminism have developed in a critical, even dialectical relationship to those two great movements of twentieth-century modern thought, Marxism and psychoanalysis, as well as in response to the development of liberal political thought, taking up positions in relation to fascism, various nationalisms, communism, colonialism and the legacies of imperialism. How else might one find a means to consider Valentine de Saint Point's Nietzschean celebration of a superwoman for the new 'fascist' superman in her 'Futurist Manifesto of Lust'?[60] In this volume, Joanna Frueh offers a three-part comparison in the figure of Margarett Sargent, contrasting her life and work with those of Carolee Schneemann and Joan Semmel. Joanna Frueh weaves these three narratives of dissimilar lives, social/artistic dilemmas and choices to offer poetic/politic ways of addressing both the proactive and reactive elements of subjectivity and Otherness — playing on the slippage in categories offered by the Monstrous and concepts of messiness in opposition to contained femininity. Rosemary Betterton's essay, again through three pairs of comparisons, explores representations of women in the work of women artists in relation to the suffrage movement in both Germany and Britain between 1890 and 1920. Her comparisons reveal contrasts in the conception of space; of the depiction of historical time through use of allegory; and of genre, using the concept of hybridity. She concludes by suggesting that suffrage offered a different direction for women artists and led many women away from normative definitions of modernism.

While differentiating between women as subjects in respect of class, race and sexuality, and placing the emphasis upon their basis in culture, is important to gain a

view of the particular subject in question, these factors are not indices for measuring discrimination or establishing hierarchies between women.[61] Differentiation may help to unravel the determinations upon women's lives and belief systems in both broader social structures and contemporary ideologies, but it may also help recover a view of women as agents by considerations of how typical or unusual their activities and views were in their historical moment. The idea here is to avoid the impression that women are simply vectors 'overdetermined' by their time, while recovering some sense of their agency in terms of actions and positions in the world which neither disregards the context in which they worked nor universalises their experience by jumping into false comparisons with today (1998).[62] Susan Platt's discussion of the critic Elizabeth McCausland attempts to show the development of an engaged form of art criticism in the context of the 1930s, but also how this was produced through her sense of identification with and conception of women artists in her writing. My own essay on Barbara Hepworth seeks to question the idea of women's autobiography as a self-determined transparent 'truth', while reviewing constraints upon the production of an artist's statements. This becomes a means to question the criticism produced about her work which even taken over thirty years of art production continued to repeat and categorise the feminine as defined by a binary opposition. The idea, as with the other essays in this anthology, is to break the monopoly of women positioned perpetually as 'Other' and to open up a multiplicity of enquiries to problematise the question of women, their art practices and modernism itself as a 'determinant discursive field'.

## Notes

1 G. Pollock, 'Vision, Voice and Power', *Block*, No. 6, 1982, p. 9. See also Elizabeth Fox-Genovese, 'Placing Women's History in History', *New Left Review*, May/June 1982, No. 433, pp. 5–29; Joan Kelly, 'The Doubled Vision of Feminist Theory', in J. Kelly, *Women, History and Theory* (Chicago, University of Chicago Press, 1984), pp. 51–64; and Joan Wallach Scott, 'Gender: A Useful Category of Historical Analysis?', in J. W. Scott, *Gender and the Politics of History* (New York, Columbia University Press, 1988), pp. 28–50. My own research highlights the fact that the representation in art history is considerably less than the numbers of women artists exhibiting their work in Britain: see K. Deepwell, 'A Fair Field and No Favour', in S. Oldfield (ed.), *This Working Day World: Women's Lives and Culture(s) in Britain, 1914–1945* (Brighton, Taylor and Francis, 1994).

2 Mara Witzling, *Voicing Today's Visions* (London, Women's Press, 1994/95) and *Voicing Our Visions* (London, Women's Press, 1992); C. Harrison and P. Wood, *Art in Theory, 1900–1990* (Oxford and Cambridge, Mass., Blackwell, 1992).

3 A. J. Barr, *Cubism and Abstract Art* (New York, Museum of Modern Art, 1936); on periodisation see Raymond Williams, 'When was Modernism?', in R. Williams, *The Politics of Modernism* (London, Verso, 1989), pp. 31–6; Charles Jencks, 'The Postmodern Agenda', in C. Jencks (ed.), *The Postmodern Reader* (London, Academy Editions, 1991), pp. 10–24; Peter Osborne, 'Modernism, Abstraction and the Return to Painting', in Andrew Benjamin and P. Osborne, *Thinking Art: Beyond Traditional Aesthetics* (London, ICA, 1991), pp. 59–80; and Andreas Huyssen, 'Mapping the Postmodern', in L. Nicholson (ed.), *Feminism/Postmodernism* (London, Routledge, 1990), p. 260.

4 Meyer Schapiro, 'On the Nature of Abstract Art', *Marxist Quarterly*, January–March 1937, pp. 77–8, discussed in Pollock, 'Vision, Voice and Power', p. 3.

5  Griselda Pollock, 'Modernity and the Spaces of Femininity', in her *Vision and Difference: Femininity, Feminism and Histories of Art* (London, Routledge, 1988), pp. 50–1; and Griselda Pollock, 'Painting, History and Feminism', in M. Barratt and A. Phillips (eds), *Destabilising Theory* (London, Polity Press, 1992), pp. 136–76.

6  Open University course material, both videos and documents, on Modern Art and Modernism from 1983 is exemplary in this respect; see the critique in S. Watney, 'Modernist Studies: The class of 83', *Art History*, 7:1, March 1984, pp. 102–9.

7  MoMA videos in the Modern Art and Modernism course; P. Virgo, *The New Museology* (London, Reaktion Books, 1989); and C. Duncan, *Aesthetics and Power* (Cambridge, Cambridge University Press, 1993).

8  Raymond Williams, 'Base and Superstructure in Marxist Cultural Theory', in R. Williams, *Problems in Materialism and Culture* (London, Verso, 1980), p. 38.

9  *Ibid.*, p. 39.

10  *Ibid.*, pp. 37–49.

11  Raymond Williams, *Culture* (London, Fontana, 1981), pp. 12–13.

12  C. Duncan, 'MoMA's Hot Mama's', in Duncan, *Aesthetics and Power*.

13  M. Foucault, *The Archaeology of Knowledge* (London, Tavistock Press, 1985). See also Nancy Fraser, *Unruly Practices: Power, Discourse and Gender in Contemporary Social Theory* (Cambridge, Polity Press, 1990).

14  Else Honig Fine, 'Women Artists and the Twentieth Century Art Movements: From Cubism to Abstract Expressionism', in Judy Loeb (ed.), *Feminist Collage: Educating Women in the Visual Arts* (New York, Columbia University; Teachers College Press, 1979), pp. 21–34; Whitney Chadwick and Isabelle de Courtivron, *Significant Others: Creativity and Intimate Partnership* (London, Thames and Hudson, 1993).

15  P. Burger, *Theory of the Avantgarde* (Minneapolis, University of Minnesota Press, 1984); R. Krauss, *The Originality of the Avant-Garde and Other Modernist Myths* (Cambridge, Mass., MIT Press, 1981). See also L. Tickner, 'Men's Work? Masculinity and Modernism', in N. Bryson, M. Ann Holly and K. Moxey (eds), *Visual Culture* (London, University Press of New England, 1994), pp. 42–82.

16  Thomas Kuhn, 'Paradigms, Tacit Knowledge and Incommensurability', extracts and discussion in C. Harrison and F. Orton, *Modernism, Criticism, Realism* (London, Harper and Row, 1984), pp. 229–42.

17  Pierre Bourdieu, 'The Aristocracy of Culture', *Media, Culture and Society*, 2, 1980, pp. 225–54, from his *Distinction* (London, Routledge, 1989 [Paris, Editions de Minuit, 1979]).

18  L. Nochlin, 'Starting from Scratch: The Beginnings of Feminist Art History', in N. Broude and M. Garrard (eds), *The Power of Feminist Art* (New York, Harry Abrams, 1994), pp. 130–7. See also the Introduction to N. Broude and M. Garrard, *The Expanding Discourse: Feminism and Art History* (New York, Icon, HarperCollins, 1992); R. Parker and G. Pollock, *Framing Feminism: Art and the Women's Movement, 1970–1985* (London, RKP/Pandora, 1987).

19  Donna Haraway, 'Manifesto for Cyborgs', in L. Nicholson (ed.), *Feminism/Postmodernism* (London, Routledge, 1990), p. 198. See also on US Third World Feminism, Chela Sandoval, 'New Sciences: Cyborg Feminism and the Methodology of the Oppressed', in C. Gray (ed.), *The Cyborg Handbook* (New York and London, Routledge, 1995).

20  Mary Kelly, 'Reviewing Modernism', in B. Wallis (ed.), *Rethinking Representation: Art After Modernism* (New York, Godine and New Museum of Contemporary Art, 1984), p. 99.

21  David Harvey, *The Condition of Postmodernity: An Enquiry into the Origins of Cultural Change* (Oxford, Blackwell, 1990); Margaret A. Rose, *The Postmodern and The Post-Industrial: A Critical Analysis* (Cambridge, Cambridge University Press, 1991).

22  Harvey, *The Condition of Postmodernity*; Barbara Marshall, *Engendering Modernity* (Cambridge, Polity Press, 1994).

23  Williams, *The Politics of Modernism*, pp. 37–64; Marshall Berman, *All That is Solid Melts into Air: The Experience of Modernity* (New York, Simon and Schuster, 1982).

24  E.g. J. Habermas, 'Modernity – An Incomplete Project', in Hal Foster (ed.), *Postmodern Culture* (London, Pluto Press, 1985), pp. 3–15; Scott Lash and Jonathan Friedman (eds), *Modernity and Identity* (Oxford, Blackwell, 1992).

25  Marshall, *Engendering Modernity*, p. 160.

26  *Ibid.* for an extended analysis.

27  E. Wilson, *Only Half-Way to Paradise: Women in Post-War Britain, 1945–1968* (London and New York, Tavistock Press, 1980).

28  Jane Lewis, *Women in England 1900–1950* (Brighton, Wheatsheaf, 1984) for a picture of changing work in the inter-war period. See also Marian Glucksmann, *Women Assemble: Women Workers and the New Industries in Inter-War Britain* (London and New York, Routledge, 1990). For analysis of broader trends and sociological methods see Rosemary Crompton and Kay Sanderson, *Gendered Jobs and Social Change* (London, Boston, Sydney and Wellington, Unwin Hyman, 1990) and Cynthia Fuchs Epstein and Rose Laub Coser (eds), *Access to Power: Cross-National Studies of Women and Elites* (London, George Allen and Unwin, 1981).

29  Nancy F. Cott, *The Grounding of Modern Feminism* (New Haven and London, Yale University Press, 1987); Olive Banks, *Becoming a Feminist: The Social Origins of 'First Wave' Feminism* (Brighton, Wheatsheaf, 1986).

30  Rosalind Rosenberg, *Beyond Separate Spheres: Intellectual Roots of Modern Feminism* (New Haven and London, Yale University Press, 1982).

31  P. Gerrish Nunn, *Victorian Women Artists* (London, Women's Press, 1987); D. Cherry, *Painting Women: Victorian Women Artists* (London, Routledge, 1993); T. Garb, *Sisters of the Brush: Women's Artistic Culture in Late Nineteenth Century Paris* (New Haven and London, Yale University Press, 1994); and C. Yeldham, *Women Artists in Nineteenth Century France and England* (New York, Garland, 1984).

32  V. Woolf, 'Mr Bennett and Mrs Brown' (1924), quoted in J. Wolff, *Feminine Sentences: Essays on Women and Culture* (Cambridge, Polity Press, 1991), p. 51.

33  J. Wolff, 'The Invisible Flâneuse: Women and the Literature of Modernity', in Wolff, *Feminine Sentences*, pp. 34–50. See also Keith Tester (ed.), *The Flâneur* (London, Routledge, 1994).

34  For critical analysis of modernism and masculinities see Roger Cranshaw, 'The Possessed: Harold Rosenberg and the American Artists', *Block*, No. 8, 1983, pp. 3–10; Mary Bergstein, 'The Artist in his Studio: Photography, Art and the Masculine Mystique' and Lynda Nead, 'Seductive Canvases: Visual Mythologies of the Artist and Artistic Creativity', both in *Oxford Art Journal*, 18:2, 1995, pp. 45–58 and 59–69.

35  As examples of this type of biography see Denise Hooker, *Nina Hamnett: Queen of Bohemia* (London, Constable, 1986) or Gretchen Gerzina, *Carrington: A Life of Carrington* (Oxford, Oxford University Press, 1990).

36  Pollock, 'Modernity and the Spaces of Femininity', pp. 50–90.

37  L. Nochlin. 'Morisot's Wet Nurse: The Construction of Work and Leisure in Impressionist Painting', in L. Nochlin, *Women, Art and Power* (London, Thames and Hudson, 1989).

38  Alicia Foster, 'She Shopped at Bon Marché: Gwen John and Shopping', *Women's Art Magazine*, No. 65, July/August 1995, pp. 10–14.

39  Such images form the basis for popular films and TV programmes in the 1980s on artists like Gwen John, Frida Kahlo and Camille Claudel.

40  Jane Lewis, *Women's Experience of Home and Family, 1850–1940* (Oxford, Basil Blackwell, 1986);

Deidre Beddoe, *Back to Home and Duty* (London, Boston, Sydney and Wellington, Pandora, 1987); Gail Braybon and Penny Summerfield, *Out of the Cage: Women's Experiences in Two World Wars* (London, Pandora, 1987).

41 Lucy Lippard, 'Sexual Politics: Art Style', in L. Lippard, *From the Center: Feminist Essays on Women's Art* (New York, Dutton, 1976), pp. 28–37, especially the list of sexist behaviour, p. 31.

42 A. Wagner Lee Krasner as L. K., *Representations*, No. 25, Winter 1979, p. 43. As the essay argues, this is but one representation among many in the public construction of Lee Krasner.

43 B. Elliott and Jo-Ann Wallace, *Women Artists and Writers: Modernist (Im)Positionings* (London and New York, Routledge, 1994), pp. 16–17.

44 Whitney Chadwick, *Women Artists and the Surrealist Movement* (London, Thames and Hudson, 1985).

45 Briony Fer, 'What's in a Line? Gender and Modernity', *Oxford Art Journal*, 13:1, 1990, pp. 77–88.

46 D. Cherry and Jane Beckett, 'Sorties: Ways Out from Behind the Veil of Representation', *Feminist Art News*, 'Women, Modernism and Modernity' Issue, *c.* 1990, 3:4, pp. 3–5. See also W. Chadwick, 'Fetishizing Fashion/Fetishizing Culture: Man Ray's 'Noire et Blanche', *Oxford Art Journal*, 18:2, 1995, pp. 3–17.

47 Gayatri Spivak, 'Criticism, Feminism and the Institution', interview with E. Grosz in G. Spivak, *The Post-Colonial Critic: Interviews, Strategies, Dialogues* (London, Routledge, 1990), p. 10. For a cultural geography approach, see also Steve Pile and Nigel Thrift, *Mapping the Subject: Geographies of Cultural Transformation* (London, Routledge, 1995), especially pp. 13–51.

48 Elliott and Wallace, *Women Artists and Writers*, pp. 19–29.

49 K. Deepwell, *Ten Decades: The Careers of Ten Women Artists born 1897–1906* (Norwich, Norwich Gallery, Norwich Institute of Art and Design, 1992).

50 Diana M. A. Relke, 'Models, Muses, and Mothers of the Mind: Mentrix Figures in the Early Lives of Artist-Heroines', in Christine Mason Sutherland and Beverley Matson Rasporich (eds), *Woman as Artist: Papers in Honour of Marsha Hanen* (Calgary, University of Calgary Press, 1993), pp. 19–39.

51 Shari Benstock, *Women of the Left Bank, 1900–1940: Paris* (Austin, University of Texas Press, 1986); Diana Souhami, *Gluck: Her Biography* (London and New York, Pandora, 1989); and Elliott and Wallace, *Women Artists and Writers*.

52 For historical analysis, Sheila Jeffreys, *The Spinster and Her Enemies: Feminism and Sexuality, 1880–1930* (London, Boston and Henley, Pandora, 1985); Jeffrey Weeks, *Sexuality and Its Discontents* (London, Routledge, 1985); for three contrasting views of lesbianism at different historical moments, but drawing on psychoanalysis, Simone de Beauvoir, *The Second Sex* ([1949] Harmondsworth, Penguin, 1981), pp. 424–44, Adrienne Rich, *On Lies, Secrets and Silences* (London, Virago, 1984) or Judith Butler, *Bodies that Matter: On the Discursive Limits of Sex* (London, Routledge, 1993).

53 As one example, M. Kelly, *Post-Partum Document* (London, Routledge, 1983).

54 Olive Banks, *Faces of Feminism* (Oxford, Martin and Robertson, 1982).

55 L. Tickner, *The Spectacle of Women: Imagery of the Suffrage Campaign, 1907–1914* (London, Chatto and Windus, 1988).

56 De Beauvoir, *The Second Sex*. See also J. Butler, 'Variations on Sex and Gender: Beauvoir, Wittig and Foucault', in S. Benhabib and D. Cornell (eds), *Feminism as Critique* (Minneapolis, University of Minnesota Press, 1987), pp. 128–42.

57 For early analysis of this ideology see Viola Klein, *The Feminine Character* (London, Kegan, Paul, Trench and Trubner, 1945); Helen Rosenau, *Woman in Art: From Type to Personality* (London, Isomorph, Nicholson and Watson, 1944).

58 Betty Friedan, *The Feminine Mystique* (New York, W. W. Norton and Co., 1963).

59 Toril Moi, *Sexual/Textual Politics: Feminist Literary Theory* (London, Methuen, 1985); E. Grosz, *Sexual Subversions: Three French Feminists* (Sydney, Allen and Unwin, 1989); M. Whitford, *Luce Irigaray: Philosophy in the Feminine* (London, Routledge, 1991).

60 Valentine de Saint Point, 'Futurist Manifesto of Lust', printed with M. Barry Katz, 'The Women of Futurism', *Women's Art Journal*, Fall 1986/87, pp. 13–14.

61 Parveen Adams, 'A Note on the Distinction Between Sexual Division and Sexual Differences', in P. Adams and E. Cowie, *The Woman in Question: m/f* (London, Verso, 1990), pp. 102–9, from *m/f*, 3, 1979.

62 See Teresa de Lauretis's discussion of different framing of the subject by Althusser and Foucault in 'Technologies of Gender', in her *Technologies of Gender* (Basingstoke, Macmillan, 1986), pp. 9–26.

# Women artists, modernity and suffrage cultures in Britain and Germany 1890–1920

'Modernism', a highly selected version of the modern which then offers to appropriate the whole of modernity.[1]

At the close of his short essay 'When was Modernism?', Raymond Williams calls upon us to 'break out of the non-historical fixity of *post*-modernism' and to 'counterpose an alternative tradition taken from the neglected works left in the wide margin of the century, a tradition which may address itself . . . to a modern *future* in which community may be imagined again'.[2] William's 'modern future' might easily be dismissed as a utopian appeal made at the very moment when, historically, the radical promise of socialism as a political and aesthetic force finally collapsed. Yet his plea for a reclamation of the radical project of modernity in the place of an ahistorical and selective field of modernism has had a powerful resonance for feminist cultural critics too. This is not only because women's cultural production has been written out of histories of modern art, as feminist art historians have shown, but because women have a vested interest in reclaiming the project of modernity.

In this essay, I shall explore some of the ways in which the categories of 'women' and of the 'modern' were being re-formed in Germany and Britain in the early twentieth century. The last decade of the nineteenth century and the first two decades of the twentieth saw a period of intensified struggle over sexual politics: women's rights to education, to the professions, to family income, as well as to the vote itself. While these changes were uneven and unpredictable in their outcomes and brought both greater choice and conflict, they did mark an irrevocable alteration in the way in which women as a historical category were constituted in Western society – as well as in the lived experience of individual women. As a result of an engagement with gendered politics, some women artists were able to develop representations of their diverse experiences of modernity that took different forms to those which characterised contemporary avant-garde art practice.[3] Such women traced maps of their presence in the modern city in ways that suggest a shifting set of gendered boundaries, spaces and parameters which crossed public and private spheres, offered new engagements with domestic life and sexuality, and encompassed a range of spiritual and political identities. By focusing on examples of representational practice that appeared to offer a space for women to articulate a changing sense of themselves as

new political subjects, I want to explore how such 'modern' self-determined female identities could be constructed and articulated in and across artistic and political cultures. What representational forms would be appropriate to women's new-found sense of themselves as artistic *and* political subjects?

## Space

There are two interconnected aspects of recent feminist critiques of modernism: the first examines how the construction of categories of sexual difference imposed limitations on women's experience of modernity and on their representations of that experience, and the second explores ways in which ideologies of modernism and its structures of inclusion and exclusion have continued to marginalise cultural practices by women. Feminist critics have focused precisely on the exclusion of women from the cultural experiences of the metropolis which came to be definitive of modernity; as Janet Wolff puts it succinctly, 'The literature of modernity describes the experience of men.'[4] Feminist historians have shown that it was the separation of public and private space in the nineteenth century, with the consequent exclusion of women from the public world of work, politics and the city, that marginalised women's cultural production. In addition to this literature of exclusion, recent historical accounts have begun to fill out the complex and varied ways in which women did participate in professional artistic life in the latter part of the nineteenth century.[5] And by the first decade of the twentieth century, the avant-garde critique of bourgeois cultural forms appeared to offer some women artists, at least, a means of escaping from the constraints of bourgeois femininity. Gillian Perry examines how, within the Parisian avant-garde, women artists were increasingly engaging with 'modern life' themes and techniques in their work, suggesting that historical shifts in the spaces of femininity were indeed occurring by the second decade of the twentieth century. As women entered into higher education and the professions, the boundaries between their experiences of modernity and those of men became less clear-cut, enabling a fragile space to open up within which women could position themselves as producers of modern art.[6] In Germany and Britain too, the metropolis provided greater opportunities to aspiring artists for education and training, as well as the possibility of economic independence and a range of cultural contacts that were less available in a provincial or rural setting. This new cultural formation with its more open, complex and mobile social relationships gave to women a degree of freedom which they could not experience within the confines of a more traditional environment. But this freedom could be an illusion. As Andreas Huyssen has argued, the creative self continually privileged within modernist discourse was founded on categories of sexual difference reinscribed across the divide between high and low culture. While individual women were able to participate, apparently as equals, within modern art practices, femininity remained the condition of difference against which authentic (masculine) creativity continued to define itself: 'the gendering of an inferior mass culture goes hand in hand with the emergence of a male mystique in modernism'.[7]

Käthe Kollwitz made the journey in 1885 from her provincial home town,

Königsberg, to Munich and Berlin in search of training and professional status, at the same time moving from a liberal bourgeois family circle into direct contact with the lives of the urban industrial classes in Berlin Prenzlauer Berg, where she settled with her husband in 1891. Many bourgeois women like Kollwitz who were involved in cultural or political work undertook this dual form of migration into the city, one that signified not only a geographical journey, but a move from private feminine space into the public sphere of higher education and the professions and towards new social identities. More precisely, it was a shift of the private *into* the public by a 'generation who transcended the confines of domesticity and marriage to invade the spaces of male culture'.[8] The representational forms that emerge from this doubly articulated shift are many and diverse. One response was to redefine the domestic *within* the public sphere and, in this way, precisely to interrogate its meanings in relation to women's experience.

Kollwitz was sympathetic to the German Socialist (SPD) women's movement, and her early graphic series on the theme of working-class revolt, *A Weaver's Rebellion*, exhibited in 1898, placed women at the forefront of political struggle, exploring how the interaction of the public and private domains was mediated through the bodies of women and children. In later work, like the illustrations produced for the Munich satirical magazine *Simplicissimus* between 1908 and 1911, Kollwitz represents domestic labour, poverty and homeworking as part of a wider discourse on family rights and social responsibilities.[9] But in a series of self-portraits beginning in 1889, she showed herself to be strikingly alone, characteristically depicting herself bust-length in full or profile face with only minimal background definition, her head isolated within the frame. Without obvious expression or emotion, her face emerges uncompromisingly from darkness, giving no clues to psychological insight, gendered or social status which might place her within a recognisable cultural discourse. In the language and traditions of portraiture, self-portraits by male artists have an ideological function as forms of self-legitimisation, even where, as within modernism, the figure of the artist is constructed as socially marginal. This gendered or cultural authority is especially evident where the artist presented his private life for public display by using the presence of his female model and/or wife as 'both the subjects of his painting and the subjects of his domain'.[10] But in Kollwitz's many self-portraits, family relationships are notably absent. As a female artist, the connection between public and private realms was necessarily structured in more contradictory ways.

In an early charcoal and chalk sketch, *Self-Portrait on the Balcony* from 1892, Kollwitz unusually gives the specific context of the balcony of her apartment overlooking the Wörther Platz in Berlin, from which she habitually drew (Figure 1). The figure gazes out over the city, her line of vision level with the roof-tops but framed still by the interior, a liminal space between the private and the public spheres. The balcony becomes a vantage point from which the artist can begin to engage with the city below her, a threshold opening on to the street beyond. This is in many ways at odds with the conscious stance of alienation adopted in many male avant-garde self-portraits, for example, in those by Kollwitz's contemporary, Edvard Munch, also newly arrived in Berlin in 1892. Walter Benjamin described the 'shock of conscious-

ness' which defined modernist sensibility as closely connected to the experiences of male bourgeois intellectuals thrown for the first time into intimacy with the urban masses in the public streets of the new metropolis in Paris, London and Berlin.[11] Raymond Williams has similarly argued that the emergence of modernism was crucially related to 'metropolitan perceptions', to 'the effect of the modern city as a crowd of strangers' and, more precisely, to the new (dis)location of artists and intellectuals within the changed social relations and cultural conditions of the metropolis.[12] The 'shock' effect of the modern city with its accompanying experiences of mobility, acceleration and discontinuity produced the effect of *distance* necessary to the male intellectual in the formation of a modernist aesthetic. Indeed, Williams suggests that

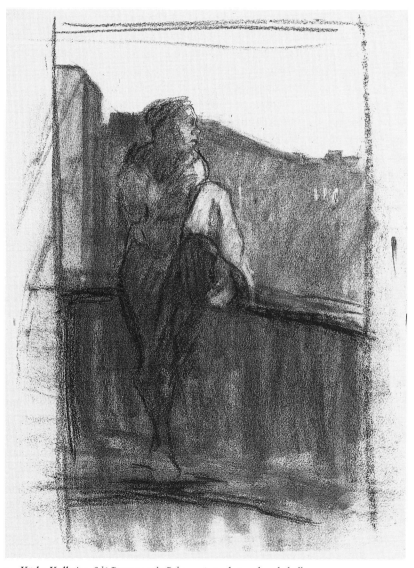

1    Käthe Kollwitz, *Self-Portrait on the Balcony*, 1892, charcoal and chalk

themes of alienation and estrangement make up a significant part of the repertory of representation in early modernist art. But, as Andreas Huyssen suggests, the psychological distance from the masses shared by many male intellectuals of the period also had a specifically gendered significance: 'In the age of nascent socialism *and* the first major women's movement in Europe, the masses knocking at the gate were also women, knocking at the gate of a male dominated culture.'[13] If male fear of women and bourgeois fear of the masses had become indistinguishable by the end of the century, one can assume that for Kollwitz, whose stated artistic sympathies lay with women *and* the masses, these specific forms of alienation and distance were not central to her subjective experience. And yet, in *Self-Portrait on the Balcony*, the fragile boundary between interior and exterior space holds the figure apart from the object of her gaze. The dynamic pose with one knee raised upon the barrier of the balcony ledge and arms wrapped around her body implies an active self-protective stance. Neither fully inside nor out, the figure is hesitant, suspended on the threshold of a new professional status. Split between self and spectator, Kollwitz projects herself within the double frame of the domestic *and* the urban world.

In Britain as in Germany before 1914, the women's movement marked out a new set of physical territories and psychological boundaries for women in the city that were often signified by a tendency to 'export the private into the public'.[14] When women made a public spectacle of their own bodies in mass demonstrations, in political discourse and even when subject to medical invasion, women's traditional concerns with family, sexuality and the domestic entered into the political arena to provide a new configuration of private and public space. In Britain, suffrage propaganda often integrated domestic and public concerns within its iconography. A satiricial pamphlet with a set of verses, *Beware! A Warning to Suffragettes*, by Cicely Hamilton, is one example published by the Artists' Suffrage League, an organisation which used commercial art forms including posters, cards, advertisements and pamphlets to communicate suffrage principles. The verses ironically contrast the contented figure of the wife with the 'ramping tearing Suffragette', and the illustrations by C. Hedley Charlton similarly set up and subvert popular feminine stereotypes, using a range of stock figures beloved of the mass press, from the 'happy wife' with her pots and pans to 'perfect frights' with huge, blue-stockinged feet. The final image shows an idealised youthful figure of a suffragist prisoner bound in chains yet upright and resistant, while the accompanying verse satirically enjoins her, '*Don't* earn your living – if you can, have it earned for you by a man. Then sit at home from morn till night, and cook and cook with all your might' (Figure 2). The inverted moral is clear: domesticity enslaves, while political sacrifice can bring into being a new kind of feminine subject, one who inhabits the street as well as the kitchen – and the prison cell in place of the nursery.

In these two very different types of image, a private self-portrait study by an artist and a commercial suffrage illustration, there is a common concern with a new sense of identity for women which lies beyond their circumscription within the confines of the feminine and the domestic. The ambiguity of Kollwitz's self-representation in 1892 – the balcony forms both a physical barrier and the vantage point for her vision – is supplanted by the 1900s by a different kind of spatial contradic-

tion. The prison that encloses the body of the young suffrage prisoner is symbolic of the social restraints that bind her still, but the deliberate irony of the juxtaposed text and image is addressed to a new feminine political subject who was confident that the first decade of a new century would bring changes to the gendered and sexual order.

## Time

For if the spaces of modernity were differentially gendered, so too were its temporalities. The German sociologist Georg Simmel, writing in 1902–3, characterised the experience of male intellectuals in the metropolis as one of spatial *and* temporal dislocation. In 'The Metropolis and Mental Life', Simmel identified this characteristic

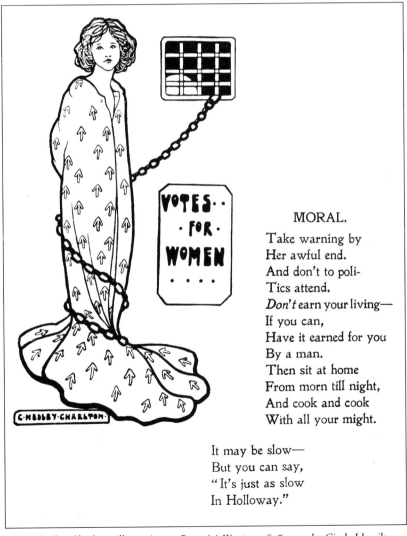

VOTES··
·FOR·
WOMEN
····

MORAL.

Take warning by
Her awful end.
And don't to poli-
Tics attend.
*Don't* earn your living—
If you can,
Have it earned for you
By a man.
Then sit at home
From morn till night,
And cook and cook
With all your might.

It may be slow—
But you can say,
"It's just as slow
In Holloway."

2   C. Hedley Charlton, illustration to *Beware! A Warning to Suffragettes*, by Cicely Hamilton

type of subjectivity as defined by '*the intensification of nervous stimulation* which results from the swift and uninterrupted change of outer and inner stimuli'.[15] He concluded that the effect of this stimulation was both to intensify the individual's 'personal core' as a defence against the impersonality of external culture, and to exaggerate a rejection of everything associated with the industrial city. Jürgen Habermas has also linked the philosophical writings of Henri Bergson, a major influence on the male avant-garde, to a new consciousness of time, 'the experience of mobility in society, of acceleration in history, of discontinuity in everyday life'. Habermas suggests that this betrays a central paradox within modernism:

> The new value placed on the transitory, the elusive and the ephemeral, the very celebration of dynamism, discloses a longing for an undefiled, immaculate and stable present . . . Historical memory is replaced by the heroic affinity of the present with the extremes of history — a sense of time wherein decadence immediately recognises itself in the barbaric, the wild and the primitive.[16]

The desire to abstract itself from history connects with the avant-garde consciousness of an aesthetic break with traditions handed down through memory and practice; a renewing of itself through an embrace of the Other. Shulamith Behr makes a further connection between primitivism in early German modernism and its regression to a 'myth of pre-Oedipal infantile unity' using the well-tried strategy of returning to women and nature as the escape from an intolerable present.[17] But while for male intellectuals the speed of modern city life — as well as flight from it into forms of primitivism — was a crucial condition for modernist subjectivity, in women it was popularly supposed to have quite the contrary effect. For women intellectuals in particular, it was believed to induce deleterious results, even mental breakdown, only curable by enforced passivity and seclusion from the excitations of the modern world. In contemporary medical opinion, women's more fragile emotional and physical constitution when exposed to the extremes of the modern world was likely to disintegrate into neurasthenia or hysteria.[18] Women were thus placed in a contradictory position within the formation of modernist ideologies: on one hand they were emblematic of the primitive and mythologised zone of eternal femininity, on the other they were seen as subject to specifically feminine frailties in the face of the modern world.

Women's representations of the modern world before the First World War were thus necessarily contradictory also. These ranged from an enthusiastic embrace of its metropolitan possibilities by artists like Sonia Delaunay Terk in Paris or Natalia Gontcharova in Moscow to a withdrawal to rural communities evident in the early work of Paula Modersohn Becker in Worpswede or Laura Knight in St Ives. A third response can be found in the work of some artists and writers in Germany and Britain who engaged with feminist politics and developed a symbolic and abstract language through which to address contemporary realities. This strand of women's emancipatory discourse and representational practices has been of some embarrassment to feminist and modernist critics alike. Why did many women like Sylvia Pankhurst, Annie Besant and Olive Schreiner in Britain, or Cornelia Paczka Wagner and Käthe Kollwitz

in Germany, use a spiritual and symbolic rhetoric through which to represent a radical vision of new gender positions at the turn of the century?

Denise Riley reminds us that the term 'women' as a collective category denoting 'real' women was very unstable in the early twentieth century. While the nineteenth-century category of 'women' was a product of increased sexualisation and differentiation which ascribed sharply separated gender roles to each sex, the emergent but highly contradictory formation within suffrage emphasised both equality and difference – the right to the vote on equal terms to men and to be the 'womanly woman'. It developed both from *within* the highly sexualised divisions of Western bourgeois society *and* as a protest against it. As Riley suggests: 'There are different temporalities of "women", and these substitute the possibility of being "at times a woman" for eternal difference on the one hand, or undifferentiation on the other.'[19] The years between 1890 and 1920 were a time of heightened awareness of 'being a woman', and as such have become the focus for a 'recovery' of women's history which has emphasised their role as *social* actors. For Riley this historical project is a necessary but limited one, because it assumes 'women' to be an underlying and constant social group subject only to changing description, rather than itself a historical category subject to change: 'It was not so much that women were omitted, as that they were too thoroughly included in an asymmetrical manner. They were not the submerged opposite of man, and as such only in need of being fished up; they formed, rather, a kind of continuum of sociality against which the political was set.'[20] It was precisely this 'continuum of sociality' which women campaigners – and artists – sought to challenge.

One strategy was to assert a different relation to history, one which would lead both to the creation of a new identity for women and a resistance to patriarchal history. In this light, the attraction of female heroes like Joan of Arc and of symbolic concepts such as 'woman's destiny' may be understood as the mobilisation of certain representations of 'being a woman' which had meaning in the historical present, rather than as an appeal to an undifferentiated womanhood. These representational practices focused on the spiritual and symbolic, sometimes embodied in overt religious iconographies derived from Theosophy and Catholicism, or elsewhere subsumed within an explicitly feminist rhetoric. Should we understand this as a female version of the 'primitive', a failure to address the new century in terms which recognised its fundamental materialism? Or should we see it as an inability to imagine the new without reference to a legacy of nineteenth-century radicalism which drew on religious imagery to represent social change?[21] These crucial components in the making of modern subjectivities seem to have had particular significance to those women participating in the radical artistic, intellectual and 'free-thinking' circles of the period. That they have subsequently been excluded from modernist (and feminist) discourse perhaps tells us more about an intellectual distaste for the emotional, sentimental and spiritual than about their significance as means of articulating women's desires in the early twentieth century. For example, Lisa Tickner has suggested that the angelic, spiritualised figures of women sowers and trumpeters in Sylvia Pankhurst's designs for the Women's Social and Political Union (WSPU) exhibition held at the Prince's

Skating Rink in London in 1909, with their overt references both to biblical tradition and late-nineteenth-century adaptations of Pre-Raphaelite allegory, represent a dilution of the 'embryonic social realism' of her earlier pictorial studies of working-class women.[22] She suggests that this shift in iconography and its subsequent widespread adoption in WSPU campaigns is indicative of the retreat from specific engagement with working-class women and the socialist movement at a time when the leadership was seeking to widen its political appeal to the middle classes. Historical evidence supports this interpretation, yet does not explain the widespread interest in the spiritual as well as the social in suffrage imagery of this period, nor in the work of other artists engaged with feminism, for example, that of Käthe Kollwitz in Germany.

A German contemporary of Kollwitz, the sculptor, painter and graphic artist Cornelia Paczka Wagner, also used symbolic and religious imagery to explore the themes of a 'woman's destiny' at the turn of the nineteenth and twentieth centuries.[23] Like Kollwitz, she had come in the 1880s under the influence of the graphic work of the popular German artist Max Klinger, with its mixture of symbolist allegory and social realism. The choice of themes for her symbolic works, including *Psyche, Maria Mater Consolatrix* and *Phantasie and the Poor Girl*, showed an especial sympathy for feminine subjects. In 1895 she was at work on a series of paintings under the general title *A Woman's Soul*, one of which, *Vanitas*, was shown in the Berlin Künsthalle in 1899. According to one contemporary critic, this should more accurately have been entitled '*And the woman saw the outrageous idolatry*'; he describes it thus:

> From the right, young and old procuresses have drawn near to a girl, to whom 'Death' is also a visitor; one of the procuresses is even tempting her with a golden wreath. In the middle ground mocking figures surround a creature in women's clothing, sunken on the ground, the fallen one, who is no longer able to rise up again.[24]

While the anonymous reviewer turned with relief from the 'feminine subjectivity' and 'sombre fatalism' of Paczka Wagner's painting to the 'masculine clarity' of another artist, we might see in her choice of theme a particular interest in the problem of 'women', albeit veiled in heavy Symbolist allegory. Like Kollwitz, Paczka Wagner used the female nude primarily as a vehicle of emotional meaning. Divested of erotic significance, it could stand for a range of expressive possibilities ranging from spiritual feeling to maternal loss. By seeking expression through the body, Paczka Wagner was able to explore the connections between physical and mental states, as is shown in a series of later studies of a female nude whose rapid variation of body outline and corporeality prefigures the New Woman of the 1920s (Figure 3). This engagement with a female viewpoint and experience is characteristic of the interests of artists like Kollwitz and Paczka Wagner in Germany and suffrage artists in Britain, who were addressing the problem of 'women' through forms of symbolic and social representation.

This dual temporality of women is at the heart of Julia Kristeva's conceptualisation in her essay 'Women's Time'. Kristeva distinguishes between *linear* and *monumental* time, the former defined by the unity of history, economy and language linked to production, the latter being linked to reproduction. While linear time corresponds

to the paternal principle, she argues that female/maternal subjectivity is linked both to repetition and eternity through biological rhythms; thus the two types of temporality which are traditionally connected to the female are the *cyclical* and the *monumental*. While Kristeva suggests that the early feminist movements 'aspired to gain a place in linear time as the time of project and history', her analysis of women's different temporalities does provide a means of exploring the simultaneous representation of the historical and the symbolic in women's art practice at the turn of the century.[25] In this light, social realism may not have seemed the most obvious strategy for women to adopt in order to represent themselves within history, since within social reality in both Britain and Germany women were still profoundly marginalised. For Paczka

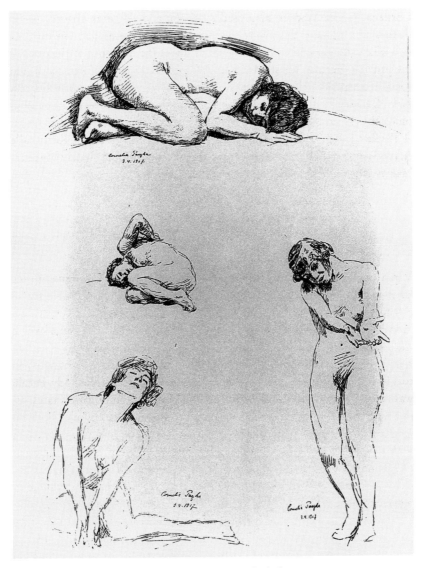

3    Cornelia Paczka Wagner, *Nude Studies*, 1917, pen and ink drawing

Wagner, the choice of utopian allegories of women's destiny rather than the natural-istic genre scenes favoured by her husband, Franz Paczka, indicates a deliberate emphasis on the cyclical and monumental over the social–historical. Equally, Kollwitz's depiction of maternal figures as both *socially* inscribed and *monumentally* placed implies an awareness of the limits of social realism for women.

## Impurity

There is a further paradox for women at the heart of modernism. The early modern-ist doctrines of art formulated in Britain and Germany before the First World War isolated aesthetic experience and categorised it as distinct from social life. Both Roger Fry in London in 1909 and Wassily Kandinsky in Munich in 1911 articulated a set of theories which proposed a fundamental separation between the making and viewing of art and the production and consumption of mass culture.[26] Idealist in conception, this modernist aesthetic insisted upon the separation and unity of the artwork. It allowed no space for the articulation of the aesthetic within the political sphere; such representation was understood as inevitably banalised, trivial or illustrative, lacking the purity of the true artwork which could only exist on and within its own terms. The paradox was that this contradicted the experience of modernity as multiple, frag-mented and discontinuous, as initially described in the writings of Baudelaire: 'By "modernity" I mean the ephemeral, the contingent, the half of art whose other half is eternal and immutable.'[27] Baudelaire's identification of Constantin Guys as the modern painter *par excellence* has been dismissed subsequently as a critical misjudge-ment, yet it was precisely Guys's ability to represent the ephemeral world of *fashion* that Baudelaire so admired. In dismissing Guys from the canon of modern art history, the notion of the artwork which has remained central has been one of unity, coherence and purity. By the second decade of the twentieth century, in the formative period of modernist aesthetics, the association between the modern artwork and anything so trivialised and feminine as fashion had almost disappeared. The exception can be seen in modernist art practices by women, including Sonia Delaunay Terk and Sophie Tauber Arp in France and Liubov Popova and Varvara Stepanova in Russia, but this has in turn relegated much of their work to the secondary status of 'applied' arts.[28] The aesthetic forms and devices of modernist art sought the means of representing the flux of modern life, but only at the cost of setting themselves apart from the mass culture and new technologies of reproduction which were the very condition of its existence. As Andreas Huyssen comments:

> The autonomy of the modernist art work is always the result of a resistance, an abstention, a suppression – resistance to the seductive lure of mass culture, absten-tion from the pleasure of trying to please a larger audience, suppression of every-thing that might be threatening to the rigorous demands of being modern and at the edge of time.[29]

The 'seductive lure' of mass culture was persistently gendered as feminine in aesthetic discourses at the turn of the nineteenth and twentieth centuries and the identification of women with the masses had particular cultural implications during

the period of mass suffrage campaigns. The use of popular and commercial images and contexts in book illustrations, banners, postcards and posters by professional artists in the Artists' Suffrage League doubly marginalised their production as feminine and as inferior products of mass culture. One example of this was their use of embroidery, a domestic feminine craft, to make public and political statements on marching banners. As Roszika Parker comments, 'the form and content of the banners depicted femininity not as frailty but as strength, and embroidery was presented not as women's only appropriate medium but co-existing with paint'.[30] The League's own banner, probably designed in 1908 by its chairman, Mary Lowndes, combines text and image using a mixture of appliquéd materials, embroidery and metal braid (Figure 4). While the design is formal and abstract, the use of hybrid symbolic forms and mixed media, as well as its political function and collective production, placed this firmly outside the modernist canon. But although banners had an evident propaganda purpose, being used primarily in mass suffrage processions, they also had an aesthetic value for their makers and intended audience. Mary Lowndes's article on 'Banners and Banner-making', first published in *The Englishwoman* in September 1909, places suffrage banners within a historical account of feminine creativity and suggests a set of clear aesthetic guidelines for their design in which the garden is a model and source of inspiration. In this way, 'indifferently ugly and dreary' banners will be banished from the streets and replaced by beautiful ones, for 'A banner is not a literary affair, it is not a placard; leave such to boards and sandwichmen. A banner is a thing to float in the wind, to flicker in the breeze, to flirt its colours for your pleasure, to half show and half conceal a device you long to unravel: you do not want to read it, you want to worship it.'[31] The deliberately seductive language of this passage indicates an attempt to marry the political and the personal in suffrage culture in a way that embraced feminine sensibility but relocated it clearly within the public sphere. Suffrage banners were multiply 'impure' in the sense that they drew on mixed aesthetic modes and traditions, addressing the pleasures of a mass audience and connecting aesthetic form with political content. In this way they were opposed to a given tradition of high art *and* to a modernist aesthetic, both of which sought to expel the feminine.

Representation of the experiences of fragmentation and impurity can of course be found elsewhere in modernist art practices, particularly in hybrid artworks like Cubist collage and Dada photomontage which attempted to reintegrate art with life. Thomas Crow has argued that such modernist appropriations of mass culture were merely tactical and temporary; the modernists' self-conscious search for 'ideal origins and a purified practice' produced a closure which wrote this moment of the radical avant-garde out of its history.[32] Yet the repeated adoption of mass cultural techniques and imagery by women artists in the early-twentieth-century avant-garde may be seen as part of a more sustained attempt to integrate feminine difference within modernism. Hannah Höch's famous Dada photomontage *Cut with the Kitchen Knife Dada through the Last Weimar Beer Belly Cultural Epoch of Germany*, shown at the First International Dada Fair in Berlin from July to August 1920, draws on mass cultural imagery and is explicitly political in its address (Figure 5). Höch shared the revolutionary stance of the Berlin Dada group at the end of the First World War, but had

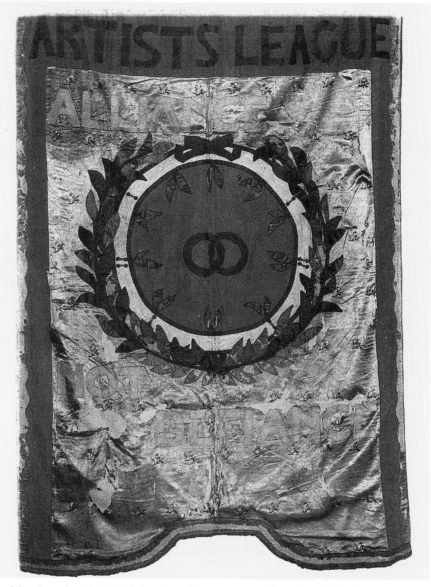

4    Mary Lowndes, *The Artists' Suffrage League Banner*, c. 1908, textiles and metal braid

a specific commitment to women's political emancipation. *Cut with the Kitchen Knife* is Höch's manifesto, offering both a cultural critique of Weimar bourgeois politics and a positive commitment to women and modernity, as Maud Lavin explains: 'Höch expresses her utopianism by celebrating the female pleasures of political liberation founded on the dissolution of the Weimar government and leading to a Dadaistic anarcho-communist alternative.'[33] At the centre of Höch's satirical photomontage a small portrait photograph of Käthe Kollwitz appears isolated in space, the vortex of a destabilised, centrifugal composition. Placed above the arms and torso of a con-

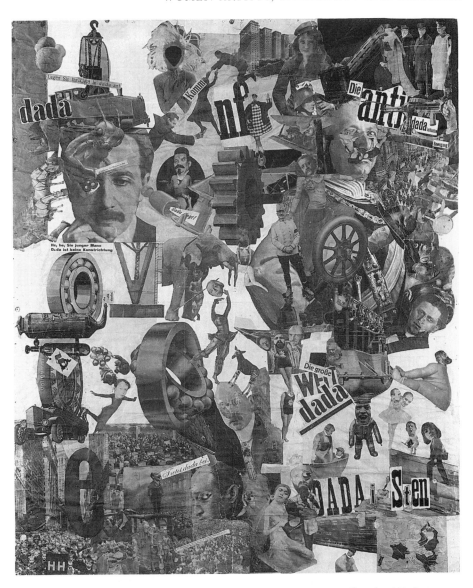

5    Hannah Höch, *Cut with the Kitchen Knife Dada through the Last Weimar Beer Belly Cultural Epoch of Germany*, 1919–20, photomontage

temporary dancer and sliced through with a spear, the head may be read as either tribute or caustic comment, in the year that Kollwitz was made the first female professor at the Prussian Academy of Fine Arts.[34] The difference between the two artists is one of generation and politics: whereas Kollwitz's post-war maternal figures aspire to a monumental and eternal humanity, the women represented in Höch's ironic collages are resolutely modern and mechanistic. Both artists, however, draw on feminine culture and reinscribe it within the public sphere of gendered politics. Like Kollwitz, Höch employs the feminine as a disruptive force – the weapon that the artist uses to

slice through the inflated masculine political culture of Weimar Germany is a female and domestic one, the kitchen knife.

As I have tried to show, there was no single set of responses or identities adopted by women artists in relation to the ambivalent and contradictory role of the 'modern woman' in the early twentieth century. The example of suffrage provided a model for some artists, whether they were explicitly committed to its campaigns or not, to redefine the spatial, temporal and aesthetic boundaries of their practice. Through a relationship to gendered politics, artists as diverse as Käthe Kollwitz, Cornelia Paczka Wagner and Hannah Höch in Germany and suffrage artists Sylvia Pankhurst and Mary Lowndes in Britain found modern means of representation that challenged the emerging canons of modernism. The alliance between women and modernity in the first two decades of the twentieth century may have been an uneasy one, but it did provide a sense to women themselves of being the new subjects of and participants in cultural change. Looking back at the end of that century, we can read in their work some of the struggles and contradictions that they faced, many of which remain unresolved for women today. As Marshall Berman has commented: 'To appropriate the modernities of yesterday can be at once a critique of the modernities of today and an act of faith in the modernities – and in the modern men and women – of tomorrow and the day after tomorrow.'[35]

## Notes

1   Williams, R. (1989), 'When Was Modernism?', in R. Williams, *The Politics of Modernism*, London, Verso, p. 33. This essay was first delivered as a lecture in 1987, a year before Raymond Williams's death and two years before the collapse of socialism in the Soviet Union and Eastern Europe. It perhaps marks the final point at which the radical political and aesthetic enterprise of socialism could be harnessed together in the West.

2   Williams, *The Politics of Modernism*, p. 35.

3   It is not my intention to enter here into debates over definitions of modernism and the avant-garde, which are many and complex. Hal Foster offers a useful overview of theories of the avant-garde in Foster, H. (1996), *The Return of the Real: The Avant-Garde at the End of the Century*, Cambridge, Mass., MIT Press, pp. 8–20. Thomas Crow distinguishes between modernism as 'an autonomous, inward, self-referential and self-critical artistic practice' and the avant-garde as 'more inclusive, encompassing extra-artistic styles and tactics of provocation, group closure, and social survival', in Crow, T. (1985), 'Modernism and Mass Culture in the Visual Arts', in F. Frascina (ed.), *Pollock and After: The Critical Debates*, London, Harper and Row, p. 234. Susan Rubin Suleiman defines the avant-garde as 'a collective project . . . that linked artistic experimentation and a critique of outmoded artistic practices with an ideological critique of bourgeois thought and a desire for social change', in Suleiman, S. R. (1990), *Subversive Intent: Gender, Politics and the Avant-Garde*, Cambridge, Mass., Harvard University Press, p. 12.

4   Wolff, J. (1990), *Feminine Sentences: Essays on Women and Culture*, Cambridge, Polity, p. 34.

5   For instance, Griselda Pollock has demonstrated that these key spaces in the formation of modern consciousness were inaccessible to bourgeois women who inhabited separate spaces of femininity in Paris in the second half of the nineteenth century. Women artists in the Impressionist group were excluded from participation in urban experiences which came to define the parameters of the 'modern' in art, primarily within the spaces of the street, the bar

and the brothel. For an account of the role of professional women artists in this period see Garb, T. (1994), *Sisters of the Brush: Women's Artistic Culture in Late Nineteenth Century Paris*, New Haven and London, Yale University Press.

6  Perry, G. (1995), *Women Artists and the Parisian Avant-Garde*, Manchester, Manchester University Press, p. 31.

7  Huyssen, A. (1986), *After the Great Divide: Modernism, Mass Culture, Postmodernism*, London, Macmillan, p. 50.

8  Behr, S. (1995), 'Anatomy of the Woman as Collector and Dealer in the Weimar Period: Rosa Schapire and Johanna Ey', in M. Meskimmon and S. West (eds), *Visions of the Neue Frau: Women and the Visual Arts in Weimar Germany*, London, Scolar Press, p. 97.

9  Kollwitz's political sympathies were close to those of the Bund für Mutterschutz (League for the Protection of Mothers), which was the main organisation uniting radical, socialist and bourgeois feminists around arguments in favour of improved maternal rights and benefits. See Betterton, R. (1996), 'Mother Figures: The Maternal Nude in the Work of Käthe Kollwitz and Paula Modersohn Becker', in R. Betterton, *An Intimate Distance: Women, Artists and the Body*, London and New York, Routledge, for a fuller discussion of Kollwitz's relation to German feminism and in particular to maternalist debates.

10  Rogoff, I. (ed.) (1991), *The Divided Heritage: Themes and Problems in German Modernism*, Cambridge, Cambridge University Press, p. 134. There are a number of images by Kollwitz that do include the figures of her husband and two sons, but these were usually either preliminary studies for compositions or linked to the memorial sculpture *Mourning Parents*, erected in 1932 to her dead son, Peter.

11  Benjamin, W. (1977), 'On some Motifs in Baudelaire', in W. Benjamin, *Illuminations*, London, Fontana/Collins, p. 165. Benjamin also cites Friedrich Engels, Edgar Allan Poe and E. T. A. Hoffmann describing street scenes in Manchester, London and Berlin respectively.

12  Williams, *The Politics of Modernism*, p. 39. For Williams, the development of the city into the metropolis was more than a matter of size. It required three crucial conditions: the concentration of capital within a network of imperial relations that extended access to and subsumed subordinate cultures both regionally and nationally; a complexity and mobility of social relations which enabled a new liberty of movement and expression in contrast to traditional social and cultural codes of behaviour; and a concentration of the institutions of cultural production and dissemination that allowed both orthodoxy and consent to coexist. Williams cites the experience of migration to the metropolis as the key factor in the aesthetic transformations which constituted modernism: it was the dislocation from native languages and visual traditions effected by such immigrants which liberated form and provided a new freedom to transform aesthetic discourse.

13  Huyssen, *After the Great Divide*, p. 47. Perry Anderson has defined modernism in terms of 'a cultural field of force triangulated by three decisive co-ordinates', which he summed up as 'the intersection between a semi-aristocratic ruling order, a semi-industrialised capitalist economy and a semi-emergent or – insurgent labour movement': Anderson, P. (1984), 'Modernity and Revolution', *New Left Review*, 144, March–April, 105. He has nothing at all to say about the emergent women's movement of the period.

14  Wolff, *Feminine Sentences*, p. 60. The contrast can be made with the previous generation of artists in the Impressionist movement who also used the motif of a female figure framed by a balcony within interior space. For example, Berthe Morisot's *On The Balcony*, 1872, in the Art Institute of Chicago, can be compared with Kollwitz's *Self-Portrait on a Balcony*, 1892, but in the former the woman and child are clearly located in the *suburban* space of Passy and clearly separated from the city.

15  Simmel, G. (1992), 'The Metropolis and Mental Life', reprinted in C. Harrison and P. Wood (eds), *Art in Theory 1900–1990*, Oxford and Cambridge, Mass., Blackwell, p. 131. Simmel cites Nietzsche in particular as one of 'the preachers of the most extreme individuality' who har-

boured a bitter hatred against the new metropolis, which was the reason why he was 'so passionately loved . . . [by] the metropolitan man as the prophets and saviours of his unsatisfied yearnings' (Simmel, p. 135).

16  Habermas, J. (1985), 'Modernity – An Incomplete Project?', in H. Foster (ed.), *Postmodern Culture*, London, Pluto Press, p. 5.

17  Behr, 'Anatomy of the Woman as Collector and Dealer in the Weimar Period', p. 99.

18  Victoria Glendinning parodies this medical viewpoint in her novel *Electricity*, set at the end of the nineteenth century, in which the monstrous Dr Bullington Huff attributes the contemporary epidemic of disordered young females to 'defective organisation, and the deleterious speed of the modern world combined with a harmful amount of mental exertion for which women are poorly adapted' (Glendinning, V. (1996), *Electricity*, London, Arrow Books, p. 179). Her fictional 'mad-doctor' is based on the American neurologist Silas Weir Mitchell, whose treatment is famously described in Charlotte Perkins Gilman's short novel of 1892, *The Yellow Wallpaper* (reprinted London, Virago Press, 1981). Mitchell's methods, which involved total seclusion, immobility, massage, electricity and an infantile diet, were introduced to Britain in the 1880s and, in milder forms such as the rest cure imposed on Virginia Woolf after her father's death, became the standard treatment for female emotional and mental disorders.

19  Riley, D. (1988), *'Am I that Name?' Feminism and the Category of 'Women' in History*, London, Macmillan, p. 6.

20  Riley, *'Am I that Name?'*, p. 15.

21  This religious tradition in British radical art can be traced through Walter Crane's socialist 'Angel of Liberty' to William Blake's utopian imagery at the end of the eighteenth century. Ernst Bloch's analysis of such revivals as 'utopian traces' in his theory of 'non-synchronous time' is discussed in Lavin, M. (1993), *Cut with the Kitchen Knife: The Weimar Photomontages of Hannah Höch*, New Haven and London, Yale University Press, p. 29.

22  Tickner, L. (1987), *The Spectacle of Women: Imagery of the Suffrage Campaign 1907–14*, London, Chatto and Windus, p. 28.

23  Like Kollwitz, Cornelia Wagner came from an educated bourgeois family. Born in Göttingen in 1864, the daughter of a well-known political economist, she studied in Berlin and Rome where she married a Hungarian artist, Franze Paczka, in 1890. In 1895 they settled in Berlin where she pursued a successful career as an artist with the support of her husband.

24  *Grosse Berliner Künsthausstellung*, 15 June 1899, translated by John Brooks. Although this painting is referred to in several published sources, I have been unable to trace any image of it.

25  Kristeva, J. (1986), 'Women's Time', in T. Moi (ed.), *The Kristeva Reader*, Oxford, Basil Blackwell, p. 193. Kristeva also suggests that these temporalities are characteristic of mystical experiences: 'the radical positions of certain feminists would rejoin the discourse of marginal groups of spiritual and mystical inspiration and strangely enough, rejoin recent scientific preoccupations . . . both space science and genetics' (p. 192). See also Prelinger, 'Kollwitz Reconsidered', for a useful discussion of the importance of symbolism in Kollwitz's work, in Prelinger, E. (1992), *Käthe Kollwitz*, New Haven and London, Yale University Press, pp. 13–86.

26  Wassily Kandinsky in *Concerning the Spiritual in Art* (New York, Dover, 1977) rigorously excludes pattern and decoration from his definition of abstraction in art. Roger Fry's 'Essay on Aesthetics' (in his *Vision and Design*) makes more positive reference to mass culture, most notably in his example of the new experience of the cinematograph as illustrating a separation between 'the imaginative life' and ordinary life. See R. Fry, *Vision and Design* (1937), Harmondsworth, Penguin Books, 1961, pp. 24–5.

27  Baudelaire, C. (1964), 'The Painter of Modern Life', in J. Mayne (ed.), *The Painter of Modern Life and Other Essays*, London, Phaidon, p. 13.

28  For a useful discussion of the adoption of craft and commercial design by the artistic avant-

garde, see Chadwick, W. (1990), *Women, Art and Society*, London, Thames and Hudson, pp. 236–64.

29  Huyssen, *After the Great Divide*, p. 55.

30  Parker, R. (1984), *The Subversive Stitch: Embroidery and the Making of the Feminine*, London, Women's Press, p. 199.

31  Lowndes, M. (1909), *Banners and Banner-making*, London, Artists' Suffrage League. For further information on the Artists' Suffrage League, see Tickner, L. *The Spectacle of Women*, especially pp. 13–52. Tickner points out that a number of men also produced images for the League, including the modernist painter Duncan Grant.

32  Crow, 'Modernism and Mass Culture in the Visual Arts', p. 236.

33  Lavin, *Cut with the Kitchen Knife*, p. 30.

34  The photograph of Kollwitz was cut from the issue of the *Berliner Illustrierte Zeitung* which announced her appointment. For a full reading of this composition, see Lavin, *Cut with the Kitchen Knife*, pp. 13–46.

35  Berman, M. (1983), *All That Is Solid Melts Into Air*, London, Verso, p. 36.

# Modern women, modern spaces: women, metropolitan culture and Vorticism

Vorticism was the only avant-garde grouping in Western Europe before 1914 to include women among its members.[1] This essay will consider four women artists, Jessica Dismorr (1885–1939), Kate Lechmere, Helen Saunders (1885–1963) and Dorothy Shakespear (1886–1973), who were in diverse ways engaged with Vorticism.[2] Jessica Dismorr and Helen Saunders were among the signatories to the Manifesto in *Blast 1* of 1914. Both contributed writings and visual imagery to *Blast 2* of 1915, Saunders also sharing responsibility for the magazine's distribution.[3] The two also contributed to the Vorticist exhibitions in London in 1915 and in New York in 1917. Work by Dorothy Shakespear was included in *Blast 2* and commissioned for covers of Ezra Pound's publications. Lechmere and Saunders were important creators of Vorticist spaces at the Rebel Art Centre and the *Tour Eiffel* restaurant respectively. Yet there has been little agreement as to their inclusion or their participation in the contributions and significance of Vorticism. While it can be argued that within a highly volatile avant-garde there was no settled or agreed membership, there has certainly been no consensus in art-historical writing.[4] For women artists the appeal of Vorticism undoubtedly lay in its engagement with modern city life.[5] Formed when London was rapidly being rebuilt, the name of the movement seems to have had London resonances, Pound writing in December 1913 of the British capital as 'the Vortex'.[6] Vorticism was developed within the new urban spaces of modern metropolitan London. Saturating the pages of *Blast 1* and *Blast 2*, the Vorticist magazine produced in 1914 and 1915, urban life and metropolitan perceptions haunt the imagery of artists associated with the movement. This essay is concerned with a mapping of women within the avant-garde territories of modern London alongside a consideration of new kinds of spatial mappings beyond the perspectival towards modern forms of urban representation concerned with a (re)organisation and multiplicity of vision.

Feminist studies have challenged canonical narratives of modernism as much for their genealogies and myths of masculine creativity as for their exclusions of women artists and marginalisations of women's art. Unravelling the terms and the aporias of modernism assists in distinguishing between modernity, as the historical experiences and processes of modernisation, and modernism, which may be defined as a 'discursive and historical field' with identifiable institutional structures.[7] It is in these discourses and institutions of modernism that the displacement of women has been managed through a variety of strategies including logocentric, polarising discourses. Andreas

Huyssen has maintained that adversarial definitions of 'culture' and particularly modernism which have been pitched against mass culture have been decisively gendered.[8] Furthermore, to extend Mary Douglas's analysis in *Purity and Danger*, it may be argued that the concerns with purity and culture in formalising modernist discourses on art from Roger Fry to Clement Greenberg have functioned as one of the means of expelling as 'impure' women's artistic practice and production from the cultural field of modernism.[9] Modernist discourses and institutions have claimed authorising powers, both to legitimate certain kinds of artistic work and to constitute the authorial/artistic subject with an *œuvre*, a corpus of known and collected work which supplements the person and body of the artist. Researching the historical presence and work of women artists in the modern period and their uneasy, variable relations to and in excess of the workings and definitions of modernism is of critical importance to feminism, for as Bridget Elliott and Jo-Ann Wallace have explained in an outstanding analysis of women and modernism, what is at issue here is the 'continuing struggle for certain kinds of symbolic power'.[10]

### Avant-garde geographies

Vorticism, like other avant-garde formations, was a metropolitan phenomenon. Modernist polemicising flourished in metropolitan spaces. Shaped by and in the pressures of modernity, increasing industrialisation, mechanisation, technological change and financial expansion on a global scale, London was perceived by contemporaries as changing from city to sprawling metropolis and in its global relations as 'the heart of empire'. More than the city, the metropolis was a centre for the proliferation of leisure, spectacle and consumerism. Geographies of the avant-garde can be mapped on to this metropolitan setting, with its developed travel network and wide variety of meeting-places. Often within walking distance and within a cheap-rent neighbourhood, artists and writers lived and worked in proximity, generating intellectual communities within London's central districts, organising studio showings and exhibitions, holding salons, staging performances, giving lectures, issuing publications.

If modernist culture was caught up in, defined by and exploitative of increasing commodification, it was, in the years before the First World War, constantly in the process of re-forming and rebuilding. Alliances were temporary, like the fabric of London, taking their names from particular areas – as, for example, the Fitzroy Street Group or the Camden Town Group – or from the metropolis itself, as in the case of the London Group. At the height of avant-garde rivalry, there was a contest over territory in central London. The Rebel Art Centre, set up to stage Vorticism, opened in spring 1914 at 38 Great Ormond Street, Queen Square, not far from the Omega workshops showroom (established in May 1913) in Fitzroy Square and Sickert's studio showings at 19 Fitzroy Street. All were sited near the cafés, clubs, cabarets and restaurants frequented by artists and not infrequently decorated by them. At the *Tour Eiffel* restaurant, decorated by Saunders and Lewis in 1915, as at the earlier Cabaret Theatre Club at the Cave of the Golden Calf opened by Mme Strindberg in 1912, artists exhibited their work to a self-conscious metropolitan audience, outside a gallery or studio

setting. Café and cabaret culture was occasionally imaged by Vorticist artists, from Lawrence Atkinson's *Café Tables* of *c.* 1914–18 to the numerous images of dancers by male artists. Helen Saunders's drawing *Cabaret* (probably executed in 1913–14) shows her interest in metropolitan entertainment; irregularly squared up, it may be a preparatory study for a decorative scheme.[11]

References to London places and figures filled the pages of *Blast 1*. Its manifestos and writings were produced in and about London, as a capital city and imperial centre.[12] The Manifesto hailed 'the great art vortex sprung up in the centre of this town'. The 'blasted' included 'the Bishop of London', the entertainment of the 'London Coliseum', 'Daly's Musical Comedy', 'The Gaiety Chorus Girl', 'Messrs Chappell', the music publishers, and the 'purgatory of Putney', a London suburb. *Blast 1* proclaimed, 'LONDON IS NOT A PROVINCIAL TOWN . . . We do not want the GLOOMY VICTORIAN CIRCUS in Piccadilly Circus.'[13] *Blast 2* included Dismorr's 'London Notes' and 'June Night', along with Etchells's *Hyde Park* and Wyndham Lewis's 'The Crowd Master', which was set in London in July 1914.

The work of women in creating the institutions of Parisian modernism, particularly in setting up and funding salons, meeting-places and publishing houses, is well documented.[14] That of women in the London avant-garde is less well known. The Rebel Art Centre was funded and largely organised by Kate Lechmere, co-director with Wyndham Lewis.[15] It is uncertain how, or from whom, this venue, registered as The Cubist Art Centre Ltd, acquired its name.[16] The word 'rebel' was already in currency in claims for modernity, the art critic Frank Rutter dedicating his defence of Post-Impressionism in 1910, *Revolution in Art*, to '*Rebels of either sex* all the world over who in any way are fighting for freedom of any kind' (our italics).[17] As the building is now demolished, the centre, its layout and decoration can only be partially reconstructed. Lechmere took premises on the first floor and organised building works to create the space comprising a large room to be used for showing works, holding meetings and lectures, a smaller room used as a picture store, and an office. In July 1914 she wrote to Lewis that 'the large Studio at the end of the corridor is large enough for anything that you will require & hold[s] 40 people or more for lectures'.[18] She organised and presumably paid for the interior decoration.[19] The *Daily News* reported doors of 'lawless scarlet' and 'decorous carpets of dreamy blue'. The walls were painted lemon yellow. Lechmere painted a large divan red and covered it with red, blue and white striped fabric from Liberty. With another woman, as yet unidentified, she made curtains apparently designed by Atkinson or Hamilton. The *Daily News* commented on '[c]urtains of crocus gold falling in long laughing lines' and on a white curtain hung across the room, dividing the space, on which 'points of purple and cubes of green and yellow, intermingling with splashes of deep rose-red, formed themselves . . . into fantastic human figures'.[20] Of the 'series of large mural paintings and friezes' promised in the prospectus only Lewis's semi-abstract mural is known to have been begun. The prospectus also announced that the Rebel Art Centre would 'by public discussion, lectures and gatherings of people . . . familiarise those who are interested with the ideas of the great modern revolution in Art'.[21] Saturday afternoon gatherings were held, apparently along the lines of those initiated by Sickert in Fitzroy Street, where

6   Photograph of Kate Lechmere at the Rebel Art Centre with her painting of 1913 entitled *Buntem Vogel*

invitations were issued to view works displayed on easels and selected from stacks. Existing accounts give little indication that women artists exhibited work or painted wall decorations at the centre, but this may be as much to do with the reporting of women artists in the press as with the extensive disappearance or destruction of their work. Only one of the contemporary photographs taken at the Rebel Art Centre, that of Lechmere with her painting *Buntem Vogel* (exhibited at the Allied Artists' Association in 1913), shows work securely identified as that of a woman artist (Figure 6).[22] On 19 May 1914 Lechmere requested contributions towards the payment of the rent from artists then showing work at the centre, namely Lewis, Wadsworth, Nevinson and Atkinson.[23] This may suggest that neither she, Dismorr nor Saunders showed or stored work there, or that she had already received the women's contributions, or that she was somewhat desperate to get economic assistance from the *confrères* whose artistic masculinity, distinctly egoistic and individualistic, shied away from collective or financial responsibility.

At the Rebel Art Centre there were schemes for the production of decorative arts, and some items were displayed at the group stand at the Allied Artists' Association exhibition of 1914. Like Bloomsbury painting and perhaps to rival Omega, Vorticist painting was forged around redefinitions of modern interior space. Lechmere had trained at La Palette in Paris and the plan for an art school run along the lines of a French atelier, to impart training in the principles of 'Cubist, Futurist and Expressionist' art, with Lewis acting as visiting professor, may have been hers. It failed, however, to attract pupils and by July Lechmere wrote that 'the fate of the

School rather hangs in the balance'.[24] Despite wide press coverage and lectures by Pound, Marinetti and Ford Madox Ford, the Rebel Art Centre foundered after four months on quarrels between the co-directors and difficulties over its funding.[25]

The *Tour Eiffel* restaurant in Percy Street was a popular meeting-place for Vorticists. A first-floor dining room was decorated by Helen Saunders and Wyndham Lewis in the latter half of 1915. This complex decorative interior comprised, it would appear, wall panels, light fittings and table decorations, all completed in some six months. Not long after the interior was opened for viewing in January 1916, *Colour Magazine* reported that 'gay Vorticist designs cover the walls and call from the table-cloth'. Another visitor considered that 'the appeal of the colour is undeniable', concluding that 'provocative and arresting power is also to be felt when confronting the storied walls'.[26] Long demolished, the scheme can only be glimpsed from contemporary reports, the 1938 sale catalogue and reminiscences, and it is extremely difficult to ascertain the contributions of either artist. Although the decorations have been attributed to Lewis, the possibility of more direct and equal collaboration should not be ruled out. Saunders's acquisition in late 1915 of two watercolour and pen drawings by Lewis — *Composition in Blue* and *Composition in Red and Purple* — tantalisingly suggests that these might be associated with the *Tour Eiffel* wall panels, being schematic cartoons and/or gifts to Saunders following their joint work. William Roberts recalled that there were three abstract panels: if these two watercolours by Lewis can be linked to the decorative scheme, could a third panel have been by Saunders? This can only remain speculation. Both contemporary and later evidence single out colour and a Vorticist formal syntax. Harry Jonas recollected that the predominant colours were 'bright red and green' and 'very raw' yet 'low-toned'.[27] Certainly Lewis's two watercolours are built up from modulated low-toned red/purple and blue respectively. The predominant purple can be tied to a recollection that the floors of the decorated room were stained purple.[28] If Saunders did contribute a panel, either *Abstract Composition in Blue and Yellow* or *Vorticist Composition in Blue and Green*, both executed at this date, are possible contenders, demonstrating the range of her work as a daring and effective colourist, prepared to take risks. On the second theme, explicit in a review in *Colour Magazine* of May 1916 which remarked on the effects of giddiness induced by Vorticist spatial structures, a more complex analysis may be offered, and we return to this below.

### Bodies/spaces

Elizabeth Grosz has theorised a particular relation between bodies and cities, writing of the body as the site of inscription for specific modes of subjectivity and sexuality by and in the urban environment. The city is considered to be 'one of the crucial factors in the social production of (sexed) corporeality, . . . the condition and milieu in which corporeality is socially, sexually and discursively produced'. Grosz's analysis of 'the constitutive and mutually defining relation between bodies and cities'[29] proposes that sexualities were not only located in time, as historians have readily admitted,[30] but figured in specific sites and spaces. The profound re-formations of sexuality

from the 1890s to *circa* 1920 took place within the contexts of the city and were fought out in the territories of the avant-garde.[31] What is of interest, therefore, are the 'volatile bodies', the 'polymorphous sexualities',[32] proliferating in the excess of categorisations produced by theorists such Havelock Ellis, J. Arthur Thomson and Patrick Geddes and the intersections between mappings of sexuality and mappings of London. If, after 1900, London was the subject of an increasing number of publications, social inquiries, guidebooks and route maps, the city seemed to slip beyond these cartographies.[33] The modern metropolis of London and modern sexualities both eluded relentless investigation and classification.

Metropolitan life facilitated restless and continual movement – across the city, between its spaces, over and underground, to work, to study, to shop and eat, to meet and network, to make, exhibit and sell work. In the volatile formations of ever-changing modernist groups, membership came by invitation and depended on urban encounters in the new spaces of the modern metropolis. Urban mobility, so central to modern women's independence, was also a key factor in their participation in the avant-garde. From the 1880s onwards women had strategically claimed a street presence and contested urban space.[34] City streets and urban spaces were the stage for the performances of and contestations over modern subjectivities and sexualities. The most highly contested construction in femininity at the beginning of the twentieth century was that of the modern woman, a formation developed from the 'New Woman' of the 1890s. Defined by the historian Lucy Bland as 'a young woman from the upper or middle class concerned to reject many of the conventions of femininity and live and work on free and equal terms with the opposite sex', the distinctive characteristics of 'New Woman' were personal freedom, individualism and independence.[35] 'Modern' women went out to work, socialised unchaperoned in mixed company, rented rooms, travelled widely and lived independently of family and kinship ties. Both Jessica Dismorr and Helen Saunders left home to live in rented rooms in London, and Dismorr, like Kate Lechmere, studied and worked in France.[36]

Jessica Dismorr was remembered by a friend as a 'New Woman'.[37] Helen Saunders, through her friendship with Harriet Weaver, may have come in contact with a group of radical women associated with the journals *The Freewoman* and *The New Freewoman*.[38] These 'new moralists' were critical of the family and of marriage as a social and legal system which supported prostitution, arguing instead for monogamous unions freely entered and left. The publication of Rebecca West's short story on the hypocrisy of marriage in *Blast 1* indicates some of the links across radical circles in 1914.[39] But as several feminist historians have indicated, these new sexual and social relationships with men were not without problems, for men as much as for women. Women's redefinitions of sexuality and urban space challenged masculine as well as feminine codes of behaviour.

Any reconstruction of city encounters and urban behaviours in this period remains highly speculative. Much of what is now known about Vorticist meetings is drawn from the reminiscences of protagonists. Some of the most circulated stories in Vorticist literature were provided by Kate Lechmere, who, speaking of the Saturday afternoon gatherings at the Rebel Art Centre, recalled, 'I had to do the honours

because Lewis insisted that the organising of tea parties was a job for women, not artists.'[40] Sickert had written to Ethel Sands that she and Nan Hudson, the only two women showing work at 19 Fitzroy Street, were to act as hostesses.[41] If these two respectable, wealthy and socially well-connected women offered a touch of class for buyers who frequented these events, what might have been offered by Lechmere pouring tea at Great Ormond Street? That male artists then, like male managers today, expected women colleagues to facilitate social events was doubtless the case.

Masculine behaviour has been extravagantly mythologised in the literature on Vorticism; stories of masculine aggression and sexual harassment which provided material for reminiscences have been uncritically repeated in scholarly accounts. There is no doubt that in several instances men acted against women in the formation of modernist groupings, by limiting the number of women members or by excluding women entirely, as did the Camden Town Group, formed in 1911. By declining to abide by the codes of conduct expected of men of their class in polite mixed society, male artists, particularly those associated with Vorticism, problematised the position and social relations of women in modernist groupings. To conclude, however, that pouring tea might constitute women artists' main contribution to Vorticist meetings would be to leave in the historical archive only the deposits of masculine desires and to propose them as the truth. As Foucault so often cautioned, historical 'truth' is a fabrication, produced in and by institutions and discourses. Judith Walkowitz has pointed out that mythologies of masculine aggression acted to police the activity, conduct and mobility of women in the modern city.[42] Little is known of women's responses to the conduct of male Vorticists, apart from Lechmere's scornful riposte to Lewis. When he lost his temper over the Rebel Art Centre and the distribution of *Blast*, she reprimanded him for 'lossing [*sic*] your self command & using such ugly insulting language & again letting that extravagant imagination of yours run away with you'.[43]

### Performing the modern

Vorticism, the Rebel Art Centre and *Blast* all enjoyed spectacular and prolific news coverage. General arts coverage in the period ranged from broadsheet newspapers and illustrated papers to specialist magazines. Whereas specialist papers offered inter-pretative readings, conjuring a community of well-informed London readers, photo-stories in the illustrated papers presented the antics of modern artists as strange, bizarre and baffling. Vorticists performed for the press and exploited the relatively new techniques and technologies of photo-journalism. Publicity was also generated in *Hello!*-style coverage of the aristocracy, many of whom patronised 'modern' art.[44] As John Rodker writing in *Dial Monthly* reported, 'the leaders of the new movement, be it in painting, music or literature, are photographed daily, their eccentricities detailed and their photographs scattered broadcast'.[45] A photo-story on the 'Centre for Revolutionary Art: Cubist Pictures and Cubist Curtains' which appeared in the *Daily Mirror* of 30 March 1914 included a photograph of Lewis at work on an unfin-ished mural, another with Hamilton (?), Wadsworth, Nevinson and Lewis hanging

Wadsworth's painting *Caprice* and a third featuring Kate Lechmere standing by the curtains.[46] Underneath was the caption, 'With these revolutionary "works" however it is not always possible to tell "t'other from which" and until the average man can learn to penetrate their meaning he will probably pin his faith on the old schools.' Sexualities and identities were carefully staged. Lewis and his male companions appeared with neat, clipped hair and attired in the dark suits favoured not only by Marinetti and the Futurists but by middle-class businessmen. This far from eccentric presentation marked out a masculine identity at variance with Augustus John's 'gypsy patriarch' swagger or Fry's studied informality. A picture-feature in the *Daily Mirror* headed 'A Post-Impressionist flat: what would the landlord think?' included a cropped snapshot of Roger Fry, his hair unkempt and tousled, captioned 'Mr Fry thinking out some new futurist nightmare'. There was a sharp divergence in the presentation of the two art groups: against the action shots of the Vorticists, Fry is caught in a moment of deep concentration, seemingly unaware of his spectators.[47]

By contrast to these masculine performances, femininity was staged as appearance. In the *Daily Mirror* feature on the Rebel Art Centre Kate Lechmere was posed beside the curtains, gracefully fingering them. Of the two photographs of interiors accompanying the paper's feature on 'A Post-Impressionist flat', one shows a seated woman intent on her sewing, surrounded by cushions; the mood is calm and tranquil and the emphasis is on Omega products and decorative style. However, a photo-feature in the *Evening Standard* entitled 'School of Cubist Art' shows Lechmere and Wadsworth seated on the striped divan, Hamilton (?) and Lewis standing in front of the curtains and a stack of paintings arranged beside the group.[48] Lechmere is positioned equally within the group, although differentiated by appearance. For the newspaper photographs Lechmere wore formal yet artistic attire in a fashionable tubular shape and composed of layers and/or bands of different patterned and plain fabrics.[49] In photographs not published in the contemporary press Lechmere wears a loose white blouse worn with a softly tied dark-coloured bow and plain skirt: the hallmark of the modern woman, these separates are also worn by her female companion.[50] Sexualities and subjectivities were not fixed, but staged and shifted in performance. Enactments varied, for while neither Dismorr, Saunders nor Shakespear appeared in photographs of the Rebel Art Centre, Lechmere, who was blessed in *Blast 1*, was not featured in either issue of the Vorticist journal as signatory, artist or writer.

Much avant-garde positioning took place in the pages of national broadsheet newspapers, as much a performance as any staged for the tabloid press. Women artists neither initiated this polemicising nor contributed greatly to it. Neither the published letter disputing the commission for the Ideal Home Exhibition which gave Lewis and his associates their first opportunity to break with Fry and Omega nor the repudiation of 'Vital English Art. Futurist Manifesto' was signed by women artists.[51] Dismorr lent her support for the former in a letter to Lewis: 'I wonder how you are getting on with the Fry campaign. I am really with you in spite of my apparent want of sympathy.'[52] As a signatory to the Manifesto in *Blast 1* in 1914, Helen Saunders's last name was printed as 'Sanders', as it was in the captions to her graphic work published in *Blast 2* of 1915, in the announcement of her inclusion in *Blast 3*, and in the catalogue

for the Vorticist exhibition in London in 1915. Whether this spelling was a transliteration of the pronunciation, a persistent typographical error, a careless disregard on the part of the editor, or in deference to the proprieties of her family, remains unknown. However, in Gaudier-Brzeska's review of the Allied Artists' Association in 1914 and on the poster for the Vorticist exhibition of 1915 the artist's name is given correctly.[53] Shakespear's name was rendered 'Shakespeare' in the caption to 'Snow scene' in *Blast* 2. There was at least one occasion elsewhere on which Dismorr was rendered as 'Dismore'.[54] As uncommon men's names seem not to have been subject to transformation, the point at issue may have been the gendering of the artistic name, certainly a concern for women students at the Slade, who in the second decade of the twentieth century preferred to be addressed by their patronymics, as, for example, Carrington or Brett.[55]

## Street haunting

In an essay written in 1930 Virginia Woolf coined the phrase 'street haunting'. Complexly resonant, street haunting conjures both haunts as often-frequented places, the spaces visited and enjoyed by women, which, for Woolf, include shops (the piece takes as its ostensible purpose the purchase of a pencil, necessary for the writer's craft), and haunting as an elliptical form of presence on the streets, which includes a metamorphosis of the self along with the pleasures of walking and watching. Leaving behind, temporarily, 'the straight lines of personality' and slipping out of the familiar self left at home, the solitary rambler observes the city, spinning stories about its inhabitants.[56] Along the way flickering glimpses of hidden lives come into view. The evening light fragments the city's surfaces into 'islands of light' and 'long groves of darkness'. An essay on urban il/legibility and the feminine reader and traverser of urban space, 'Street Haunting' provides a metaphor for, a way of thinking through, Vorticist women's representations of the body in the city.

'June Night', Jessica Dismorr's prose piece in *Blast* 2 of 1915, may be read as a 'street haunting'.[57] The narrator is portrayed as a hybrid, 'a strayed bohemian, a villa resident, a native of conditions, half-sordid, half-fantastic'. This changefulness is linked to movement; feminine sexuality in the city is in flux, unfixed, provisional, liminal. Like Woolf's stroller, this figure escapes her everyday self to be remade on and by the street. With a male escort she embarks on a journey from the suburbs to the city centre:

> No. 43 bus: its advertisements all lit from within, floats towards us like a luminous balloon. We cling to it and climb to the top. Towards the red glare of the illuminated city we race through interminable suburbs. These are the bare wings and corridors that give on to the stage. Swiftness at least is exquisite . . .
>
> We stop for passengers at Regent's Corner. Here crowds swarm under green electric globes. Now we stop every moment, the little red staircase is besieged. The bus is really too top heavy.[58]

The narrator, however, gets off the bus, tempted by 'spacious streets of pale houses' and taking 'refuge in mews and by-ways'. In common with Miriam Henderson in

Dorothy Richardson's *Pilgrimage* novels, begun in 1915, the female figure of 'June Night' moves alone through the diverse spaces of the city, at times with pleasure and security, at times with an acute sense of danger, of the risks to a corporeal presence marked as feminine.[59] The silence of uninhabited streets brings insecurity, and the 'widening circles of alarm' are only dispelled by returning 'to the life of the thoroughfares' to which she belongs.[60] 'June Night' conjures a watchfulness which is at once corporeal and ocular: in the empty by-ways the protagonist is alert, for it is her body which is at risk. Although Woolf conjures no danger, she, too, is concerned with the triangulation of female body, space and sight-lines. In 'June Night' the female figure dispenses with her male escort, his itinerary and the bus route to wander round the city alone. In 'walking in the city'[61] she charts another route and declines to appear on 'the stage'. Wandering, travelling, shopping, marching, sketching, women in London in the early twentieth century hatched routes, scripted pathways, mapped cartographies. It is this mapping, hatching and inscribing which generates their textual/visual representations.

### Cities (s)crypts

A concern with the representation of city spaces links several surviving works by Vorticist women artists.[62] There are shared interests in and diverging approaches to the interplays of perspective, architectural construction and the inscription of sight-lines and a noticeable move towards indefinition in which bodies and cities interrupt each other, in which space seems indeterminate, boundaried yet borderless.[63] Strategies of reading, derived from the philosophical writings of Jacques Derrida, assist in a consideration of 'undecidability' in which images slip between site and body, slide across delineations of interior and exterior, move towards and away from literal and literary referents.

This irresolution, in which bodies and architectural forms are mutually defining, comes with the processes of abstraction. New perspectival configurations were developed in which the initial subject was undermined, displaced and fractured through an interrogation of one-point perspective. From 1913 to 1914 Vorticist artists took up the spatial propositions of analytic Cubism and Futurism (both, however, marginalised in *Blast 1*). In his account of Vorticism published in the *Fortnightly Review* in 1914, Ezra Pound drew on mathematics and geometry as paradigmatic exemplars of the interrelatedness of knowledge and representational forms, drawing attention to analytic geometries of space. A glance at Lewis's overmantel for Lady Drogheda's dining room, designed 1913–14, indicates this exploration of new spatial geometries. The framing of the central mirror with narrow black bands projects orthogonal lines converging as if to a central vanishing-point, but left unresolved in the mirrored surface itself, which reflects ambiguous spatial relationships through chance perception. Lewis here seems to employ a form of axonometric projection in which receding parallel lines remain in a fixed relation, without resolution in the vanishing-point. The result is both a flat plane and an infinite space (in both cases the mirror) unsettling the spectator and putting in play the vertiginous giddiness often referred to in contemporary accounts of Vorticist spaces. This play with perspective to unsettle the

resolution of sight-lines and to dissolve the plotting of space is also present in Dismorr's prose poem 'London Notes', a series of disconnected, fragmentary perceptions of London, which concludes, 'Curiously exciting are so many perspective lines, withdrawing, converging; they indicate evidently something of importance beyond the limits of sight'.[64] Tantalisingly rich, the phrase 'beyond the limits of sight' suggests the Vorticist break with monocular perspective. Made in relation to Vorticist representations of the urban, there is an intimation in this phrase of the cavernous, underground and hidden spaces of the city, from crypts to basements to sewers to underground transport.

A concern with space and an irresolution of bodies and architecture may be glimpsed by proposing a sequential relation between Saunders's *Vorticist Composition with Bending Figure* of *c.* 1913–14 and her *Abstract Multicoloured Design* of *c.* 1915.[65] In the first a bending figure, almost ovoid in shape, leans forward, hands gesturing with three strings or staves.[66] Linking it to William Blake's *Newton*, Richard Cork has interpreted this figure as 'involved in a measuring, mathematical task'.[67] Traces from this study, notably the converging lines, semi-circular and serpentine shapes and a hand, are also to be seen in *Abstract Multicoloured Design*. If the latter was grounded in the former, then *Abstract Multicoloured Design*, with its sharp and at times close contrasts of colour, may be read in terms of an interplay between interiors and exteriors of bodies *and* cities, as a representation in which architectural forms pierce and fragment the body and in which the body reshapes architectural space. The corporeal/architectural forms float, indeterminately, between two and three dimensions.

Bodily traces may be seen in other works by Saunders, including *Vorticist Design (Man and Dog)*, *c.* 1915; *Vorticist Composition (Study for Cannon?)*, *c.* 1915; *Vorticist Composition with Figure in Blue and Yellow*, *c.* 1915; and *Monochrome Composition with Ascending Figures*, *c.* 1915.[68] Brigid Peppin's suggestion that in *Vorticist Composition (Study for Cannon)* 'an angular figure is represented simultaneously as gunfire and victim' may be displaced by a reading of the whole as mechanical forms (fins?), indicating Vorticist preoccupations with the body as machine. *Vorticist Composition with Figure in Blue and Yellow* may depict a figure ascending along the constructional diagonal, a massive head facing left, and/or intersecting shapes. These oscillations are intensified by the colour movement of yellow and blue, pushing planes into recession and thrusting them forward. This work may be distantly related to *Vorticist Composition in Black and White*, *c.* 1915. In *Vorticist Composition: Black and Khaki*, *c.* 1915, the forms conjure images of architecture (perhaps a stairwell) as well as the form of a head (Figure 7).[69] In this irresolution, internal conduits of buildings and the body come to visibility. This 'slicing through' also appears in an early 'Vorticist' drawing by Jessica Dismorr, *Landscape: Edinburgh Castle, c.* 1914–15 (Figure 8).[70]

In a brilliant and witty analysis of architecture and the text, architecture as text, Jennifer Bloomer has proposed, in contrast to conventional architectural drawing in which line delimits space, 'scrypt'. She defines this as 'a writing that is other than transparent, a writing that is illegible in the conventional sense', continuing, 'this writing of something that is empty space, where something secret and sacred – something unspeakable or unrepresentable – is kept, a holey space'.[71] To read Saunders's

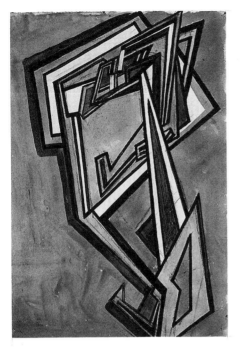 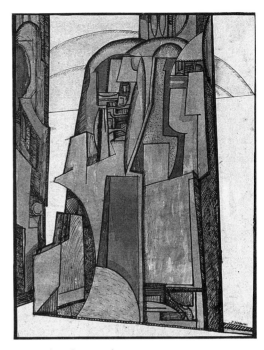

7    Helen Saunders, *Vorticist Composition: Black and Khaki*, c. 1915, ink and watercolour on paper, 22.5cm × 18cm
8    Jessica Dismorr, *Landscape: Edinburgh Castle*, c. 1914–15, pen and ink on paper, 24.2cm × 18.9cm

drawings and watercolours as 'scrypts' is not simply to perceive line as drawing round space, colour as filling it in, but to attend to the inscription of line, line as cutting into the paper, cutting out and into space. In Saunders's dazzling displays of vertiginous perspectives are cavernous voids, unplumbed depths, uncertain reaches. Dizzying heights plunge to uncharted depths in *Vorticist Composition: Black and Khaki*; ascent risks a fall into a void over which, in *Vorticist Composition (Study for Cannon)*, a hook, outlined in eye-catching blue, swings. For Bloomer, 'scrypt' doubles upon 'crypt', a cavernous void hewn into solid material. Crypts and caves are also present in Dismorr's *Edinburgh Castle* and Saunders's drawings, from the cavities of *Untitled Drawing*, c. 1913, which shape and are formed by the figures within, to the internal depths of *Vorticist Composition with Figures in Black and White*, c. 1914–15.[72] In both these works the voids are visible through the 'slicing through': 'scrypt' delineates 'crypt'. Yet these un/seen spaces are uncertain: as the cave is hollowed out, so the cavity may cave in, jeopardising solidities and securities of form.

More than any other work by Saunders, *Atlantic City* (Figure 9), reproduced in *Blast* 2 of 1915,[73] provides an image of the fragmentation, dispersal and non-unitary nature of the modern city. Sight-lines converge and depart; sights and sites collide. Richard Cook has remarked upon the lack of internal coherence of Saunders's compositions, which indeed seem to lack the logical variation of those by contemporaries such as Lewis.[74] In *Atlantic City* the image seems to explode outwards from the centre. Broken shards of urban architecture are lit by arrows of brilliant light. The

incisive glare of electric light (so unlike the soft diffusions of gaslight) breaks up surfaces (as in *Vorticist Composition in Green and Yellow, c.* 1915), highlights facades of buildings, gleams from illuminated windows and borders deep caverns. In common with other Vorticist artists, Saunders breaks with two representational strategies devised in the nineteenth century and retained in some modernist practices: the framing of a view of the city from the threshold of a window, and the depiction of urban interiors.[75] In *Atlantic City* the view is everywhere and nowhere; it is not fixed at any point which can be granted to the spectator, who is precipitated into its unhomely/*unheimlich* spaces.[76]

If *Atlantic City* is centrifugal, *War Scare, July 1914*, by Dorothy Shakespear, inscribed 'done when the Stock Exchange shut, before war was declared', maps a vortex imploding.[77] Arcing and angular forms converge on a displaced centre, which oscillates from concave to convex. There is nothing here of Saunders's spatial projections. In Dismorr's painting *Abstract Composition, c.* 1914–15 (Figure 10) (which also works with single-point perspective as well as with a strong vertical axis), shapes, distantly derived from architectural and mechanical forms, move.[78] An interest in the representation of motion may have underpinned Dismorr's titling of her works in the Vorticist exhibition of 1915, *Shapes, Interior, Movement* and *Design*, and also provided the rationale for her contributions to *Blast 2, The Engine* and *Design*. Women artists participated in and contributed to the Vorticist movement in a variety of ways, and they by no means all shared a common aesthetic.

For Saunders's second contribution to *Blast 2, Island of Laputa*, many readings may be proposed.[79] Not only is it one of several works in which the outline of a head may be traced, but the drawing also suggests a promontory and the island of its title. In Jonathan Swift's *Gulliver's Travels*, first published in 1726, life on the island of Laputa is devoted to mathematics, geometry and music, and Swift is bitterly satirical of misapplied science and technology. As Gillian Beer has noted, island stories have figured largely in writings about England, which is conflated with the island and perceived as the mythic centre of Empire.[80] Bounded by seas and famed for its ports, England is blessed in *Blast 1* as this 'industrial island machine, pyramidal workshop . . . discharging itself on the sea'. Only from 'this lump of compressed life' can a new movement in art arise.[81] Such representations of defensive insularity, secure and inviolate borders and marine supremacy played into and were part of contemporary imperialism, heightened in the Vorticist years of 1914 to 1918. It has been suggested that the flying island of *Gulliver's Travels* was an allegory for English imperial violence against the Irish, a reading which may well have been reactivated in the crisis of Anglo-Irish relations of 1913–14.

As Beer points out, an island is a conjunction of land and water with permeable edges and interiors traceried by lakes and rivers. If the crisp lines and rows of hatching in *Island of Laputa* signify the waves of the sea, they also double in the hatched areas to delineate land. The island in Saunders's woodcut seems to move from the right, over the hatched lines on the left, as if hovering, like the flying island of *Gulliver's Travels*, not fixed by time, space or direction. The mapped surface of the island is made up of geometric forms, not organised by a monocular perspectival system. There are

9   Helen Saunders, *Atlantic City*,
reproduced in *Blast 2*, 1915

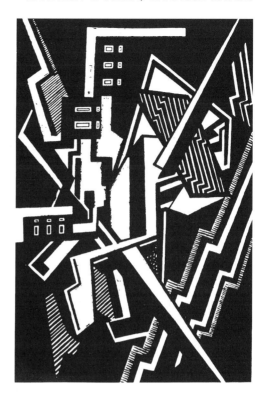

10   Jessica Dismorr, *Abstract Composition*,
*c.* 1914–15, oil on canvas, 41.3cm × 50.8cm

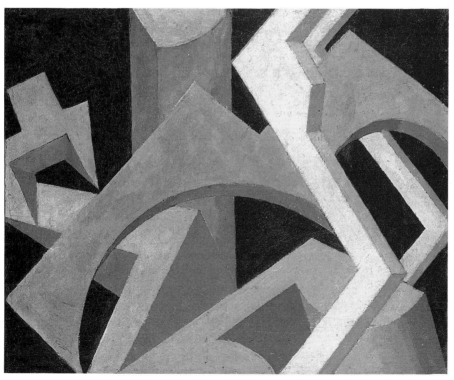

constant changes of scale, ambiguities of space, irresolutions of figure and ground, an undecidability. The island is seen apparently from above, as if from the vertical perspective of the aeroplane. Writing of the impact of the aeroplane, a new technological invention which had a profound impact on modern culture, Beer has suggested that for Virginia Woolf, who wrote in novels, essays and diaries about air travel, air crashes and air raids, flight became a metaphor for a feminist critique of insularity, masculinity and patriotism. Whether this reading can be sustained for modernist women artists remains open to question, but certainly a multiplicity of view projected in the work of women artists associated with Vorticism enabled a movement beyond defined boundaries, away from linear perspective, and a resiting of sight-lines.

## Notes

1   The term 'avant-garde' has been subject to considerable definition; see R. Poggioli, *The Theory of the Avant-garde* (Cambridge, 1968); P. Burger, *Theory of the Avant-garde* (Minneapolis, 1984); R. Krauss, *The Originality of the Avant-garde and Other Modernist Myths* (Cambridge, 1985). It is used here in the historical specificity argued for by Susan R. Suleiman in her *Subversive Intent: Gender, Politics and the Avant-garde* (Cambridge, 1990). The involvement of women in the modern movement in Russia is well documented. In Britain none of the other modernist groups, such as the 'Bloomsbury Group' or the Camden Town Group, issued manifestos.

2   It is of interest to consider why Jessica Etchells (1893–1933), associated with similar art circles before 1914, did not join the Vorticist group; see J. Beckett and D. Cherry, 'Women Under the Banner of Vorticism', ISCAC (Internationaal Centrum voor Structuuranalyse en Constructivisme) *Cahiers*, 8/9 (1988).

3   Saunders's address at 4 Phené Street, Chelsea, is given in *Blast* 2. In addition Shakespear and Saunders contributed endpieces to this issue (pp. 47 and 16, respectively); see B. Peppin, *Helen Saunders, 1885–1963* (Oxford, Ashmolean Museum, 1996). *Blast 3*, announced but never produced, was to have included 'Poems and Vortices' by Dismorr and reproductions of work by Dismorr and Saunders.

4   Wyndham Lewis liked to maintain that 'Vorticism in fact was what I personally did and said at a certain moment'; see W. Lewis, 'Introduction', *Wyndham Lewis and Vorticism* (London, Tate Gallery, 1956). This was refuted by William Roberts, who counter-claimed: '"Vorticism" in fact was a word used to symbolise the painting and sculpture of the artists named below who agreed to be named as the "Vorticist group" at a certain period . . . Gaudier-Brzeska, Wadsworth, Etchells, Dismorr, Saunders, Roberts, Lewis'; see W. Roberts, *The Resurrection of Vorticism and the Apotheosis of Wyndham Lewis at the Tate Gallery* (London, Tate Gallery, 1956). As recently as 1987, in his essay on 'The Vorticist Circle, Bomberg and the First World War' for the catalogue of the exhibition *British Art in the Twentieth Century: The Modern Movement* (London, Royal Academy, 1987), Richard Cork declined to include any of these four artists, although he had given them some coverage in his monumental study, *Vorticism and Abstract Art in the First Machine Age* (London, 1976). They were included in J. Beckett, *'A Terrific Thing': British Art 1900–1916* (Norwich, Castle Museum, 1977) and discussed in M. Speight, 'The Women in the Picture', *Enemy News*, 9 (1978).

5   Lisa Tickner has proposed another interpretation, arguing that Vorticism 'offered opportunities for a *feminist* repudiation of femininity'. She contends that 'in its rejection of sentiment, narrative, moralising and passivity [Vorticism] also rejected much that was feeble and titillating in images of women'; see L. Tickner, 'Men's Work? Masculinity and Modernism', *Differences*, 4:3 (1992), pp. 21–2.

6   D. D. Paige (ed.), *Letters of Ezra Pound, 1907–41* (New York, 1950), p. 28.

7   B. Elliott and J.-A. Wallace, *Women Artists and Writers: Modernist (Im)positionings* (London and New York, 1994), p. 1.

8   A. Huyssen, 'Mass Culture as Woman, Modernism's Other', in his *After the Great Divide: Modernism, Mass Culture, PostModernism* (Bloomington, 1986), p. 47.

9   M. Douglas, *Purity and Danger: An Analysis of the Conceptions of Pollution and Taboo* (London, 1996).

10  Elliott and Wallace, *Women Artists*, p. 2.

11  Peppin, *Helen Saunders*, no. 9. All references to Saunders's surviving work are to this catalogue.

12  The numerous references to Africa and to modern artists as 'savage', 'primitive mercenaries' (*Blast 1* (1914), pp. 33, 30) take place within this colonial/imperialist rhetoric.

13  *Blast 1*, pp. 11, 18, 19, 21.

14  See S. Benstock, *Women of the Left Bank: Paris, 1900–1940* (Austin, 1986); Elliott and Wallace, *Women Artists*; and G. Perry, *Women Artists and the Parisian Avant-garde* (Manchester, 1995).

15  In the prospectus Lewis is named as manager and Lechmere and Lewis as directors; see Cork, *Vorticism*, p. 158.

16  'Cubist'/'Cubism' were highly volatile terms in these years; see J. Beckett, 'Cubism and Sculpture', in *British Sculpture in the Twentieth Century* (London, Whitechapel Art Gallery, 1980).

17  Frank Rutter was an art critic, founder and secretary of the Allied Artists' Association, whose exhibitions were based on open submission of works; unlike other art institutions the AAA seems not to have participated in the schisms of the period.

18  Kate Lechmere to Wyndham Lewis, 23 July [1914], Cornell University Library.

19  Lechmere's apartment above was, according to *Vanity Fair*, 25 June 1914, decorated with 'black doors in cream walls, and black curtains in addition to the usual orgies of colour'; in addition she painted her window-boxes with abstract patterns.

20  'Rebel Art in Daily Life', *Daily News*, 7 April 1914.

21  Cork, *Vorticism*, p. 158.

22  Cork, *Vorticism*, p. 147. The painting is now lost.

23  Kate Lechmere to Wyndham Lewis, 19 May [1914], Cornell University Library. Works by Gaudier-Brzeska, Bomberg and Roberts were also shown at the club.

24  Kate Lechmere to Wyndham Lewis, 23 July [1914], Cornell University Library. For the brochure see Cork, *Vorticism*, p. 157.

25  Lechmere's surviving letters to Lewis at Cornell University Library are primarily concerned with financial matters. For a more detailed account see Cork, *Vorticism* and Beckett and Cherry, 'Women Under the Banner of Vorticism'. For discussion of the relations of women, wealth and the institutions of modernism see Elliott and Wallace, *Women Artists*.

26  'Restaurant Art', *Colour Magazine*, April 1916, xiv; 'Futurism in Furnishing', *Colour Magazine*, May 1916. The card, dated January 1916, 'to view the room with Paintings and Ornament by Mr Wyndham Lewis', attributes the decoration to Lewis.

27  R. Cork, *Art Beyond the Gallery in the Early Twentieth Century* (New Haven and London, 1985), p. 271.

28  Cork, *Art Beyond the Gallery*, p. 321.

29  E. Grosz, 'Bodies/cities', in B. Colomina (ed.), *Sexuality and Space* (Princeton, 1992), pp. 242–3.

30  For example, J. Weeks, *Sex, Politics and Society* (London, 1981) and L. Bland, *Banishing the Beast: English Feminism and Sexual Morality, 1880–1914* (London, 1995). Michel Foucault, however, wrote of the locations and institutions shaping discursive formations of sexuality and the body; see his *History of Sexuality, Volume 1: The Will to Know* (Harmondsworth, 1981).

31  While it can be argued, following Virginia Woolf, that 'in or about December 1910 human

character changed', it should be noted that this pronouncement was made in an essay written in 1924 and first presented as a lecture in which Woolf was plotting a break between the Victorians and the Georgians; see 'Mr Bennett and Mrs Brown', in *Collected Essays of Virginia Woolf, 1* (London, [1924] 1966), pp. 319–37 (p. 320). Another chronology presents the decades *c.* 1880 to 1920 as a period of crisis; see M. Langhan and B. Schwarz (eds), *Crisis in the British State, 1880–1920* (London, 1985).

32   These quotations are taken from E. Grosz, *Volatile Bodies* (Bloomington and Indianapolis, 1994) and Foucault, *History of Sexuality*.

33   C. Booth, *Life and Labour of the People of London* (London, 1889–1903); W. Besant, *South London* (London, 1899), *East London* (London, 1901), *The Thames* (London, 1903); C. F. G. Masterman, *The Condition of England* (London, 1909); G. R. Sims, *Living London: Its Work and its Play, its Humour and its Pathos, its Sights and Scenes* (London, 1902–3). While Sims favoured a fragmentary photo-journalist approach, historians like Besant researched local histories and commentators like Masterman drew on organic metaphors to convey the scale and sprawl of London.

34   Feminist historians are by no means agreed on the freedoms offered by new city spaces; see R. Bowlby, *Just Looking: Consumer Culture in Dreiser, Gissing and Zola* (London and New York, 1985); J. R. Walkowitz, *City of Dreadful Delight: Narratives of Sexual Danger in Late Victorian London* (London, 1992); and L. Walker, 'Vistas of Pleasure: Women as Consumers of Urban Space, 1850–1900', in C. C. Orr (ed.), *Women in the Victorian Art World* (Manchester, 1994).

35   L. Bland, 'Purity, Motherhood, Pleasure or Threat', in S. Cartledge and J. Ryan (eds), *Sex and Love: New Thoughts on Old Contradictions* (London, 1986), p. 134.

36   Saunders's address at 4 Phené Street (*c.* 1912–17) was near to Dismorr's at 183 King's Road. Dismorr lived in France from 1910 to 1913, studying with Max Bohm in Étaples and at La Palette; in Paris she was a member of the 'British Fauves' and contributed to *Rhythm*; see Beckett and Cherry, 'Women Under the Banner of Vorticism', pp. 135–7.

37   Cork, *Vorticism*, p. 414.

38   H. Saunders, 'Notes on Harriet Weaver', in J. Lidderdale and M. Nicholson, *Dear Miss Weaver* (London, [1962] 1970).

39   R. West, 'Indissoluble Marriage', *Blast 1*, 1914, pp. 98–117.

40   Cork, *Vorticism*, p. 148. According to the prospectus, 'Saturday afternoon meetings of artists' were held from 4 to 6 p.m. (Cork, *Vorticism*, p. 158). Of the launch party for *Blast 1*, Douglas Goldring wrote, 'Jessica Dismorr, an advanced painter and poetess . . . was ordered by the Master, after a counting of heads, to get tea for us. She obeyed with as much promptitude as I used to obey my guru' (Cork, *Vorticism*, p. 414).

41   W. Baron, *Miss Ethel Sands and her Circle* (London, 1977), pp. 66–8.

42   Walkowitz, *City of Dreadful Delight*, passim.

43   Kate Lechmere to Lewis, 25 July 1914, Cornell University Library.

44   The *Daily Mirror*, 2 and 3 December 1913, and the *Daily News* both carried photo-features on Futurist gowns in 1914, and the *Sketch*, 24 March 1914, reported on Lewis's schemes and sketches for the decoration of Lady Drogheda's dining room.

45   W. C. Wees, *Vorticism and the English Avant-garde* (London, 1972), pp. 38–9.

46   *Daily Mirror*, 30 March 1914, p. 7. The interior was completely rearranged for the photographer of the *Graphic*, 25 April 1914, p. 276: a painting by Lewis was hung over the fireplace and another version of *Caprice* was placed over a door.

47   'A Post-Impressionist Flat: What Would the Landlord Think?', *Daily Mirror*, 8 November 1913, p. 3. Thanks to Geoff Archer for bringing this to our attention.

48   'School of Cubist Art', *Evening Standard*, 30 March 1914; Cork, *Vorticism*, p. 149.

49   In its cut, layering and looseness (there is probably no corseting), it is comparable to the 'ori-

ental' gowns popularised by Paul Poiret and the Ballet Russe. Did Lechmere purchase it in Paris, or, like other women artists, design and make her clothes? See Alicia Foster, 'Gwendolen Mary John', Ph.D. thesis, University of Manchester, 1996.

50  Cork, *Vorticism*, pp. 147, 149. According to Lechmere, Lewis set a dress code for women appearing at the centre of 'simple white blouses and long dark skirts', which in Lechmere's recollection was the attire of 'a high-class shop girl' (Wees, *Vorticism*, p. 146).

51  Elliott and Wallace have noted 'the degree to which many of the women associated with various avant-gardes publicly and privately distanced themselves from any sort of political engagement, particularly feminism' (*Women Artists*, p. 153).

52  Dismorr to Lewis (?1913), Cornell University Library.

53  Cork, *Vorticism*, p. 275.

54  'Vorticists at the Doré Gallery', *Observer*, 4 July 1915, p. 9, in which 'Sanders' and 'Dismore' are included in the grouping 'six different men'.

55  D. Cherry, 'Carrington: The Exhibition', *Texte zur Kunst*, 6:2 (1996), pp. 190–2.

56  V. Woolf, 'Street Haunting: A London Adventure', *Collected Essays of Virginia Woolf, 4* (London, [1930] 1967), pp. 155–67. For an inspired reading of this essay see R. Bowlby, 'Walking, Women and Writing: Virginia Woolf as *Flâneuse*', in I. Armstrong (ed.), *New Feminist Discourses* (London, 1992).

57  Cork interprets 'June Night' as a parable of the artist's move from Fauvism to Vorticism (*Vorticism*, p. 417), a reading which emphasises women's fascination with the modern city.

58  J. Dismorr, 'Poems and Notes: June Night', *Blast* 2 (1915), pp. 67–8.

59  Richardson sets seven of the thirteen novels of *Pilgrimage* (1915–35) in the area of Fitzrovia/Bloomsbury, precisely that struggled over by modernist art groups. There are parallels between Dismorr's prose pieces and the early novels of *Pilgrimage*. Woolf's *Night and Day* of 1919 was also set in London.

60  This anxiety is also conjured in Dismorr's urban 'Promenade': 'It is possible that we are being led by different ways into the same prohibited and doubtful neighbourhood' (*Blast* 2 (1915), p. 69).

61  The concept 'walking in the city', reworked here to propose gendered mappings of the city, is developed from Michel de Certeau, *The Practice of Everyday Life* (Berkeley, 1984).

62  Extant works include two oil-paintings by Dismorr; several watercolours and drawings by Saunders, who in 1956 was 'unable to find the only pre-1916 work that she had thought worth preserving [a non-figurative oil-painting, *c*. 51cm × 61cm]' (Peppin, *Helen Saunders*, p. 41); a number of watercolours and drawings by Shakespear; and no work by Lechmere. While these artists did depict landscapes, titles such as those of Saunders's contributions to the Vorticist exhibition of 1915 – *English Scene*, *Swiss Scene* and *Cliffs* – need not be construed as evidence of such practice. Dismorr's titles for works in the same exhibition did not specify location.

63  For a more extended consideration see J. Beckett and D. Cherry, '"Jenseits des sichtbaren": Frauen, Großstadtkultur, Vortizismus', in K. Orchard (ed.), *Blast! Die erste Avantgarde in England, 1914–1918* (Berlin, 1996), pp. 58–73.

64  *Blast* 2 (1915), p. 65.

65  Peppin, *Helen Saunders*, nos. 5, 17 (Tate Gallery, London). Loss of work makes it difficult to ascertain or reconstruct such processes, but *Hammock*, *c*. 1912–13 (no. 6), may be an abstraction from a popular Edwardian subject of a young woman reclining in a hammock. Lewis's *Portrait of an Englishwoman*, reproduced in *Blast* 1 (1914), utilised architectural and mechanical forms for the rendition of the female body.

66  According to Peppin (*Helen Saunders*, no. 5), this drawing was cut down by the artist to its present irregular shape.

67  Cork, *Vorticism*, p. 150.

68  Peppin, *Helen Saunders*, nos. 14, 16, 22, 21. Peppin has linked no. 16, one of the few signed with the artist's initials, with *Cannon*, one of the three drawings by Saunders which were purchased by John Quinn.

69  Peppin, *Helen Saunders*, nos. 11, 12. Peppin has connected no. 12 to an exhibit at the Vorticist exhibition of 1915 entitled *Black and Khaki*.

70  Victoria and Albert Museum, London. Dismorr exhibited a drawing entitled *Edinburgh Castle* in the Vorticist exhibition of 1917. A painting of the same title (oil on plywood, 51.5cm × 47cm) was in the collection of R. H. M. Ody. The composition of this massive structure depends on an observation of Assyrian sculptures housed in the British Museum in London. A consideration of the pronounced relations in Vorticism between imperialist collecting and visual culture is beyond the scope of this essay.

71  J. Bloomer, *Architecture and the Text: The (S)crypts of Joyce and Piranesi* (New Haven and London, 1993), pp. 11, 48.

72  Peppin, *Helen Saunders*, nos. 8, 13. Taking Cork's title (*Vorticism*, p. 150), Tickner has argued that in no. 8 'Saunders probably comes closer than anyone else in the pre-war avant-garde to producing an overtly feminist painting'; see 'Men's Work?', p. 22.

73  Now lost, Saunders's painting entitled *Atlantic City* was shown at the Vorticist exhibition of 1915.

74  Cork, *Vorticism*, pp. 419–24. Lewis's *New York* of 1914, *Workshop*, 1914–15, *The Crowd*, 1914–15, do not have the complex perspectival experimentation of Saunders.

75  City views out of windows include V. Bell, *46 Gordon Square*, c. 1909–10 (private collection), and works by the Camden Town painters, who depicted urban interiors. For a detailed study see Jane Beckett and Deborah Cherry, 'When Painting was/as Murder: Walter Sickert and Camden Town', forthcoming.

76  Freud's concept of the unhomely/*unheimlich*, from his essay 'The Uncanny', is developed in relation to visual culture in our forthcoming essay, 'When Painting was/as Murder' (note 75, above).

77  Private collection. The inscription begins, 'Not to be shown to anyone.' The impact of war, declared in August 1914, on these artists awaits further study.

78  Tate Gallery, London.

79  A squared-up study survives (Cork, *Vorticism*, p. 425); a drawing so titled was shown at the Vorticist exhibition of 1915 and in New York in 1917, where it was dated 1915. The size, 25.5cm × 21.5cm, was given in the Quinn sale catalogue of 1927.

80  G. Beer, 'The Island and the Aeroplane: The Case of Virginia Woolf', in R. Bowlby (ed.), *Virginia Woolf* (London, 1992), p. 137.

81  *Blast 1* (1914), pp. 23–4, 32.

# Black awakening: gender and representation in the Harlem Renaissance

Although the recent literature on the phenomenon of the Harlem Renaissance has been extensive, it has largely been written in narrative and anecdotal forms.[1] Accounts which have celebrated the achievements of Afro-American artists and writers have not examined the meaning of their work with any theoretical rigour. The visual imagery of the 'new negro' produced by the Harlem Renaissance did not merely document or reflect their reality. The artists depicted conflicts of gender, sexuality and racial identity which can only be understood today when the images are put in a historical context with contemporary texts. Instead of adopting a traditional art-historical iconographical framework,[2] I intend to explore two images from the Harlem Renaissance as examples of the contestation of dominant images of race and gender, exposing the relationship between picture-making and power in the manner developed by Michel Foucault, which also contest his theory of the subject. For the Harlem Renaissance the achievement of subjecthood was a struggle in itself, and this essay will examine the role of images in that struggle. Debates on 'black aesthetics' in a number of publications produced in the 1910s and 1920s generated a new conception of black identity, and I will consider these debates in relation to Meta Warrick Fuller's *Ethiopia Awakening* (1914) (Figure 11) and Aaron Douglas's *Aspects of Negro Life: The Negro in an African Setting* (1934) (Figure 12).[3] By examining the writings of black philosophers like William E. B. Du Bois and Alain Locke, who became critics on art and literature, Wallace Thurman, who was literary critic and editor of *Fire!!!*, and Marcus Garvey, founder of The Universal Negro Improvement Association, it is possible to consider the process of myth-making in relation to images of the 'new negro' during the Harlem Renaissance.

    If we consider the structures of knowledge analysed by Foucault in terms of institutional frameworks, practices and discourses which form both subjects and subjectivities,[4] it is possible to understand the construction of the 'new negro' during the Harlem Renaissance. If one follows Foucault's analysis of discourse as a means to analyse the texts of Locke, Du Bois, Thurman and Garvey, they can be seen to challenge the representation of the black body found in nineteenth- and early-twentieth-century ethnographical and archaeological documentation, which had led to negative stereotyping of non-European people. In this literature, stereotypes of Africans and Afro-Americans are commonplace, based on their body shape and physiognomy. Thick lips, for instance, and the size of a person's skull could describe the character

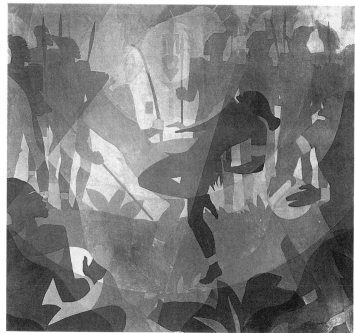

12    Aaron Douglas, *Aspects of Negro Life: The Negro in an African Setting*, 1934, *c.* 187cm × 187cm

11    Meta Warrick Fuller, *Ethiopia Awakening*, 1914, bronze, 174cm × 41cm × 52cm

of a negro and define him or her as untrustworthy. Similarly archaeology frequently described the culture and lifestyle of 'primitive' people as stagnant.[5] The idea of a new negro subject found in the writers of the Harlem Renaissance challenged the boundaries which had previously circumscribed areas of knowledge and topics for research. In Foucault's work, such boundaries can be destroyed by alternative readings and histories of the subject, and it is this shift in boundaries for research which characterises the Harlem Renaissance.

The idea of a subversive visual representation of the black body among Afro-American artists was stimulated by Alain Locke's 1925 essay 'The New Negro', printed in a special March edition of *The Survey Graphic* entitled 'Harlem: Mecca of the New Negro', which Locke edited. The essay was written at the time when many Afro-Americans were emigrating from the rural areas in the south to cities in the north and when Harlem in New York became the cultural centre of Afro-American creativity.

This essay, and the edition of which it was a part, was significant because of its acknowledgement of the development of Afro-American art. Locke described how the Afro-American turned to the arts to overcome racial oppression. He wrote:

> Similarly the mind of the negro seems suddenly to have slipped from under the tyranny of social intimidation and to be shaking off the psychology of imitation and implied inferiority. By shedding the old chrysalis of the Negro problem we are achieving something like a spiritual emancipation . . . In Harlem, Negro life is seizing upon its first chances for group expression and self-determination . . . That is why our comparison is taken with those nascent centers of folk-expression and self-determination which are playing a creative part in the world today.[6]

The texts of Locke, Du Bois, Thurman and Garvey which criticised Western culture also attacked each other's view of the Afro-American body. They looked for historical precedents in Africa to establish their views of a 'new negro' vitality in their re-creation of a black body. Their discrete cultural analysis involved a historical periodisation that traced black civilisation through cultural traditions, and this process, coupled with its analysis of masculinity, restricted ideas of sexual difference. The images of the 'new negro' as masculine led to problems of defining black 'womanhood'. Within the structures of black identity, there was the possibility of some space where a critique could be developed against the victimisation of women. The re-emergence of a black subject was given institutional support by those who supported Afro-American artists during the Harlem Renaissance.[7] There were a few private galleries where Afro-American artists could exhibit, but many Afro-American artists were dependent on shows where they could submit their work. White patrons were financially important to Afro-American artists, but usually problems occurred because of a conflict between the expectations of the patrons and the desires of the Afro-American artists.

The Afro-American artist Meta Warrick Fuller had started producing work in the early 1900s. Her sculpture *Ethiopia Awakening* (Figure 11) was used to bring to fruition theories that combined modernist ideas with ancient Africa and which served to authenticate the modernist identity of the 'new negro'. Du Bois had met Fuller in Paris in 1900 after he had already started to develop his ideas against racial oppression. *Ethiopia Awakening* was shown for the first time in New York at the *Making of the American Exposition* in 1922. It echoed ideas about Africa in Du Bois's book *The Negro* (1915). In this book Africa is seen as a mystical motivation for the visual imagination:

> Africa is at once the most romantic and most tragic of continents. Its very names reveal its mystery and wide reaching influence. It is the 'Ethiopia' of the Greeks, the 'Kush' and 'Punt' of the Egyptians, and the Arabian 'Land of the Blacks'. To modern Europe it is the 'Dark Continent' and 'Land of Contrasts', in literature it is the seat of the sphinx.[8]

This view of Africa and of the relationship between Egypt and Ethiopia was mediated as much by sources from Egyptian archaeology in the nineteenth and early twentieth centuries and its ideas lay behind the increase in Pan-Africanism from 1919. From the early nineteenth century Egyptian antiquities and travel books on ancient

Egypt were widely accessible in America, leading to the creation of collections at the Museum of Fine Arts in Boston and the Metropolitan Museum of Art in New York. In France, where Fuller studied from 1901 to 1902 at the Académie Colarossi and in Rodin's studio, Egyptian artefacts had been on view in the Louvre from 1826. Orientalist paintings depicting Egyptian clothing, antiquities and settings could also be seen in the Louvre from 1900. The historical importance of ancient Egypt lay in its status as a precursor of a classical culture based on the writings of ancient Greek and Roman scholars. Through the processes of ethnology and archaeology, Egypt was incorporated into a biblical chronology. Ancient Egypt was essential to promoting a view of Western civilisation where knowledge progressed to a Graeco-Roman world as its own culture disintegrated. By the early twentieth century these views were wide-spread. In 1922 Howard Carter discovered the tomb of Tutankhamun, and the sensa-tional press coverage surrounding this revived popular interest in Egyptology. Carter's pamphlet *The Tomb of Tutankhamun* was published in instalments between 1923 and 1933 and included Harry Burton's black-and-white photographs.[9] Critical enthusiasm for Egypt and Africa among Afro-American artists was part of the critique of colonial-ism levelled against the art establishment as well as against contemporary academic scholarship. How images of the 'new negro' were represented in relationship to this discourse was important to both Locke and Du Bois.

The academic training that both Meta Warrick Fuller and Aaron Douglas received in Paris equipped them to produce particular images of the 'new negro' which are closely related to Du Bois's and Locke's writings. Academic training based on studies from Greek and Roman models remained the dominant method taught in the art academies. Fuller's initial training at the Pennsylvania School of Art and Design was basic, because it was believed unnecessary to train black people for careers in fine art. Industrial design was considered more appropriate. Douglas studied at Nebraska University in Topeka, then with Winold Reiss from 1925, before receiving a Barnes Foundation sponsorship. He was introduced to Albert Barnes in 1927 by Charles Johnson, who sat on the committee of the National Association for the Advancement of Colored People (founded in 1910). At the Barnes Foundation, he made sketches from African masks and Cubist paintings owned by Albert Barnes, which were syn-thesised in works like *Aspects of Negro Life: The Negro in an African Setting* (Figure 12). Barnes discussed the possibility of Douglas receiving funding for his work. What needs to be clarified and understood is that both Fuller's and Douglas's works reacted to the ever-increasing ambitions of black art to deal with gender, power, sexuality and sub-jecthood during the Harlem Renaissance. Both artists are seen to move away from conformist or standard prejudices about the 'primitive'. We can only understand this by looking at Locke's and Du Bois's notions of 'black aesthetics', where the under-standing of African–American art was comprehended through particular ideas of Western beauty joined with shared concerns about a conscious black racial self. Their ideas were related to contrasting notions of the 'primitive' and influenced visual repre-sentations of the black subject.

Du Bois's and Locke's understanding of the racial self was rooted in the psychological and philosophical teaching of William James and Benjamin Jowett;

their differences lay in Du Bois's interest in the philosophy of George Santayana in contrast to Locke's use of David Hume's philosophy.

Du Bois was taught at Harvard University by William James between 1888 and 1891. James's first book, *The Principles of Psychology* (1890), and a subsequent essay 'The Will', in *To Students: On Some of Life's Ideals* (1899), used neo-Platonic notions derived from his reading of Benjamin Jowett's translation of the *Dialogues of Plato* (1860). Jowett had worked at Oxford University in the mid to late nineteenth century and had introduced the work of Hegel and Kant to Oxford students. Locke studied philosophy and classics at Oxford between 1907 and 1910. This was at a time when Jowett still had a major influence on the Oxford syllabus and where, from 1903, classical teaching was based on humanistic ethics.

For Du Bois, race identity depended on self-consciousness, how the body responded consciously to itself and to the environment. Racism was an essential part of black consciousness, and its impact in creating self-awareness is described by Du Bois in his essay 'On Being Black', originally published in the *Modern Quarterly* in 1920. In the essay, the difference between black existence and a white population is acknowledged:

> The children jeer as I pass to work. The women in the streetcar withdraw their skirts or prefer to stand . . . I hurry home through crowds. They mutter or get angry . . . suddenly your heart chills . . . Then the fear surges in your soul, the real fear beside which other fears are vain imaginings; the fear lest right there and then you are losing your own soul; you are losing your own soul and the soul of a people: that millions of unborn children, black and gold and mauve, are being there and then despoiled because you are a coward.[10]

The psychological fear of racism and the presence of a disenchanted self is evident. Du Bois intended to show how self-consciousness acted as a functional feature of the construction of blackness. Through a consideration of the ideas of William James it is possible to see what Du Bois borrows from the interpretation of his ex-tutor. For James, pragmatic theory used consciousness as a functional source in relation to a self-image. James's notion of self-image had come from neo-Platonic ideas taken from Jowett's *Dialogues of Plato*, where the self and environment have some control over moral conduct.[11] Sensory particulars and consciousness are acquired through experience and restrict the transcendental ego:

> In attending to either an idea or a sensation belonging to a particular sense-sphere, the movement is the adjustment of the sense-organ, felt as it occurs. I can not think in visual terms, for example, without feeling a fluctuating ply of pressures, convergences, divergences and accommodation in my eyeballs. The direction in which the object is conceived to lie determines the character of these movements, the feeling of which becomes, for my consciousness, identified with the manner in which I make myself ready to receive the visible thing. My brain appears to me as if all shot across with lines of direction.[12]

For Du Bois, the black self-image occurred at the moment when fear and isolation affect consciousness. Observation of the environment increased these feelings, as in the Du Bois quotation, where distance is maintained to prevent the ever-present threat of violence.

In another *Modern Quarterly* essay, 'The Social Origins of American Negro Art' (1925), Du Bois wrote that the black soul cried for self-expression. The body physically revealed the desire of the soul and negro art bears witness to the indisputable sign of the black soul: 'It is the cry of some caged soul yearning for expression and this individual impulse was combined with a certain group compulsion. That social compulsion in this case was built on the sorrow and strain inherent in American slavery, on the difficulties that spring from emancipation, on the feelings of revenge, despair, aspiration.'[13]

Alain Locke had also written about the psychological tensions caused by racism. His notion of self was also based on experience and the need for proper education for Afro-Americans. Where Locke differed from Du Bois was in his understanding of the function of sense impressions, which can be traced to the influence of David Hume's theories. Hume, in *A Treatise of Human Nature* (1739–40), wrote that the reflected self-image not only depended on experience, but that the reflection generated in the mind was a reaction of sense experience, and that sense experience gave rise to impressions which arose from psychological necessity: "'tis impossible perfectly to understand any idea, without tracing it up to its origin, and examining that primary impression, from which it arises'.[14] This suggested that impressions and ideas became a procedure for intelligibility and affirmed the idea of causality. Psychological necessity became a means through which to understand a necessary connection between cause and effect which mapped out an individual's response or result after an experience. Repeated exposure to the same psychological phenomena meant the mind could be conditioned to expect a particular effect after a certain cause. In Locke's 1923 essay 'The Ethics Of Culture',[15] directly influenced by Hume, he described how psychological effects of racial discrimination create a feeling of isolation which can only be removed by education. Higher forms of education were a way for Afro-Americans to learn about the ideals of a white society, but these could be reinterpreted to become ideals of a black community. Discrimination should psychologically make Afro-Americans want to learn about culture:

> It follows if there is any duty with respect to culture, that it is one of those that can only be self-imposed. No one can make you cultured, few will care whether you are or you are not . . . Culture begins in education where compulsion leaves off . . . Mentioning the former as the neglected aspect of American education, former President Eliot contends that, since it is the business of senses to serve the mind, it is reciprocally the duty of the mind to serve the senses. He means that properly to train the mind involves the proper training of the sensibilities, and that, without a refinement of the channels through which our experience reaches us, the mind cannot reach its highest development.[16]

Mark Hebling has suggested that Locke attempted to combine rationalism and empiricism to assume an objective world independent of human consciousness.[17] This is not necessarily correct, as Locke attempted to create an objective world which moved towards the edge of consciousness through the process of psychological experience. Locke's notion of the racial self is not rooted in the social environment of Afro-Americans, but in a cultural formation that would lead to a 'pure' form of black

aesthetics, while Du Bois, by contrast, emphasised the social contact between Afro-Americans and their environment. Both of them believed that weaker artists should imitate talented artists, but while Locke emphasised they should not lose their individuality ('genius and talent must more and more choose the role of group expression or even at times the role of free individualistic expression'),[18] Du Bois wanted a group of talented artists to serve a black community. Many Afro-Americans were not familiar with fine art, and needed to be shown how to look at visual imagery.

Locke and Du Bois had already seen the 'primitivism' of the Western avant-garde. Their advocacy of the 'primitive' style was inseparable from their plans for the success of black art. Their writings documented the advance of black aesthetics, which relied on privilege and patronage governed by intellectuals and collectors like Albert Barnes and Charlotte Masson, who were looking for a modern 'primitivism'. Charlotte Masson, who gave financial support to Afro-American artists such as Aaron Douglas and to exhibitions, wanted Afro-American artists to produce a crude 'primitive' style based on Western modernism and which she believed to be inherent in all Africans. By 1927, in a letter to Locke she lamented what she felt was a decline in black 'primitivism'.[19] Albert Barnes understood 'primitivism' as an instinctive or irrational force which an artist felt when producing an original piece of work.[20] In this light he endorsed the modernist view of his friend and sometimes dealer Paul Guillaume, in so far as the plastic endowments of negro sculpture had resurfaced in the aesthetic qualities of Picasso, Matisse and Brancusi.[21] Barnes believed that African sculpture passed beyond mere ethnological significance and felt that negro art was integrated into the milieu of African tribes. African art was given equal visibility with modern art.

Du Bois had attempted to reclaim 'primitivism' as an instinctive source for Afro-Americans. His ideas were derived from George Santayana's book *Reason in Art* (1905). As in modern art, Du Bois considered 'primitivism' to be the irrational force behind all creative forms that sought to produce an ideal image. In 'The Social Origins of American Negro Art' he wrote that the creative instinct of the Afro-American was an impulse that resulted in artistic production but was controlled by rational thought.[22] In 'What Is Civilisation? Africa's Answer'[23] he wrote that it was possible for African cultural forms to revive this creative force for black artists. It was essential that Afro-American artists superseded the 'primitive' art forms of the past to show that their work moved beyond a fixed cultural history defined by the West. Locke had similar views in so far as he saw Western 'primitivism' as exotic pattern-making. In 1925 in 'The African Legacy and Negro Artists' Locke argued that by looking back at African sculpture Afro-American artists could establish a racial bond which would act as a foundation to create a new racial self.[24] For Locke, the work of Aaron Douglas displayed the obvious 'primitive' signs, for instance the exaggerated line and simplified shapes. Douglas had developed this style tentatively during his two years as a student with the German painter Winold Reiss. Reiss had combined German folk art with graphic designs from the Jugendstil movement to produce 'primitive' designs. He was also searching for a pure form to reveal inner emotions by using abstract design. Douglas's relationship with Reiss enabled him to produce

graphic designs for Locke.[25] Locke promoted Douglas's talent and made it possible for Douglas to receive commissions for his various projects by introducing him to the right people or putting his name forward for awards. Douglas's friendship with Locke irritated Barnes, who was always suspicious of Locke's friendships with Afro-American artists and his influence within black exhibitions. Locke's understanding of 'primitivism' remained influenced by William James's arguments that a thinking self lay at the centre of other selves and generated an intimate organic feeling which is brought into consciousness by the other selves.[26] It remained possible for other selves to be united with the central self because the central self continuously thinks about other selves, which means that the central self thinks it sees an identical bodily relationship which can exist continuously. For Locke Afro-American artists who used African cultural forms could make an intimate contact with another racial self based on progressive thinking which translated old artworks into new styles that had connections with mainstream art but did not lose their cultural heritage or African personality. Douglas's use, for instance, of Cubist techniques for composition combined with Egyptian art seen through the horizontal position of the hand and the square-chested forms of the dancers fitted this model.[27] Douglas had encountered similar ideas about self-consciousness. In 1924 he was introduced to the philosophy of Ivanovitch Gurdjieff by Jean Toomer. Gurdjieff's philosophy focused on an invisible source which combined the body, intellect and emotion.[28] Douglas later claimed he rejected this philosophy, and it is not known if he discussed it with Locke, but he did feel that Afro-American artists naturally responded to colour and 'exaggerated' and rhythmic impressions, even if they did lose some of their 'primitive' impulses.[29]

These ideas were not without their critics. Wallace Thurman criticised Locke's and Du Bois's 'primitivism' in his 1928 story 'Nephews'.[30] He affirmed that Afro-Americans were absorbed in American culture and were not attuned to the aesthetics of the African jungle, while George Schuyler, editor of *The Nation* magazine, argued in a 1926 essay called 'The Negro Art Hokum'[31] that Afro-American art was not distinct from Western art, and any primitive qualities which existed in the art produced by Afro-American artists had come from images produced by white artists. American art had an aesthetic tradition which was based on an American identity.

Nevertheless, Locke's and Du Bois's shared concerns with a racial self was associated with their shared interest in culture. On one level this can be understood as an aspect of artistic achievements, and this is how we should understand the aesthetic qualities of *Ethiopia Awakening*. Fuller's neo-classical training, in which she copied from plaster casts and clothed models, enabled her to construct a body made with fragmented parts whose physiognomy revealed her concern with facial expression and a kind of physiognomical abstraction that formulated a human type based on nineteenth-century ethnographical scholarship. Fuller had noted every salient expression of the negro face. She combined them to formulate an image which conformed to the dominant means of imaging an ideal unity which also had a continuity with an ideal past, however romantically expressed. This was similar to Orientalist paintings which combine romantic colour and expression with classical and lavish backdrops for their biblical subjects and events, evoking romantic lands derived from their own imagina-

tions. The presence of the black subject within *Ethiopia Awakening* also suggests a disassociation from the dominant discursive system defined by colonialism in spite of the romanticism. In this image Fuller had also drawn on a view of Africa based on ethnographical writings published in the nineteenth century, specifically Egyptology.

The scope which Egyptology provided for the understanding of the 'new negro' was fully acknowledged at the time. Yet Du Bois's hesitancy towards a tribal paganism was in contrast to his affinity towards Egyptian religion, Islam and Christianity. Du Bois's early and later writings described a spiritual purity that could assure a route to salvation for the black race. Christianity was united with visionary ideals from the cult of Isis, which could be traced from Egyptian religion to a Graeco-Roman world. American Christianity and philanthropy in the nineteenth century were based on Victorian conservatism. Du Bois in the late nineteenth century rejected Western Christianity and philanthropy which continued to see Afro-Americans as deviant social inferiors. In his 1960 essay 'The Black Sudan'[32] he described a common religious goal in Islam and Christian Egypt which had attempted to construct a black race that could live by particular laws based on humanism. To establish a relationship between Egypt and Islam Du Bois used Edward Blyden's book *The Negro in Ancient History*[33] on Islam and Ethiopian psychology. Furthermore, Isis in Egyptian religion symbolised wisdom. Du Bois attempted to create a black personality through mysticism, using Isis as a metaphor for the history of black civilisation in his book *Darkwater* (1940).[34] Isis became united with the radical Christian uprising known as Ethiopianism which opposed the conservative Christian missions founded in the late nineteenth and early twentieth centuries in Africa. Du Bois's use of Isis as a universal symbol for black nationalism may also have been influenced by Madame Blavatsky's 1877 manifesto 'Isis Unveiled', which discussed spiritual purity based on humanist principles.[35] Marcus Garvey had similarly used secular language which concealed religious imagery in his speeches at Madison Square in New York and in 'editorials' in *The Negro World*. Garvey, for example, referred to a rising sun which would take its place among a brilliant constellation of nations.[36] Africa was the rising sun which would be saved by a black redeemer. In *Isis in the Greco-Roman World* R. E. Witt described how when Isis as queen travelled from Ethiopia to Egypt her face became blackened by the Ethiopian sun.[37] Du Bois in *Dusk of Dawn* suggested that the black Isis had a saintly visage which was so bright as to blind those who gazed on her.[38]

Isis is used to help establish a black subject. The notion of subjecthood that attempts to talk of one black body positioned against colonialism and internal struggles for power is essential to understand the images of the Harlem Renaissance. In a formal sense Du Bois is engaging closely with conceptions of power implicit in new social and political practices and events which occurred during the Harlem Renaissance. Power as a dispersed and what Du Bois would have seen as a ramifying network remained a particular monocausal function of the 'new negro'. A further explanation from the classics is needed to clarify the significance of Du Bois's mysticism and its relationship to Fuller's female figure in *Ethiopia Awakening*. For the Graeco-Roman world Isis was a notable precedent for its religious beliefs. Artemis–Isis had

vowed perpetual chastity and abhorred sexual intercourse even for propagation within marriage. Yet she was also seen as a fertility goddess and symbolised motherhood. In Egyptian mythology Isis represented a perfect union with her husband, brother and son Osiris. She was the giver of life after she had resurrected Osiris. She presided over the mummification, holding the symbol of life. The Nile where Osiris' bodily parts are found became his attribute, but Osiris commingles with Isis in this form, enabling her to become fertile. Osiris' status was changed in Roman and Greek literature. Isis too is metamorphosed into many forms which continue to symbolise her fertility and motherhood. Her attributes were many, but in ancient Egypt she could be recognised by her coloured linen tied by a girdle with a mystic knot that rested between her breasts. Sometimes she would be depicted wearing a Greek mantle. Her fertility gave her control over the sky. She was seen as the influential queen of heaven, the mother of the stars and parent of the seasons. *Ethiopia Awakening* more closely reflected the image of Isis in a Greek mantle. It is not possible to see if the mystic knot exists underneath the hand resting between the breasts in Fuller's image, but the reference is there. For Du Bois, the theme of salvation through birth and resurrection is closely linked to Isis as a fertility goddess, as a mother, and as an Egyptian and Ethiopian queen to the rebirth of a black personality and nationalism. In 1915 Du Bois included a pageant in his play *The Star of Ethiopia*, performed in Washington, Philadelphia and Los Angeles. The pageant herald asks Afro-Americans to consider the past glory of Ethiopia, who symbolised the mother-figure, while the Nile is represented as the father-figure. In *Dusk of Dawn* he wrote that Isis' foot rested on heaven and hell and that 'All religion from beauty to beast lies on her breast, her body bears the stars, while her shoulders are necklaced by the dragon.'[39]

However, Isis as the all-powerful mother-figure of black nationalism and 'new negro' was problematic. Du Bois's and Locke's humanism, including their shared concern for consciousness, was based on the need of the will to seek a truth of itself by creating a body that could be publicly recognised. For Du Bois and Locke the 'new negro' image was interpreted as male, even when she was symbolised collectively through a female image. The body politic in terms of change in particular forms of government and self-government remained historically constituted by the experience of the black male body. Du Bois was influenced by George Santayana, who in *Reason in Art* argued that the self-image was acquired by moral actions in society through relations with others.[40] Du Bois saw virtue as an aspect of masculine ideals in America which could be obtained through education. The Christian gentleman as one of these ideals relied on moral order and self-sacrifice, and was reinforced by neo-Platonic ideals of the soul deriving from his reading of Jowett's translation. Masculine achievement depended on a dynamic self-drive that could construct character through hard work and industry. These ideals were to act as a positive incentive for the 'new negro' image which Du Bois defined in 1903 in 'Of the Training of Black Men'.[41] Du Bois struggled to master the body and soul of a black community who he believed found it difficult to allow their own soul to guide their bodies, behaviour and dress. Yet manliness also depended on overcoming ideas about the 'primitive' influenced by the cultural forms of white America in the early nineteenth century, which based its

metaphors upon man's control over nature, ideas of the master and savage, and where 'civilisation' was achieved through powerful superior instincts winning the struggle for survival in a harsh wilderness. For Locke and Du Bois, the black male in Douglas's painting *Aspects of Negro Life: The Negro in an African Setting* has certain similarities with this type of image. The African is master of his land and knows how to respond to its demands, but the African is only the ancestor of the 'new negro', who has a different knowledge of culture and civilisation.

In sharp contrast to this was the representation of the Afro-American woman as a nurturing mother. The nurturing female figure was closely associated with the old African ties of motherhood. In *Darkwater* Du Bois commented on the mother's love for her child, and in this she was linked to Isis as protector of her chosen children. His ideas about motherhood and women's moral influence within the home were similar to those advanced by the black suffragettes in the late nineteenth and early twentieth century in the National Black Women's Club.[42] For black women it was important to recover positive images of their biological selves. Black women wanted to avoid sexual exploitation and appropriated notions of motherhood defined by a white middle-class society. White women were idolised for their chastity and their role as mothers whose function was to provide moral guidance in the home. The nineteenth-century cultivation of a pure heart remained an important attribute of motherhood even in the early twentieth century. The role of the working mother was complicated; her positions as teacher or nurse were not considered to be important. In his 1907 article 'The Work of Negro Women in Society'[43] Du Bois wrote that motherhood was a duty and necessary sacrifice for propagation. It was the responsibility of virtuous women to provide moral support for fallen women and men. In his 1920 essay 'The Damnation of Women' he discussed how the virgin's chastity and the demure mother represented ideal images for black womanhood.[44] This allotted a woman's sexual awakening to marriage. It was difficult for black women to be both types. Education was important because it would enable black women to comprehend the thin line between virtue and vice. Josephine Bruce argued in 1905 in *The Voice of the Negro* that black women's self-preservation depended on their education.[45] To be cultured was an attribute of womanhood, not a natural condition.

To understand the particular notions of body during the Harlem Renaissance we also have to comprehend the complex situation between Marcus Garvey's concern for the 'pure' African and the position of mulattos in the Afro-American community. Locke and Du Bois were concerned with uniting all Afro-Americans, while Marcus Garvey considered mulatto bodies to be prisons that were tainted with white blood. These 'prisoned' bodies, Garvey argued, entrapped the 'pure' African body and reduced the struggle to material means. Accusations of Western aspirations and desire for power over a black population were aimed at mulattos, and especially at Du Bois, by Garvey. Sexual fantasies about mulattos by a 'pure' African were considered undesirable. Even though Garvey did eventually acknowledge that some mulattos were trying to escape the stigma associated with them and were joining his Universal Negro Improvement Association, it was only the 'pure' Afro-American body which could attempt to create a psychological likeness to

its ancestors, and this dual image was meant to take on a divine element. In his 1920 'Declaration of the Rights of the Negro People' and other texts,[46] Garvey refers to the lives of mortals who could live in an ambiguous realm where spirituality and abjection shifted roles and where sexual desire was played out between these shifting planes. For Locke and Du Bois, any sexual desire for mulatto or 'pure' African brought with it sexual tension, restlessness and anxiety, which was only to be resolved in marriage. This category of a national sexual body only made sense in terms of heterosexual discourse. The institution of marriage for the black community was meant to be specific in its intensity and strength for both procreation and companionship. Extreme intensity of desire for the female was rooted in a primordial physical tendency. Relationships among men were different, because these were premised on close friendship based on non-physical love. Similar characteristics constructed by these types of rules and regulations could cause attraction between men and boys or between men of the same age. This love was superior to married love because it was based on spiritual bonds. This was why the 'new negro' image was eulogised in speeches and writings by Du Bois, Locke and Garvey.[47] Marcus Garvey referred to the black woman as a soul-giver, but only fraternity groups would lead the struggle for equality. Similarly, the black male existed to protect the honour and virtue of black women, but the racial bond between black men lay in the desire for a universal salvation.[48]

Female sexuality in the 1920s was problematic because the 'primitive' instinct within the female could result in sexual deviation. While sexual freedom represented a form of liberation for women in the 1920s, it was also a taboo subject within the black community. For Du Bois, sexual 'primitivism' in women led to social decay, and the black female should be made aware that her flesh was an integral component of her personhood. This was related to notions of Isis as linked to an aspect of the 'new negro', while her mythical sexual freedom and practice of incest were suppressed by Du Bois in his writings. Black women's sexual liberty, in his view, brought only pain, frustration and isolation for the black male. The black woman's role as a possible dominant figure would leave the black male helpless, so it was necessary to render her body inferior to the male's. Her dependence on material needs and sexual desire restricted her, and her body was seen to have malfunctioned. Yet it was possible for her to transcend these needs by use of her rational faculties. Wallace Thurman emphasised sexual freedom in his 1926 story 'Cordelia the Crude' in *Fire!!!*[49] In this story Thurman attempted to give a positive image of black female sexuality that would counter Du Bois's view of black sexuality. Thurman believed black women could find the strength through 'primitivism' to dramatise their basic instincts and construct a new subject with which to represent their own identity. Cordelia is a southern negro with no education who makes her way to Harlem. On her way she adopts the gestures of the Harlemites, enters into prostitution and enjoys the lifestyle she has chosen. She has control over her body and decides who she sleeps with when she has an urge to do so. Her body-parts are emphasised through her gestures and descriptions of her large breasts and big hips that move in time when she is walking. Cordelia's dress-sense and primitive desire were closely related to the image of the white flapper women of the 1920s. The flapper image represented another view of

sexual freedom and independence. The primitive desire of the black female body described by Thurman is definitely opposed to the moral tone of the black suffragette movement in the late nineteenth and early twentieth centuries.

In this essay I have attempted to show the interplay of power and knowledge through the various structures and criticisms of the 'new negro' and in images of the Harlem Renaissance where the self is explored as a response to society, the black community and the individual. Each example contains its own shifting set of regulations and each attempt to produce an image of the 'new negro' to represent the black community proved problematic.

## Notes

1  I am referring to books such as Mary Schmidt Campbell, *Harlem Renaissance: The Art of Black America* (New York, Abrams, 1987); A. Gary Reynolds and Beryl Wright, *Against the Odds: African–American Artists and the Harmon Foundation* (Newark, N.J., The Newark Museum, 1989); Romare Bearden and Harry Henderson, *A History of African–American Artists: From 1792 to the Present* (New York, Pantheon Books, 1993).

2  E. H. Gombrich, *Symbolic Images* (Oxford, Phaidon Press; reprinted 1975). For an alternative view of art history see Tim Clark, *Images of the People* (London, Thames and Hudson, 1973).

3  Art historians are still debating the decline of the Harlem Renaissance. For some the period began in 1919 and ended in 1940, while for others it started in 1920 and ended in 1930.

4  Michel Foucault, *The Order of Things* (New York, Random House, 1970); *The Archaeology of Knowledge* (New York, Pantheon, 1972); 'Two Lectures', in his *Power/Knowledge* (New York, Pantheon, 1980), pp. 99ff.

5  George Stocking, Jun., *Victorian Anthropology* (London, Free Press, 1987), chap. 2: 'Ethnology on the Eve of Evolution (1830–1858)', pp. 46–74.

6  Alain Locke, 'The New Negro', reprinted in *The New Negro* (New York, Athenaeum Books, 1968), pp. 4–7.

7  The Harmon Foundation was one of the important institutions that funded exhibitions by Afro-American artists; see Reynolds and Wright, *Against the Odds*. Fuller and Douglas had shown work in the 1934 Harmon Foundation Exhibition.

8  William E. B. Du Bois, *The Negro* (London, Oxford University Press, [1915] 1970), p. 5.

9  H. Carter, *The Tomb of Tutankhamun* (London, Cassell, 1923–33).

10  Du Bois, 'On Being Black', in Meyer Weinberg, ed., *W. E. B. Du Bois: A Reader* (London, Harper and Row, 1970), pp. 4–5.

11  B. Jowett, *Dialogues of Plato* (Oxford, Oxford University Press [1860], 4th edition, 1924).

12  W. James, 'Principles of Psychology', in Bruce W. Wilshire, ed., *William James: The Essential Writings* (New York, State University of New York Press, 1984), pp. 89–90.

13  Du Bois, 'The Social Origins of American Negro Art', in Weinberg, *W. E. B. Du Bois: A Reader*, pp. 247–8.

14  David Hume, *Treatise*, Book 1, quoted in John Jenkins, *Understanding Hume* (Edinburgh, Edinburgh University Press, 1992), p. 43.

15  Leonard Lewis, ed., *The Philosophy of Alain Locke*, Philadelphia, Temple Press, 1989.

16  Alain Locke, 'The Ethics of Culture', in Lewis, *The Philosophy of Alain Locke*, pp. 177–8.

17  Mark Hebling, 'Ambivalence and Hope', *Journal of Philosophical Enquiry*, June 1979, pp. 374–9.

18   Alain Locke, 'Art or Propaganda', *Harlem*, Vol. 1, November 1928, p. 12.

19   Undated letter, Charlotte Masson to Locke. Locke papers, Atlanta University, Georgia. From events referred to in the letter and Locke's comments, it is possible to place her letter as written between August and November 1927.

20   See P. Guillaume, 'The Triumph of Ancient Negro Art', and Thomas Munro, 'Primitive Art', *The Survey Graphic* (special edition on 'Harlem: The Mecca of the New Negro'), March 1925, pp. 229–31 and 225–8, respectively.

21   Barnes, 'Negro Art and America', *The Survey Graphic*, March 1925, p. 226.

22   Du Bois, 'The Social Origins of American Negro Art', in Weinberg, *W. E. B. Du Bois: A Reader*, pp. 247–8.

23   Du Bois, 'What is Civilisation? Africa's Answer', in Weinberg, *W. E. B. Du Bois: A Reader*, pp. 374–9.

24   Locke, 'The African Legacy and Negro Artists' (1925), in Locke, *The New Negro* (New York, Athenaeum Books, 1968), pp. 247–8.

25   Douglas had his graphic designs printed in the special edition of *The Survey Graphic*, March 1925.

26   James, 'Principles of Psychology', pp. 89–90.

27   Locke, 'The African Legacy and Negro Artists', pp. 247–8.

28   Amy Kirschke, *Aaron Douglas: Art, Race and the Harlem Renaissance* (Jackson, University Press of Mississippi, 1995).

29   *Ibid.*, p. 53.

30   W. Thurman, 'The Nephews of Uncle Remus', in *The Independent* (New York), 24 September 1928, pp. 296–8.

31   George Schuyler, 'Negro Art Hokum', *The Nation*, June 1926, pp. 243–5.

32   Du Bois, *The World and Africa* (New York, International Publishers, 1965), pp. 201–6.

33   Blyden's book was published in 1869. See Henry S. Wilson (ed.), *Origins of West African Nationalism* (London, Macmillan, 1969), chap. 10, 'The Black Sudan', pp. 249–53.

34   Du Bois, *Darkwater* (New York, Schocken Books, [1940] 1969).

35   Eric J. Sundquist, 'The Spell of Africa', in his *To Wake the Nations* (Boston, Mass., Harvard University Press, 1993), pp. 593–625; H. P. Blavatsky, 'Isis Unveiled', *The Nineteenth Century*, Vol. 8, 1877.

36   See Robert Hill, ed., *Marcus Garvey and UNIA Papers*, Vol. 4, September 1924–1927 (Berkeley, California University Press, 1989).

37   R. E. Witt, *Isis in the Greco-Roman World* (London, Camelot Press, 1971), esp. chap. 1, pp. 13–25 and chap. 4, pp. 46–59.

38   Du Bois, 'The Damnation of Women', in his *Dusk of Dawn* (New York, Library of America, 1986), p. 953.

39   *Ibid.*, p. 954.

40   George Santayana, *Reason in Art* (London, Macmillan, 1905).

41   Du Bois, 'Of the Training of Black Men', in his *The Souls of Black Folk* (New York Library of America, 1903), pp. 234–44.

42   The National Black Women's Club was organised to educate black women in health and child care from the late nineteenth to the early twentieth century.

43   Du Bois, 'The Work of Negro Women in Society', in Herbert Aptheker, ed., *Writings in Periodical Literature 1891–1909* (New York, Kraus–Thompson Organisation, 1982).

44  Du Bois, 'The Damnation of Women', pp. 952–68.

45  Josephine Bruce, 'What Has Education Done for Coloured Women?', *The Voice of the Negro* (1905), pp. 233–4.

46  Marcus Garvey, 'Declaration of the Rights of the Negro People', in Amy Garvey, *Philosophy and Opinions of Marcus Garvey* (Temple Press, 1977), pp. 135–43; Hill, *Marcus Garvey and UNIA Papers*, Vol. 4, September 1924–1927.

47  Du Bois, 'The Talented Tenth', in Booker T. Washington, ed., *The Negro Problem: A Series of Articles by Representative American Negroes of To-Day* (New York, James Pott & Co., 1903), pp. 33–75.

48  Marcus Garvey, 'Declaration of the Rights of the Negro People, pp. 135–43.

49  Wallace Thurman, 'Cordelia the Crude', *Fire!!!* (New York, 1926). *Fire!!!* was funded by private money and only one issue was produced, which Wallace Thurman edited. Alain Locke was invited to contribute to *Fire!!!* but failed to do so, and Du Bois criticised it for its ungenteel behaviour and moral conduct.

# Performing the picture or painting the Other: Romaine Brooks, Gluck and the question of decadence in 1923

Yesterday I made all the arrangements to paint 'Peter' and I promised to sit in return . . . I started the portrait of 'Peter'; it is already well advanced. But she wants me to pose as well, which is a bit of a bore but I shall have to perform. I am sure you would like her a lot but she would not hold any attraction for you. Nor for me. She has no mystery, no allure. But I think the portrait will be amusing, it would have been a shame not to do it . . .

   I spent my Christmas packing. I'm sorry but Nat Nat will not see the portrait . . . I had a dreadful scene with Peter. I have reached the conclusion that women who want to be like men are nothing more than schoolgirls.

Romaine Brooks[1]

Romaine wasted so much sitting time in making a row that at last I was only left an hour in which to do what I did – but my rage and tension gave me almost superhuman powers . . . she insisted I should do one of my 'little pictures'. I refused, so she left me with the unfinished portrait. However, I had to give away many photographs of it to her friends.

Gluck *alias* 'Peter'[2]

If one takes these accounts seriously, painting each other in 1923 was a traumatic experience for both artists. At least in material terms one would have to conclude that the results of their encounter were mixed. Brooks's painting of *Peter (A Young English Girl)* (Figure 13) was subsequently exhibited in her 1925 solo exhibitions in Paris, London and New York. The artist eventually donated the painting to the National Museum of American Art. In contrast, all traces of Gluck's unfinished portrait of Brooks were virtually eliminated when the artist recycled the unfortunate canvas. It was not until the mid-1980s that various researchers discovered that Gluck was 'Peter',[3] and not until 1988 that Gluck's first biographer, Diana Souhami, realised that the few remaining photographs of another portrait (Figure 14) documented Gluck's picture instead of a missing self-portrait by Brooks.[4] In the course of examining papers held by the Gluckstein family, Souhami discovered the lines I use as an epigraph pencilled in Gluck's hand on the back of a photograph of the portrait.[5]

      But what does one make of the dreadful scene or 'row' that both artists describe? Certainly, one senses it must have been fuelled not only by the clash of two powerful and unyielding (no doubt some would have said cantankerous) egos reluc-

tant to exchange the canvases as agreed, but also by a generation-gap of some twenty years between Brooks and the younger Gluck.[6] One cannot help feeling the 48-year-old Brooks was assuming the smug tone of experience when she scathingly dismissed Gluck as a schoolgirl. While it is important not to lose sight of the important differences between these two women artists, I should like first to focus on the similarities that such differences might obscure.

One of the more important practices the two women shared was that of regularly and repeatedly presenting a public artistic persona in male dress. While much has recently been written on the subject of male modernists cross-dressing as women, there has been considerably less interest in women artists dressing as men. Amelia Jones has argued, for example, that those dandified male artists who cross-dressed as women (Duchamp, Delacroix and Wilde among others) were more radical in their disruption of gender stereotypes than were those male artists, like Renoir and Gautier, who crossed class lines by adopting working-class guises. According to Jones, by insisting on their own sartorial display and catering to an exhibitionist desire to be seen rather than to see, male artists problematised their masculinity as an increasingly ironic project which in some cases extended into the late-capitalist period of postmodernity.[7]

Jones is, of course, building upon the sorts of arguments most recently advanced by Christine Buci-Glucksmann and Elizabeth Wilson, who claim that many

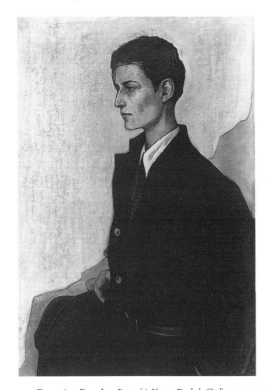 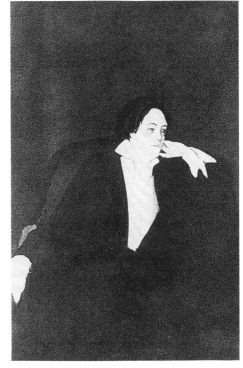

13   Romaine Brooks, *Peter (A Young English Girl)*, 1923–24, 91.9cm × 62.3cm
14   Gluck, *Mrs Romaine Brooks*, 1923

sensitive men, particularly writers and artists such as Charles Baudelaire and Walter
Benjamin, responded to the increasing commodification of urban society by hyster-
ically reinscribing themselves as female. This is particularly evident in the figure of
the *flâneur*, who was frequently described as 'prostituted', 'dispersed' and 'fragmented'.
Discussing Walter Benjamin's *Passagen-Werk*, Buci-Glucksmann points out, 'the
woman's body . . . in particular the prostituted body, stands as a metaphor for
extremes: desire/death, animating/agitating, life/corruption, skeleton . . . and serves
to materially convert that "petrified anxiety" (*Erstarrter Unruhe*) . . . *that is the same formula
as "the Baudelairean image of life"* (*Lebensbild*), the image that knows of no "development".
[. . .] For this reason . . . the scenarios of the "feminine body" serve as metaphors for
the "commodity-body".'[8] One only has to think of those endless parades of prosti-
tutes by artists such as Kirchner, Dix and Grosz to realise the full ambivalence of such
allegorised femininity.

Elizabeth Wilson develops these ideas by suggesting that existing feminist
readings of *flânerie* by writers such as Janet Wolff and Griselda Pollock have not ade-
quately addressed the empirical historical evidence of women's increasing mobility
during the period nor the inherent instability of and anxieties surrounding the figure
of the *flâneur*. Instead of primarily focusing on the 'invisible *flâneuse*', a term coined by
Wolff to signal the fact that women did not enjoy equal access to this important trope
of modernity, Wilson suggests it is more useful for feminists to situate this figure
within important historical shifts in nineteenth-century capitalism and gender rela-
tions. Wilson takes considerable pains to stress that she is not invoking some sort of
unproblematic 'reality' by turning to empirical evidence from the period. Nevertheless,
she argues that such evidence must be factored into any account of the trope of the
*flâneur* in order to better understand its complexities. Wilson criticises what she sees as
Janet Wolff and Griselda Pollock's overly rigid distinction between 'ideology' and
'reality': 'By an inversion of reflectionist theories of ideology, instead of ideology mir-
roring reality, reality becomes but a pale shadow of ideology, or even bears no relation
to it at all. This approach is unhelpful to the political cause of feminism, since it creates
such an all-powerful and seamless ideological system ranged against women and one
upon which they can never make an impact.'[9] Instead Wilson argues that ideology must
be understood as always under construction and contestation, processes which can
only be adequately understood in relation to changing material conditions.

In terms of the figure of the *flâneur*, Wilson argues that it is more useful for
feminists to read its emergence as a nervous response to the increasingly commodified
and regulated nature of late-capitalist human experience and significant changes in
gender relations, such as the rise of bourgeois feminist movements as well as the
increasing employment of women in all social classes. In other words, at the same time
that many male writers felt their individual agency was increasingly being curtailed by
the commodification of everyday life, they felt threatened by the fact that women
seemed to be moving into areas of employment and public life that had formerly been
seen as male preserves. As Wilson stresses, 'The *flâneur* represented not the triumph
of masculine power, but its attenuation. A wanderer, he embodies the Oedipal under
threat. The male gaze has failed to annihilate the castrate, woman. On the contrary,

anonymity annihilates him. The *flâneur* represents masculinity as unstable, caught up in the violent dislocations that characterized urbanization.'[10] The rise of a largely oppositional (or counter-discursive) rhetoric of *flânerie* favoured by male writers such as Charles Baudelaire and Walter Benjamin is one which was generally less accessible to women, although, as we shall see, individuals such as Brooks and Gluck found parts of the rhetoric appealing, despite tendencies which might be construed as misogynist.

Some of the urban dislocations that worried the *flâneur* and other men of the period were caused by the increasing mobility of women both as workers and consumers. As growing numbers of women entered various 'white-collar' professions as teachers, clerks, shop assistants and secretaries – to list only a few of the emerging occupations available to them – shops, theatres, restaurants, tea-rooms and washrooms were needed. For instance, J. Lyons & Co., a highly profitable catering business, operated a chain of clean, safe and reasonably-priced teashops (Lyons Corner Houses) in central London which particularly suited women.[11] Significantly, the company and its teashops were owned by the Gluckstein family into which Hannah Gluckstein, later known simply as Gluck, was born in 1895.[12] While Wilson insists that women still experienced discrimination during the 1920s and 1930s, particularly in terms of equal access to and safety within public urban spaces, she argues that the sites of gendered oppression tended to be contradictory and shifting. In other words, different classes of women enjoyed varying degrees of social mobility, just as some urban centres, neighbourhoods and institutional sites were more receptive to women than others.

Women's increasing agency and mobility is something that is clearly celebrated and even flaunted in the cross-dressed portraits by Brooks and Gluck, who are both presented in immaculately tailored men's suits. In the more highly finished work by Brooks, Gluck is shown as something of a sartorial dandy, sporting a fancy green striped waistcoat, black silk tie, starched white linen shirt and dark wool jacket with brass buttons that is drawn in at the waist with a narrow leather belt. In Gluck's portrait, the precise details of Brooks's clothes are less apparent, although her tailored white shirt and cuffs are readily visible beneath the casually worn suit-jacket which falls open as she leans against her left hand.

Although in both cases such attire was clearly performative, these portraits did not intentionally stage a cross-gendered *alter ego* as in the case of Man Ray's famous 1920–21 photographs of Duchamp as Rrose Sélavy. Unlike Duchamp, Gluck and Brooks had long histories of publicly cross-dressing in everyday life which extended well beyond the confines of these portraits. As Gluck explained in a letter to her brother, written in 1918 when she was in her early twenties,

> I am flourishing in a new garb. Intensely exciting. Everybody likes it. It is all black though I can wear a coloured tie if I like and consists of a long black coat like a bluecoat boy's with a narrow dark leather belt. It was designed by yours truly and carried out by a mad dressmaker. Utterly loony. She thought I was mad and I was damn certain that she was mad . . . It is old masterish in effect and very dignified and distinguished looking. Rather like a Catholic priest. I hope you will like it because I intend to wear that sort of thing always.[13]

Her decision to adopt male suits was part of refashioning a publicly visible lesbian identity which also involved changing her name from Hannah Gluckstein to Gluck and refusing to conform to her conventional family's expectations. For the rest of her life she would insist on all other titles, names and initials being dropped, as she carefully noted on the back of publicity photographs of her work: 'Please return in good condition to Gluck, no prefix, suffix or quotes.'[14]

Like Gluck, Brooks often wore tailored suits, apparently first donning such clothes and cropping her hair during her short-lived marriage to the pianist and writer John Ellingham Brooks in 1902. To outfit herself when she decided to go on a sketching tour, she acquired baggy trousers and gun-boat shoes from Our Boys Shoppe in London, which apparently horrified her husband.[15] However, Brooks was less irrevocably wedded to male attire than Gluck and, as snapshot photographs of her posing with various friends indicate, she went on sporadically wearing dresses and skirts throughout her life. Nevertheless, she apparently preferred trousers for informal wear when among friends and, more significantly for our purposes, when she was photographed as an artist or when she modelled for portraits.

It is important to emphasise that, although Gluck and Brooks habitually cross-dressed in other areas of their lives, their portraits of each other should be seen as no less performative than Man Ray's photographs of Duchamp. However, if one accepts the recent arguments of researchers such as Katrina Rolley, their performances were, at least in part, directed towards a different sort of audience. Closely studying the self-presentation of both Radclyffe Hall and her lover Una Troubridge, Rolley suggests that the couple adopted a style of dress which experimented with the latest fashions of their upper-class social milieu during the 1920s and 1930s in order to establish a visible identity as lesbians who believed in theories of 'congenital inversion'.[16] As 'active' rather than 'passive', 'feminine' or 'pseudo' invert, Hall's case closely paralleled those of Gluck and Brooks, who both assumed similarly 'active' roles in relation to the women in their lives. All three came from highly privileged social backgrounds and had considerable private incomes, and all saw themselves as important artistic or literary figures.

It was especially important for these women to differentiate themselves in subtle ways from the *garçonne* look initiated by *haute couture* designers such as Paul Poiret and Coco Chanel, who made an androgynous appearance particularly fashionable during the twenties. As fashion historians have recently pointed out, the vogue for bobbed hair and severely tailored suits seems to have peaked between 1925 and 1928.[17] In this sense then, Hall, Gluck and Brooks (and, one might even argue, Duchamp) were all early trend-setters, experimenting with a style that was still very much in the making. While Hall, Gluck and Brooks were often described as 'ultra-modern' in the 1920s, they continued wearing short hair and simple tailored clothes in the 1930s after women's fashions had returned to more 'feminine' lines. But even during the 1920s they tended to adopt rather eccentrically extreme variations of male dress that included dramatic cloaks, flowing evening jackets and old-fashioned or 'old masterish' suits rather than the typical straight-lined jersey suits of Chanel. As Rolley notes, such distinctions were part of a strategy of discreetly making their lesbianism visible

to friends and other interested women. But this is not the kind of performance I wish to investigate here.[18]

Nor do I want to pursue the notion of gender construction as a discursive or performative act, as it has been recently theorised by such scholars as Elizabeth Grosz and Judith Butler.[19] Certainly one could make an excellent case for Gluck and Brooks generating a 'performance' of masculinity which was never intended to pass as such, and therefore constantly threw traditional gender constructions into crisis by refusing prevailing notions of a stable or fixed gendered identity. The resulting confusion is nicely captured in an incident where Gluck pulled rank and gave the family name after being refused entry to the Trocadero Restaurant, an establishment owned by the Glucksteins. The flustered doorman who apparently exclaimed, "Ere, . . . 'e says she's Miss Gluckstein' eloquently attests to the disturbing effect of Gluck's self-presentation.[20] Similarly, the frequent placement of Gluck's 'boyish' publicity photographs next to 'real' men and women in the press traded on the reader's momentary dislocation. Various newspapers also sensationally juxtaposed Gluck's 'male' image with captions identifying her as 'female'. One of the main publicity photographs used in connection with her 1926 solo exhibition (Figure 15) was

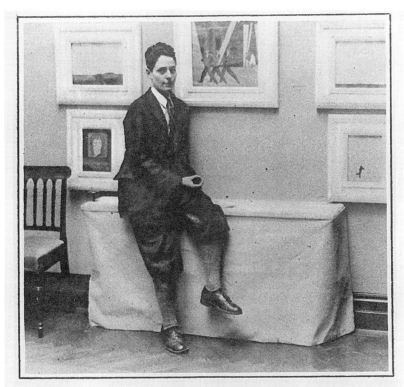

A YOUNG ARTIST IN "PLUS FOURS": MISS GLUCK, WHO IS HOLDING AN EXHIBITION AT THE FINE ART SOCIETY'S GALLERIES IN BOND STREET.

15   Press photograph of Gluck, 1926

variously reprinted with captions that described the artist as 'Miss Gluck', 'a girl artist' or a 'woman artist'.[21]

Instead of looking at mechanisms of gender construction *per se*, here I want to explore why Gluck and Brooks chose to rework a highly self-conscious cult of artifice which was first celebrated in the aesthetic and decadent movements of the 1880s and 1890s rather than engaging with a more contemporary avant-garde rhetoric of primary colours, fractured perspectives, simultaneity and mechanistic forms. In fact, both artists shared a passion for Whistler's subdued tonalities and flat decorative patterning. When Brooks returned to England in 1904 to take up painting seriously she deliberately moved to Tite Street in Chelsea, taking a studio only a short distance from John Sargent, Charles Condor and Augustus John, who all lived in Chelsea, and most significantly of all, close to Whistler's White House. Although Whistler had died a few months earlier, she deliberately set out to paint in his favourite range of blue-greys. When she went to St Ives several months later, instead of painting from nature and capturing the bright blues of the sky and the sea, the only work she exhibited to her friends was a series of grey pieces of cardboard, each attempting to capture various nuances of the colour.[22] These were the tonalities she would use for the rest of her painting career, and critics would repeatedly discuss Whistler's impact on her work. Gluck seems to have shared Brooks's passion for Sargent and Whistler, apparently deciding to become a painter after seeing a work by Sargent[23] and renting Whistler's former studio in Tite Street, which was where Brooks sat for her portrait.[24]

The continued importance of the decadent movement for cultural practitioners during the early years of the twentieth century is a subject which has received surprisingly little attention. Perhaps this is partly because so many early modernist writers and artists vehemently denounced their Victorian past, and subsequent scholars seem to have taken such condemnations at face value.[25] Further complicating the situation is the fact that, because we are rapidly approaching the twenty-first century, most recent studies of decadence have tended to leapfrog over the early-twentieth-century modernist period in order to draw comparisons between postmodern cultural forms and those of the 1890s, pointing to parallel interests in questions relating to women's rights, gender relations, sexual orientation, socialism, colonialism, the discourse of 'Others', the proliferation of commodity culture and the wide heterogeneity of cultural forms and styles.[26]

In one of the few recent studies to explore the relationship between decadence and literary modernism, David Weir argues that decadence should be understood not as a period of transition (during the 1890s from late-Victorian to modern), but as a dynamics of interference involving a reformation of aesthetic codes that can take place in any period.[27] Taking up Matei Calinescu's argument that decadence addresses the future rather than nostalgically longing for the past (although individual writers may indeed mobilise past achievements in order to criticise the present), Weir asserts that decadent movements are modern because they celebrate individualism at the expense of 'traditional authoritarian requirements such as unity, hierarchy, objectivity, etc.'[28] In effect, decadence transforms or subverts

existing literary norms, rules and conventions by attacking the natural in the name
of the artificial and abandoning traditional mimesis and narrative in favour of poesis
and style.

Weir further asserts that women in particular were awkwardly placed in rela-
tion to the decadent dynamics of the late nineteenth century. As women became the
main consumers of novels and cultural production was increasingly viewed as women's
work, many male writers felt emasculated. As a way of displacing their consequent
anxieties and criticising the patriarchal underpinnings of late capitalism which had
pushed cultural production to the margins, many male writers (and, one might also
add, artists such as Duchamp) symbolically cast themselves as 'feminine' outsiders.
And yet, paradoxically, such poses could still be profoundly misogynist in terms of
the distinctions that were drawn between symbolic and experiential femininity, as
Weir explains:

> The decadent writer's self-idealization of himself [*sic*] as woman coupled with the
> negative fantasy of woman as the embodiment of all that is natural and therefore
> antithetical to the art he practices is another pattern of interference important to
> the concept of decadence itself. In terms of cultural history, this double gendering
> can be seen as a double negation – of both 'male' modernity and 'female' romanti-
> cism. In any event, the result of this double negation is a form of decadence that
> ends up participating in patriarchy even as it rejects masculinity. Small wonder, then,
> at the scarcity of female writers in the canon of decadent–aesthetic literature.[29]

While one can appreciate the ambiguities and complexities surrounding the
decadent constructions of femininity that Weir delineates, it is his final sentence that
gives one pause for thought. Although women writers (and artists) might not belong
to an established canon of decadent work, I think one *can* point to a significant
number of women writers and artists who were strongly attracted to decadence in the
late nineteenth and early twentieth centuries. For instance, not only Frances and
Margaret Macdonald at the turn of the nineteenth and twentieth centuries, but also
Djuna Barnes, Natalie Barney, Hannah Höch, Claude Cahun – and, of course,
Romaine Brooks and Gluck – in the early twentieth century, all experimented with
decadently artificial representations of the 'modern' or 'new woman'.[30] Whether these
women can be said to form a shadow or alternative canon of decadence is certainly a
question worth pondering.

In a recent article examining the work of Georgia O'Keefe, Marcel Duchamp
and Florine Stettheimer, Susan Fillin-Yeh demonstrates that American women artists
also participated in an aesthetic dandyism which involved playfully cross-dressing as
well as revamping and exaggerating such feminine clichés as jewels, flounces and lace.[31]
In particular, Fillin-Yeh suggests that O'Keefe and Stettheimer were attracted to the
strolling *flâneur*/dandy as a figure for their own artistic positioning as modern voyeurs
standing on the sidelines, looking at a world where the viewer assumes new and ever-
changing relationships to the objects of her desire: 'Each in her own way gives us
images of modernism's mobile spaces in a world no longer grounded in certainty, no
longer marked out in traditional perspective or rules of painting – or in clichéd sexual
roles.'[32]

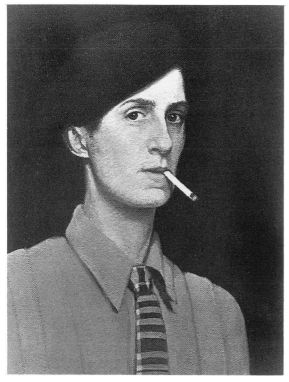

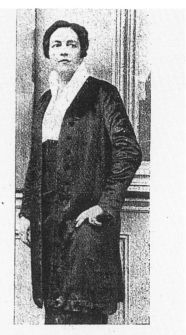

*Romaine Brooks whose remarkably forceful paintings aroused much favorable comment at her recent exposition in the Charpentier Gallery.*

16    Gluck, *Self-Portrait*, 1925
17    Unidentified press photograph of Romaine Brooks, *c.* 1925

     As we have already seen, Brooks and Gluck also adopted the pose of the dandy/*flâneur* by deliberately dressing as men in self-portraits and publicity photographs exhibited in or published in connection with their solo exhibitions between 1924 and 1926.[33] Some idea of Gluck's public persona can be gleaned from an examination of her publicity photographs (e.g. Figure 15), including two taken by the society photographer E. O. Hoppe, which were circulated in various articles during the years between 1924 and 1926, as was a 1925 self-portrait (Figure 16).[34] Similarly, Romaine Brooks wore 'male' attire in a publicity photograph (Figure 17) and in a self-portrait of 1923 (Figure 18), both of which were reproduced in the press coverage of her three solo exhibitions in 1925.[35]

     At the very least, such images troubled the traditional identification of women and nature, given that such 'unnatural' women were more closely associated with art and artifice than most of their male counterparts. After all, by posing as men, Brooks and Gluck were adding another performative layer to the old Bohemian game of men posing as artists. In Weir's terms, this additional layering of aesthetic discourse can be understood as a decadent dynamics of interference. By taking a late-nineteenth-century cultural stereotype – in this case, the figure of the decadent dandy – and ironically echoing it with the added twist of a further gender inversion, Brooks and Gluck established themselves as players while simultaneously criticising the limited rules of

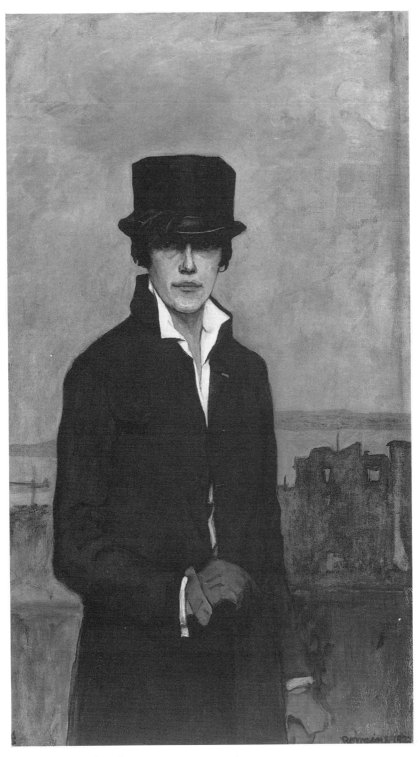

18   Romaine Brooks, *Self-Portrait*, 1923, 117.5cm × 68.3cm

the game. One has to admire their logic: if viewers appreciated their performance, it was evident that women could also play the artistic game, and if viewers were irritated, the game was exposed as hardly worth playing in the first place.

But this all begs the question of why Gluck and Brooks chose to look back to a cult of artifice rooted in the late nineteenth century rather than taking up the inorganic and fragmented language of the avant-garde movements of their day, such as Fauvism, Cubism and Vorticism. It seems to me that any answer must take account of their privileged social position and unorthodox artistic training. Both Gluck and Brooks had to endure initial family opposition to their artistic pursuits, and only belatedly and sporadically acquired the rudiments of formal training. Neither earned a living from the art market and both were reluctant to part with their work, often pressuring buyers to return it. Furthermore, both women could afford to purchase a certain degree of social acceptance, despite the fact that they defied conventional sartorial and sexual expectations. With this came the freedom to engage with those artistic precedents that they found most meaningful, and clearly the sexual unorthodoxy, irony and idiosyncratic individualism of many decadent writers and artists from the 1890s was highly appealing to them.

Yet in spite of these many similarities, the altercation over their intended exchange of portraits reminds us that Brooks and Gluck saw themselves neither as part of a community of women artists nor as participants in any school or group. Perhaps Natalie Barney best summed up their stance when she wrote of Brooks that she belonged to 'no time, to no country, to no circle, to no school, to no tradition'.[36] Indeed, both women fiercely guarded their independence and eventually became quite reclusive in their later years. In some respects, the similarity of the two portraits represented a momentary point of convergence between two artists who were otherwise preoccupied with rather different concerns. If we take their remarks seriously, each artist tended to find the practice of the other somewhat shallow, even amateurish. On the one hand, Gluck seems to have found Brooks's work tediously elitist, complaining that many of Brooks's sitters from her 'lesbian *haut monde*' were very boring and that Brooks's work was technically and psychologically inferior to her own.[37] On the other hand, when Brooks dismissed Gluck's schoolgirl antics, one senses that she was irritated by the vulgarity of a younger artist who was willing to court the media in endless rounds of sensational interviews and photographs. One imagines that she would have had even less time for Gluck's paintings of vaudeville acts, boxing-matches and controversial trials of the day. Given the circumstances, it is perhaps not surprising that both artists were attracted to the highly individualistic, idiosyncratic and ironic stance of dandyism, where highbrow and vernacular culture could be combined in curious ways and where looking back to the past could be a way of reshaping the future.

## Notes

This work has been funded by the Social Sciences and Humanities Research Council of Canada. Special thanks to Claire Sykes for research assistance.

1 Brooks's correspondence to Natalie Barney, dated 7 and 26 December 1923 and cited in

B. Chavanne and B. Gaudichon, *Romaine Brooks (1874–1970)* (Poitiers, Musée Sainte-Croix, 1987), p. 159. I have translated the following French citations:

'Hier j'ai tout arrangé pour peindre "Peter" et j'ai promis de poser en retour . . . J'ai commencé le portrait de "Peter"; il est déjà bien avancé. Mais elle veut que je pose aussi, cela m'ennuie plutôt mais je dois m'exécuter. Je suis sûre que vous l'aimeriez beaucoup mais elle ne vous attirerait d'aucune manière. Moi non plus. Elle n'a ni mystère, ni allure. Mais je pense que le portrait sera amusant; c'eût été dommage de ne pas le faire . . .' (7 December 1923).

'J'ai passé mon Noël à faire mes bagages. Je suis désolée mais Nat Nat ne verra pas le portrait . . . J'ai eu une scène affreuse avec Peter. J'en suis arrivée à la conclusion que les femmes qui veulent être comme des hommes rétrogradent en écolières et rien de plus' (26 December 1923).

2  D. Souhami, *Gluck: Her Biography* (London, Pandora, 1988), p. 63.

3  L. Mohin and A. Wilson, *Past Participants: A Lesbian History Diary for 1984* (London, Only Women Press, 1984) and E. Cooper, *The Sexual Perspective: Homosexuality and Art in the Last 100 Years in the West* (London, Routledge, 1986), p. 97.

4  Chavanne and Gaudichon, *Brooks*, p. 169 had published this image as a self-portrait by Brooks.

5  Souhami, *Gluck*, p. 63.

6  Brooks was born in 1874 and Gluck in 1895.

7  A. Jones, '"Clothes Make the Man": The Male Artist as a Performative Function', *Oxford Art Journal* 18:2 (1995), 18–32.

8  C. Buci-Glucksmann, 'Catastrophic Utopia: The Feminine as Allegory of the Modern', *Representations* 14 (Spring 1986), 226, 228.

9  E. Wilson, 'The Invisible *Flâneur*', in S. Watson and K. Gibson (eds), *Postmodern Cities and Spaces* (Oxford, Basil Blackwell, 1995), pp. 66–7. Wilson is referring to J. Wolff, 'The Invisible *Flâneuse*: Women and the Literature of Modernity', *Theory, Culture and Society* 2:3 (1985), 37–46 and G. Pollock, 'Modernity and the Spaces of Femininity', in *Vision and Difference: Femininity, Feminism and the Histories of Art* (London, Routledge, 1988), pp. 50–90.

10  Wilson, 'The Invisible *Flâneur*', p. 74.

11  This chain of restaurants is discussed by Wilson, 'The Invisible *Flâneur*', and by L. Walker, 'Vistas of Pleasure: Women Consumers of Urban Space in the West End of London 1850–1900', in C. Campbell Orr (ed.), *Women in the Victorian Art World* (Manchester, Manchester University Press, 1995), pp. 70–85.

12  The Gluckstein family's involvement with Lyons is discussed at some length in Souhami, *Gluck*, chapter 2.

13  *Ibid.*, pp. 35–6.

14  *Ibid.*, p. 9.

15  S. Langer, 'Fashion, Character and Sexual Politics in Some Romaine Brooks' [*sic*] Lesbian Portraits', *Art Criticism* 1:3 (1981), 30.

16  K. Rolley, 'Cutting a Dash: The Dress of Radclyffe Hall and Una Troubridge', *Feminist Review* 35 (Summer 1990), 55. Rolley takes some pains to assert that not all lesbians of the period found the theories of the sexologists convincing.

17  M. L. Roberts, 'Sampson and Delilah Revisited: The Politics of Women's Fashion in 1920s France', *American Historical Review*, June 1993, 659.

18  For a more detailed discussion of this issue in relation to Natalie Barney and Romaine Brooks, see B. J. Elliott and J. Wallace, '*Fleurs du Mal* or Second-Hand Roses? Natalie Barney, Romaine Brooks, and the 'Originality' of the Avant-Garde', in their *Women Artists and Writers: Modernist (Im)positionings* (London, Routledge, 1994), pp. 31–55.

19  E. Grosz, *Volatile Bodies: Towards a Corporeal Feminism* (Bloomington, Indiana University Press,

1994); J. Butler, *Gender Trouble: Feminism and the Subversion of Identity* (London, Routledge, 1990); and J. Butler, *Bodies That Matter: On the Discursive Limits of 'Sex'* (London, Routledge, 1993).

20   Souhami, *Gluck*, p. 11.

21   See, for example, the captions for this photograph that are printed in the *Sketch* (21 April 1926), the *Daily Mirror* (8 April 1926), the *Daily News* (8 April 1926), the *Sheffield Mail* (8 April 1926) and the *Evening Post* (26 April 1926).

22   M. Secrest, 'Shades of Gray', *FMR* 2 (July 1984), 130.

23   M. Battersby, 'Foreword', in *Gluck* (London, Fine Art Society, 1973).

24   Souhami, *Gluck*, p. 62.

25   L. Dowling, *Aestheticism and Decadence: A Selective Annotated Bibliography* (New York, Garland, 1977), p. xvi.

26   E. Showalter, *Sexual Anarchy: Gender and Culture at the Fin de Siècle* (New York, Viking, 1990) and S. Ledger and S. McCracken (eds), *Cultural Politics at the Fin de Siècle* (Cambridge, Cambridge University Press, 1995).

27   D. Weir, *Decadence and the Making of Modernism* (Amherst, University of Massachusetts Press, 1995), p. 15.

28   *Ibid.*, p. 6. Weir is referring to M. Calinescu, 'Decadence', in his *Five Faces of Modernity: Modernism, Avant-Garde, Decadence, Kitsch, Postmodernism* (Durham, NC, Duke University Press, 1987), pp. 149–95.

29   Weir, *Decadence and the Making of Modernism*, p. 19.

30   For further discussions of the connections to decadence as well as the exploration of the 'New Woman' themes in the work of these women artists and writers, see Janice Helland, *The Studios of Frances and Margaret MacDonald* (New York, St Martin's Press, 1996); Elliott and Wallace, *Women Artists and Writers*; Maud Lavin, *Cut with the Kitchen Knife: The Photomontages of Hannah Höch* (New Haven, Yale University Press, 1993); François Leperlier, *Claude Cahun: Une Monographie* (Paris, Éditions Jean Michel Place, 1993).

31   S. Fillin-Yeh, 'Dandies, Marginality and Modernism: Georgia O'Keefe, Marcel Duchamp and other Cross-Dressers', *Oxford Art Journal* 18:2 (1995), 41.

32   *Ibid.*, p. 42.

33   Gluck's exhibitions were entitled *Gluck*, held at the Dorien Leigh Galleries in London (14 October–10 November 1924), and *Stage and Country*, held at the Fine Art Society in London (8–24 April 1926). Brooks's exhibitions were held at the Galerie Charpentier in Paris (20 March–3 April 1925), the Alpine Club Gallery in London (2–20 June 1925) and the Wildenstein Galleries in New York (20 November–31 December 1925).

34   The photograph by Hoppe was reproduced in the *Tatler* (5 November 1924, xviii, and 31 March 1926, 562). Another photograph by Hoppe was reproduced in various places, including an exhibition announcement in the *Daily Sketch* (14 October 1924, 13) and an article by E. O. Hoppe, 'As Others See Us', *Royal Magazine* LVII: 338 (December 1926), 110, and in *Drawing and Design* (November 1924, 199). For some of the locations of Figure 15, see the article by Jones cited in note 7, above. Gluck's 1925 self-portrait (Figure 16) was reproduced on the cover of *Drawing and Design* (April 1926).

35   Her self-portrait was reproduced in the *Sketch* (17 June 1925, 528); *Bulletin de l'Art Ancien et Moderne* (1925), 113 and in several other unidentified press clippings held in the Archives of American Art at the Smithsonian Institution.

36   N. Barney, *Aventures de l'esprit* (Paris, Émile–Paul Frères, 1929), p. 245, which I have translated from the French.

37   Souhami, *Gluck*, p. 63.

# Elizabeth McCausland: art, politics and sexuality

> The critic is not supposed to be a partisan. He is not supposed to feel, to share the feelings of others, to suffer himself. His emotions are assumed to have been surgically removed, as perhaps his brains have been. I am glad I escaped the scalpel. I am glad I share the experience of my fellow human beings, including that particularly intense and articulate expression called art.
>
> Elizabeth McCausland[1]

Elizabeth McCausland (1899–1965) wrote emotionally charged articles on contemporary art during the 1930s that call for the modern artist to be immersed in society.[2] Coming to art from her own transgressive position as a lesbian feminist active in left political causes, she intervened in both public affairs journalism and the domesticity of the art world to exhort all artists to belong to the world. She articulated a politically engaged avant-garde art that included both women and men. The separation of the public as political, activist and male from the private as aesthetic, passive and female, with all artists positioned as the female Other (as June Wayne has pointed out),[3] is broken down by McCausland and replaced with an ongoing negotiation between those two positions. She further complicates her argument by polemics on gender politics and cloaked sexual games. In this essay I will look specifically at McCausland's reviews of women artists in terms of these shifting lenses of aesthetics, politics, sexuality and gender.

Elizabeth McCausland's criticism provides a stark contrast to the post-Second World War critical hegemony of modernist abstraction. The 'American Action Painters', as characterised by Harold Rosenberg, were celebrated for being active only in terms of moving paint around a canvas.[4] In the modernist ideology, most famously perpetrated by Clement Greenberg, references to issues outside the artwork were seen as violating its 'purity'. Greenberg (and many others) returned the artist to the domestic sphere. The 'best' or most 'ambitious' modernist artist rejected politics and the world entirely.[5]

Under the sway of this ideology, the history of twentieth-century art has, until recently, been based on the paradigm of the isolated artist who rejected society. Such a perspective edited earlier art with an eye to locating a pedigree for post-Second World War abstract modernism. 'Ideological linkages' constructed a narrative of a constant push towards abstraction.[6] All art that engaged politics, social concerns, and frequently even imagery at all, was excluded from this canon.

Many artists, critics and historians, particularly in the United States, still accept the simplistic idea that addressing political issues compromises art. The most recent example of this position was seen in the critical response to the 1993 Whitney Biennial. Critics dismissed the first Biennial as having a significant representation of women and people of colour and, not coincidentally, politically engaged art. Arthur Danto, for example, declared that it was 'mawkish, frivolous, whining, foolish, feckless, awful and thin'.[7] There was no analysis of the political issues presented or the legitimacy of the artists' relationship to those issues. This knee-jerk, canonical separation of art from politics basically forces artists to remain as part of the powerless 'Other', while arbitrarily privileging some artists within that controlled place if they play the game 'successfully' (i.e. without any 'real' political concern). 'Apolitical' art is a political position that diminishes the power of art and artists.

Many revisionist historical studies, both feminist and Marxist, also suffer from this narrow historical template of an apolitical, formalist, modernist canon. *Modernism in Dispute*, for example, a recent effort at revisionism, is obsessed with the criticism of Clement Greenberg and the white male artists of abstract expressionism. It includes only brief token references to political art and art by women as the 'Other' to the dominant hegemony of abstraction.[8] The book purports to 'dispute' by means of the social and political contextualising of modernism, but it endlessly and repeatedly discusses the canonical Greenberg as the central reference point for everything else.

More oppositional writers wonder why modernism is even privileged at all. Houston Baker calls it 'an assumed supremacy of boorishly racist, indisputably sexist and unbelievably wealthy Anglo-Saxon males'.[9] Post-structuralist feminists see its definitions as 'constructions necessary to a highly political and successful cultural production of a highly privileged subject position. Modernist self-fashioning is accomplished . . . over and against a feminized and devalued other, a space of not-self.'[10] A few literary historians look at that devalued space in political terms. They reject the dismissal of all communist writing as 'prescriptive'. In the women writers on the far left, for example, they find not a useless wedding of art to communist orders, but an intersection of genre conventions, communism, sexuality and gender constructions that results in a rich and complicated literature.[11]

I argue here that Elizabeth McCausland can be grouped with these women. She intervened through writing to make a place for women artists within the politically engaged discourse of the 1930s. McCausland operated from a much marginalised place. Aside from the obvious factor of being a woman (that was not marginal in art writing) and working for a newspaper outside of New York, the genre of newspaper art criticism itself is regarded by front-page editors as much closer to society gossip than to hard news. In function, journalistic art criticism is normally affirmative, enhancing the commodity value of the art on the market, and seen as irrelevant to more serious criticism published in art magazines and journals. None the less, McCausland succeeded in redefining art criticism and becoming a widely respected presence. Her art 'column' became an art 'page'. At the same time she was personal, subjective and obviously polemical, never even pretending to the 'objectivity' of tradi-

tional art criticism. And, finally, she linked art to public issues, political ideology and to women. Those linkages underwent constant revision in response to various pressures, many of which were the historical pressures of the 1930s as a whole. In many ways McCausland's positions were a product of those pressures.

As the Depression severely undermined both capitalism in general and the private patronage of art in particular, many middle-class artists moved to the left. They affiliated with communism, with workers and with the strategies of strikes and confrontation. The Federal Art Project relief programmes as well as the United States Treasury mural programmes responded with government support. As a result, the 'art world' expanded its boundaries from an elitist legitimising endeavour for the middle class to a dispersed activity often practised by politically radical artists in communities throughout the United States. McCausland was the critic who most clearly articulated the significance of this new expansion of the role, placement and practice of art.

From my own perspective as a feminist art historian who studies the history of twentieth-century art history and practises contemporary criticism,[12] I see Elizabeth McCausland's writing as emblematic of the politically engaged art discourse of the 1930s, as a feminist act of intervention and as a model for analysis of contemporary political art.

Coming from a pioneering family who helped develop Wichita, Kansas, in the late nineteenth century, McCausland seems an unlikely candidate to redefine art criticism and bear the epithet 'radical feminist'. Although a profound respect for the efforts of pioneers occasionally crops up in her writing, her effort is not to domesticate, but actually to undomesticate art, to get it out of the homestead and reposition it in the landscape of social issues.

It would seem to have been her sexuality that moved her to the activist left and gave her the confidence to intervene. Although never publicly identifying herself as a lesbian, her closest companions from 1930 until her death were other women who were politically on the left. Her leftist politics as well as her sexual orientation sparked deep compassion for the disadvantaged in society. This also made her profoundly aware of the limitations for women who were not playing the game according to the sexual rules of the male-dominated public arena. Her anger emerged in long, still unpublished poems that condemned the deep injustices and hypocrisies of American life at the same time that they celebrated the American land and its people. Later in life her anger turned to bitterness and alcoholism. But during the 1930s she achieved recognition and success as the most articulate art critic of her generation.

McCausland left Wichita, Kansas, in 1919 to attend Smith College, the year the national Woman's Suffrage Amendment was passed in the United States Congress (it was passed in Kansas in 1912). She received a master's degree in English in 1923.[13] Her master's thesis was on Chaucer, rather than her first choice, Emily Dickinson, or her second choice, Walt Whitman; McCausland started out by pressing the restraints of an academic tradition that regarded all American writers as less significant than British and other European writers.

She was immediately hired as a feature writer in the Sunday Department of

the *Springfield* (Massachusetts) *Republican*. The newspaper had a long tradition of liberalism, dating back to the 1820s.[14] One editor, Waldo L. Cook, a member of the Sacco and Vanzetti defence committee, was to be a supporter of McCausland throughout her association with the newspaper.[15] As a result McCausland had an ever-increasing amount of space in the paper, and, even more unusually, freedom to say what she chose. Her correspondence records that she had an enthusiastic following that reached throughout New England and New York City and embraced many different audiences. In the art world her articles were highly respected and frequently posted at museums and galleries.

McCausland identified, to some extent, with women workers. She saw herself quite literally as a 'worker' because of her demanding and exhausting job at the daily newspaper which frequently extended to seven days a week. At the same time, though, she was firmly linked to the middle class through her family and education.

McCausland's affiliation with the political left was accelerated between 1930 and 1933 by her partner, Ruth Fisher. Fisher was a journalist specialising in industrial relations, and an activist for better labour laws for women.[16] This intersection of feminism and communism was a marginalised and difficult position.[17] While there is no evidence that McCausland herself was ever a member of the Communist Party, she felt the injustice of economic inequality deeply. She wrote lengthy newspaper articles analysing labour–capital relations in New England textile strikes. In a model of the type of intersection she would later advocate for artists, she incorporated her public political commitments into her private life. As she commented in a letter to her mother: 'pretty soon my daily life ought to embody all my economic and social beliefs. I think that people ought to do what they can to give their principles support. Recently we raked together a lot of old clothes to send to the striking mill workers in Gastonia.'[18]

Two years later she wrote to her mother that she and Ruth were 'waging a battle practically single handed to maintain the labor laws for women'.[19] Such a close union of personal convictions and public issues would become the foundation for her commitment to advocating a socially engaged art world.

In 1930 she described her early years as a feature writer for the Sunday Department with some irony: 'a newspaper man (there is no sex really in newspaper work) is a permanently disenfranchised citizen of the world'. What she really knew was that there was only the male sex. She commented on her marginal status: 'I've never gone to Russia . . . I have never tracked Coolidge . . . There is no prospect that I will be sent to London to cover a disarmament conference . . .'.[20] She wrote instead on 'almost anything from sports to philosophy'.[21]

Although all of her articles until 1932 were anonymous, McCausland was outspoken, and her work generated a lot of mail. In March 1928 under the pseudonym 'Libertas' she wrote a series of editorials objecting to the censorship activities of right-wing organisations and proudly reported to the Smith College alumnae magazine that she had been blacklisted.[22] She went after the hot-button issues of the day, including, as she enumerated them: 'Abolition of capital punishment, unemployment insurance, book censorship, . . . minimum wage law enforcement; the right of married women

to work in industry; birth control; free speech, and feminism'. In preparing these articles she interviewed Jane Addams, Margaret Sanger, Felix Frankfurter, Bertrand Russell, Oliver Wendell Holmes and the Hungarian pacifist–feminist Rosika Schwimmer.[23] McCausland had an interest in almost everything. She wrote book reviews and drama reviews, as well as articles on construction, aeroplanes, dams, scientific processes and education.

It was a long way from exploited women workers in factories to the pampered visual artist. Initially the art world seemed to her a precious, self-indulgent sphere with little soul. Until the early 1930s, she wrote on it as a cloistered, although intriguing, manifestation of a small enclave, far from the powerful social forces with which she was principally preoccupied. She found it disappointingly superficial, the artists were 'men of little faith, men who did not bleed their hearts', compared to Sacco and Vanzetti, for example.[24]

Her first signed art review was on Georgia O'Keeffe, already a somewhat defiant protest against the norms of objective criticism, since O'Keeffe was a close personal friend.[25] O'Keeffe's public persona as a reclusive woman artist immediately presented contradictions for McCausland to sort out as she examined the intersections of the politics of gender and art. McCausland first set aside the verbiage that had accrued to O'Keeffe's work, verbiage that created so many interpretations that she felt it made it 'impossible to see the artist and her work for words (not her own to be sure, for what she says about her paintings is modest and often merry)'. Such an aside, a personal interpolation that marks McCausland's friendship with the artist, intentionally interrupts the reporter's tone.

The exhibition had six skull paintings and several New Mexico landscapes. McCausland saw 'an O'Keeffe [who is] . . . sometimes almost too clever in her technical mastery, but still a pilgrim'. The pilgrimage to which she referred was the embrace of New Mexico as a place: 'There is another O'Keeffe present, who goes out and paints directly from Nature, who responds defiantly to the terrible majesty and fear that is New Mexico.' Yet McCausland also felt that the profound emotion of that landscape was not yet part of O'Keeffe's work. She understood the effect of the landscape from personal experience; she herself had had a life-changing romantic encounter in New Mexico that had stimulated her to produce a huge outpouring of poetry and to turn more seriously to an identity as an art critic rather than as a general reporter.[26]

McCausland defended O'Keeffe against those who saw her as only a 'precious' artist,[27] as well as those who sought 'proletarianism', 'social significance' or the 'American scene'.[28] She made space for the reclusive, but independent, O'Keeffe, an artist who would seem to be the antithesis of the engaged artistic practice that McCausland herself advocated. As she defended O'Keeffe, she defended women artists in general. She felt that O'Keeffe had become 'a myth, as well as a symbol, of a withdrawn and esoteric state of blissful contemplation said to be peculiar to women (women artists perhaps one should say) which has done her no particular good and certainly has done the artist (feminine gender) no good at all'.[29] In overturning the stereotype of O'Keeffe as a recluse, McCausland sought to expand options for all

women artists. O'Keeffe's notoriety was based on an already very public intersection of gender-construction and modernist aesthetics paired with sexuality through her early association with Alfred Stieglitz. This provided McCausland with an easy opportunity to polemicise about gender, but one full of ambiguity, as she endeavoured to counter the contradictory construct of a public image of the woman artist as a private person. In working with these contradictions McCausland was working not only with the obvious dialectic of the public space and the private person, but also with the internal tensions within the artists themselves, particularly in the case of O'Keeffe.[30] O'Keeffe herself was bisexual, and by the mid-1930s she had shed the persona of the seductress and adopted an austere androgynous identity.

Käthe Kollwitz presented an entirely different challenge. In writing on Kollwitz in the United States, McCausland was a pioneer. Although well known in Germany, she had been little seen in the United States; her art was the antithesis of the popular School of Paris modernism that had prevailed in New York since the Armory Show of 1913.[31] McCausland wrote the first major studies of the artist in the United States, mainly emphasising the intersection of activism and aesthetics, with gender as a subsidiary theme. She struck the note throughout of Kollwitz's importance both as a profound social critic addressing a woman's perspective on war and as a profound artist in her handling of the print-making medium. She openly argued with the orthodox communist position that art was a tool of the working class in the class struggle. In Kollwitz she read the technique as part of the political message, both literally and metaphorically:

> At first sight the prints shown in the present exhibition exemplify the Communist dictum 'Art is a weapon'; it is their social significance, their tremendous indictment of the needless waste of war, of which one is immediately conscious. But these prints are more than propaganda . . . Here is life wasted, violated, raped, needlessly offered up on the altar of war. Against this waste and this violence [Kollwitz] poses the etcher's plate, the lithographer's stone, the woodcutter's block, paper, ink and a few lines, a few dots . . . the self-portraits become . . . the portrait of all stricken and suffering women, bereaved and struck down by the violence of war. In the face of this aging woman may be read the history of her times, of her country . . . the woodcuts . . . are strong and violent in their contrasts, a use of black and white is emotionally consonant with the artist's mood of rebellion at the needless waste and sufferings of the era depicted.[32]

Kollwitz was paradigmatic for McCausland as an artist who intensely and personally addressed public issues. The politics are gendered in that Kollwitz speaks unequivocally of the mother's excruciating sense of loss when her child dies in war, but they include the condemnation of all war as immoral. McCausland's own words also invoke the strong bite of Kollwitz's etched lines. McCausland here uses the written word as a means of political confrontation.

Gertrude Stein, a celebrated writer and publicly declared lesbian, fresh from the Left Bank in Paris, stimulated a different type of writing and polemic. McCausland here explored a more traditional model of modernist aesthetics as politically confrontational. At the same time she inserted the surging energy of Stein's

powerful sexual persona.[33] When Stein actually came to nearby Hartford, Connecticut, in conjunction with the opening of her opera *Four Saints in Three Acts*, McCausland was euphoric. She attended three performances in Hartford and New York, then tackled the subject with a passion. The opera included music by Virgil Thomson, sets by Florine Stettheimer and a stunning all-black cast of dancers from Harlem. Notably, McCausland only briefly referred to the sets, dancing and music. Her main emphasis was on the text, which seemed to have washed over her physically, almost orgiastically:

> For the time being one may say that 'Four Saints' is about life, about reality, about the constant flow and flux of human experience . . . Moreover the opera is about experiences not solely and not chiefly in terms of volitioned and censored thought but in terms of those deeper and more organic rhythms of existence, those buried sensory knowledges of sight and sound and kinesthetic sensation which explorers of the sub-conscious plumb and which the surrealists especially have invoked in their effort to translate the principle of automatic writing into many mediums.[34]

McCausland identified Stein as the 'first' Surrealist and seemed to adopt the automatic process in her own writing. At the same time she clearly felt a deep attraction and even 'hero worship' for Stein which is contained within the intense words (and also seen in a contemporary photograph) (Figure 19). She evoked personal physical feelings, while at the same time connecting the personal to the public:

> this matter of creating rhythms, cadences, concepts and connotations and connections of words which echo or are the equivalent of this age's experience of existence. Speed, broken rhythms, disconnected phrases, sentences without verbs, books without punctuation, these somehow seem consonant with the inner tempo of life as it beats through the western world today. This cadence, this beat, this irresistible pulse is the thing that Gertrude Stein (and her collaborators) have . . . created in 'Four Saints'.[35]

Clearly, the opera forced McCausland to reach beyond her known boundaries in terms of her writing and her feelings, and she allowed those powerful feelings to emerge clearly. In a subsequent article, McCausland characterised Stein as a political activist in her own terms: 'she has helped change the world insofar as an artist can with his intangible weapons of art'.[36] The gender switch in this sentence simply underscores the normative patriarchal language that even the feminist McCausland used without thinking in reference to 'the artist'. McCausland here, though, affirms the idea of aesthetic radicality as a type of confrontation that can be political. Aesthetics, politics and gender were in a powerful conjunction in Stein.

Martha Graham, like Stein, was obviously subverting tradition through the forms of her dance. But as Graham moved to the political left in the mid-1930s, she provided McCausland with the chance to elaborate on the relationship of aesthetics and social concerns. In her first lengthy account of Graham's work McCausland declared that 'The ideal of the dance today, not as an escape from life but as a means of putting one close to life, takes on an added importance in Martha Graham's eyes.' McCausland further saw the dance as a 'very powerful weapon of propaganda' in its correspondence 'to the society that produced it'.[37] The particular model that

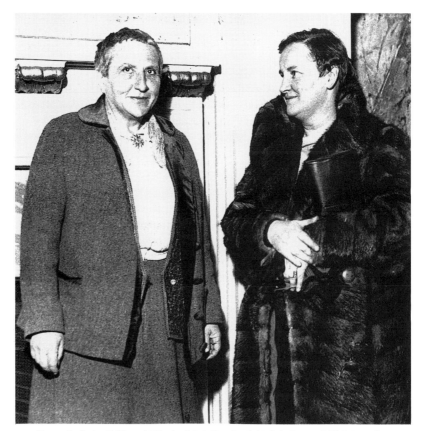

19    Gertrude Stein (left) and Elizabeth McCausland (right), Springfield, Massachusetts, 1934

McCausland had in mind in this article was native American dance.[38] In co-opting the rhythms of native dance, Graham was seemingly following very much the same course as Picasso in his use of African imagery. McCausland saw it more as an intervention in the traditions of classical European dance that brought it closer to 'life' in America.

Graham apparently wanted to be seen as a formalist. The following autumn, under the headline 'Insistence that Dance be Understood in Terms of Itself, as Movement of the Body in Space', McCausland spoke of Graham as declaring that her work was purely abstract: 'it is eternity the artist faces, not time'.[39] Two years later, though, Graham modified her commitment to formalism. In 1935 McCausland, now supported by the artist's program notes, stated that *Panorama* expressed the harshness of fanaticism in the United States through the metaphor of dance. It culminated in a sense of liberation as people awakened to 'social consciousness' in the present:

> To be sure the fanatical intensity of our Puritan forefathers is in the American blood, as is the dreadful inheritance of slavery and sadism. There is also in the country's psyche the memory of the violence and brutality of the Western vigilante, the lust for power of the early empire builders . . .

That is why we may speak of *Panorama* as new and revolutionary. It is not a propaganda or proletarian work of art . . . it is to supply energy to mobilize the beholder as well as the dancer. Therefore the justice of the adjective 'revolutionary', for motion is change and change is revolution.[40]

Here McCausland distinguishes Graham's work from the communist position on political art as the workers' art (proletarianism) and aligns it with the more generic principle of opposition to the inequities and abuses of society.

In a characteristic intersection of public and private, the emotional intensity of the articles on Graham and Stein in 1934 and 1935 coincided with a new personal relationship for McCausland. In the autumn of 1934 she first met the photographer Berenice Abbott.[41] As she reviewed Abbott's photography, McCausland posited: 'the social muse and the artist can consort without either yielding position, the idea not subservient to the medium, the medium not the slave of communication . . .'.[42] The language signifies her personal feelings as much as the character of Abbott's work. The verb 'consort' points to a courtship within the article, a courtship that resulted in the most important relationship in McCausland's life. McCausland here again inserts sexuality itself into her theorising on the relationship of art and society.

In the late winter of 1935 McCausland moved to New York City, propelled there by her new relationship with Abbott. She began to write for radical publications such as the *New Masses Fight* and *Art Front* under the pseudonym 'Elizabeth Noble' (her grandmother's name), as well as writing sedate articles for the College Art Association journal *Parnassus*. But her primary work continued to be as the main art writer for the *Springfield Republican*. Despite continued efforts over the next thirty years, McCausland never had a permanent position with the New York press.

On the other hand, her friendship with Abbott as well as her own reputation as a critic immediately brought McCausland into the centre of the action in New York. In early 1936 feminism and modernism were both subsumed by the specific anti-fascist agenda of the American Artists' Congress. McCausland's experience in reporting labour strikes was perfect to articulate the now widely confrontational and activist spirit of the art world. She wrote excited articles about the new 'world of reality' that the artists now occupied, in contrast to the 'ivory towers' of the past.[43]

The spirit of unified political purpose notwithstanding, McCausland continued frequently to feature women in her reviews. In 1936 she wrote on a Peruvian artist, Julia Codesido, in an article on the Latin American delegation to Congress. In the midst of the rhetoric of the American Artists' Congress, McCausland used a Marxist analysis to examine Codesido's art in relationship to the degree of capitalist exploitation in Peru.[44] She saw Peru as still intact compared to Mexico: 'such paintings as these are a standard by which we can judge a world in transition, passing from a primitive agrarian culture to a highly organized economy. Wait till the American metallurgical interests get their hands on the Andes and see what sort of art comes out of Lima then.'[45]

McCausland now had more sophisticated theoretical tools. She could move beyond the unhistorical 'artist' looking at the 'world', to look at the production of art in the larger historical perspective of economic forces. In an article on the printmaker

Mabel Dwight, McCausland cited the 'social handicaps with which women even in this age of equal suffrage are still attended'. She saw the effects of 'this struggle' in formal terms, in a 'dryness and tightness of line'. The connection of aesthetics and politics here is a provocative parallel to her analysis of Kollwitz's work. But now the struggle is more gendered, more located in the art world, and more historical; it is the struggle of all women as artists in a hostile environment. She characterised Dwight's work as having

> an emotion pressed back because the artist did not dare let herself go. Probably women will always show this last quality in their work until they are free from the beginning instead of having to fight bitterly for every opportunity and recognition. A quality in fact something like that of those pioneer workers for women's suffrage, who were not the most beautiful and seductive women of their age, but who were the true pioneers.[46]

McCausland hits here on both the struggle of the woman artist and the struggle of women in general. The reference to the pioneers of women's suffrage provides a historical reference that would have been familiar to most women at that time when suffrage had so recently been passed in the United States. At the same time McCausland again raises the ambiguity of women's position in the public sphere: the need to 'fight bitterly for every opportunity' speaks of the sexism encountered by women trying to make it in the public arena with a paying job and their consequent need to hold back their own opinions. In her own case, her ongoing effort to gain a position with a New York newspaper continued, and her frustration with the inequities of the world increased. The 'emotion pressed back' is clearly her own.

McCausland used a review of drawings of steelworkers by Elizabeth Olds (Figure 20) to look at the position of women artists historically, giving a perspective that would not be repeated for many years.[47] She compares Olds to Berthe Morisot and Mary Cassatt, who had 'no option except to glorify motherhood and children. In our time women have too often been driven back to a position of priestess or prophetess . . . or at least [been] concerned with personal emotion as of comfort, love and narcissism.' In Olds McCausland saw someone who was moving out of the domestic and into the public arena, in her case in her subject of steelworkers: 'After the smell of hot damp earth from hothouses, [it is] a welcome relief.' But, McCausland firmly stated, the artist had not yet made a 'full identification' with her subject, something which McCausland felt led to a loss of 'passion or emotional power' in the drawings.[48] She saw sympathy and support in Olds's drawings of steelworkers, not the kind of engagement that would realise social change. McCausland was not willing to settle for an art that was less than compelling as it negotiated with social and political concerns. She never hesitated to call on artists to engage more deeply in both aesthetic and social issues. She believed that artists collectively and individually, male and female, could make a difference in changing the world.

After 1938 McCausland wrote less frequently on women.[49] Feminism seems to have taken a back seat to fear for the survival of humanity as Hitler's army marched across Europe. McCausland became increasingly activist herself. She moved from her

exhortatory role as a critic to become publicly involved in the American Artists'
Congress. This bold act ran counter to the general tenor of the times. At the end of
the 1930s artists were leaving the public arena and retreating to the more familiar
studio as they were disillusioned by the Hitler–Stalin pact, the loss of the Spanish
Civil War, and the increasing pressure within the United States from the House
UnAmerican Activities Committee.

In 1946 the *Springfield Republican* closed, and McCausland lost the freedom of
writing long polemical articles. During the remaining years of her career she wrote
commissioned books and monographs, all of them on men. Her feminism and even
her commitment to social engagement was effectively silenced by the necessity of
making a living and the atmosphere of the 1950s. But she remained an articulate writer
who laced her writing with concerns that were equally threatening to the profit-
oriented 1950s, such as the relationship of the artist to the market.[50]

At her death in 1966 McCausland had published only one book on a woman,
an introduction to a portfolio of prints by Käthe Kollwitz in 1941.[51] Her major work
on the social history of the artist in America remains in typescript to this day, and
has not even been acquired by a public archive.[52] It is only in the *Springfield Republican*
that her radical, feminist intervention in the staid tradition of art criticism survives.

As a writer and a poet, as well as an art critic, Elizabeth McCausland can be
grouped with other recently republished feminist writers of the 1930s like Tess
Slesinger, Meridel Le Sueur, Josephine Herbst, Muriel Rukeyser, Genevieve Taggard
and Agnes Smedley.[53] While less officially and publicly aligned with the far left than

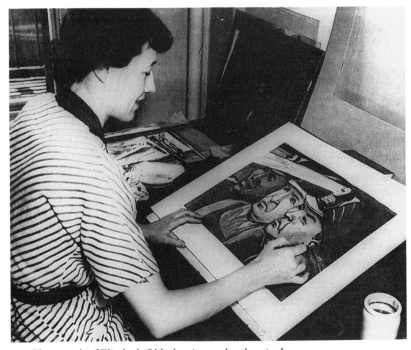

20   Photograph of Elizabeth Olds drawing steelworkers in the 1930s

these women, McCausland, like them, successfully inserted herself, as well as the concerns of women, into the male-dominated world of left politics, journalism and art. In the process, she formulated a model for a vanguard culture that was both politically and artistically engaged, and negotiated the relationships between aesthetics, gender, sexuality, social concerns and politics.

## Notes

1  Elizabeth McCausland, 'A Critic Explains', *American Contemporary Art*, 2:3–4 (1945), 3–4.

2  Previous articles on Elizabeth McCausland are Garnett McCoy, 'Critic and Idealist', *Journal of the Archives of American Art*, 6:2 (1966), 16–20 and Susan Dodge Peters, 'Elizabeth McCausland on Photography', *Afterimage* (1985), 10–11. Susan Peters is also working on a book on McCausland's criticism of photography, 'Eyewitness: The Rise of Modern Photography.' McCausland is also treated in my forthcoming book *Art and Politics in the 1930s*.

3  June Wayne in Judy Loeb, ed., *Feminist Collage: Educating Women in the Visual Arts* (New York, Columbia University Press, 1979), 129: 'It appears to me that society unconsciously perceives the artist as a female . . .'.

4  Harold Rosenberg, 'The American Action Painters', *Art News*, 11:8 (1952), 22–3, 48–50.

5  Clement Greenberg, 'Modernist Painting', *Art and Literature*, 4 (1965), 193–201, summarises this position.

6  Cary Nelson, *Repression and Recovery: Modern American Poetry and the Politics of Cultural Memory, 1910–1945* (Madison, Wisconsin, University of Wisconsin Press, 1989), 38, uses this phrase. As far as I know, the earliest formulation of this idea was in Alfred Barr, *Cubism and Abstract Art* (New York, Museum of Modern Art, 1936).

7  Arthur Danto, *Embodied Messages: Critical Essays and Aesthetic Meditations* (New York, Straus, Giroux, 1994), 312–17.

8  Paul Wood, Francis Frascina, Jonathan Harris and Charles Harrison, *Modernism in Dispute: Art Since the Forties* (New Haven, Yale University Press, 1993).

9  Houston Baker, *Modernism and the Harlem Renaissance* (Chicago, University of Chicago Press, 1987), 4; Rita Felski, *The Gender of Modernity* (Cambridge, Harvard University Press, 1995), 16.

10  Deborah Jacobs in Lisa Rado, ed., *Rereading Modernism: New Directions in Feminist Criticism* (New York, Garland, 1994), 275; Felski, *The Gender of Modernity*, 11–13.

11  Nelson, *Repression and Recovery*; Paula Rabinowitz, *Writing Red: An Anthology of Women Writers 1930–1940* (New York, Feminist Press, 1987); Barbara Foley, *Radical Representations* (Durham, NC, and London, Duke University Press, 1993).

12  My first book, *Modernism in the 1920s* (Ann Arbor, UMI Research Press, 1985), looked at the historiography of modernism at a time when I was still a brainwashed advocate of modernism myself.

13  In going east she was following her sister, Helen, who attended Simmons College. After earning her B.A. in 1920, McCausland returned to Wichita for one year of gruelling teaching at Fairmount College and then went back for her master's degree. McCausland also had other relatives in the east, including an uncle, John Noble, who was an artist on Cape Cod (interview with Ross McCausland, 30 July 1996).

14  Richard Hooker, *The Story of an Independent Newspaper* (New York, Macmillan, 1924).

15  Elizabeth McCausland, 'Americans We Like, Waldo L. Cook', *The Nation*, 4 July 1928, 11–12. The Sacco and Vanzetti committee attempted to reverse the decision that condemned two

Italian anarchists to death. It was unsuccessful; they were put to death in 1927. They were a familiar example of injustice throughout the 1930s.

16  Fisher also spent much of her free time providing young factory workers with recreational activities. When her job was terminated, she emigrated to the Soviet Union in 1933 and is last referred to as writing for the *Moscow Daily News* in 1935. Information on Fisher is based on McCausland to Paul Strand, 1 September 1933 and 17 April 1935 (Paul Strand Archives, Center for Creative Photography, Tucson).

17  Barbara Foley, 'Women and the Left in the 1930s', *American Literary History*, 2:1 (1990), 150–69; Debrorah Rosenbelt, 'From the Thirties: Tillie Olsen and the Radical Tradition', *Feminist Studies*, 7:3 (1981), 371–406; Robert Shaffer, 'Women and the Communist Party, USA, 1930–1940', *Socialist Review*, 9:3 (1979), 73–118; Susan Ware, *Holding Their Own: American Women in the 1930s* (Boston, Twayne, 1982), especially chapter 5.

18  Elizabeth McCausland to Isabelle McCausland, 23 May 1930 (Elizabeth McCausland Papers, Archives of American Art). See her articles 'Capital–Labor in New Bedford I–III', *Springfield Republican*, 24, 26 and 28 August 1928, and 'Easthampton Makes Denial', 22 December 1928. Unless otherwise indicated, all articles cited by McCausland are from the *Springfield Republican*. All the references here are from clippings with no page numbers in the McCausland Papers, but her articles frequently appeared on page 6.

19  Elizabeth McCausland to Isabelle McCausland, 5 December 1932 (McCausland Papers).

20  Elizabeth McCausland, 'Behind the Front Page', *Purple Pastures, 1920 Reunion Booklet* (Northampton, Mass., Smith College, 1930), 15, 16.

21  Smith College *Alumnae Quarterly* Class Notes, 1925, College Archives, Sophia Smith Collection, Northampton, Mass.

22  The articles were collected in a pamphlet, *The Blue Menace*, under her own name, and sold through the *Springfield Republican* 'To those interested in Free Speech and Liberal Opinion'.

23  'Experiences on *Springfield Republican*' (McCausland Papers); Smith College *Alumnae Quarterly* Class Notes, 1928.

24  'In Retrospect', 9 July 1930.

25  Georgia O'Keeffe to Elizabeth McCausland, 15 July 1935 and undated correspondence (McCausland Papers). The article was signed with an 'E'.

26  'Georgia O'Keeffe Exhibits Skulls and Roses of 1931', 10 January 1932.

27  'Georgia O'Keeffe from 1919 to 1934', 17 February 1935.

28  'Georgia O'Keeffe's Flower Paintings', 28 April 1935. McCausland's trip to New Mexico in the fall of 1931 is treated in my forthcoming book, *Art and Politics in the 1930s*.

29  'Georgia O'Keeffe Shows Her Latest Paintings', 2 January 1938.

30  Barbara Marshall, in her *Engendering Modernity: Feminism, Social Theory and Social Change* (Boston, Mass., Northeastern University Press, 1994), 114, analyses the tensions of public and private. See also Barbara Buhler Lynes, *O'Keeffe, Stieglitz and the Critics, 1916–1929* (Ann Arbor, UMI Research Press, 1989) on the construction of O'Keeffe's identity by earlier critics.

31  Jean Owens Schaefer, 'Kollwitz in America: A Study of Reception 1900–1960', *Woman's Art Journal*, 15:1 (1994), 29–34, examines McCausland's writings in comparison to the writings on Kollwitz during the hegemony of formalism.

32  'Käthe Kollwitz's Work Being Shown at Museum Here', 11 December 1933.

33  Her first review was a matter-of-fact book review, 'Gertrude Stein's Reminiscences', 3 September 1933.

34  'Super-Sense Applied to Twentieth Century Life', 4 March 1934. In November McCausland published an interview with Stein, following the poet's tour of the United States and spurred by the knowledge that Stein was scheduled to speak in Springfield in January 1935 at the

Springfield Museum of Art ('Stein Sits Listening to America After Thirty-One Years' Absence', 11 November 1934; 'Stein and Toklas Here', 8 January 1935).

35  'Super-Sense Applied to Twentieth Century Life'.

36  'Stein Sits Listening to America After Thirty-One Years' Absence'; 'Stein and Toklas Here'.

37  'American Dancer is Evolving a Typically American Rhythm', 30 April 1933; see also 'Study of Modern Dance in America: Pioneering Venture', 22 July 1934.

38  'Indian Dances Parallel Cycle of the Seasons', 1933 (no day or month given). Graham had a Guggenheim Fellowship to New Mexico to study southwestern Indian dances in 1931–32.

39  'Absolute and Abstract Art is Dance of Martha Graham', 9 September 1933.

40  'Modern Dance Takes Another Step Forward', 25 August 1935.

41  Berenice Abbott to Elizabeth McCausland, 29 October 1934. A letter from Elizabeth McCausland to Berenice Abbott uses the word 'passion' eleven times: 5 November 1935, Abbot Archives, Commerce Graphics as cited in Bonnie Yochelson, *Berenice Abbot: Changing New York, The Complete WPA Project* (New York, New Press and Museum of City of New York, 1997), 19.

42  'New York City as Seen in Abbott Photographs', 14 October 1934.

43  'Artists Thrown into World of Reality Present Their Case at Recent American Artists' Congress', 1 March 1936. McCausland covered the American Artists' Congress throughout its history in more detail than any other critic.

44  'Mexican Art with Social Message', 19 March 1936.

45  *Ibid.*

46  'Mabel Dwight's Art in a Lithograph Showing', 9 January 1938.

47  Griselda Pollock, *Vision and Difference* (London, Routledge, 1988) finally again brings together Marxism and feminism.

48  'Steel Mill Drawings by Elizabeth Olds', 5 December 1937.

49  Later articles include 'Lisette Model Show "Candid" Photographs', 27 May 1941; 'Irene Rice Pereira', *American Magazine of Art*, December 1946, 374–7.

50  'Must Artists Starve?', *New Masses*, 10 July 1945, 9, 10, and 'What is the Economic Future of the Artist?', *The Art Digest*, 1 November 1951, 22, 66.

51  Introductory Essay, *Käthe Kollwitz* (New York, Curt Valentin, 1941).

52  The incomplete manuscript entitled 'The Artist in America 1641–1941: A Social History' resides in a private collection in New Jersey.

53  Paula Rabinowitz, *Labor and Desire* (Chapel Hill, University of North Carolina Press, 1991) and *Writing Red*.

# Hepworth and her critics

Two feminist anthologies on women artists have recently reproduced Barbara Hepworth's writings from *Barbara Hepworth: Carvings and Drawings* (1952) and *A Pictorial Autobiography* (1970). In both Mara Witzling's *Voicing Our Visions* (1992) and Susan A. Waller's *Women Artists in the Modern Era* (1991),[1] Hepworth's words reappear in a new context among statements from other notable women artists in the twentieth century. The reprinting of extracts from Hepworth's two autobiographies celebrates her life and struggle as an artist and a woman. This essay is an attempt to problematise Hepworth's words through attention to both the 'context' in which statements were made and the 'discursive formations'[2] they negotiate, in order to highlight new potential readings of her project.

In Hepworth's case, the reproduction and repetition of the artist's statements are not confined to feminist accounts. In the criticism published during her lifetime, it is remarkable how often her own published statements are quoted in the work of male critics. How this is done is referred to in the analysis of critics' writing on Hepworth which follows, but her words are rarely used to further discussion; more often, they are used to settle an argument, to close down upon the potential meaning(s) in what she has to say. If feminist presentation has highlighted her voice in terms of her struggle as a woman to realise her potential as an artist, male critics from the 1930s to the 1960s have used her statements to define and designate their view of the limits to her artistic practice. Hepworth's own recourse to artist's statements and her decision to produce two autobiographical texts can, however, also be seen as an intervention in the critical discourse on her work: a strategy she adopted to resituate her work and open up its theoretical and philosophical tropes for analysis,[3] a strategy which was not always successful.

The representation of women's autobiography as a form of 'truth'[4] is frequently regarded as empowering in a culture where women's words are readily dismissed as 'personal'. Yet autobiographical narratives typically construct a retrospective and often highly selective view of their subject's life. In most autobiographies, the subject moves relentlessly and with a certain inevitability from birth to his or her present position in life; a view only possible with the benefit of hindsight. Attending to the disjunction between the moment at which the work was written and how the past has been framed and produced by a set of historical determinations at the time of writing can be productive.

The production of *A Pictorial Autobiography*[5] was part of a set of strategies which I believe Barbara Hepworth adopted to speak positively about her ideas and

artistic practice while at the same time negotiating and mediating the effects of the (then) familiar critical stereotypes about women artists. This reading is contingent upon a shift in the reading of her autobiographical writings and artist's statements not as manifesting the 'pure presence' of a fixed subject but as the result of negotiated, highly mediated and historically contingent representations of 'self' designed for particular envisaged or imagined audiences. It is also an attempt to demonstrate how historical enquiry combined with analysis of art criticism can open up an investigation into competing readings of artists and their work against developing stereotypes.

The narrative of *A Pictorial Autobiography* presents a chronological view of Hepworth's life in four sections: childhood and youth; the years with Ben Nicholson; St Ives; and 'A New Decade' (the 1960s, which draw to a close as the book ends). The steady progress of her career as a productive and celebrated artist forms the dominant narrative. The text itself emphasises her negotiation of career and family, successfully combining art production with motherhood through the possession of a strong work ethic and a passionate dedication to sculpture. Hepworth's words are juxtaposed with photographs, not just a sequence of artworks, but different views of the artist in her studio, at official functions in her honour, with her family and friends on 'working holidays', of her pets and of significant places in her life – the Yorkshire and Cornish landscapes. The collage effect of the book is further emphasised by facsimiles of reviews, catalogues/frontispieces, telegrams awarding prizes and statements written in her own hand, either about pieces of work or speeches she made. The collage of images adds another layer to the text. This is why reproduction of the text alone (in a feminist context) makes no sense, as the visual documentation provides significant links to aspects of her life which are not discussed.

The book was conceived in 1968, which was a highly significant year for Hepworth in terms of recognition of a lifetime of achievements through exhibitions and awards. She became one of only five women to be given a major retrospective at the Tate during her lifetime; she was awarded an honorary D.Litt. from Oxford University; became a Bard of Cornwall; and received the Freedom of the Borough of St Ives. This is documented photographically at the end of the book. The final section of the text becomes almost entirely a series of statements about her artistic practice and philosophy, rather than a description of her reactions to the sequence of events and awards shown in the last section.

The first two sections of the book conclude with the end of each of her two marriages. In each case, she emphasises how a new phase of artistic endeavour began after separation, and included meeting new and important people in both her artistic and creative life. The first section ends with the defiant statement that

> Friends and relations always said to me, that it was impossible to be dedicated to any art and enjoy marriage and children. This is untrue, as I had nearly thirty years of wonderful family life: but I will confess that the dictates of work are as compelling for a woman as a man. Not competitively, but as complementary, and this is only just being realised.[6]

In a strictly chronological view, this section marks the end of her marriage to John Skeaping and the birth of her first child in 1929, but the statement refers retrospectively to both her marriages, and the thirty years incorporate her other three children, triplets (born in 1934). No direct references to Ben Nicholson's first wife, also an artist, and their children appear in the text. Winifred's work is reproduced once (under the name Dacre, not Nicholson) in a reproduction of a Seven and Five Society catalogue (*A Pictorial Autobiography*, p. 32). The point is not that Barbara Hepworth is obliged to reveal every facet of her life, but that we should be aware of the emphases within her own account of herself. Here she is defying the view that to combine marriage and career was impossible and that being a wife and mother is incompatible with any creative life for a woman as an artist, a calculated broadside against the sexist view evident when she trained in the 1920s and manifesting itself again in the teaching practices of the 1960s in a younger generation of male sculptors like Reg Butler,[7] in spite of the fact that women artists who were also mothers have been far from exceptional in this century. Hepworth was well aware of discrimination within the art world against women artists, and these often-quoted statements were written in defiance of these prejudices.[8] Barbara Hepworth was also conscious that the book had a corrective job to do: 'Its main use was to put beyond dispute certain dates. My dates have been much altered by writers on Henry Moore. And of course, apart from being a woman, it has not been easy always having great bears breathing down one's neck.'[9] Hepworth's consciousness of the distortion occurring in the work of writers on Henry Moore by the late 1960s included the writing out of Hepworth's role in English modernism in the 1930s, and the influence of her work upon younger generations of artists who emerged in the 1950s. In the 1960s the majority of criticism on Hepworth was produced by Alan Bowness, Bryan Robertson and Edwin Mullins.[10]

Though the book is dedicated to her friends Nancy and Fred Halliday, the narrative generated by the reproduction of reviews and catalogue essays in this book carries a carefully staged tribute to her relationship with Herbert Read, who died in 1968. Read is mentioned only twice in the text, as defining the 'gentle nest of artists'[11] in Hampstead in the 1930s, and in the last section in a paragraph somewhat isolated from the rest of the text, where she wrote of him as her 'first sponsor and friend', whose 'great courage and understanding helped me so much'.[12]

The facsimiles provide references to the majority of texts which Read wrote about her work: catalogues from Tooth's, with Ben Nicholson, 1932 (*A Pictorial Autobiography*, p. 21) (Figure 21); Bankfield Museum, Halifax, 1944 (p. 46); the British Council, 1950 (frontispiece only, p. 57); Galerie Chalette, New York, 1959 (p. 79); Marlborough Gerson Gallery, New York, 1966 (p. 104); an article for the *Listener*, 1948 (p. 51); his introduction to *Carvings and Drawings* (frontispiece, p. 63); and her article for Read's 1934 book *Unit One* (p. 30); a press cutting about a portrait of Read by Patrick Heron which Hepworth and Henry Moore donated to the National Portrait Gallery; and, finally and most significantly, as the second to last page of the book, a full-page reproduction of a magazine article with his photograph and the beginning of the text of his last public speech.

This subtext on Read was not just the result of Read's recent death, it was a

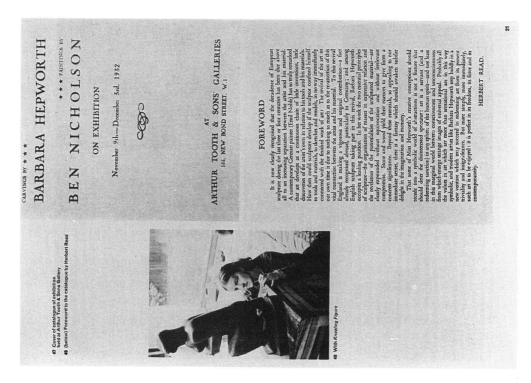

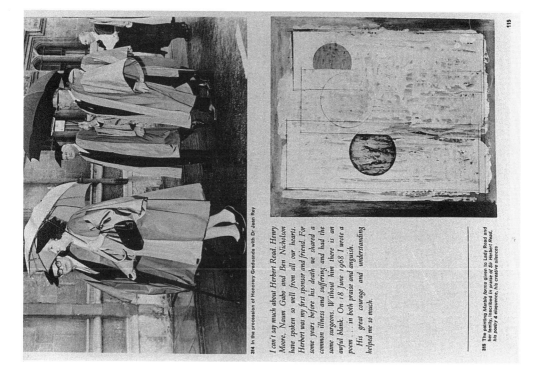

**21, 22** Pages 21 and 115 of Barbara Hepworth, *A Pictorial Autobiography*, 1970

particularly significant relationship which Hepworth (and Bowness, who assisted Hepworth in the book's production) decided to emphasise. Only several short reviews by Read for Parisian magazines in 1938, 1939 and 1959 and the reproduction of short passages of discussion in his numerous publications on contemporary British art or sculpture are actually excluded. Read was not the only critic to write repeatedly and at length on Hepworth's work, but he is the only critic to receive such attention within the reproductions in *A Pictorial Autobiography*. At the particular moment of its production, Hepworth chose to right the 'wrongs', the distortion produced by Moore scholars, by highlighting her own relationship to Read, and there is, I believe, a very cruel irony in that this seals a perception of Hepworth within a Read/Moore paradigm which has actually closed down upon curatorial and scholarly attention to Hepworth after her death, rather than initiating further research (until 1995).[13]

Read's publications presented Hepworth's work to audiences in the United Kingdom, but it was a promotion which consistently linked her to Henry Moore and Ben Nicholson (Figure 22). Her inclusion in Herbert Read's books from *Art Now* (1933) to *Contemporary British Art* (1966) is generally at the same point in the argument where their work was discussed. In Read's writing as a whole, Hepworth is significantly the only woman artist on whom he wrote repeatedly and at any length, although the volume of writing on Hepworth is meagre when compared to that on Moore.

As is well known, Read did much to establish Moore's relative importance as an English sculptor, creating a critical framework for understanding his work — even going so far as to write down the artist's early statements for publication.[14] Read also wrote the majority of the catalogues for the numerous and highly successful British Council tours of Moore's work. As has often been noted by many art historians, Read promoted Moore as the most significant example of the development of contemporary modernist sculpture in Britain.[15] The effect of using Moore as the 'norm' in Read's writing created a particular asymmetry in the way each artist was discussed or referenced in relation to the other. In Read's (and Donald Hall's) biographies of Moore, for example, all references to Hepworth are confined to the repetition of a few facts: that they both came from Yorkshire to study at the Royal College of Art,[16] both spent time studying in Italy on scholarships;[17] that Moore was several years older and, it is therefore always implied, her intellectual and artistic senior;[18] that they lived nearby in Hampstead in the 1930s and Moore briefly moved into Hepworth's and Ben Nicholson's studio in 1939 when they left for St Ives, until it was bombed in October 1940.[19]

Read's commentary on Moore contributed to a number of critical biases: firstly, as she was significantly younger, Moore must claim seniority in age and professionalism; secondly, that her work is derivative of Moore (because of the age gap, their only relationship could have been one of teacher to pupil) or, if it is recognised that the two artists were peers, because the facts of Hepworth's early scholarships are acknowledged, any real exchange of ideas between them has to be recognised in the context of the 'gentle nest' in Hampstead and, more often than not, it is argued that its mature significance can only be found in Moore's work. Moore, therefore, owes

nothing to Hepworth, and comparisons with her work are irrelevant to any criticism of his life or work. Discussion of Hepworth's work by comparison with Moore's can thereby be neatly avoided in the majority of Moore's biographies.

By contrast, in accounts of Hepworth's work, where comparisons to Moore are made, they are made to establish the significance of her work through his achievements, outlining what it is she shares or potentially developed in parallel with his work. Here, a different set of points recurs as significant: the influence of the landscape, particularly the Yorkshire landscape, for each as children, since neither worked there during their adult life;[20] their absorption in the qualities of the sculptor's materials and the use of carving in the 1930s (in line with Read's understanding of the project of the modern artist); the fact that both established pierced forms in their work in the 1930s and employed strings in their sculptures of the early 1940s.[21] These latter two 'innovations' are often credited to Hepworth in accounts of her own work, but the absence of any reference to Hepworth's work in accounts of Moore has perpetuated the damaging illusion that Hepworth's claims to such 'originality' must be derivative, false retrospective claims, or lacking in any real aesthetic significance.

When one focuses on what Read said rather than repeating the framework which his views established, what becomes interesting are the difficulties he had in actually engaging with Hepworth's work on any critical level. Read generally does not attempt to comment critically on Hepworth's words, which he liberally quotes, nor does he engage in criticism of any specific works. His statements are never openly negative, just ambivalent. They are damning because of their faint praise and a reluctance to name her achievements.[22] His writings are characterised by a noticeable dependence either on extended quotations from other sources or on the artist's own words. In 1959 Read felt able to describe Hepworth's achievement as 'secure', the result of a 'sense of fulfilment', but he begins by telling the reader that he wanted to refuse the writing commission as he felt he had little to say and the convention of introducing the artist's work to an audience felt rather stale.[23] This is an extraordinary statement from such a prolific and committed advocate of English modernism! Read offers a critical context through references to an observation about the modern artistic dilemma by Nolde, the ancient Chinese philosophy of Chuang-Tzu, and references back to her two nearest contemporaries, Moore and Nicholson. In a comparable text on Moore from 1961, Read reveals no such hesitancy either in praising or in positioning the artist in terms of greatness, making liberal allusions to Moore's genius, to his international importance, to his inheritance from Ruskin, from Michelangelo, i.e. to both a specifically English and a grand tradition of European sculpture.[24]

David Burstow has also identified the differentiated use of vocabulary by Read in the 1950s to classify the two artists, but asserts that this distinction is not identifiable in terms of gender alone, and is a repetition of 1950s conceptions of appropriate models for the masculine and feminine as possessing complementary qualities. Burstow argues that Read 'used the sculptor's own words to distinguish between their ideals. Hepworth's desire for a "sense of mystery", "loveliness" and "some universal or abstract vision of beauty", Read valued less highly than Moore's

desire for "power" and "vitality", although he resisted any simple explanation of this in terms of their gender.'[25]

Hepworth was well aware of the consequences of this system of recognition, as Read refused to recognise her own contribution as a 'parent' to a younger genera-tion of post-war British sculptors.[26] Read does, contrary to Burstow's assertion above, make sex-attributes explicit in this complementary model of masculinity/femininity. In *Barbara Hepworth: Carvings and Drawings* he chooses Jungian theories, balancing anima and animus to make the point:

> But if these qualities can be sufficiently differentiated as ideals, it must not then be supposed that one is sentimental or feminine, the other realistic or masculine. What one might venture to suggest is that they represent the components of the psyche which Jung had differentiated as the anima and the animus. According to this hypothesis, we all carry in us an image of the other sex, 'the precipitate of all human experience pertaining to the opposite sex', as we tend to project everything that is latent and undifferentiated in the psyche . . . But the projection of images from the unconscious is never direct (except in dream or trance); the woman has to disguise her animus in feminine attributes (loveliness) the man his anima in masculine attrib-utes (vitality and virility). In each case the secret power of the projected image comes from this state of tension, this sexual ambiguity or dialectic.[27]

Read's conception of sexual ambiguity or dialectic, however, reinforces the notion that a woman artist can only succeed if she embraces or is conscious of her psychic masculinity while remaining predominantly female in her 'loveliness'! In the 1950s Hepworth's statements also stressed a complementary, not a competitive, model,[28] but it is not until the 1950s that Hepworth made any critical or public state-ments on women's position and the 'derogatory feminine'.[29] This was after her own children had grown up and left home and when her reputation had been established by several international showings at Venice and São Paulo. Hepworth's argument is also pitched against the 'negative' lack which contemporary critical reviewing prac-tices (executed overwhelmingly by men) routinely ascribed to women's work.[30]

In the quotation above Read also associates Moore's virility with the quality of vitality. In contrast to this association of the 1950s, 'vitality' was repeatedly used in the 1930s as a critical term to indicate avant-garde artistic ambition and originality, privileging men for its possession while criticising women for their lack of this elusive quality. J. M. Richards, for example, reviewing the last Seven and Five show in 1935, argued that Ben Nicholson's work could be distinguished for its 'vital concentration', Moore was the 'most vital' sculptor, while Hepworth appears as 'following Ben Nicholson's lead' (no doubt as a dutiful wife), but in such a way that 'the necessary vitality does not seem to have survived the change'.[31]

'Vitality' was, however, internalised as the mark of genius by many women artists. Frances Hodgkins, another member of the Seven and Five Society until it became exclusively devoted to showing abstract work, wrote to her mother in 1924 (a decade before) of her position as a woman, modernist and expatriate: 'New Zealanders like myself cannot help becoming de-nationalised – they have no country – it is sad but true . . . Art is like that – it absorbs your whole life and being. Few

women can do it successfully. It requires enormous vitality. That is my conception of genius – vitality.'[32]

The elusive quality of vitality in a woman was what first attracted Ben Nicholson to Barbara Hepworth and a point of judgement about other artists, as he wrote to his first wife, Winifred, in 1932, that Barbara's 'understanding of life is profound and vital . . . She is a bigger artist than any man or woman I have met. Frances [Hodgkins] is a very real artist – so is Harry [Henry Moore] and Kit [Christopher Wood] as a person not in his painting, I don't feel the same about David [David Jones] – his point of view is not yet vital'.[33]

In the 1930s Hepworth used the terms 'power' and 'vitality' regularly in her own published statements. In *Circle* she makes clear that 'vitality' is for her 'spiritual vitality', and not linked to masculine strength, genius or 'virility'. She does not mention 'loveliness':

> When we say that a great sculpture has vision, power, vitality, scale, poise, form or beauty, we are not speaking of physical attributes. Vitality is not a physical, organic attribute of sculpture – it is a spiritual inner life. Power is not male power or physical capacity – it is an inner force and energy. Form realisation is not just any three-dimensional mass – it is the chosen perfected form, of perfect size and shape for the sculptural embodiment of the idea. Vision is not sight – it is the perception of the mind. It is the discernment of the reality of life, a piercing of the superficial surfaces of material existence that gives a work of art its own life and purpose and significant power . . . A vital work has perfect co-ordination between conception and realization; but actual physical contours do not limit a perfected idea.[34]

'Vitality' is here neither a physical attribute of the artist nor of the sculpture, and as such is not gendered. Possession of this quality is to be found in the realisation and conception of the idea, and as such it is a quality which women do not automatically or necessarily lack. A great deal could also be said about the centrality of 'Englishness' linked with 'genius' and 'vision' in Read's construction of the dominant critical discourse on Moore, because nationality is noticeably absent from all critical discussion of Hepworth's work. While other writers do identify Hepworth's work as produced by 'genius' and discuss the importance of specific landscapes, Cornish or Mediterranean, or the landscape of her Yorkshire upbringing, these are never used to locate her as a product of English culture or in a nationalistic framework.[35]

In the 1930s Moore was frequently identified as the *English* sculptor, an English genius, owing much to the landscape, producing humanistic images of women and as an artist involved in biomorphic abstraction and engaged with abstraction/Surrealism. Hepworth, by contrast, was positioned as more abstract, daringly modern, an abstract/Constructivist, and her work was described as both cold and emotional/intuitive.[36] The experimental character of her work was compared to Continental Constructivism and positioned as a search for absolute values.[37] The two artists never showed together except in the context of large group exhibitions where what marked any point of comparison between them was the fact that they were both sculptors.[38] Hepworth was one of the few women sculptors to take part in abstract exhibitions and publications, though we should not forget the constructions of Eileen

Holding or the paintings of Winifred Dacre/Nicholson, Jessica Dismorr, Mainie Jellett, Evie Hone, Paule Vezelay, Sophie Taeuber-Arp or Marlow Moss (under the collective auspices of *Abstraction–Creation*).

Most of the critics who wrote about Hepworth between the 1930s and 1960s also wrote about Moore, but the gendered distinctions were not always made in the same way, as examples from William Gibson in the 1940s, David Lewis in the 1950s and J. P. Hodin across this period indicate. Negative criticism of Hepworth in comparison with Moore centres on the identification of invention as opposed to influence. Moore was credited by Hugh Gordon Porteus in the avant-garde magazine *Axis* in 1935 as being 'the first to turn Arp's toy into a work of art' and praised for his 'genius' in adapting a new idea and superseding his initial influence.[39] Porteus hints that 'it seems likely that work by Barbara Hepworth suggested to Moore the possibilities of this new game', but positions her work as ultimately only derivative of Moore, Brancusi and Arp.[40] It is worth noting that Moore's Englishness and inventiveness were positioned not only against a woman sculptor but also against Epstein as an 'older semitic genius'.

William Gibson in the 1940s offered contrasting and complementary characteristics in the two sculptors' work to interpret gender difference through 'temperament'.[41] He characterises Hepworth's project as moving from figuration to geometrical abstraction, while Moore's experiments with abstraction returned him to exploring 'distortions of the human figure'.[42] Gibson praises the boldness of Hepworth's abstraction as moving away from a monumental, static and compact conception of sculpture towards experimentation with balance, a configuration in space in which the negative space within the sculpture is as suggestive as the carved form of the sculpture itself. He nevertheless offers a model of separate development for both artists marked as a 'natural' distinction, which by extension of his argument I take to mean an innate, biological difference – a sex difference defined in this characterisation of the two artists' temperaments. Underlying the argument is the unstated, if obvious, point that Moore's object is 'woman' whereas Hepworth's arises from consideration of bodily experience of 'being a woman'.

In 1955 David Lewis linked the two artists because of their similar background and preoccupation with carving, but rapidly distinguished their projects as different responses to both the observation of nature and their perception of the inequality of forces and conflicts in the natural and human world.[43] Lewis characterises Moore as a 'realist rather than an idealist', a 'tragic artist' whose response is at best a form of passive and defiant resistance to the disequilibrium observed in nature: 'a figure by Moore gives us a sculptural contrast of particular meaning and a controlled yet tremendous power'.[44] Hepworth, by contrast, refuses to accept the reflection of conflict in the world as inevitable, and her optimistic forward-looking carving is 'intended as an object in which a fact of integration takes place. It is a meeting place where a fact of living concordance occurs between innumerable separate forces: form, light, colour, rhythm, space, environment.'[45]

The only other critic besides Read to have written about Hepworth repeatedly over the course of several decades is J. P. Hodin (from 1948 until 1966); he too

also wrote about Moore.[46] His criticism was largely for art journals published in Belgium, Austria, the Netherlands, Germany and Italy, but he also wrote the catalogue for her showing at the São Paulo Biennale in 1959, for her British Council tour of Scandinavia in 1964–65 and for a show in Zurich in 1960.[47] Hepworth was shown more widely and earlier in the Netherlands than Moore (the only anomaly in terms of international recognition through touring exhibits, where Moore generally preceded Hepworth). Unlike Read, Hodin appears to have acknowledged the significance of Hepworth's work as the resolution of what he identified as a basic conflict in modern art between two essentially different approaches: formalist and expressionist art. Hepworth's work carried for him a life-affirming monism, a reverence for life, which could answer what he identified as idealism in the face of crisis and which for him was a resolution of the dilemma of being modern: 'unless we glorify life's forms in their ultimate significance, unless we reconcile emotionalism and analytical cerebralism in line, colour and handwriting with the finality of life's formative processes, we shall not create an art which is congenial to the wholeness of life'.[48]

Hodin's approach, because of its sympathies with Constructivism, endorses Hepworth's position as stated in her interview in *The Studio* in 1946, of a passionate affirmation of life and ideas in her work and an indication of how closely her values coincided with post-war humanism and the idealism embodied in the United Nations:

> A constructive work is an embodiment of freedom itself and is unconsciously perceived even by those who are consciously against it. The desire to live is the strongest universal emotion, it springs from the depths of our unconscious sensibility — and the desire to give life is our most potent, constructive, conscious expression of this intuition.[49]

Hodin's criticism is a very useful counter-example to Read, for Hodin did not share Read's perceptions of Moore. Unlike Read's characterisation of her as 'Other' to a masculine 'norm', Hepworth becomes paradigmatic in Hodin's analysis. Nevertheless, his account tends to emphasise reading Hepworth as an 'idealist', or as Edwin Mullins calls her, 'an exultant optimist',[50] whereas Moore, by contrast, is positioned as a 'realist'. The difference is clear in Hodin's argument about the significance of Hepworth piercing through the stone in 1932:

> A new function of space was discovered and she explored its possibilities with unfailing enthusiasm. But she did not and does not now use concavities and holes in the same sense as Henry Moore. Hers is a classical, a static conception; his is basically organic, nature-bound, romantic. Whereas the hole in a work of Barbara Hepworth pierces straight through a figure, Moore is inclined to widen and to wind through it. In reducing mass, he often diminishes the figure to a shell covering, as it were, the most important message, the secret of within. Endless new aesthetic possibilities appeared to Barbara Hepworth of exploiting the music and the rhythm of lines created by light and shadow and by the boundaries where form and space meet.[51]

Hepworth's project is read as classical, static, seeking and attaining 'absolute beauty', whereas Moore is an expressive sculptor who expresses 'a biological formative will' in our technical age.[52] Hodin uses Moore's (often tautological) statements to support

this view of the man, for example: 'A real sculptor must be a man with the mental equipment of the sculptor', and: 'Purely abstract thinking is a matter of taste and design, it is not sculpture', and: 'I pierced an abstract geometrical form because I felt strongly its inadequacy. The hole might be a mouth, and the two points look like the small eyes of a skate; here the will to express the organic is manifest.'[53]

Hodin nevertheless establishes a different set of co-ordinates for reading Hepworth, one engaged in linking philosophy, science and society in a way that Read's reduction of Hepworth to a search for 'loveliness' and the 'feminine' cannot accommodate. As David Thistlewood has established concerning Read's modernist paradigm, 'the artist had to empathise (i) with subject-matter (whether phenomenal or noumenal), (ii) with the nature of materials (respecting their legitimating form), and (iii) with organic nature (permitting creative concepts to evolve naturally rather than constraining them with a false aesthetic)'.[54] In Hodin's critical assessment, on the other hand, the artist's quest for the 'meaning of the work of art' lay, as K. Mitchells has argued, 'in the framework of contemporary culture and ideology and its meaning as an artistically expressed philosophical statement about the mysteries of life and creation, as philosophy in paint, in stone, in tone, in rhythm'.[55]

Read's emphasis upon the artist's relationship and reactions to materials (manifest in Moore's statements above) can be contrasted with Hodin's emphasis upon the artist's necessary relationship to developments in European intellectual thought and philosophy. Read's writing emphasises that the function of art is determined by the use art has socially and politically to different societies, whereas in Hodin's account the artist's project is determined through insights which parallel developments in contemporary philosophy/literature/psychology as well as modern science and technology. Hodin was also critical of nationalism as the grounds for promoting or forming an understanding of any artist, which by my extension of his argument includes Read's framework for promoting Moore.[56]

Hepworth's reactions to nature and the relationship of sculpture, sculptor and landscape can be reread through this model in a way which avoids the stereotyping of her work as an 'eternal feminine' or closer to nature and begins to open up an examination of her philosophy and politics. This would enable a reading of Hepworth – against an assimilable femininity or 'woman' as complementary to the (male) dominant critical ethos – as marking women's entry into modernist discourse, thus introducing a destabilising subject position which cuts against the dominant ethos. It might also open up ways of reconceiving Hepworth's stress on the distinctive perspective of women's experience of the world – as a critique of philosophical, scientific and political 'truths' in abstraction and Constructivism. Perhaps it would allow us to re-emphasise her ideas as emerging from an embodied experience (mind in body) in terms of new models for physical sensations through abstraction and as parallels for human/political relationships. In *Barbara Hepworth: Carvings and Drawings* she wrote: 'From the sculptor's point of view one can either be the spectator of the object or the object itself. For a few years I became the object. I was the figure in the landscape and every sculpture contained to a greater or lesser degree the ever-changing forms and contours embodying my own response to a given position within the landscape.'[57]

Perhaps it may enable us to conceive of the movement she made from the string sculptures in the 1940s, where she identified the strings as 'the tension I felt between myself and the sea, the wind or the hill'[58] (herself as the object), to the work in the 1960s which she positions as a new exploration of her ideas from the 1930s, now she had the money, studio space and assistants to realise them.

> I find it easier now I'm more free to make forms and move them around. I don't feel so personally involved – I'm not exactly the sculpture in the landscape any more. I think of works as objects which rise out of the land or the sea, mysteriously. You can't make a sculpture without it being a thing – a creature, a figure, a fetish . . . It's something you experience through your senses, but it's also a life-giving, purposeful force.[59]

Edwin Mullins identifies this as a move from a bipartite formula, a 'fusion of "I" and object', to a tripartite formula, 'the "I", an object, a landscape', where 'The object is no longer mainly a projection of the "I" but possesses a mysterious life of its own – also for its maker. Its existence and that of the "I", producing the image–object, are two, and it presents a concrete presence *vis-à-vis* the third element, the landscape, as well. "I" returns to spiritual/ritualistic.'[60]

This move from the extreme internalisation and identification with woman as object in the 1940s could by the 1960s also be read as the change in women's experience of the world as 'becoming a subject', which is so central to redefining public/private distinctions in modernism. It might also help to make sense of the statement Hepworth made to Edwin Mullins: 'This is not an optical sensation: it's a matter of physical relationship',[61] in so far as it stresses an embodied concept of experience over visuality – another point of difference from the dominant readings of modernism.

## Notes

This essay is a revised and edited version of 'Barbara Hepworth and Her Critics', in David Thistlewood (ed.), *Barbara Hepworth Reconsidered* (Critical Forum Series, No. 3) (Liverpool, Tate Gallery, Liverpool and Liverpool University Press, 1996), pp. 75–93.

1   Mara S. Witzling, *Voicing Our Visions: Writings by Women Artists* (London, Women's Press, 1992), pp. 270–87 includes extracts from *A Pictorial Autobiography*, interviews in *The Studio* 132:645, October 1946, her statement for H. Read (ed.), *Unit One: The Modern Movement in English Architecture, Painting and Sculpture* (London, Cassell, 1934) and 'Greek Diary', in W. Kern (ed.), *J. P. Hodin: European Critic* (London, Cory, Adams and McKay, 1965) along with other short extracts. Susan A. Waller in her *Women Artists in the Modern Era: A Documentary History* (Metuchen, New Jersey, London, Scarecrow Press, 1991) reproduces extracts from *Barbara Hepworth: Carvings and Drawings* on pp. 339–50.

2   Michel Foucault, *The Archaeology of Knowledge* (London, Tavistock Press, 1985), pp. 31–71.

3   Barbara Buhler Lynes, 'The Language of Criticism: Its Effect on Georgia O'Keefe's Art in the 1920s', in Christopher Merrill and Ellen Bradbury (eds), *From the Faraway Nearby: Georgia O'Keefe as Icon* (USA, Addison Wesley, 1992); edited version, *Women's Art Magazine*, No. 51, March/April 1993, pp. 4–8.

4 See Leigh Gilmore, *Autobiographics: A Feminist Theory of Women's Self-Representation* (Ithaca, NY, Cornell University Press, 1994), especially chapter 2, pp. 65–86.

5 Hepworth, *A Pictorial Autobiography* (New York, Praeger, 1970).

6 *Ibid.*, p. 17.

7 See Reg Butler's remarks on 'frustrated maternity' (1962), quoted in R. Parker and G. Pollock, *Old Mistresses: Women, Art and Ideology* (London, Routledge and Kegan Paul, 1981), pp. 6–7. For the educational context, see K. Deepwell, 'A Fair Field and No Favour: Women Artists in Britain between the Wars', in S. Oldfield (ed.), *This Working-Day World: Women's Lives and Culture(s) in Britain, 1914–1945* (Brighton, Taylor and Francis, 1994), pp. 141–55.

8 Compare Bryan Robertson: 'There is an unspoken, undeclared conspiracy in most art circles against the idea of a woman artist, though this absurd and unfair attitude has changed considerably in recent years' (from the introduction to *Barbara Hepworth, 1952–1962* (London, Whitechapel Art Gallery exhibition catalogue, 1962), no pagination).

9 Letter from Hepworth to Nicholson, 31 May 1970, quoted by Penelope Curtis in P. Curtis and Alan Wilkinson, *Barbara Hepworth: A Retrospective* (Liverpool, Tate Gallery, Liverpool exhibition catalogue, 1994), p. 147.

10 Alan Bowness wrote the catalogue for her 1961 British Council exhibition, *Barbara Hepworth: Drawings from a Sculptor's Landscape* (London, Cory, Adams and McKay, 1966), and *The Complete Sculpture of Barbara Hepworth, 1960–1969* (London, Lund Humphries, 1971). Bryan Robertson wrote the catalogue essay for Hepworth's 1962 retrospective at the Whitechapel Art Gallery and reviewed her work in the *Spectator* (in 1967 and 1968) and the *Observer* (1964). Edwin Mullins reviewed her work several times in the *Sunday Telegraph*, wrote catalogue notes on her work for Coventry Cathedral's exhibition of British sculpture in 1968 and catalogues for her exhibitions at the City Art Gallery, Portsmouth and Hakone Open-Air Museum, Japan in 1970.

11 A quote from *A Pictorial Autobiography* reproduced in Witzling, *Voicing Our Visions*, p. 280.

12 *A Pictorial Autobiography*, p. 115. The poem she refers to is not reproduced.

13 The Tate Gallery, Liverpool exhibition (1994) was the first major retrospective since 1969. Although her studio was established as a museum after her death, the first set of critical essays on her work arose from the conference accompanying this exhibition.

14 D. Thistlewood, 'Herbert Read's Paradigm: A British Vision of Modernism', in B. Read and D. Thistlewood, *Herbert Read: A British Vision of World Art* (Leeds City Art Gallery/Henry Moore Foundation/Lund Humphries, 1993), p. 77.

15 *Ibid.*

16 H. Read, *Henry Moore: A Study of His Life and Work* (London, Thames and Hudson, 1965), p. 32; Donald Hall, *Henry Moore: The Life and Work of a Great Sculptor* (London, Gollancz, 1966), p. 41.

17 Hall, *Henry Moore*, p. 59.

18 Read, *Henry Moore* (1965), p. 32.

19 *Ibid.*, p. 83; Hall, *Henry Moore*, p. 106.

20 See J. P. Hodin, *Barbara Hepworth* (London, Lund Humphries, 1961).

21 See A. M. Hammacher, *Barbara Hepworth* (London, Zwemmer, 1959) and A. Wilkinson in Curtis and Wilkinson, *Barbara Hepworth*, pp. 31–78.

22 In Read's introduction to her 1966 exhibition at the Marlborough Gerson Gallery, New York in *A Pictorial Autobiography*, p. 104, Hepworth is praised as 'greatly honoured in her own country and her fame is now worldwide', but his choice of words makes clear that his own writing or value judgements about her work have not contributed to her acclaim.

23 H. Read, *A Letter to a Young Painter* (London, Thames and Hudson, 1962), pp. 120–7.

24 *Ibid.*, pp. 151–71.

25  D. Burstow, 'The Geometry of Fear: Herbert Read and British Modern Sculpture after the Second World War', in Read and Thistlewood, *Herbert Read: A British Vision of World Art*, p. 122.

26  *Ibid.*, p. 123.

27  Read, introduction to *Barbara Hepworth: Carvings and Drawings* (London, Lund Humphries, 1952), p. ix.

28  See Hepworth's comments '1949–1952' from *Barbara Hepworth: Carvings and Drawings* in Waller, *Women Artists in the Modern Era*, pp. 349–50.

29  *Ibid.*

30  K. Deepwell, 'A Fair Field and No Favour'.

31  J. M. Richards, 'Ben Nicholson at Lefevre: 7 & 5 at Zwemmer's', *Axis*, No. 4, November 1935, pp. 21 and 24.

32  E. H. McCormick, 'Frances Hodgkins: A Pictorial Biography', *Ascent*, Commemorative Issue, December 1969, p. 8.

33  Letter from B. Nicholson to W. Nicholson (7 March 1932, Tate Gallery Archive, exhibited in the Tate Gallery exhibition, London, 1993).

34  Barbara Hepworth, 'Sculpture', in J. L. Martin, B. Nicholson and N. Gabo (eds), *Circle* (London, Faber and Faber, 1937), p. 113.

35  E.g. Hammacher, *Barbara Hepworth*.

36  'Nothing could be more remote from humankind than these superbly cold, calm, faceless works in an abstract idiom. And again, we may remark the contrast with Moore, whose figures are saturated by human feeling and personality' (Patrick Heron, *Barbara Hepworth: Sculpture and Drawings* (Wakefield City Art Gallery catalogue, 1951), no pagination.

37  E.g. 'Living Art in England', *The London Gallery Bulletin*, January–February 1939 or Geoffrey Grigson, 'Comment on England', *Axis*, January 1935, pp. 9–10.

38  Martin, Nicholson and Gabo (eds), *Circle*; H. Read, *Unit One* (London, Cassell, 1934); 'Living Art in England'; *Abstraction–Creation*, No. 2, 1933 and No. 3, 1934.

39  Hugh Gordon Porteus, 'New Planets', *Axis*, No. 3, 1935, pp. 22–3. A very similar line is taken in Wyndham Lewis's review of Hepworth and Moore in the *Listener*, 17 October 1946, p. 506.

40  *Ibid.*, p. 22.

41  W. Gibson, 'Art – Two English Sculptors', *Britain Today*, 129, January 1947, pp. 30–1.

42  *Ibid.*, p. 30.

43  D. Lewis, 'Moore and Hepworth', *College of Art Journal*, Summer 1955, pp. 314–19.

44  *Ibid.*, 319.

45  *Ibid.*

46  Hodin's first essay on Moore was for *Pallaten* (Stockholm), 1947; *Henry Moore* (London, Zwemmer, 1956) (Modern Sculptor's series); *Henry Moore* (Buenos Aires, Carlos Hirsch, 1963).

47  J. P. Hodin, *The Dilemma of Being Modern: Essays on Art and Literature* (London, Routledge and Kegan Paul, 1956), p. 130.

48  *Ibid.*

49  Hepworth, 'Sculpture', in Martin, Nicholson and Gabo (eds), *Circle*, p. 116.

50  E. Mullins, *Barbara Hepworth* (British Council exhibition, 1970; Hakone Open-Air Museum, Japan), unpaginated.

51  Hodin, *The Dilemma of Being Modern*, p. 132.

52  *Ibid.*, p. 104.

53  *Ibid.*, pp. 104–5.

54 Thistlewood, 'Herbert Read's Paradigm', p. 77.

55 K. Mitchells, 'Art Criticism and Weltanschauung: The Cultural and Philosophical Background of J. P. Hodin's Writings', in W. Kern (ed.), *J. P. Hodin: European Critic* (London, Cory, Adams and McKay, 1965), p. 127.

56 Vladimir Vanek, 'J. P. Hodin: A Biographical Study', in Kern (ed.). *J. P. Hodin: European Critic*, pp. 103–4. Hodin is relatively neglected today, but he came to live in Britain in 1944. From 1949–54 he was Director of Studies and Librarian at the Institute of Contemporary Arts (ICA) and remained on the ICA board after 1954 while continuing his long career as a European-wide art critic (from the mid-1930s he was writing for and editing a large number of European art magazines).

57 *Barbara Hepworth: Carvings and Drawings*, quoted in Waller, *Women Artists in the Modern Era*, p. 19.

58 Bowness, *The Complete Sculpture of Barbara Hepworth, 1960–1969*, p. 14.

59 *Ibid.* 'I am always concerned with the human relationship', i.e. physical relationships of human scale: 'All my life through I've wanted to put a form on a form on a form as an offering' (*ibid.*, p. 13).

60 E. Mullins, introduction to *Barbara Hepworth: Family of Man: Recent Carvings*, Marlborough Fine Art, April–May 1972, p. 9.

61 Mullins, *Barbara Hepworth*.

# Cornubia:[1] gender, geography and genealogy in St Ives modernism

The 1985 Tate Gallery exhibition *St Ives 1939–64: Twenty-five Years of Painting, Sculpture and Pottery* claimed to be the first survey by a major museum of the St Ives School.[2] Although it celebrated English modernism of the 1940s and 1950s, it was staged curiously at a time when postmodernism, premised on a reaction against or rejection of modernism, was gaining both artistic and cultural dominance. The exhibition and catalogue became a canonising event and document about modernism in the southwestern region of Cornwall. It mapped the St Ives School in terms of a temporal span, geographic location and a list of significant artists, and also increased both academic and popular interest in the art produced there.[3] The narrative offered in the catalogue and the discourse established there have been frequently quoted and uncritically replicated since the exhibition.

This essay offers a partial archaeology of the criteria, assumptions, intentions and sources which inform the representation of women in the catalogue. What were the operative strategies which restricted the coverage of women practitioners belonging to the St Ives group? While considerable attention was given to Barbara Hepworth in the exhibition, the other women artists who were included were discussed in restricted terms and a minimal number of illustrations of their work reproduced. Artists who were married to famous male artists were cast mainly in their roles as 'wives of', such as Margaret Mellis and Miriam Gabo, or else as sources of information about their male colleagues. At best when their art was discussed it was largely in terms of their role as disciples and followers of their friends, partners and husbands, depriving these women's work of any independent expressive focus or its own logic and evolution. Nowhere in the catalogue was a woman artist given the position of an innovator or of having influenced her male counterparts. Among the 59 colour plates, only 1 of Wilhelmina Barns-Graham's and 1 of Mary Jewels's works were reproduced,[4] compared to 12 works by Nicholson, 9 by Hepworth, 6 by Alfred Wallis and 4 illustrations each by Gabo, Lanyon, Hilton and Heron. Omitted from the catalogue were reproductions of works of artists like Winifred Nicholson and Marlow Moss, to name but two. The information for a critique of the catalogue was derived mainly from the correspondence between Winifred and Ben Nicholson; David Lewis's interviews with Wilhelmina Barns-Graham and Margaret Mellis,[5] as well as his letters; and my own interviews and conversations mostly with the artists Wilhelmina Barns-Graham and Margaret Mellis as well as with Rowan James and David Brown from summer 1995 to February 1997.

From the moment of its inception to its realisation the exhibition and its catalogue proved to be an all-male project.[6] Lewis recalled that 'The origin of the idea to hold an exhibition of what we came to refer to as the "middle"[7] generation of St Ives artists, active roughly between 1946–1966, was a dinner table conversation between me and Patrick Heron at Eagle's Nest in the late seventies . . . At Patrick's urging I promised to see whether my friend Leon Arkus, the then Director of the Carnegie Museum of Art in Pittsburgh, would have any interest in such an exhibition. The artists I proposed were Peter Lanyon, Patrick Heron, Bryan Wynter, W. Barns-Graham, Terry Frost, John Wells, and Roger Hilton. Leon . . . suggested three (Lanyon, Heron, and Hilton) plus William Scott . . . I resisted strongly and stuck with my list. I should add . . . that Patrick Heron urged me to drop Barns-Graham but I felt that she had as central a role as any of the others and should be included.'[8] The original idea underwent changes, reschedules and delays, until it was finally taken up by Alan Bowness.[9] Bowness insisted that the exhibition include Ben Nicholson, Barbara Hepworth and Naum Gabo, 'because they had established the "setting" in which the younger artists were working'.[10] Bowness, indeed, had the interest and authority to add 'power' to Lewis's initial efforts.[11]

Lewis, who wrote the main essay in the catalogue, and Bowness, who took on the project, had personal involvement with artists included in the exhibition: Bowness is married to Sarah, one of Hepworth and Nicholson's children while Lewis was married to Wilhelmina Barns-Graham from 1949 to 1963.[12] Thus, by virtue of their social and marital relationships, Bowness's and Lewis's contributions to the catalogue are those of insiders of, and participants in, the social group they are concurrently informants of and whose history they were constructing.[13] Therefore, despite their claim to position St Ives on the map of cosmopolitan modernism within a cultural genealogy, their authorial voice is not free from personal interest. This in turn is especially implicated in how women artists were treated in the hindsight historicising of the group because of familial allegiances, a patriarchal form of what is in effect the writing of biological genealogies.[14]

David Brown, the appointed curator of the exhibition, resisted the narrow definition of 'major figures'[15] by writing a chronology of the St Ives artists' colony as a whole for the catalogue and by insisting on the inclusion of potters (Leach) and cabinet-makers (the Nance brothers),[16] and most significantly by including women artists other than Hepworth. Thus, the catalogue contains the unresolved and conflicting narratives which are evident in the contradictions between the title's commitment to the years 1939–64 and to St Ives and the time-span covered in each of its sections. Each contributor within it considered a different grouping of artists and different time-spans: for example, Lewis locates his own experience of St Ives between 1947 and 1955, as opposed to his originally intended view of the period from 1935 to 1975.[17] The chronology spans the years 1811–1975 and the catalogue's list of works section[18] includes works from 1926 (Wood) to 1975 (Hilton).[19] Most of these determining dates are not intrinsic artistic markers. An alternative set of dates which would highlight modernism in a broader context of the 'art world' would include, for example, 1927, the founding of the St Ives Society of Artists (SISA); 1945, when SISA

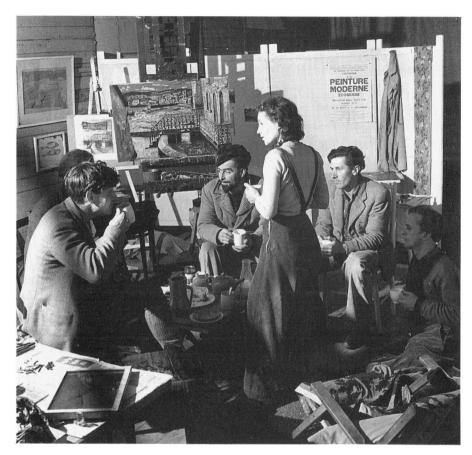

23   The Crypt Group in Wilhelmina Barns-Graham's studio, 1947. From left to right: Peter Lanyon, Bryan Wynter, Sven Bertin, Wilhelmina Barns-Graham, John Wells and Guido Morris

acquired the deconsecrated Mariner church as an exhibition venue; 1946, when the Crypt, the first modernist group *in* St Ives, was founded (see Figure 23); or 1949, when a group of artists resigned from SISA and reorganised themselves into The Penwith Society.[20] The catalogue does not consider patterns of social spaces or interactions to map out spatial axes of interaction. Nor does it outline those 'social spaces', subsumed under Bourdieu's concept, where various 'networks' mark and structure both art politics and stylistic exchanges.[21]

The catalogue emphasised periodisation, especially before, during and after 'the war years', establishing a sequence of three generations, identified and measured in constant relation to Nicholson, Hepworth and Gabo. Gabo's arrival in Carbis Bay was articulated in mythologising terms and was also incorporated as a part of the cosmopolitan macro-migration. Alan Bowness embedded this British migration into the general pattern of modernism, isolating the fate of the avant-garde from the broader social realities of war, when he wrote that 'of the smaller abstract avant-garde of the 1930s, a substantial proportion ended up in St Ives'.[22] This meta-narrative is the back-

drop against which the exhibition narrows its attention towards a handful of British artists and presents the modernist project as an autonomous event, even within the context of mass destruction. Highlighted in the catalogue's title and text are key biographical events in the lives of those considered to be 'major' artists: for example, August 1928, when the over-mythologised 'discovery' of Alfred Wallis by Ben Nicholson and Christopher Wood occurred; 1939, the year in which the Constructivists fled London to St Ives; or 1975, the year of the deaths of Bryan Wynter (11 February), Roger Hilton (23 February) and Barbara Hepworth (20 May).

The town of St Ives is verbally and visually represented by the large number of documentary photographs and maps included in the catalogue, and the town in turn lends significance to those artists living and working there. Cornish-born artists like Peter Lanyon were singled out for extreme privileging. St Ives thus connotes a variety of meanings. It is invoked as a *locus genii*, a quintessential artistic location, with the additional quality of being primordial, and is also imbued with special climatic and extraordinary visual qualities. It is cast both as an ideal location for artistic activities and as a place of symbolic evocation. It is in this last meaning that we can understand the appropriation of the name of St Ives for the activities of the Constructivists at Carbis Bay. They were both geographically and stylistically apart from St Ives, and rather than consisting of three 'major figures' they were three couples, six artists: Stokes–Mellis, Nicholson–Hepworth and Miriam and Naum Gabo. The last two couples arrived as evacuees from London and were invited as guests by Adrian Stokes to his and Margaret Mellis's new house, Little Park Owles, in Carbis Bay.[23] The question remains, what was being mapped by the name? Or, as Elliott and Wallace put it, 'what do the differences between (and within) various maps reveal about cultural production . . . ?'[24] By the double privileging of the Constructivists, and coupling them with St Ives, a misleading representation of events was being constructed, because their artistic involvement *in* the town of St Ives began only in 1943.[25] Throughout their years at Carbis Bay and in line with their prior and common interests in Hampstead, especially their collaboration in *Circle*,[26] this group defined itself as 'advanced', in clear self-differentiation from the 'traditionalists' – the academic painters in St Ives. The notion of two different centres of activity was regularly stressed by Mellis and Barns-Graham in my interviews with them. In effect these three couples established Carbis Bay as a 'salon des réfugies', but as Mellis wrote, with a shrewd plan to take over St Ives's enviable exhibiting space.[27] The bracketing of St Ives with the modernists was an appropriation, even colonisation, of the place's prior reputation.[28]

The representation of modernism in St Ives as centred in the work of the Constructivists is inaccurate, on historic, geographic and stylistic grounds. Carbis Bay and St Ives are two separate locations, with different stylistic practices in each at different times, which did sometimes, especially initially during a period when exhibition groupings emerged, exchange influences, and indeed splinter. Stylistically modernism in these two locations consisted of three distinct artistic circles with the following properties: Constructivists at Carbis Bay; Academicians at St Ives; and after 1946 modernism, especially abstractionists, at St Ives. In this respect, Barns-Graham

recalled that after her initial brief stay at Little Park Owles in March 1940 when she found accommodation and a studio in St Ives and joined SISA, the Stokeses teased her for her association with the Royal Academicians.[29] Even after they joined SISA in 1943, Hepworth and Nicholson remained living and working in Chy-an-Kerris, located at the far end of Carbis Bay. Following their example, the rest of the Carbis Bay group also exhibited with SISA, except for Naum Gabo, who was the only Constructivist never to join it. Miriam Gabo (née Israels) and Margaret Mellis (Mrs Stokes) used their maiden names in SISA exhibitions. In 1946, after the departure of the Gabos and the break-up of the Stokes's marriage, Hepworth and Nicholson regrouped as the new active unit in Carbis Bay. When their marriage failed in 1949, they moved separately to St Ives.[30] The founding of the Penwith Society of Artists in 1949 was, in effect, a merger of the Carbis Bay representatives with the first St Ives modernist group, The Crypt, alongside other dissident SISA artists. Naming the society after the Penwith region served not only to differentiate the avant-garde from SISA, but at the same time reflected with greater accuracy the social space of artistic activity among the various founder-members.

Two omissions in the 'Before 1939' subsection of the catalogue[31] are those of Winifred Nicholson and of Mary Jewels. Winifred features in the catalogue in Ben Nicholson's biographical data, as his first wife (1920–32),[32] but what is omitted is any discussion of her own artistic output or, indeed, her companionship and influence on his early figurative and abstract art. Furthermore, her presence in and around St Ives together with Ben and Christopher Wood during the famous 1928 visit, and independently in 1932, after her marriage break-up, are not deemed important enough to warrant her inclusion in the exhibition. She is represented only once in the catalogue as the subject of a work by Wood in St Ives in 1928.[33] Why was she excluded despite Ben's acknowledgement of her influence on his art?[34] Was it because, cast in the position of a follower, or just as his first spouse, she was 'safe'; otherwise she might have represented direct competition with Hepworth?

If avant-garde self-identity is reflected in a masculinist project of defining self against the Other, the Others in the case of St Ives were not just women but also 'primitive' self-taught artists. Alfred Wallis, in the catalogue, stands as a sign for untutored, 'unspoiled' expression, and functions as a double trope of 'primitivism'.[35] His lower-class status and previous occupation as a mariner embodied for these artists a set of primordial qualities which the peninsula signified in the modernist imagination. By contrast, the Cornish-born artist Mary Jewels, who was self-taught and defined as a 'naive' painter, has attracted little critical attention.[36] While their artistic impetus had some parallels, there were significant differences between Wallis and Jewels. Jewels was born and lived in Newlyn, where she met many artists through her brother-in-law, the sculptor Frank Dobson. In 1918, as a young widow, she was encouraged by Cedric Morris to start painting. During and after the war years Ben Nicholson frequently visited her and expressed his appreciation of her art.[37] But in contrast to his appreciation of Wallis, in Jewels's case these connections were put forward to argue against her as an untutored primitive artist, while Wallis's 'primitive status', in connection with his gender, class and previous profession, proved extremely

useful as a 'magnificent exception' to his gender. Wallis's model is a gendered inversion of the model of 'magnificent exception' which usually applies to explain instances of gifted women. Despite the fact that the term 'primitive' implies both patronising and unequal power relationships which are generally seen culturally as 'natural' to women and to which in this instance Wallis was subjected,[38] Jewels was instead defined as a 'naive' artist. She is identified as civilised, for as photographs of her indicate, Jewels was a stylish woman,[39] but without having attained a high degree of sophistication. To Wallis's ennobled primitive she is the undeveloped naive woman.

The specific conditions of production for women artists need to be inserted into the broader political mapping of modernism in Penwith. Mellis's and Barns-Graham's art was marginalised and fixed as being that of eternal disciples, unlike John Wells or Peter Lanyon (both from Newlyn), who were allowed to graduate from followers to masters. In addition, they were excluded from belonging to any generational group in the construction of modernism in the region. Their age was constantly at odds with the formula imposed on the narrative. While they were too young in relation to the first generation, they were also excluded from the pivotal role of the second generation *because* of their association with the first generation.

Hepworth is the only woman to be attributed a central creative role in *St Ives 1939–64* and remains an undisputed pivotal artist in the construction of the St Ives group although, like many other avant-garde groups, the St Ives School is constructed from a masculine perspective.[40] Thirty-nine of her works were included in the catalogue, second only to the forty works of Ben Nicholson. The category of 'major figure', apart from outlining a hierarchical division of a core group alongside lesser artists, also covers over a gendered division, whereby the overt division of claimed excellence overlaps a covert gendered division. Hepworth's success has served as tokenism, whereby an illusion of equality was created and supported by the erroneous impression of having given adequate representation to women artists. Women practitioners who were friends, colleagues and co-founders of modernism, like Mellis and Barns-Graham, feature in the catalogue as artists, but mainly in the role of informants, whereby they are cast as disciples to the 'major (male) figures', while their artworks still await basic collation, documentation and critical appraisal. Hepworth's acclaim has situated her differently and in opposition both to her male colleagues and to other women artists.[41] Gabo's and Ben Nicholson's seniority over Hepworth in age did not affect her reputation in the way that her own seniority over Mellis and Barns-Graham (of twelve and nine years, respectively) affected them. Another significant variant was the often uneasy relationship between Hepworth and other women painters. In the words of Douglas Hall, she has claimed for herself the position of 'one undisputed Queen' in St Ives,[42] despite Hepworth's pronouncement that 'we women must stick together'.[43]

Throughout the catalogue Margaret Mellis features mainly in such roles as wife, hostess and disciple during the 1940s and as an informant about other artists ever since, despite her own adherence to abstract art since 1940 and her constant, rich and varied creativity.[44] The questions asked of her during the St Ives interviews were

clearly defined as seeking information about other practitioners and events, and she was invariably interrupted whenever she attempted to speak about her own art or Nicholson's interest in it, or, indeed, the fact that he found her work inspirational at times.[45] In my conversations with her Mellis has stressed her delight in and commitment to exploring the possibilities of abstraction and collage. These she continued to make even during difficult domestic circumstances such as presented themselves in 1939.[46] Then, as a young bride, she was still negotiating her new marital status when she also had to host the influx of guests/evacuees at Little Park Owles.[47] But despite having to give up her own studio she recalls these days as exciting and creative times, even though she made her temporary studio in any space available, mostly in the corridors.[48] If Mellis's information digressed from the interviewers' preconceived ideas, she was either interrupted or ignored, while the questions put to her were principally about other artists.[49] Melis's description of outings to draw with Ben Nicholson and Adrian Stokes indicates the impatience and disregard of these two men for her own creative needs.[50]

Mellis and Barns-Graham were active in the right place and time to be included in accounts of British modernism; and yet they have been subjected to multiple marginalisations: for their gender, for their age, for adhering to abstract painting, and finally also for working in close proximity to Hepworth. While Hepworth's work-ethic was an inspirational model for Wilhelmina Barns-Graham, neither she nor Mellis derived any artistic inspiration from her in contrast to the initial impact Ben Nicholson and Gabo had. Mellis was initiated to collage-making because of Nicholson's insistence.[51] His active promotion of abstraction was balanced by Gabo's tacit example, which Mellis and Barns-Graham claim had the greatest impact on their art. Mellis's adoption of abstraction in 1940 places her among her peers at Carbis Bay, and the 'advanced' style of Barns-Graham made her 'one of the boys' among the modernists at St Ives, in spite of the fact that these practices decreased their immediate income from selling their paintings.[52] In 1936, when Margaret Mellis met Stokes in Paris, she was already preoccupied with the expressive role of colour. Stokes, who had just written *Colour and Form*,[53] where he argued for the equal and mutual importance of colour alongside form, was for her a welcome change from the then overstressed concept of 'significant form'. In Paris she studied the works of Cézanne, Matisse and Bonnard carefully for that reason. Stokes's theories framed the very issues she had been exploring in her paintings, namely the expressive qualities of colour, free from subordination to form: Stokes's terms 'carving' and 'modelling' were conceptual enablers. Even now in the 1990s she still analyses art by referring to these two terms as qualifying terms for artistic cohesiveness. By 'carving' she understands a mode of working in which the colours and forms resonate beyond the frame and enliven the space around it, a concept Patrick Heron has, she believes, also appropriated and made use of in his paintings.[54] While her expressive aims found a theoretical framework in Stokes's ideas, her abstract collages soon became her own form of interpretation, related to ideas found in Nicholson's abstractions. Despite having seen abstract and Cubist art in Paris, she only began making abstract collages at Nicholson's prompting, but merged these with her own exploration of colour in a configuration

of coloured geometric collages. Two of these early constructions were exhibited in 1985, their catalogue entries supported mainly by the artist's own comment, which sadly consisted mainly of the works' provenance. Beyond this, there has been no fuller appraisal of Mellis's work. In the St Ives catalogue, because of her own claim of Stokes's and Nicholson's influence on her, her artistic output was marginalised as only that of a disciple, and thus her main role is to enhance the masters' significance. In her statement accompanying *Collage with Red Triangle II*, 1940 (Figure 24), she identifies it as the eleventh collage and her first true *Constructivist* work.[55] Its composition consists of interlocking and overlapping coloured geometric shapes on a grey back-

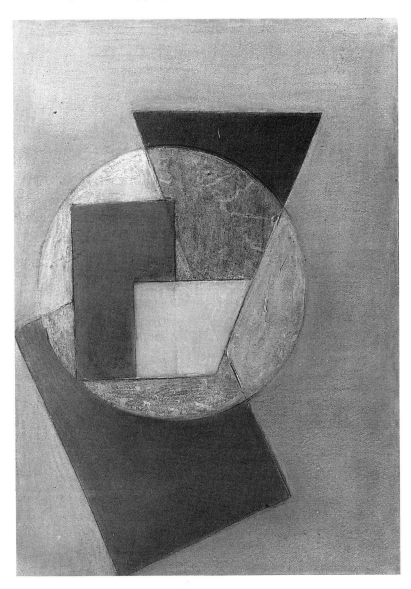

24    Margaret Mellis, *Collage with Red Triangle II*, 1940, 22.2cm × 16.2cm

25    Margaret Mellis, *Pandora's Box*, 1992, construction, 25cm × 34cm × 36cm

ground, with the uppermost part of the red triangle at the top left-hand side being the most saturated colour and balanced by a green-tinted rectangle in the bottom left-hand corner of the collage. All the shapes gravitate towards the chalk-coloured central circle which in turn modifies their colours into tints wherever they overlap the circle, which contains the trapezoid shape, and is whitest. The use of chalk and thin paper in the collage give it a fragile, ephemeral quality, supported by the sensitive colour harmony. Similar explorations of colour, time, space and fragility recur in her later work; for example, in a series of dying flowers, in flower drawings on inner opened-up surfaces of envelopes, and most expressively in her recent relief constructions. Since 1978 she has been nailing and screwing together driftwood, usually coloured planks of wood from defunct and rotten boats, which she reassembles into large, sculptural collage-like objects (Figure 25).

Mellis and Barns-Graham were each pivotal to wartime modernism in West Penwith. Both enjoyed immediate contemporary recognition and have exhibited extensively since, but not in the context of the so-called 'St Ives School'. Both won major awards when students at Edinburgh College of Art, including travel scholarships with which they travelled mainly to Paris and other parts of France during the mid-1930s.[56] In 1942, Mellis's work was selected by Nicholson for the exhibition *New Movements in Art: Contemporary Work in England*, held at the Museum of London. Now her work is in various British public collections such as the Tate Gallery, the Scottish National Gallery of Modern Art, Edinburgh and the Victoria and Albert Museum, London.

For Barns-Graham the late 1940s and 1950s were a time of recognition, in which her art attained national and international attention. She exhibited abroad in four British Council exhibitions between 1951 and 1960 and her work is included in

many public and private collections.[57] Now, at the time of writing (1997), both artists are in their eighties and are as dedicated to abstraction and to a regular and rigid regime of daily working, with much welcome, if disruptive, administration in planning and preparing for further exhibitions. Both artists consider their Scottish identity as central, and it is in their native Scotland that they have gradually gained recognition. Mellis, for one, wishes to be recognised and remembered as a Scottish artist, while for Barns-Graham the seduction of the colours and images of Penwith is the greater because of their resemblance to Scottish landscape colours and light qualities. Both artists' critical recognition, however, suffered after their marital break-ups.

In March 1940, Wilhelmina Barns-Graham made St Ives her home, the only woman of the group to arrive unaccompanied. To date she is the only artist of the early modernist group who still lives and works there, and she has the longest association with the town.[58] The Tate St Ives, which professes to adhere to 'the modernist art made in St Ives, or by artists associated with the town . . . from the 1920s onwards',[59] has rarely shown her work. Making St Ives her home and creative environment was for Barns-Graham a bid for freedom, freedom to dedicate her energies to her art, away from disapproving familial pressures. She postulates several reasons for her exclusion: her initial self-imposed position as a 'lone wolf'; belonging to the gentry, as manifested in her double-barrelled name; her age as well as her Scottish descent. An extreme example for the last argument is associated with her house in St Andrews, Balmungo, which was bequeathed to her in 1960, and where she spends some three months every year. This has regularly been cited in claims that she no longer lives in or, indeed, belongs to the artistic community of St Ives.

In the St Ives 1939–64 catalogue, David Lewis's 'Memoir' is largely based on his intimate friendship with Lanyon, Wells, Nicholson and Hepworth. Barns-Graham does not appear in this context. The omission of Barns-Graham possibly indicates an uneasy attempt to negotiate between a subjective account and an intimate disclosure of a personal nature.[60] Yet Lewis, who arrived in Bosporthennis in 1947, when Adrian Stokes, Margaret Mellis and Naum and Miriam Gabo had already departed, did feature those two couples extensively in his 'subjective' narration.[61] On the whole, Lewis's authorial voice oscillates between two perspectives, each belonging to a different genre, one personal, anecdotal, and the other that of an art critic and historian, pertaining to factual objectivity, especially when he attempts to evaluate well-known artists.

Barns-Graham features in Lewis's 'Memoir' in three short and dispersed sections, rendering the narration one of brief and discontinuous episodes: their first encounter, their wedding in Scotland, where Lanyon was best man, and just one paragraph discussing her art.[62] He recalled his surprise when he first met the artist 'Willie' in 1948: 'At the time she was painting a series of street scenes of houses with steps and balustrades, and she was known as W. Balustrade Graham . . . I was surprised to find that "Balustrade" was not a man but a woman, and a beautiful woman at that . . .'.[63] Inadvertently, he insulted both her professional and personal reputation, by obliterating her surname and concurrently dismissing her artistic practice. By this

identification he undermines her recognition as an artist and positions her instead as only an object of pleasure for the male gaze. This objectification is reinforced by the two accompanying photographs – one on Porthmeor beach with David Lewis, another in which she is standing in her studio – which are in stark contrast to the photograph of Gabo working in his studio on the facing page.[64] Lewis positions women, artists or otherwise, according to their desirability, as objects to be looked at. Barns-Graham, like Hepworth, is referred to in terms of feminine appearance[65] rather than as a *producer* of images. He similarly recalls 'a sunbronzed goddess of a waitress called Mary'.[66] Thus, Barns-Graham is positioned in between Hepworth, who has also been discussed for her artistic merit, and the other extreme of Mary, whose sole identity was reduced to her appearance. In discussing Barns-Graham he imposes a masculine gaze which ought to be directed at her art.

Lewis's bias limits any in-depth consideration of the work of Barns-Graham. As opposed to Lewis's denigration of her 'Balustrade' series, these works need to be considered as a comment relating to the economic and societal reality of wartime St Ives. In these Barns-Graham inscribes her visual and emotional awareness of the transformations of the townscape caused by the war, which forced the tearing down of iron balustrades and thereby a change in the appearance of the town. War and its aftermath is a recurrent theme in Barns-Graham's paintings, as in *Box Factory Fire*, 1948, and *Sleeping Town*, 1948, and more recently *Bosnia*, 1993. Lewis wrote during the 1980s in high modernist language, which owes much to Clement Greenberg's American formulation of modernism,[67] of how 'she freed herself from literal figuration, and began a series of abstract compositions'.[68] Furthermore, in 1985 Lewis repeated his initial acclaim for Barns-Graham's Swiss glacier series of 1948–52 (Figure 26), and reduces her total *œuvre* to this one example. In addition his reading of the series' meaning as a signifier of St Ives neatly accommodates and locates the paintings within both his own biography and the aspirations of the exhibition.[69] Ironically the town was discussed as the principal referent for Barns-Graham's art when she was painting Grindelwald, Switzerland! Here, an irreconcilable tension emerges between the cosmopolitan aspiration of the catalogue and its nationalism, which are mapped over a gendered differentiation and consistently operate in a detrimental fashion for women artists. Another instance where such gendered evaluation is evident is in the implicit language of metaphors used when describing landscape paintings.[70] The artist herself wrote about the glacier series in terms of 'solid rough edges' and of definite shapes, strength and monumentality which she then translated into an 'all round' presence, to communicate her own 'total experience'.[71] The language in which she describes the control of abstract ideas over her own experience and its formulation in art is similar to that in which the authors of the catalogue write about the landscapes of Ben Nicholson.[72] Yet another possible reading of the glaciers can be teased out by considering that during her visit to Grindelwald, Barns-Graham was deciding whether to commit herself to marriage – a difficult decision to make, given her fear of losing her hard-won freedom. The emotional ambiguity of seduction and fear are projected on to and expressed in her glacier series, which makes them representations of a state of mind, in both personal and generalised modes.

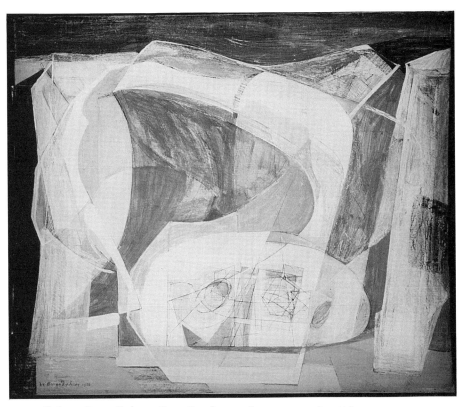

26    Wilhelmina Barns-Graham, *Glacier Crystal*, 1950, oil on canvas, 50.8cm × 61cm

During my interviews with Barns-Graham I have observed a double-speak in her discussion and evaluation of art. On the one hand, in a more formal 'interviewed' mode of discussion, she considers art in terms of formal analysis: of weights, balances, rhythms and various divisions, of cold–warm colours or of a mathematical ratio as a compositional device. On the other hand, she claims to have painted her first abstract in childhood, where a saturated outline enclosed oblongs and other forms, which are filled in by other contrasting colours. As a girl she thought of these as secret rooms, known to nobody but herself. In an analogous way, her mature abstracts also contain secretive content. Her shying away from 'decoding' their meaning might be due to her preference for being a 'lone wolf', compounded by a self-protective strategy. It is evident that her abstractions derive from figurative or narrative sources because of her claim that she paints in two modes, abstractions and abstract, as well as from her occasional (especially informal) conversations about their content and meaning. Barns-Graham persistently rejects being categorised in any way, especially as a 'woman painter', and is therefore particularly suspicious of 'feminist interpretation'. She delights in the gender ambiguity of her nickname 'Willie' as much as she prides herself on having been 'one of the boys' in the Crypt Group. Although she has not expressed it in an explicit way, it seems to me that adhering to abstraction was yet another way to evade gender categorisation. To a great extent, abstraction enabled her and other

27    Wilhelmina Barns-Graham, *Eight Lines Porthmeor*, 1986, chalk on paper

women artists to paint in a manner free from traditionally prescribed and culturally specified feminine grace.

Fire, light and water, in their many guises and transformative qualities, are recurrent themes in Barns-Graham's paintings. The representation of water has proved an ideal subject for her, poised between abstract and abstraction, in her 'Eight Lines' series (1975 onwards) (e.g. Figure 27). Two contrasting movements are in operation: one across the page, along the wavy lines, and the other – a conceptual movement – which guides the eye in and out of the illusionary depth. The duality of abstraction and abstract is also contained in the depiction's title. 'Eight Lines' is an abstract title, but in conversation with her she identified it, as indeed she sometimes does in subtitles, to be Porthmeor. Nothing in its depiction is of any identifiable landmark of the beach. It lacks any identifying topographical depiction, but is a generalised view of any sea, ocean or lake, as seen by a swimmer submerged in the water with her back turned away from the town.[73]

I have tried to show how valorising categories of place, time and practice were pivotal for the enhancement and amplification of men practitioners, even to the extent of distorting facts in order to accommodate particular narratives in the catalogue, while the same categories failed to operate on the same level for women practitioners. Much of the extensive information provided by the artists was either ignored or used in a predetermined and foreclosed fashion. The women artists mentioned were positioned in a hierarchical order, outside of and parallel to their male colleagues, a situation which totally obliterated the artistic identities of Winifred Nicholson and Marlow Moss. Marlow Moss, a founder-member of the Abstraction–Creation group in Paris in 1931, featured regularly in the group's publications. Already in 1932, the very first *Cahier*, her work was included with two illustrations, the same number as allocated to Gabo, Mondrian, Pevsner and Schwitters.[74] But despite her presence in Penwith,

and her exhibiting with the Penwith Society, she is excluded from the *St Ives 1939–64* catalogue, though like Gabo, she was an abstract practitioner with prior established connections outside England. Others were subjected to various forms of gendered marginalisation as in the cases of Mary Jewels, Mellis and Barns-Graham – all of whom were measured against the most successful woman artist – Barbara Hepworth, who in spite of her position, was not treated as equal to the men. The treatment of the women artists who were included was restricted to the role of familial supporters, of which being an informant was an integral part. The footnotes are dense with references to these women, quoting their letters, diaries and interviews, but they are hardly visible in the main body of the catalogue, which is reserved as the central stage for male artists. By revisiting the texts which were used as sources of information for the catalogue I have observed not only the degree to which their statements have been overlooked, but also the lack of interviewing discipline of the kind required in sociological research. There we see an account made of the methods employed in the collation of information and an awareness of the power relationship between interviewer and interviewee,[75] as well as a declaration of the informants' position and allegiances, a self-reflexive discipline which is absent from interviewing methodology in the history of art. The familial connections acount in part for the retrospective construction of reputations and histories which have marginalised women. The male relatives and ex-husbands of Mellis, Barns-Graham and Hepworth were in a position of power to include or exclude them from their own implicit dynastic genealogy. This is a form of biological essentialism which reduces women to the role of corporeal biological procreations, an argument which has been used for their marginalisation but this idea is here abstracted and in operation in these patriarchal dynastic patterns. Cultural stereotypes gloss over the overt masculine biological configuration of claims for a dynasty in St Ives. Paradoxically this dynastic impetus seems to be based on a tacit assumption that the women artists disappear amidst their (informative) presence.

## Notes

1   Cornubia, the Latin name of Cornwall, is the title of Mary Jewels's painting of *c.* 1940–50.

2   *St Ives 1939–64: Twenty-five Years of Painting, Sculpture and Pottery* (London, Tate Gallery exhibition catalogue, 13 February–14 April 1985). Earlier surveys: Denys val Baker, *Britain's Art Colony by the Sea* (London, George Ronald, 1958); David Brown, *Painting in Cornwall 1945–55* (London, New Arts Centre, 1977); Peter Davies, *The St Ives Years: Essays on the Growth of an Artistic Phenomenon* (Wimborne, The Wimborne Bookshop, 1984).

3   Thirty-eight thousand visitors saw the exhibition, and its catalogue has become a collectors' item; see Janet Axten, *Gasworks to Gallery: The Story of Tate St Ives* (St Ives, Janet Axten and Colin Orchard, 1995), p. 37.

4   Mary Jewels's *Cornish Landscape, c.* 1940–50 (*St Ives 1939–64*, p. 52), and W. Barns-Graham, *Island Sheds, St Ives, No. 1*, 1940 (p. 72).

5   A. Nicholson, *Unknown Colour: Paintings, Letters, Writings by Winifred Nicholson* (London, Faber, 1987). Interviews by Sarah Fox-Pitt and David Lewis with Barns-Graham (14 April 1981), Tate Gallery Archive, TAV250AB; and Mellis (31 May 1981), Tate Gallery Archive, TAV272AB.

6   All Brown's assistants were women except for one man. Ann Jones researched and compiled the catalogue entries; Caroline Odgers supervised the planning of the exhibition and catalogue. Sarah Fox-Pitt interviewed artists.

7   According to Mellis, 'middle generation' was coined by V. Waddington (6 February 1997).

8   Letter to author, 1 December 1996; also Axten, *Gasworks to Gallery*, pp. 33–7. Lewis also wrote about the dispute over Barns-Graham's role in a letter to Axten, 16 March 1994, p. 4.

9   The Director of the Tate Gallery 1980–88.

10  Letter to the author, 1 December 1996.

11  Lewis to Axten, 16 March 1994, p. 4.

12  D. Lewis, 'St Ives: A Personal Memoir 1947–1955', in *St Ives 1939–64*, pp. 13–41.

13  The terms are used in their sociological meaning where methods of reporting and interviewing are considered in various alignments of power relationship, namely the positioning of an informant in relation to the topic at hand, to identify interests, slants of bias, and the advantages and restrictive aspects of the informant's position. For feminist methodological discussions see Mary M. Fonow and Judith A. Cook (eds), *Beyond Methodology: Feminist Scholarship and Lived Research* (Bloomington and Indianapolis, Indiana University Press, 1991), pp. 1–15; also Mary Maynard and June Purvis (eds), *Researching Women's Lives from a Feminist Perspective* (Basingstoke, Taylor and Francis, 1994).

14  For feminist analysis of patriarchal genealogy see Luce Irigaray, *Sexes and Genealogies* ([1987] trans. G. C. Gill, Columbia University Press, New York, 1993), pp. v–vii, 1–5, 161, 172–6, 185–206.

15  This term was used by Bowness when he wrote about Peter Lanyon as 'perhaps the most gifted of the second generation of St Ives artists', in *St Ives 1939–64*, p. 7.

16  See O. Watson in *St Ives 1939–64*, pp. 220–41. Brown also included the embroiderer Alice Moore. Interview, 12 November 1996, London.

17  As expressed in his title of TAV272AB.

18  *St Ives 1939–64*, pp. 148–219.

19  *Ibid.*

20  The dates are derived from the catalogue's chronology (pp. 97–114).

21  Pierre Bourdieu, *The Rules of Art: Genesis and Structure of the Literary Field* ([1992] trans. Susan Emanuel, Cambridge, Polity Press, 1996), pp. 5–10; p. 351, n. 33.

22  A. Bowness, 'Foreword', in *St Ives 1939–64*, p. 7.

23  Stokes invited Hepworth and Nicholson, together with their triplets, nanny and cook, because of the imminent war. They stayed in Little Park Owles from 25 August to 27 December. Miriam and Naum Gabo arrived on 15 September and the next day found and moved into Faerystone (*St Ives 1939–64*, pp. 99–100).

24  Bridget Elliott and Jo-Ann Wallace, *Women Artists and Writers: Modernist (Im)positionings* (London and New York, Routledge, 1994), p. 156.

25  Significantly Serota indicates awareness of this inaccuracy by writing about the artistic 'region' in the *Tate St Ives* catalogue (St Ives, Tate Gallery, 1993), p. 7.

26  J. L. Martin, B. Nicholson and N. Gabo, *Circle: International Survey of Constructive Art* (London, Faber, 1937).

27  In Mellis's additions to TAV272AB.

28  How modernism in Penwith came to be named after St Ives still awaits elucidation.

29  Interviews with Barns-Graham, 1996.

30  Nicholson worked in Porthmeor studio 5, Hepworth acquired Trewyn, the site of her Museum in St Ives, and Nicholson moved to live in St Ives in 1951.

31  *St Ives 1939–64*, pp. 149–60.

32  In *St Ives 1939–64* she is mentioned on pp. 21, 31, 99, 135, 136, 146, 149, 152 and 159.

33  *St Ives 1939–64*, p. 159, cat. no. 35. See also Matthew Rowe, 'The Fisherman's Farewell', in André Cariou and Michael Tooby, *Christopher Wood: A Painter Between Two Cornwalls* (London, Tate Gallery Publishing, 1996), p. 31.

34  In *Unknown Colour*, esp. pp. 40–2. During the early 1930s Ben regularly visited her and their three children in Paris. In 1936 he included her contribution in the publication of *Circle*, which she was encouraged to put under her maiden name Dacre.

35  Wallis's painting was reproduced on the catalogue front cover and the exhibition's posters.

36  Denys val Baker, 'Primitive Visions', *Country Life*, 16 August 1984 (Newlyn exhibition, 1977).

37  Barns-Graham interview, 10 June 1996.

38  Mellis, TAV272AB, pp. 57–9. Mellis recounts Nicholson's disapproval of Buchanan's bringing Wallis some orange paint, which he believed ruined his true colour harmonies.

39  *St Ives 1939–64*, p. 127. The photograph is dated 1917.

40  Lisa Tickner, 'Men's Work? Masculinity and Modernism', in N. Bryson, M. Ann Holly and K. Moxey (eds), *Visual Culture: Images and Interpretations* (Hanover and London, University Press of New England, 1994), pp. 42–82.

41  See P. Florence, 'Barbara Hepworth: The Odd Man Out?', in D. Thistlewood (ed.), *Barbara Hepworth Reconsidered* (Liverpool, Tate Gallery, Liverpool and Liverpool University Press, 1996), pp. 23–42, and K. Deepwell in this volume.

42  Douglas Hall, *W. Barns-Graham Retrospective, 1940–1989* (Edinburgh, Edinburgh Museums and Art Galleries, 1989), pp. 1–11 (p. 3).

43  Interview with Barns-Graham, 5 June 1996. Hepworth wrote this to Barns-Graham in a letter prior to the 1950s – when their friendship deteriorated. Information from Rowan James, 29 June 1996.

44  *St Ives 1939–64*, pp. 21, 22, 24, 25, 99, 100, 101, 102, 103, 115, 124, 149, 161, and as a collector of Wallis, pp. 152, 156.

45  *Ibid.*, pp. 10–11, 24.

46  Mellis, TAV272AB, and my interviews, Southwold, 18–20 August 1996.

47  TAV272AB, pp. 3–13 deal with the domestic arrangements; we read on p. 21 '. . . it was rather a crush'. Tensions because of different preferences in music are revealed on pp. 69–70.

48  TAV272AB, pp. 7, 13, 22, and my telephone interviews in 1995/96 and January 1997.

49  For instance in a question about B & B (Ben and Barbara) paintings, p. 23, or 'Tell us about Wallis', p. 41.

50  *Ibid.*, pp. 9–10.

51  *Ibid.*, p. 30.

52  Nicholson dismissed his figurative paintings as saleable 'pot boilers' (TAV272AB, pp. 24, 49).

53  Adrian Stokes, *Colour and Form* (London, Faber and Faber, 1937). Mellis in TAV272AB, pp. 38–41.

54  TAV272AB, p. 39 (colour); pp. 43–4, (Patrick Heron). Even in her discussion about Wallis she praises his colour harmonies rather than stressing his forms and composition.

55  *Collage with Red Triangle II*, 1940, a second version of which had been made for Gabo, and *Construction in Wood*, 1941, Edinburgh, Scottish National Gallery of Modern Art, cat. nos. 60 and 61, pp. 167–8.

56  Mellis worked for one year in A. Lothe's studio in Paris.

57  E.g. *Danish, British and American Abstract Artists* (New York, Riverside Museum, 1951); *International*

*Watercolour Exhibition* (New York, Brooklyn Museum, 1953); *Abstract Art 2* (Milan, 1955); *International Exhibition of Works in Gouache* (New York, 1960). Two paintings by Barns-Graham hang as permanent exhibits at the Tate Gallery St Ives, but none by Mellis. When the Tate Gallery St Ives opened in 1993, its stated function was 'to exhibit the work of artists connected with the Cornish town.' Michael Tooby justified Wood's connection in terms of the four months he spent there (Cariou and Tooby, *Christopher Wood*, p. 7). Similarly a show was given of Rothko, who spent but a few days with Peter Lanyon, mainly at Carbis Bay in 1958.

58   *Composition, February 1954*, St Ives 1939–64, p. 31; *Island Sheds, St Ives, No. 1*, 1940, cat. no. 39, colour plate, p. 72; *Starbottom, March 1957*, Scottish National Gallery of Modern Art, Edinburgh, cat. no. 160, p. 200; *Porthleven, Upper Glacier*, 1950, The British Council, cat. no. 97, pp. 179–80.

59   N. Serota, in 'Director's Foreword', *Tate St Ives* catalogue, p. 7.

60   Mellis, Tate Gallery Archive, TAV272AB, p. 13.

61   *St Ives 1939–64*, pp. 14, 108.

62   *Ibid.* Lewis did not mention Barns-Graham either in section VI, where the Carbis Bay group are discussed, or in section VII as part of the younger generation. Their meeting appears in section VIII, p. 25, their marriage in section X, p. 29; on p. 31 Lewis discusses her art.

63   *Ibid.*, p. 25.

64   *Ibid.*, pp. 24–5.

65   *Ibid.*, p. 18.

66   *Ibid.*, p. 31.

67   For a critique and bibliography of Greenberg see Donald B. Kuspit, *Clement Greenberg, Art Critic* (London, The University of Wisconsin Press, 1979).

68   *St Ives 1939–64*, p. 31.

69   *Ibid.*

70   *Ibid.*, p. 25.

71   *Ibid.*, n. 33, p. 41 (a letter by W. Barns-Graham of 1 February 1965 quoted from the *Annual Report* of the Tate Gallery, London, 1964–65, Appendix 3, p. 30).

72   *St Ives 1939–64*, pp. 24–5.

73   Conversation with the artist, 30–31 October 1996.

74   *Abstraction–Creation, Cahier* no. 1 (1932), pp. 14, 25, 26, 30, 33. Moss's work was also illustrated in the four following *cahiers*, in each with two illustrations. In *Cahier* no. 5 (1936), published after Nicholson and Hepworth became members, they are not named but subsumed in the statistics of abstract artists outside France (p. 3), while Moss has two illustrations (p. 18).

75   In this respect, Barns-Graham felt that her interview was so strongly tinted by Lewis's and her own private past that she has put an embargo on TAV250AB, and hence I cannot quote from it.

76   For the relationship between memory and genealogies, patriarchal long-term genealogical memory, see Irigaray, *Sexes and Genealogies*, p. 160. My thanks to G. Pollock for her comments.

# Talking back: an exchange with Marcel Duchamp[1]

This is an edited version of a performance[2] I did for a conference, 'Generating Lines and Engendering Figures: A Symposium on and about Marcel Duchamp', organised by Naomi Sawelson-Gorse in association with The Museum of Contemporary Art, Los Angeles (MOCA). Held on Saturday, 28 October 1995 in the Contemporary's Ahmanson Auditorium, this all-day symposium consisted of presentations by David Joselit, Christine Magar, Sheldon Nodelman, Marjorie Perloff, Dickran Tashjian and myself. I was the last speaker and I broke with the day's format of lecture-and-slides, with a performance presentation.

These musings were prompted by reading the work of Eunice Lipton, who in *Alias Olympia*[3] blends scholarship, autobiography and the invented diaries of Victorine Meurent and Gayatri Spivak's discussions of history and fiction. In an interview, Spivak suggests that 'Fiction-making can become an ally of history when it is understood that history is a very strong fictioning where, to quote Derrida, the possibility of fiction is not derived from anterior truths. Counterfactual histories that exercise imaginative responsibility – is that the limit?'[4] Spivak's coupling of counterfactual histories and imaginative responsibility forms part of the context in which this 'Talking Back' was conceived.

My twenty-five-minute or so performance consisted of a back-and-forth play between the following components:

1. Slides of texts from an imaginary exchange of letters between myself and Marcel Duchamp. My letters were in white type on a blue background, and Duchamp's were in his handwriting, on a red background. (To my delight I had discovered there was a fount of Duchamp's actual handwriting.) I read these letters slowly out loud to the audience, who could, so to speak, read along with me.
2. Slides of works of art by Duchamp, Shigeko Kubota and Faith Ringgold.
3. Three video clips. The first was a manipulated 1982 interview with Duchamp (based on an interview with him from the 1960s) by Lynn Hershman. The second and third video clips were taken from footage I had made in Venice and New York of Shigeko Kubota's video sculpture, much of which focused on her protracted dialogue with Duchamp.
4. Musings to the audience. I delivered these 'musings' fairly quietly while gazing reflectively at the audience.

5.  Readings from my diary. On the floor beside me was a large leather-bound book which I picked up from time to time and read from in a dramatic tone. I had begun these diary entries on 16 October and wrote the last entry on 27 October, the day before the symposium. Although this made me rather insecure at the time, it was part of the ground rules I had set myself when composing 'Talking Back', i.e. I would allow the performance text to develop organically, and see where it led over time.

### Moira Roth, letter to Marcel Duchamp, No. 1, 15 October 1995

Dear Marcel,

I want to let you know that Naomi Sawelson-Gorse has invited me to participate in her 'Generating Lines and Engendering Figures: A Symposium on and about Marcel Duchamp'. I was reluctant to get engaged in this at first because for years we have been drifting apart, as you probably realise, but people tell me that you are rather restless these days, so perhaps an exchange would amuse you? Certainly, it would interest me as I have always felt that there is some unfinished business between us. Anyway, if you wish, you can respond for I have installed a fount of your handwriting on my computer.[5] You'll have a choice as to whether to use True Type or Postscript formats and there is also a bold version.

Moira

### Marcel Duchamp, letter to Moira Roth, No. 1

*Dear Moira,*

*How amusing and how modern. Perhaps Postscript would be best? By the way, I looked down at the programme for today's symposium, and noted your title, 'Talking Back: An Exchange with Marcel Duchamp'. 'Talking Back'?*

*Marcel*

### Moira Roth, letter to Marcel Duchamp, No. 2

Dear Marcel,

You probably don't know of bell hooks – she was after your time – but she wrote an essay entitled 'Talking Back'.[6] It's had a great influence on me. Hooks writes that 'in the world of the southern black community I grew up in "back talk" and "talking back" meant speaking as an equal to an authority figure. It meant daring to disagree and sometimes it just meant having an opinion.'

Moira

### Musings to the audience, No. 1

I've been getting myself into the mood to talk back to Duchamp for quite some time, but I didn't start that way.

When I was writing my dissertation on Duchamp,[7] way back in the early 1970s at the University of California, Berkeley, I used to have a positive crush on him. It was the Oedipal moment many of us experience as graduates – totally in love with one's subject, unable and unwilling to differentiate between oneself and the beloved.

I remember going to parties in Berkeley and telling so many stories about my beloved that people would come up and ask if they could meet my interesting friend. I also remember a particularly crazy time when I had been writing a draft of my dissertation for ten days straight, morning, noon and night, including a preface – and actually handed this in to my adviser – in which I fantasised about having a love-affair with Duchamp. I remember it ended with: 'She stroked his thigh and asked, "What does *The Large Glass* really mean, Marcel?" Smiling, he began to explain.'

### Marcel Duchamp, letter to Moira Roth, No. 2

*I remember your dissertation, Moira. You went around New York asking people about their reactions to me. It was quite interesting, including those amusing comments by Robert Smithson.*

### Musings to the audience, No. 2

Actually, the first cracks in my relationship with Duchamp – who had died in 1968 – came around 1973, especially triggered by a conversation with Robert Smithson.

I was in New York, taping interview after interview about Duchamp with the likes of Leo Castelli, Vito Acconci and George Segal. For example, I talked to Acconci, who said he felt forced to do homage to Duchamp: 'Since it has been assumed that Duchamp has established the context in which everyone is working, it's sort of like being forced to answer questions about the boss.'[8]

Then, just before I was to fly back to Berkeley, I stumbled on a group of artists who disliked Duchamp for a variety of reasons – among them Sol Lewitt, Carl Andre and Robert Smithson. I remember being surprised – shocked in a way, but also experiencing a little *frisson* of excitement at this 'talking back' – really the first I'd encountered since I started research on my dissertation.

I talked to Smithson, shortly before he died, in the early spring of 1973. Visiting Smithson in his well-organised New York loft, I found that he had prepared for the interview, assembling a pile of books on Duchamp with little markers for certain texts. It was like talking to another scholar as he would rifle through the pages for this or that reference.

Clearly he and his friends didn't like Duchamp or Duchamp's influence on American art. He commented that Duchamp's objects are 'just like relics, relics of the saints . . . It seems that he was into some kind of spiritual pursuit that involved the commonplace. He was a spiritualist of Woolworth, you might say.'[9] Smithson definitely saw Duchamp as 'the enemy', witness his comment in my 1973 interview: 'In America we have a certain view of art history that comes down to us from the Armory show, and Duchamp had a lot to do with that history . . . that notion of art history itself

is so animated by Duchamp . . . Duchamp is really more in line with postmodernism in so far as he is very knowledgeable about the modernist traditions but disdains them. So I think there is a kind of false view of art history, an attempt to set up a lineage.'

Smithson ended our exchange with '. . . I find his wit sort of transparently French . . . If the French have any wit at all, I don't really appreciate it. They always seem very laborious, opaque and humourless so that when you get someone like Duchamp who is putting forth the whole art notion of the amusing physics or the gay mathematics, or whatever you want to call it, I am not amused. It is a kind of Voltairian sarcasm at best.'[10]

### Marcel Duchamp, letter to Moira Roth, No. 3

*As the 1970s progressed, Moira, there began to be a slightly critical edge to your tone, although I quite enjoyed your 'Duchamp in America: A Self Ready-Made.'[11]*

### Moira Roth, letter to Marcel Duchamp, No. 3

Dear Marcel,

You do realise, don't you, that this 1977 *Arts* essay was the first time in print that I had tried to position you in American modernism (as well as to explore your personae and role playing, with the New York art world as a theatre set) and to talk about how indebted you were to that ambiance. Sheldon Nodelman[12] helped me edit the essay. By the way did you hear Sheldon's talk today?[13] I know it amuses you to read critics' interpretations of your *œuvre*. I used to worry as to what you thought of mine. I remember being so relieved when you once told me that you liked this 1977 *Arts* portrait of you as the *flâneur*–occult scholar.

Moira

### Readings from my diary, No. 1, 16 October 1995

*Dear Diary,*

*I have decided in preparation for this Los Angeles presentation that I really need to address two basic questions.*

*1. Why do I find myself so increasingly critical of Duchamp, indeed impatient with him?*
*2. Why, despite that, do I find myself returning to him? Why does he seduce, myself included, so many scholars into a reinvestment in him?*

*The answer to the first question is fairly easy. Today, rereading the Arts article, which I hadn't looked at for years, helped me think through why I have become so impatient with Duchamp these days.*

*I still like my essay's conclusion:*

*Duchamp's choice of America in 1915 was the right one for a man obsessed with the making of his own image, the perpetuation of that image, and the total control over its reading. Duchamp and America served one another well. Duchamp wanted fame and got it. America wanted to establish its place in the history of art more firmly and it used Duchamp for this purpose. The New York Dada movement and Duchamp's art, together with the more genuinely American contributions of the Stieglitz group, built the edifice of American Modernism. Duchamp was in on the ground floor.[14]*

*Surely that is at the heart of my growing impatience with Duchamp.*

*Not only did he have such a stranglehold on American art history with its insistence on modernism, and its kowtowing to European models – which these days is causing us American revisionist art historians so much trouble – but recently he has insinuated his way into postmodernism.*

*Now he's on the top floor of postmodernism.*

*The man's too much.*

*He keeps popping up just when you think he is dead.*

*He just has too much influence for my liking and he's taking up too much space and time at the moment when we should be, I believe, moving on.*

### Marcel Duchamp, letter to Moira Roth, No. 4

*I seem to recall that in 1977 you wrote 'The Aesthetic of Indifference'.[15] I forget exactly what it was about – something to do with me, John Cage, Jasper Johns, Robert Rauschenberg and McCarthyism? . . . How you felt that we were distancing ourselves from politics by irony and indifference . . . and that you thought we had made it difficult for younger artists in the 1960s to be politically engaged. Something like that, wasn't it? By 1977, of course, you had been involved in feminism for some time. But surely you must have continued to enjoy Rrose Sélavy as you were always preaching about women artists. And there I was, yours for the asking. You know I have always found you charming. She does, too.*

### Moira Roth, letter to Marcel Duchamp, No. 4

Yes, it was a temptation. I did so much want to continue the love-affair with you. In a way, Rrose might have been the feminist solution for our affair. I could have had my male genius cake, so to speak, but eaten it, also, with lesbian relish.

### Musings to the audience, No. 3
### [accompanied by a slide of Rrose Sélavy]

This talk of Rrose Sélavy is making me think of those uneasy but heady days in 1980. I had not only been involved in feminism for some ten years, but was deeply involved in performance art and had just discovered punk performance.

At the beginning of 1980, I returned from a South Sea island escapade with Crown Point Press – with a group of avant-garde superstars, including John Cage, Chris Burden and Laurie Anderson – and was on leave from the University of California, San Diego (UCSD), teaching at Hayward State. I was in the Bay area, and had plunged into nightly visits to punk clubs. I met the editor of *Damage*, a punk magazine, and he asked me to write for it. I had just got tenure at UCSD and was feeling rebellious. For a couple of months I toyed with the idea of presenting Rrose Sélavy for *Damage*, and of writing under a pseudonym, Regina Smut.

### Readings from my diary, No. 2, 17 October 1995

*Dear Diary,*

*That's it! Endless alternatives offered by the father and endless seductions by the lover.*

*Here we all are in the heady days of postmodernism, denying authorship and authority.*[16]

*And here is Duchamp saying smilingly, of course, he agrees with us – indeed anticipated all this, and so early on, too.*

*So we can, therefore, continue to have such an interesting, and such an intelligent, indeed such a postmodern and fashionable father – Duchamp.*

*Psycho-authorisation.*

*Not easy giving up the search for the father. Not easy even if you are an ardent feminist.*

*How cheaply psychoanalytic I'm becoming, but it's true.*

*It's the answer to my second question – why do I – we – always return to Duchamp?*

### Marcel Duchamp, letter to Moira Roth, No. 5

*Does your friend, Amelia Jones,*[17] *find me interesting? I see that she is one of the presenters of this conference. Not that I really care, you understand, but I was mildly curious as to what she has to say with all her talk about 'en-gendering' me. I thought she sounded rather clever. You know, Moira, I really do – I must confess – like to be included in what's going on. It's a little boring up here, and it's pleasant to be included in art conversations about postmodernism.*

### Moira Roth, letter to Marcel Duchamp, No. 5

By the way, Marcel, I've always wanted to ask you if you ever saw the 1982 interview which Lynn Hershman, the feminist San Francisco-based multi-media artist, did with you?

### Marcel Duchamp, letter to Moira Roth, No. 6

No, Moira, you must be mistaken. I was never interviewed by Miss Hershman. After all, by 1982, I had been up here for some twelve years.

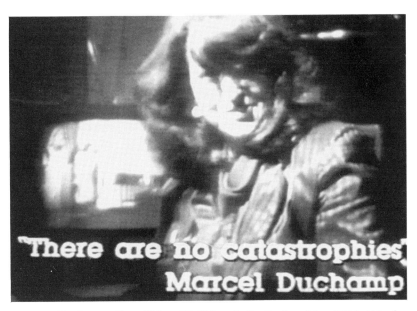

28    Lynn Hershman, video still from *The Making of a Very Rough . . . Life and Work of Marcel Duchamp*, 1982

**Musings to the audience, No. 4**
[accompanied by a three-minute video clip from *The Making of a Very Rough . . . Life and Work of Marcel Duchamp* (1982) by Lynn Hershman, in which Hershman is seen interviewing Duchamp]

Actually there is such a tape by Hershman in which she took an interview made with Duchamp during his lifetime, and inserted herself as the interviewer (Figure 28). It is a part of *The Making of a Very Rough and (Very) Incomplete Pilot for the Videodisc on the Life and Work of Marcel Duchamp* – an account of her attempt to create an inter-active videodisc which was to include Duchamp's heartbeat. There was some sort of dispute on the set over money, and a member of her video crew held the tapes of Duchamp's heartbeat 'to ransom'. The result was that Hershman never made the videodisc. She once said that she knew Duchamp would have loved the idea of his heart being held for ransom.[18]

An interesting metaphor – a heart held to ransom. How does one get one's heart back, and at what price? Did I get mine back from Duchamp, and what was the price?

**Moira Roth, letter to Marcel Duchamp, No. 6**
Did you ever read the long essay on Shigeko Kubota which I wrote in 1991 for her retrospective at the American Museum of the Moving Image?[19] You remember, Marcel, that you met her in 1968 just before you passed away? She had come to

Toronto to photograph you and Cage playing chess. She was – and is – such an admirer of yours. At the time, she had been in New York for four years and from the start she had been deeply involved there in Fluxus circles. Later she made a series of videos and video installations responding to you – among them works about *Nude Descending a Staircase, Bicycle Wheel, Fresh Widow*, your 1924 nude tableau of Adam and Eve, and the trick door you had had made for your Paris studio. She also made a video sculpture after she had visited your grave in Rouen.[20]

### Readings from my diary, No. 3, 20 October 1995
[accompanied by footage I shot in 1990 of Shigeko Kubota's sculptures – *Duchampiana: Bicycle Wheel* (1976), *Duchampiana: Nude Descending a Staircase* (1976) and the *Meta-Marcel: Window* series (1976–1991) – in 'Ubi Fluxus ibi motus, 1990–1962', a Fluxus show in Venice]

*Dear Diary,*

*Today I've been looking at the videotape I made in 1990 of three of Kubota's Duchampian pieces and I've also been amusing myself by copying passages from my Kubota catalogue essay into this diary. One section described my reactions to a prolonged session of sitting and looking at Kubota's work in a big Fluxus exhibition in Venice on the Guidecca.*

*It's quite a meditative exercise in itself – writing out by hand something that was once a printed text:*

> *The longer I spent with the three pieces, the less I thought about Duchamp. What I experienced most strongly was the works' meditative ambiance and their cyclical nature. The Bicycle Wheel began to conjure up in my mind the image of a Tibetan prayer wheel. The Window became a mantra for meditation. And what I was most aware of in The Nude was ritual movement that had no conclusion, and an almost relentless repetition of images in the footage. Kubota's Nude, a work by a woman artist with a [live] woman as her subject and the movement of the video medium, swept aside memories of Duchamp's static painted object. As I sat there amidst the Fluxus world, I speculated about the splendid bravado of a young female Japanese artist taking on the European sophisticate Duchamp – and managing to make the works her own.[21]*

### Musings to the audience, No. 5
[accompanied by a slide of *Adam and Eve* by Shigeko Kubota]

There was another work which I saw later that summer in Kubota's studio – her *Adam and Eve*, inspired partially by the famous photograph of Duchamp's 1924 tableau of a nude Adam and Eve with himself as Adam. Kubota once told an interviewer that 'Duchamp is the root of my art memory and my work. My human root is my being Japanese from a small country, an island.'[22]

For Kubota this *Adam and Eve* piece was the first time in which her Duchampian and Japanese roots had intertwined directly. She made two life-size

robots of wood and mirrors mounted on revolving platforms, and placed them in a garden of plastic mylar rocks – originally part of an earlier installation, based on Japanese rock-gardens. Video footage of cherry-blossom images played over the landscape and the rotating figures.

Adam moved slowly in a stately fashion, the smaller Eve was faster. Embedded in various parts of their bodies and faces were miniature monitors. In Adam, the monitors showed rough footage of a man talking and climbing up and down a ladder in a studio. In Eve's monitors was footage which Kubota had taken of Kyoto's Golden Pavilion – jerking up and down and zooming in and out of focus.

### Readings from my diary, No. 4, 26 October 1995
### [accompanied by Kubota's video footage of the Golden Pavilion]

*Dear Diary,*

*I now realise that for me leaving Duchamp – and I did not write on him again after this 1991 essay on Kubota – was, in effect, leaving modernism.*

*Kubota was, perhaps unwittingly, my guide in this, just as years before Smithson had first instilled in me a desire to 'talk back' to Duchamp.*

*By the time I wrote on Kubota, I had become intensely involved in cross-cultural art, activism and experimental writing. In retrospect, I now see the American Museum of the Moving Image catalogue essay as an expression of my parting of the ways with Duchamp, a rueful and affectionate but necessary parting.*

*For me Kubota supersedes Duchamp as a paradigm for postmodern negotiations. She makes Duchamp's insular ways seem a little old-fashioned, a little outdated.*

*Certainly, Kubota is a model of how to negotiate with Duchamp. She uses him as a springboard, enjoys him, generally makes peace with her seductive paternal ancestor – and then moves beyond him.*

*But I also now recognise more fully why I was, and am, so deeply drawn to Kubota's work.*

*In her art, Kubota offers much more than advice on how to deal with Duchamp.*

*Duchamp arrived in this country fully formed, and was remarkably insular to any encounter with this new culture. Kubota was not.*

*Kubota was and is interested in cross-cultural journeys, in cultural transitions, divides and hybrid states of identity – and this is what increasingly has fascinated me, as an immigrant to this country, in American art and life.*

*In* Broken Diary: Video Girls and Video Songs for Navajo Sky, *Kubota listens to the Navajo language and relates it to Japanese. Her video* Broken Diary: My Father *oscillates between Kubota sitting mourning in her New York studio, and footage of an earlier visit to her dying father in Japan.*

*In the United States, Kubota lives consciously in a hybrid world, a world governed – as Guillermo Gomez-Pena has written – by a new paradigm, 'The Multicultural Paradigm'.[23]*

**Musings to the audience, No. 6**
**[accompanied by a slide of Duchamp's *Paris Air*]**

Kubota's work is light years away from, for example, Duchamp's *Paris Air*, a work I still enjoy – that charming, witty present that he made in Paris in 1919 to bring back for his American friends, Louise and Walter Arensberg.

**Readings from my diary, No. 5, 27 October 1995**

*Dear Diary,*

*Until today I have not known how to end this presentation – and it's for tomorrow. A little unnerving.*

*Now I've got it, a runaway ending of* The French Collection *by Faith Ringgold,[24] a wry homage to French modernism, and a great example in art of 'talking back'.*

*Ringgold appreciates French modernism but she's decided to revise it more to her liking.*

*Dinner at Gertrude Stein's (Figure 29) from the* French Collection *series, twelve story quilts, whose images and handwritten texts present a narrative about a fictional young African–American, Willia Marie Simone. Ringgold's heroine moves to Paris at the beginning of the twentieth century, and for the rest of her life lives there, an expatriate artist–model–café owner.[25]*

*In order to learn how to be an artist, Willia Marie models for Picasso and Matisse, and finds out more about modernism by attending a dinner-party at Gertrude Stein's.*

*In the text of* Dinner at Gertrude Stein's, *Willia Marie – who stands in white to the left of the group – writes to her Aunt Melissa about this evening: 'I was being listening and quiet and standing so that I would not miss anything from sitting.'[26]*

*What she listens to are exchanges between different dinner-guests.*

*Of the six men being and talking with Gertrude, three of them, Richard Wright, James Baldwin and Langston Hughes, were being coloured and three of them were not [Pablo Picasso, Ernest Hemingway and Leo Stein] . . . My favourite event of the evening was Zora Neale Hurston reading from her comedic play,* Mule Bone. *Zora is being and making a classic of the black folk culture and language we are always being so ashamed of . . . Zora was being and telling the story of the "bama nigger" who struck his rival with the hock bone of an ole yaller mule.[27]*

*Willia Marie ends the account of this evening by telling her Aunt Melissa: 'Then speaking to myself only saying, "I leave here with this thinking – a 'bama nigger' is a Mississippi pickaninny, is a jewel, is a rose, is a hock bone, is an old yaller mule – and a man is a man is a woman, and there is no there, here."'[28]*

*In an interview I did with Ringgold about this story quilt, she states:*

*My process is designed to give us 'colored folk' and women a taste of the American dream straight up. Since the facts don't do that too often, I decided to make it up. It's*

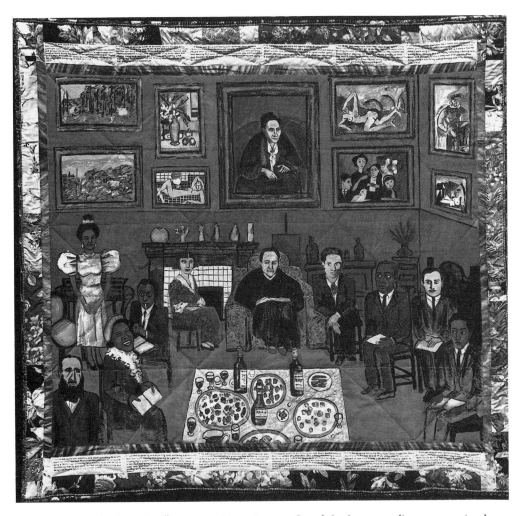

29    Faith Ringgold, *The French Collection, Part 2, No. 10: Dinner at Gertrude Stein's*, 1991, acrylic on canvas, pieced border, 197.5cm × 210cm

important, when redressing history as I am doing here, not to be too literal or his-
torical. It will spoil the magic. Who knows what could have been? I can only dream
what we would have done if those of us who were closed out of the mainstream of
American life here and abroad could have had our choice – who we would have
known and been close to. It is worth thinking about and picturing certain people
together, like the ones in Dinner at Gertrude Stein's. Whether they were or not, they
should have been. In the process it makes me feel included. That is the real power
and joy of being an artist. We can make it come true. Or look true.[29]

Ringgold is currently planning her sequel to The French Collection. Its title is The
American Collection and it's the story of Marlena, Willia Marie's daughter, who lives
in America. Like her mother, Marlena is an artist. Recently I asked Ringgold if she was
going to include Duchamp among The American Collection's cast of characters. She

*said she hasn't quite decided yet but that she might. But then again, she might not. Marcel Duchamp is not an artist Ringgold finds particularly interesting.[30]*

## Notes

'Talking back' will also be published in *Difference/Indifference: Musings on Postmodernism, Marcel Duchamp and John Cage*, a forthcoming anthology of my writings in a series, Critical Voices in Art, Theory and Culture, to be published by Gordon and Breach Arts International, New York.

1   I am deeply grateful to Naomi Sawelson-Gorse not only for her initial invitation to participate in this symposium but for her insistence – when I voiced my original hesitations, telling her I was no longer that interested in Duchamp and had, indeed, stopped writing on him – that I should nevertheless do a presentation, and her encouragement to 'do whatever I liked'.

2   I want to acknowledge the most helpful suggestions and criticisms made by fax exchange and in phone conversations with Whitney Chadwick, Irit Rogoff and Abigail Solomon-Godeau during the intense few days while I was composing this performance. Diane Tani, too, was most generous with her help in making the slides for the letter exchange between myself and Duchamp.

3   Eunice Lipton, *Alias Olympia: A Woman's Search for Manet's Notorious Model and Her Own Desire* (New York, Charles Scribner's Sons, 1992).

4   Gayatri Chakravorty Spivak, 'Bonding in Difference', interview with Alfred Arteaga, 1993–94, in Donna Landry and Gerald Maclean (eds), *The Spivak Reader* (New York and London, Routledge, 1996), p. 25.

5   This fount of Duchamp's distinctive handwriting is distributed by Richard Kegler and Michael Want of P22 Type Foundry, PO Box 770, Buffalo, NY 14213, USA.

6   bell hooks, 'Talking Back', in *Out There: Marginalization and Contemporary Cultures*, edited by Russell Ferguson, Martha Gever, Trinh T. Minh-ha and Cornel West (New York, The New Museum of Contemporary Art; Cambridge, Mass., MIT Press, 1990).

7   Moira Roth, 'Marcel Duchamp and America, 1913–1974', University of California, Berkeley, 1974. In my dissertation acknowledgements, I write at the end that 'Perhaps most of all I have a debt to Marcel Duchamp. In the last few years, sometimes I have admired him, sometimes I have had ambiguous and negative feelings about him, but in either case, his effect on me has been profound.' Much of the dissertation was drawn from a series of interviews I conducted with a wide range of contemporary artists, dealers and historian–critics concerning their readings of Duchamp's presence in and influence on American art, beginning with the 1913 Armory exhibition. They saw him variously as the Liberator and Iconoclast, the Enemy and the Cryptic Scholar.

8   Moira Roth, transcript of interview with Vito Acconci, 31 January 1973 (unpublished).

9   Moira Roth, 'Robert Smithson: An Interview', *Artforum*, October 1973, p. 47.

10  *Ibid.*

11  Moira Roth, 'Marcel Duchamp in America: A Self Ready-Made', *Arts*, May 1977, p. 47.

12  In 1977 Sheldon Nodelman and I were both teaching at the University of California, San Diego. By this time, I had completed my dissertation on Duchamp (which I never published), and was deeply involved in performance art research – hence my interest in the performative aspects of Duchamp.

13  Sheldon Nodelman had given a lecture, entitled 'Once More to this Star', earlier that day in the symposium.

14  Roth, 'Marcel Duchamp in America: A Self Ready-Made', p. 96.

15  Moira Roth, 'The Aesthetic of Indifference', *Artforum*, November 1977. In the postscript to this essay (p. 43), I explain that 'The period I have written about is the period of my adult life. I came to the United States (from England) during the McCarthy period. I lived in Berkeley during the 1960s and wrote a dissertation on Duchamp and America. I have had a long and ambivalent history of attitudes towards Duchamp, Cage, Rauschenberg, and Johns. Writing this essay has been a way of trying to write a partial intellectual autobiography, an accounting of my interests in these artists.'

16  E.g. Michel Foucault, 'What is an Author?' (originally published in 1969), reprinted in P. Rabinow (ed.), *The Foucault Reader* (New York, Pantheon Books, 1984).

17  Amelia Jones, one of the participants in this October 1995 conference, had just made her presentation prior to mine with a lecture entitled 'Duchamp and the En-gendering of the Artistic Subject', a subject that she had already explored at length in her book *Postmodernism and the En-gendering of Marcel Duchamp* (Cambridge, Cambridge University Press, 1994).

18  Moira Roth and Diane Tani, 'Interview with Lynn Hershman', in Lynn Hershman, *Lynn Hershman*, Chimaera Monographs 4 (Belfort, France, Centre International de Création Vidéo Montbéliard Belfort, 1992), p. 116.

19  Moira Roth, 'The Voice of Shigeko Kubota: "A Fusion of Art and Life, Asia and America . . ."', in *Shigeko Kubota: Video Sculpture*, edited by Mary Jane Jacob (Astoria, New York, The American Museum of the Moving Image, 1991).

20  Shigeko Kubota, *Duchampiana: Marcel Duchamp's Grave* (1972–75), which is a free-standing plywood construction that can contain up to twelve monitors.

21  Roth, 'The Voice of Shigeko Kubota', p. 81.

22  *Ibid.*, p. 76.

23  Guillermo Gomez-Pena, 'Border Culture: The Multicultural Paradigm', *The Decade Show: Frameworks of Identity in the 1980s* (New York, Museum of Contemporary Hispanic Art, The New Museum of Contemporary Art and The Studio Museum in Harlem, 1990).

24  I have been profoundly influenced by Faith Ringgold's work and politics, and since the mid-1980s I have written a number of essays on her. I also edited her autobiography in 1994–95, and in the last three years we have travelled together to Paris twice and once to Morocco.

25  Coloured reproductions of the twelve story quilts of the *French Collection* series by Faith Ringgold can be found in her autobiography, *We Flew over the Bridge: The Memoirs of Faith Ringgold* (Boston, Mass., Little, Brown and Company, 1995). The texts and black-and-white reproductions of the first eight story quilts are contained in Faith Ringgold, *The French Collection, Part 1* (New York, Being My Own Woman Press, 1992). The last quilt, *Moroccan Holiday*, is currently being completed. Coloured reproductions of the text and the images of twelve story quilts of the *French Collection* series can be found in *Dancing at the Louvre: Faith Ringgold's French Collection and Other Story Quilts* (New York and Berkeley, The New Museum in association with the University of California Press, 1998).

26  *Dancing at the Louvre*, p. 139.

27  *Ibid.*

28  *Ibid.*, p. 140

29  Moira Roth, 'Dinner at Gertrude Stein's: A Conversation with Faith Ringgold', *Artweek*, 13 February 1992, p. 11.

30  Ringgold is now at work on *The American Collection*, and has decided that there will be no references to Duchamp in it. See my essay, 'Of Cotton and Sunflower Fields: The Making of the French and American Collections', in *Dancing at the Louvre*.

# Making a mess: women's bane, women's pleasure

### Messiness, modernism, and monsters

When I say that women artists make a mess, I speak lovingly. The modernist myth of genius constructs the artist as a man lauded for making a mess: the avant-gardist 'messes' up canons of beauty, and his habits and sex-life 'mess with' bourgeois conventions.[1] Modernist 'mess' conflates the aesthetic, the erotic, and the visual. Within modernist discourse and modern life, the woman artist who 'makes a mess' has not experienced success equal to men's. This is because tidiness has been and remains a norm imposed by culture on women. My goal is to recuperate messiness for women as erotic, optical, and aesthetic.

I include in modernist discourse scholars' work and its uses and abuses; and myth and rumour that grow in and from art historians', art critics', and journalists' writing.

The erotic is pleasure in its many forms. The erotic exists in genital sexual gratification, but operates much more expansively in recognitions of plenitude and in the development of wisdom regarding satisfactions unadulterated by pain, hostility, shame, or frustration. Pleasure in these terms is neither utopian nor Pollyanna-ish. It is an urgent instinct beneath the cultural burden of belief in pleasure and pain as necessary correlates and feminist theories, so problematising women's desire and pleasure as to suppress their ability to represent, let alone trust, their own pleasure, thus squelching an erotics of experience.[2] That images substantiate reality and reality substantiates images means that both women's lives and art reify the pleasure/pain model. Yet some women's art has substantiated pleasure, and those artistic confirmations are not starry-eyed visions, for pleasure is necessary to human well-being and social transformation.

As I create a kaleidoscopic telling – erotic, restless – the pattern I produce mixes narratives and literary genres. As I speak lovingly, I also speak analytically, interpretively, theoretically, and poetically. My collage makes a mess of art-historical rhetoric, which is a methodology of seamless storytelling. I rip the discursive fabric and repiece it differently for pleasure and healing. Healing and pleasure refuse modernism's unconscious construction of many famous women artists' lives or work as

paramount in pain or abnormality. Healing and pleasure reject modernism's trajectory of expectation for female stars, whose 'success' entails domestic, maternal, or mental failure, or whose art manifests qualities that culture-at-large believes make women women: masochism, victimage, and hysteria, the last in both its psychoanalytical and popular meanings. In modernist discourse, women's femininity is a necessary and aberrational condition; femininity is a mess and a monstrosity.

The monster is a cautionary figure that signifies disorder. She is meant to be shown as a warning that visibly reveals unreason – a mess – and she is a prophetic character that demonstrates the horror of difference.[3] Monsters make messes of their own and other peoples' lives, and monsters beget monsters and monstrosities.

*Louise Claudel might have called Camille her prodigal daughter. (Sweet beauty becomes a haunting face.)*

*'You waste our money and my dream of perfect girls. I hate imagining your body, too much perspiration, sweating in artistic labour, in the unconjugal embrace of Rodin.'*

*Camille Claudel authored 'The Waltz', a man and woman clinging prodigiously together. Is madness as effortless as ballroom dancing and the social skills that escaped you once both are trained into a person, becoming second nature? Unnatural woman, even your supporters called you monster.[4]*

*Camille, camellia, cameo. So prodigious a spectacle of nature's roselike masquerades that she exceeded the sanity of gardens.*

*Simply, a gem, carved in relief so low that sometimes we cannot distinguish her features – from Rodin's, from madness – especially in profile.[5]*

As Diderot answered his own question, 'What is a monster?', it is 'a being whose duration is incompatible with the existing order'.[6]

Margarett Sargent's compatibility with the predominant social mores for her sex and class was generally dubious to negative. Born into a Boston Brahmin family in 1892 and dead in 1977 from the particularities of age brought about by mental illness, shock treatment, medication, strokes, alcoholism, and the severe disappointment in herself from not continuing her artmaking into mid-life and beyond, Sargent created a flourishing career, first as a sculptor, then primarily as a painter. She stopped painting in her early forties. Her words or parts of her life, drawn from her granddaughter Honor Moore's biography of Sargent, *The White Blackbird*, open each following section of 'Making a mess'. Modernist discourse has not chosen Sargent as a star, but she fits perfectly into its trajectory of expectation, for life and narrative trajectories do parallel one another.

I celebrate, develop, and counter Sargent's life with discussions of Carolee Schneemann, who has worked in many mediums, and painter Joan Semmel. I am interested in contrast and overlap, ways in which the lives and art of these living women artists who have been innovators, along with Hannah Wilke, of female and feminist pleasure in visual representation, are escaping the modernist model so poignantly lived by Sargent and simultaneously can be or have been sucked into it.[7]

One of Moore's primary intentions, as a creative woman, a writer, and a loving granddaughter, was to discover, for herself and other women, how to be a woman and an artist and not go mad. This, to my knowledge, is a unique motivation and approach to authoring the biography of an artist. Moore's intimacy with her subject, and her intimate statement of purpose; her pleasurable engagement in Sargent's sensuality and sexuality; and Moore's fear of going crazy, failing in body/mind, and the resultant effects on one's art: all contribute to an exceptionally fascinating, useful, and troubling volume to study in regard to the pleasures and pains of women artists' messiness.

Despite the fact that in the past three decades the art world has more than modestly accepted the content of women's lives in their art, modernist discourse underlies art-world ideas and practices that characterise women's messiness as a bane rather than a pleasure or that glorify and reward certain kinds of messiness — masochism, victimage, and hysteria — in women's art because they demonstrate that women themselves are a mess. Within the modernist configuration of mess and monstrosity, Semmel and Schneemann are especially relevant figures. They are sexually present as women, and their sexuality — as soul-and-mind-inseparable-from-the-body — resonates in their art's imagery, subject-matter, and content. Sexuality as a much narrower life/art element has contributed to the fine reputations of men, such as Dante Gabriel Rossetti, Auguste Rodin, Egon Schiele, and Pablo Picasso. Because Semmel and Schneemann are living artists, critics' and biographers' words have not yet frozen the women's lives into discrete modernist patterns. The two exist in a discursive limbo in which trajectories of pleasure and success are as yet undetermined.

Margarett Sargent was one of numerous women artists in Boston when she began making sculpture in 1914. By 1916 her sculpture career had blossomed. Her first solo exhibition, of sculptures and watercolours, opened in New York in 1926. Painting became Sargent's deepest love, and her depictions of contemporary figures vibrate with the spare intensity of accentuated line and often aggressive, dramatic colour that art professionals characterise as modernist style. She herself was acutely alive with wit, daring, beauty, and charisma. Sargent was at her most productive at age 38.

> *Children say, There's a monster under my bed*
> *Women say, There's a monster in my bed and I am she*
>
> *Sexed hexed*
>
> *A mess becoming a wreck that moves unwittingly at breakneck speed*
> *To madness, masochism, victimage, hysteria*
>
> *Monster, you are full of shit, modernism's mountain of doom*
> *Monster, I will love away your excremental value*

*Monsters, we are a mess of trouble*
*When we satisfy the beauty of our own desires*

### Erotic beauty

'Her deep voice telling him about a new pair of *extraordinary* chartreuse pumps.'[8]

The artist describes shoes to one of her lovers. Seductive voice, stunning accessory; colour and seeming inconsequentiality: all weave into a luxuriously erotic and playful image evoking Sargent's sensual originality, personal beauty and glamour, wildness, rich engagement in sexual activity, and genius for pleasure.

Nancy Cusick has paraphrased art historian Richard Shiff as saying that 'the public does not want its artists to act and dress like ordinary people, but to reveal themselves externally'.[9] Modernist myth consigns the artist as a spectacle to public consumption. The female artist does well to wear the external sign of femininity – beauty. In her late teens, Sargent created herself as a beauty after plainness in child-hood and her early teens, and many famous women artists have been, like Sargent, extremely aware of their beauty – Eva Hesse comes to mind – and have provoked responses to their appearance that biographers and scholars enthusiastically docu-ment. Frida Kahlo, Georgia O'Keeffe, and Louise Nevelson are outstanding examples. In some cases, critical and popular reaction to male artists' portraits of women artists with whom they are intimate makes life the stuff of legend, as we see with Rossetti's glamorising, often seductive representations of Elizabeth Siddall and Alfred Stieglitz's stylistically lean yet sensuous images of O'Keeffe.

Moore's assessment of Sargent's beauty also encompasses her grandmother's artistic talent and skill, her aesthetic flair in various aspects of living, from interior design to gardening to organising and hosting parties: Moore says, 'I want something this grandmother has', her sensuous and original taste.[10] Many women would delight in that attribute. Semmel describes herself as 'a very attractive' younger woman, and photographs confirm this. I remember admiring Semmel, born in 1932, boldly beauti-ful in a black cape in 1986. She projected cocksure sexuality, and in the videotape *Joan Semmel: A Passion for Painting* (1995), she is radiantly formidable. In a conversation between us in 1992 she spoke about her long-term love of 'sensual ethnic' clothing, its colours and flow, its accentuation of her body, her 'self-presentation as a [younger] woman' being comfortably 'dramatic, exotic, sexy'. In 1992 Schneemann said to me, as she sat in a miniskirt and heels in her loft at age 52, that she still had great legs. That same week another woman artist in her fifties told me that Schneemann's body was 'perfect to begin with and perfectly maintained' and that 'Carolee . . . personifies the goddess'.[11]

Semmel and Schneemann, neither of whom has led a 'modernist' wild life, have recognised and enjoyed their physical and sexual attractiveness, and the elo-quence, candour, and graphicness that they use when speaking and writing about sex and sexuality are fundamental in their art. Each has used her own body in her art; Semmel in a series of monumental, headless, nude self-portraits and depictions, also nude, of herself and a male lover (1971–75) and in a locker-room and sauna series of female nudes (1988–90); Schneemann in her 1965 film *Fuses*, in which she and her male

partner make love, and in numerous performance, photographic, video, and mixed-media works from her student years to the present.

'At nearly twenty-four', writes Moore, 'Margarett knew the power of her looks.' Into her fifties, this awareness — not simply her appearance — was a large part of her charisma. From her twenties on women and men responded 'to the sexuality that infused her speech, dress, and movement', and, a married woman from age 28, she had many affairs, with women and men. In mid-life, they were often younger than herself.[12] In 1919 she drew a heterosexual couple having sex as she unabashedly watched them. In 1971–73 Semmel drew and painted heterosexual couples as she and other artists observed their lovemaking in a professional studio situation. Rodin, a woman-iser, drew cunt after cunt, object of his lust and satiation. Rossetti, another woman-iser, painted covert erotica, woman-as-flower-as-cunt.

According to Betty Parsons, the well-known gallery-owner who met Sargent in 1919 and became a lifetime friend, Sargent was 'a highly sexed woman'.[13] The meaning of 'highly sexed' is not as self-evident as it may seem. A person can be highly sexed and monogamous or highly sexed and fucking hundreds of people. The phrase has more to do with passion, sexual confidence, and vulnerability to the erotic than with any drive towards conquest of bodies or counting up numbers of them fucked. A highly sexed person may well love sex and looking and feeling sexy. Semmel and Schneemann, like Sargent, and, of course, Kahlo, fit this definition. Feeling attractive and beautiful is important for an individual's well-being. It is not simply a contemporary cultural imperative for superficiality, people conforming to conventional pictures of beauty. Kahlo, Nevelson, O'Keeffe, and Sargent looked extremely different from one another. Sargent, with her moneyed elegance and *haute couture* fashion, would seem the most conventional of the four, yet her overt sexiness, 'fauve majesty,' wicked humour, and love of the *outré* — at 19, after returning from her first trip to Europe, she stripped her room of curtains and flowered wallpaper and decorated it in cement-coloured paint and a Cassatt pastel — register upper-class taste and beauty as sophisticated mess, as a form of monster/beauty.[14]

Woman is a sign of beauty. But when a woman is a monster/beauty, she destabilises both beauty as a sign of order and female loveliness as the perfection of the Knidian Aphrodite, Gauguin's vision of Tahitian flesh, the delicate sensuality of Rococo honeys, or the vapid blondeness of a Vanna White. Monster/beauty breaks the rules of passive female beauty: she is a wildness that aggressively calls attention to herself and demands response.

*Hold this asana. Flex and stretch, breathe evenly, which calms your mind, so that you can understand the meanings of sensation. Practise a concrete process of knowing the present in order to rearrange the shape you're in, which means remembering; without the painful posturing and deforming poses that have crushed your diaphragm and constricted your throat, that cause the general muscular tension that has made the word pleasure so difficult for your kissable lips and body to pronounce.*

Sargent and Claudel were wild girls. Moore recounts various incidents from her grandmother's wild childhood, which could be summed up by the following sen-

tence about Sargent at age 9: 'The Weld boys down the road [from Wareham, the Sargents' summer home] . . . named their rabbits Thunder, Chained Lightning, and Margarett Sargent.' Reine-Marie Paris writes that 'at an early age Claudel molded clay with a wild instinct'.[15] Wildness not as modernist discourse's ultrasexualised heroics, but as eros arrived full-blown in childhood as irrepressibility, untameableness; eros full-blown yet exacting, beyond reason, greater expansion.

    The richest beauty is monster/beauty, erotically saturated with a twist, a 'flaw', a nastiness of attitude or appearance, which shows up the blandness of a passive ideal. So she must suffer for breaking the rules of decorative beauty, which, like Matisse's 'armchair' aesthetic, is to provide comfort. Monster/beauty recalls the eighteenth-century sublime by inspiring terror. She is also avant-garde allure, existing always in advance of the broken heart of art as order-out-of-chaos. Beauty is a sign of art, monster/beauty a demonstration of cutting-edge art, a knife into the viscera of convention, the risk of full-blown eros.

    Hours and effort go into erotic self-creation. For good reason, feminists have severely critiqued women's expenditure of energy on the superficial benefits of cosmetic − decorative − beauty. But feminists do not think in terms of erotic self-creation, which, more than simple physical beauty, makes some women intimidating, targets of envy, anger, and yearning. An eros-negative society has made people expect themselves and others to succumb to a thanatic reality that, following cultural demands, the populace itself produces. Monster/beauty in the body/mind of a woman artist has not succumbed, and this is a heroic effort and accomplishment. It is one reason why Kahlo is a legend, and why Schneemann and Semmel, in developing the erotic throughout their art and lives, merit praise. Monster/beauty maintains a dangerous position, for life − misogyny, the art world, societal stupidity about old(er) women − and modernist discourse mete out punishment.

*Suffering, loneliness, and often death are the monster's due in the Western tradition: Medusa, Dr Frankenstein's experiment, Dracula, and Marilyn Monroe are exemplary.*
    *Be Warned*
*Sargent and Claudel were institutionalised for mental illness.*
*Siddall overdosed on laudanum.*
*Hesse was relentlessly and painfully obsessional and she died of a brain tumour.*
*Kahlo painted self-portrait martyrdoms in orthopaedic corsets and tears, as a deer shot with arrows, paintings that come from bodily injury, a street-car and bus accident that smashed her pelvis, fractured her spine, and broke her foot.*
*Ana Mendieta was pushed − fell? − from a fourteenth-story window to her death, dying young, 'prematurely', like Hesse and Siddall, in her thirties, into a modernist martyrdom built on a foundation of Romantic myth.*
*None of these artists, including O'Keeffe and Nevelson, had a normative, model marriage. Separation, divorce, the disturbance of affairs or professional jealousies characterise monster/beauty's marriage.*

*Many of the monster/beauties were involved in affectional and physical relationships with women as well as men.*

*Only Sargent and Nevelson were mothers.*

*Tragedy upon 'abnormal' femininity upon chaos: narrative and gender negatives that shape a sad myth of the woman artist's life.*

Semmel and Schneemann are both divorced. They have lived the dignified and often difficult lives of women who support themselves economically, of artists who work hard in a discipline that has not welcomed women whose unspectacularly messy — not chaotic — lives are easy for other people to identify with. Through modernist myth, the reader must long for oddity, not regularity.

Mild beauty is orderliness, while monster/beauty is the order of chaos, an aesthetic of messiness. Perhaps their challenge to erotic death has kept Schneemann and Semmel from the monetary and gallery- and museum-exhibition success that the quality and originality of their work deserves. Schneemann has not had consistent gallery representation, and until autumn 1996, with The New Museum of Contemporary Art (New York) Schneemann retrospective, neither artist had had a solo exhibition at a highly visible museum. For Semmel, an academic position has provided financial stability when she did not have gallery support. Schneemann has sold works only to two public institutions, both museums in the United States.

Intelligence compounds the erotic beauty complex. In a 1932 interview with the tabloid *Boston Sunday Post* reporter Louise Tarr, who was friends with Sargent, the artist says, 'Intellectual sensuality is the most rare and the most *devastating*.' Moore writes, 'The interview was a performance, and Tarr must have heightened the drama in her text.' Although Moore suggests that Sargent's remark may refer to Roland Balay, one of her lovers, it describes the artist herself. Parsons says, 'She had such magnetism, Margarett. Such physical magnetism plus that fantastic, witty brain. The combination was just *devastating*. You could see them being knocked down, right and left.'[16] (My italics in both sentences.) The devastator not only destroys but also makes helpless. With intellectual depth and fervour, Semmel and Schneemann have been working to neutralise men's control of the female nude, in both its high-art and pornographic representations. The achievement is at once aesthetic and more broadly cultural.

A Semmel figure from the early 1970s might be purple, green, blue, or yellow, an acid, eerie, even corpse-like colour that has murdered the female nude's frequently pearly refinement. Unnatural colour disruptively abstracts the historical idealisation — an abstraction itself — of female form and gives Semmel's single nudes an unexpected sensuousness, which, because the bodies extend beyond the canvas's edge, customary boundaries cannot contain. Surprising perspectives activate reclining figures whose heads Semmel never depicts. Rather than rendering her nudes into dumb flesh, this device forces awareness of the head, of intelligence, especially when she positions the figure in such a way that audience and subject share the same view, the same pleasure, not only in looking but also in a thinking observation of the female body as a seat of consciousness.

Apocryphal anecdote of a legend in the making, heard by me between 1972 and 1974 when I was Director of Artemisia Gallery, a women-run alternative space in Chicago: Semmel rented the gallery at 141 Prince Street, in New York's SoHo district, because no New York gallery she approached would exhibit her nudes. When men at the gallery threshold saw her boldly observed and coloured figures, they turned around and left.

Semmel's thinking observation of the female nude occurs, too, in the 1988–90 series. Semmel confronts the almost total invisibility of the old(er) female body in Western art by representing the reality of 'unfit' flesh in the female community of the locker-room and sauna. 'Unfitness' devastates the normative 'perfection' of both the historical nude and today's lithely muscled ideal.

Schneemann has consistently devastated habitual ways in visual culture and art of knowing women's bodies and pleasures. Her pornerotica is never standard pornography's exclusivity of outcome – one-shot orgasm – or extreme primacy of sight as proof of pleasure. Pornerotica gives the viewer visual and quite likely sexual pleasure, for the erotic can be prurient, and I see no problem with that. High art and prurience are not mutually exclusive. In standard pornography, seeing is believing, but with Schneemann, seeing is non-hierarchical, is relational, and orgasmic or ecstatic experience is continuous. *Known/Unknown* (1996) (Figure 30) is a video madrigal in which thirty-eight 3-second images, on two separate tapes, recycle at different intervals. The number and counterpoint of images, mostly non-sexual, create erotic headiness and mess. One image is of a penis and vagina in erotic embrace: no cum-shot, no ability on the viewer's part to know if either the lovemaking man or woman is coming.

30    Carolee Schneemann, *Known/Unknown*, 1996, videotape installation

*Fuses* is a beginning marker of women's pleasure deliberately represented in art by a woman. Ambiguous and explicit images of Schneemann and her lover flash and flow by. Close-ups of penis and vulva recur, but genitals are not the focus of sensation. Because Schneemann cut, burned, baked, and painted the film and dipped it in acid, spurts, bursts, and darting and streaming forms act with the lovemaking bodies and glistening genitals in a collage whose optical dynamism surprisingly displaces the primacy of the visual into an oceanic sensuality whose aural counterpart is waves punctuated occasionally by the voices of birds. An inter-subjective model of human relationships has been posited by feminist theorists, such as Jessica Benjamin, in contrast to traditional psychoanalytic theories' dominating and regulatory models.[17] In *Fuses* and throughout her career Schneemann creates an inter-subjective rather than surveillance model of understanding bodies, so that psyche, appearance, and sensation are given the integrity in which they actually exist.

Schneemann's work was censored over thirty times between 1965 and 1995, mostly in England and the United States.

'The essence – aristocracy, intellectuality, vulgarity', said Balay of Sargent.[18] The essence of Semmel and Schneemann: aristocrats of eros proving the pleasures of soul-and-mind-inseparable-from-the-body by using, among other idiomatic messes, the vernacular of sex acts and naked bodies. In contrast, visual and verbal postfeminist discourse has featured a more than occasionally brilliant, though often disembodied, pleasureless language of distance.[19]

Monster/beauty: the genius of pleasure who, because she will be punished, must develop stamina, a will to pleasure.

### Madness

'Mrs McKean [Margarett Sargent] possesses superior intellectual endowment and abundant creative artistic talent, . . . but it would appear she has always been emotionally labile, eccentric, opinionated, egocentric and not a little sadistic.' This is from a report written in 1962 by a doctor at New York's Regent Hospital. 'He concluded', states Moore, 'that Margarett suffered from four illnesses: manic-depressive illness; alcoholism; cerebral arteriosclerosis and associated "senile changes"; and basic psychopathic personality.'[20]

As a child Sargent endured 'harrowing' headaches and nausea. In her teens a headache came in thwarting or self-assertive situations. Moore says of Sargent's adolescence, 'The more she made her desires known to herself, the more brutal, it seemed, the attacks became.' Throughout her life, intense feeling brought suffering. Painting was pleasure, but became unbearably painful. 'Why *did* you stop?', Moore asked her 82-year-old grandmother. The former painter answered, 'It got too intense . . . For twenty years I worked . . . and then I turned to horticulture.' Looking at scrapbooks filled with reviews of her art, Moore perceived Sargent question herself, 'inconsolably', 'Why did I ever stop?'[21]

With the feminist understanding that a woman's departure from feminine and female obligations has been called and clinically treated as madness, and attributing her grandmother's mental state to her conflict between being an artist and being a woman in an old and upper-class Boston family, Moore assesses Sargent's loss of power as 'the collision of talent and illness, of an uncommon woman with a particular historical circumstance'.

Moore sees her grandmother as 'a woman who has given up'. But the granddaughter emphasises: 'Oh, yes, I understand – that kernel of pain in my own head. A feeling starts to hurt and you have no words for it . . . Must I "go mad" as you have? What must I do to live fully both as an artist and a woman?'[22] What must I do to not make a mess of my life?

Sargent was a bad wife – affairs – and a bad mother: one of her sons said that if the house was burning down, she would have grabbed a Renoir rather than a child. Sargent was a good drinker. Drinking enhances the male artist, such as George Luks, her mentor and close friend. The male artist drinker is supposedly wild, tough, devil-may-care, sexy, and dangerous: he is an icon of masculine ecstasy, the best kind of messiness. Never mind his self-absorbed chatter, egotism, and boring emotionalism, for they are not the stuff of myth, which shores up his mess. The female drunk is simply sloppy, self-indulgent, and sexually usable.

Modernist discourse and modern life do not require male artists to be domestic – good husbands or good fathers. Virility requires fucking/fathering, not fatherhood. Besides, the male artist is supremely creative, so he is a terrific mother anyway. As artist June Wayne and art historian Christine Battersby have written, over a decade apart, the male artist usurps female and feminine characteristics and transforms the negative into the positive. Within the paradoxical, ironic, and frustrating gendering of genius and of successful modern artmaking what elevates men's reputations demeans women's. In Battersby's terms, a genius must be like a woman but not a woman.[23]

Madness is messiness. The mad genius is a man. When a woman exhibits madness, she is just plain mad. The mad genius is apparently able to sustain pleasures, even when they conflict with social mores. For he is the standard-bearer of pleasure, the master of his own pleasure and the creator of others' pleasure through his art.

Women as subjects, agents, and investigators of their own pleasure? Disallowed. Woman's pleasure as mess and chaos, animalistic and devouring, as manic ecstasy; woman as celebrant of Dionysus: that is not what we see in Semmel's or Schneemann's works, where pleasure is comfortableness with and in the body, not a maenadic out-of-body experience. A classic inaccuracy, the Dionysian model of feminine ecstasy.

Schneemann's and Semmel's pursuit of pleasure in erotic self-creation and artmaking radically distinguishes them from Sargent. They have not escaped into horticulture – Sargent's garden knowledge and her landscape designs, for herself and friends and then executed professionally, were superb – in order to plant and maintain paradise

elsewhere than art. In her fourth year at Miss Winsor's School, which Sargent entered at age 12, Miss Mary Pickard Winsor herself wrote to the Sargent family home, in the recollection of Sargent's brother, Dan, 'I'm afraid we can't take back your daughter Margarett. She's a born leader, but unfortunately she always leads people in the wrong direction.'[24]

That's the trouble with monster/beauty artists: they can't seem to move in an approved direction; they are out of line, out of order, signs of disorder, so art historians, artists, and art critics may overlook or ignore their influence, exclude them from art-historical lineage. *Art in America* and *New York Times* reviews of Patricia Cronin's paintings of lesbian lovers, at Richard Anderson Fine Arts in spring 1995, do not credit Semmel's obvious influence as an artist – headless close-ups – or as a teacher – Cronin studied with Semmel in 1991 at the Skowhegan School of Painting and Sculpture.[25] Also, Semmel continued to paint during the postfeminist proliferation and lionising of appropriationist imagery, text-and-photo works, and theoretical positions and writings that advocated eliminating the female body from representation, and that condemned painting as the wrong direction for women because it was *the* high-art tradition – exclusive, patriarchal. Despite Schneemann's use of postmodern mediums, she has been taken to task for 'essentialising' the female body and exploring the Great Goddess.[26]

Both Schneemann and Semmel, along with many other women artists who made a name in the 1970s, have also been criticised for presenting so-called positive views of women, thus excluding horrors and daily damage in bodily real life, such as rape, incest, and eating disorders. Social relevance is not necessarily aesthetic necessity, visual pleasure, or a much-needed radical vision of women's pleasure, as too many postfeminist 'hurts-so-good' artworks have demonstrated.

When skilled artists exemplify this genre, unpleasure becomes a beautiful or exciting sign of femininity. Karen Finley's ranting performances, Kiki Smith's poignant though shame-filled sculptures, Sue Williams's sexual abuse paintings, and Cindy Sherman's ludicrous and chilling photographs, all high-priestess expressions of the hurts-so-good genre, reflect cultural pathology, but reflection is reproductive and, in these cases, possibly pathogenic. Repute gives authority to images of women's pain, which may move viewers to contemplation of social realities and even to activism. But reflective art treats the social as static, and images of women's pain can become a predictive model of future stagnation. That model feeds into the Dionysian model, which sacrifices everywoman's pleasure to the patriarchally sacred notion that female means excessive.

Madness is excessive. It is some women's answer to social demands for their tidiness. Women bound within the house of desire put madness in the place of pleasure. Desire may feel horrible but it is tidy: 'The more she made her desires known to herself, the more brutal, it seemed, the attacks became.' Desire manages the mess of pleasure. Self-attack is desire getting the best of pleasure.

Julia Kristeva's interest in male avant-garde writers such as Celine, Joyce, Lautréamont, Mallarmé, and Artaud, whose language, she says, operates from the semiotic, which she associates with the feminine and with the possibility of ruptur-

ing the symbolic order, situates feminine creativity without women and the male genius in a transgressives' hall of fame: be like a woman but not a woman.

Such transgressiveness is in excess of the symbolic order. For women, excess(iveness) is too easily normative, not disruptive.[27]

### Abundance not insufficiency

'It wasn't the pictures that had sustained her, but the act of painting.'[28]

Sargent's pleasure was in the process. Artistic process builds a trajectory of pleasure through mixing pigments, objects, materials, images – matter/idea, body/mind. Mixing is messy, because you never know what the outcome will be. Messes may be signs of excess, the always unnecessary. So, ironically, they may be the mark of insufficiency. Messes may also be signs of abundance, which is an erotic necessity. The hurts-so-good genre seems to display only enough, what modernist discourse finds attractive and tolerable. Also, when women make a mess they do disturb the culturally imposed normalcy of female tidiness: don't smear your lipstick or run a stocking; don't let a bra-strap show or keep a sloppy household.

Semmel's *Overlays* series (1972–92, 1994– ) comes to mind. There she paints old(er) female bodies from the locker-room and sauna series over the fucking figures of twenty years earlier. While melancholic longing pervades the paintings, the messy pleasure of painting, co-opted and theorised by men as their terrain, vitalises each piece and makes clear the connection between the erotic, the optical, and the aesthetic and the fact that the artist of *Overlays* is a sexual being. Schneemann's collaging or 'madrigaling' of materials and images in a fluid, unfocusing process messes up aesthetic and social decorum by composing, on her own terms, what art historian Kristine Stiles calls the 'passage of lived rather than observed life'.[29]

Messiness is also evident in the series in that paint sometimes resembles cum. Pigment is not simply the metaphoric ejaculation of men but also the exclamatory pleasure of the female painter. Since 1994, *Overlays* continues from scratch the representation of older bodies, small figures laid over large, fucking couples, transparency of pigment, and emotional yearning. The surfaces are fragile – cumlike, bloody, and also evoking ether and sunlight. Here, the power of looking – at sex; at physical and emotional relationships both held fast and undone; at women's and men's bodies, young(er) and old(er) – aggressively deals with melancholy: pleasure is at play, available for the long run. In *Long Distance Swimmer* (1996) (Figure 31) a muscular woman swimmer, the dark pollution of Lower Manhattan, huge, voluptuous day lilies, a hand holding a serpent, and a female nude – head ecstatically tossed back, painted in the same register/overlay as a chimpanzee – represent, in Semmel's words, a 'struggle for the woman to retain her sexuality, to fight the beast', which is the 'phallic city' of the art world, commerce, trendy styles, and misogyny, the system that deems women who do not and cannot follow its demands dead or virtually so.[30]

Because the house of desire is a tidy place, admonishments are its watchwords: don't bleed inappropriately, eat too much chocolate, play with cum, your own or others', or you'll get fat and dirty with pleasure.

31   Joan Semmel, *Long Distance Swimmer*, 1996, acrylic on canvas, pieced border, 170cm × 140cm

Based in Laura Mulvey's disquisition on visual pleasure as male territory, in Irigaray's still influential declaration that woman's pleasure is unrepresentable within phallogocentric discourse because her *jouissance* (most resonant and intense pleasure) is inarticulable, irreducible to representation, and inadvertently in the theory and practice of pleasure and pain as necessary correlates, academic and art-world feminists have negated, screened, silenced, constrained, and marginalised women's pleasure – have barely begun to develop a feminist, female erotics – and have capitulated to pain. Irigaray's feminine as 'disruptive excess' and Mulvey's analysis of the male gaze, fascinating and useful as they have been to feminist theory, have inadvertently contrib-

uted to keeping women in place as Dionysus' and Apollo's silent partners, no matter how much they scream in sexual pleasure, in rage or pain.[31]

'Feminine ecstasy' or masculinised rationality: choosing only from extremes is no pleasure. This 'choice' keeps monster/beauty a prisoner of desire. So does modernist discourse.

The 1980s dissemination in the United States of 1970s French feminist thinking about desire contributed to the phenomenon of women's desire as well as their unrepresentable *jouissance* becoming substitutes for satisfaction. Women's *jouissance*, though inexpressible, could, according to Irigaray, be fathomed in terms of multiplicity in contrast to men's big bang of ejaculation; this pinpoints male satisfaction and reduces men to machines, while submerging women in an infinite and aphasic, dismissible pleasure.[32]

Pleasure is the finite as well as the infinite. It is, like art, their mixture, a process.

Desire, from Latin *desiderare*, probably, to long for the stars. If women stay locked in desire, they will wait a long time for pleasure. Writing about Joyce Kozloff's *Pornament Is Crime*, Linda Nochlin makes pleasure a stargazer's affair: she calls pleasure 'that most desirable and elusive of experiences'.[33] Desire implies an unrealisable, even baffling goal and the pain of waiting. Desire is a speculative condition.

Desire is an illusion that puts pleasure in crisis.

The recuperation of messiness for women puts modernism in crisis.

Semmel says that she had never felt like she was going mad. She has been 'confronting the system as it exists. Direct and intentional confrontation. From day one.'

Schneemann says, 'I flipped out in 1969 and was barely functional for several years in London.' In a session with her therapist Oscar Kollerstrom, who was 'incredible – old, radical, tender', an image in motion came to her: 'a rainbow of dead women, Woolf, Modersohn-Becker, Fuller, Bashkirtseff, all of them. I knew I was leaving him, I was cured.'

> *A bridge from earth to heaven*
> *Healing     Defiance*
> *Knowing the dead the dying*
> *The success of a messy life*

## Notes

1   Christine Battersby's *Gender and Genius: Towards a Feminist Aesthetics* (Bloomington, Indiana University Press, 1989) has been invaluable for my thinking about modernist discourse and genius.

2   Feminist theorists' recognition of the need for a revolution in the symbolic order, in representation, led many away from writing experiential pleasures and (as) real bodies. A politics of experience, equated by some critics with 1970s activist feminism, which in the United States often grew out of consciousness-raising groups, was called naive. See Jane Gallop,

'*Quand nos lèvres s'écrivent*: Irigaray's Body Politic', *Romantic Review* 74: 1 (1983), 83, on such naivety; Toril Moi, *Sexual/Textual Politics: Feminist Literary Theory* (London, Methuen, 1985), 135, regarding Luce Irigaray's analysis of woman's lack of access to the pleasure of self-representation; and Jessica Benjamin, 'Woman's Desire', in Benjamin, *The Bonds of Love: Psychoanalysis, Feminism, and the Problem of Domination* (New York, Pantheon, 1988), in which she says, 'Insofar as a woman's desire pulls her toward surrender and self-denial, she often chooses to curb it altogether', and, concerning self-representation, 'The element of agency will not be restored to woman by aestheticizing her body – that has already been done in spades.'

3   See Marie-Hélène Huet, *Monstrous Imagination* (Cambridge, MA, Harvard University Press, 1993), 6, for a brief discussion of Western traditions that connect the monster with ideas of warning and showing.

4   Anne Higonnet, 'Myths of Creation: Camille Claudel and Auguste Rodin', in Whitney Chadwick and Isabelle de Courtivron, eds, *Significant Others: Creativity and Intimate Partnership* (London, Thames and Hudson, 1993), 26, writes, 'The most sympathetic critics put her gender in conflict with her talent. [Octave] Mirbeau called her "A revolt against nature: the woman of genius."'

5   See Higonnet and see Anne M. Wagner, 'Rodin's Reputation', in Lynn Hunt, ed., *Eroticism and the Body Politic* (Baltimore, Johns Hopkins University Press, 1990), for feminist discussions of their subjects. Reine-Marie Paris, *Camille Claudel* (Paris, Gallimard, 1984), is a biography.

6   Diderot, quoted in Huet, *Monstrous Imagination*, 89. Some contemporary women have figured themselves in their art as monstrous – confrontationally excessive and, for many viewers, difficult to enjoy. Obvious examples are Cindy Sherman's 'Disasters' and 'Fairy Tales', Orlan's operating-room documentation of her cosmetic surgeries, Jo Spence's photographs of her midlife body after breast-cancer surgery, and Hannah Wilke's drawings and photographs that show weight-gain from cancer treatments and bandages from a bone-marrow transplant. Listing these 'obvious' works, I'm struck by the fact that physical transformation as violence predominates. This demands elaboration not only through consideration of violence to women as a social reality and to art-historical and popular canons of the aestheticised woman, but also through discussion of monstrous self-representations that differ from those that use or suggest disease, breakdown, mutilation, and the hospital. Camille Claudel portrayed herself as a mutilated monster, the Medusa's head, in her 1902 'Perseus and the Gorgon'.

7   Wilke died in 1993. For substantial consideration of her importance regarding female and feminist pleasure see my *Hannah Wilke: A Retrospective*, ed. Thomas H. Kochheiser (Columbia, University of Missouri Press, 1989), and 'Hannah Wilke: The Assertion of Erotic Will', in my *Erotic Faculties* (Berkeley, University of California Press, 1996).

8   Honor Moore, *The White Blackbird: A Life of the Painter Margarett Sargent by Her Granddaughter* (New York, Viking, 1996), 223.

9   Nancy Cusick, 'Steel Wool Peignoir', in Judy Seigel, ed., *Mutiny and the Mainstream: Talk That Changed Art, 1975–1990* (New York, Midmarch Art Press, 1992), 189.

10  Moore, *The White Blackbird*, 5.

11  Joan Semmel and Carolee Schneemann, in conversation with the author, June 1992. The artist who made the statement about Schneemann did so in a conversation with me in June 1992, and wishes to remain anonymous.

12  Moore, *The White Blackbird*, 112, 113.

13  *Ibid.*, 161.

14  *Ibid.*, 256, quotes the playwright William Alfred, 'She had . . . fauve majesty.' *Ibid.*, 55, quotes Sargent's old friend E. Ames about the Cassatt/cement décor: 'It was very *outré*.'

15  *Ibid.*, 25, and Reine-Marie Paris, *Camille Claudel* (Washington, DC, The National Museum of Women in the Arts, 1988), 13.

16  Moore, *The White Blackbird*, 113, 219, 222.

17  Benjamin, 'Woman's Desire', particularly 45–50.

18  Roland Balay, quoted in Moore, *The White Blackbird*, 168.

19  Barbara Kruger's phototext works from the early 1980s set a postfeminist visual standard for coolness. Over and over in theoretical writing the reader finds authors bound to and in texts – their own and those of male thinkers – in a frustrating masturbatory practice. 'Rational male' scholarly narrative predominates. 'Orgasm' as intellectual and/or experiential fulfilment of desire and as the pleasure of one's separate pleasure – a pleasure in which one finds her identity in herself and another rather than losing her identity in inarticulable *jouissance* or in another's words – rarely occurs. One of numerous examples of distant discourse is Alice Jardine, *Gynesis: Configurations of Woman and Modernity* (Ithaca, NY, Cornell University Press, 1985), in which, ironically, the author becomes possessed by the philosophers she critiques as practitioners of gynesis, the possession and creation in language of woman's body. Or witness Elizabeth Grosz, 'Animal Sex: Libido as Desire and Death', in Grosz and Elspeth Probyn, eds, *Sexy Bodies: The Strange Carnalities of Feminism* (London, Routledge, 1995), remove herself from the possibility of pleasure that she offers – the relation between her own sexual pleasure and her theorising female sexuality. Exceptions to the dearth of pleasure are Trinh T. Minh-ha, 'Grandma's Story', in Minh-ha, *Woman, Native, Other* (Bloomington, Indiana University Press, 1989); Arlene Raven, 'Harmonies: Harmony Hammond', in Raven, *Crossing Over: Feminism and Art of Social Concern* (Ann Arbor, UMI Research Press, 1988); and my 'Mouth Piece', in Frueh, *Erotic Faculties*. Also see Valerie Solanas, *S.C.U.M. [Society for Cutting Up Men] Manifesto* (New York, Olympia Press, 1971), for a passionate and wildly pleasurable early example of Second Wave feminist theory.

20  Moore, *The White Blackbird*, 306.

21  *Ibid.*, 42–3, 246–7.

22  *Ibid.*, 4, 7, 308.

23  See Battersby, *Gender and Genius*, and June Wayne, 'The Male Artist as a Sterotypical Female', in Judy Loeb, ed., *Feminist Collage: Educating Women in the Visual Arts* (New York, Teachers College Press, 1979); originally published in *Art Journal*, 32:4 (1973), 128–37.

24  Moore, *The White Blackbird*, 35.

25  Mira Schor, 'Patrilineage', in Joanna Frueh, Cassandra L. Langer, and Arlene Raven, eds, *New Feminist Criticism: Art, Identity, Action* (New York, HarperCollins, 1994), discusses how 'current canon formation is still based on male forebears, even when contemporary women artists – even contemporary feminist artists – are involved'.

26  One example is David Joselit, 'Projected Identities', *Art in America*, 79:11 (1991), 116–23.

27  See Julia Kristeva, *Desire in Language: A Semiotic Approach to Literature and Art*, ed. Leon S. Roudiez, trans. Thomas Gora, Alice Jardine, and Leon S. Roudiez (New York, Columbia University Press, 1980). Rosi Braidotti, *Patterns of Dissonance: A Study of Women in Contemporary Philosophy*, trans. Elizabeth Guild (New York, Routledge, 1991), 229–38, discusses, among other things, Kristeva on semiotics, subversion, and women.

28  Moore, *The White Blackbird*, 308.

29  Kristine Stiles, 'Schlaget auf: or The Problem with Carolee Schneemann's Painting', manuscript for The New Museum of Contemporary Art Carolee Schneemann retrospective exhibition, 1996, 13. Stiles posits that misunderstandings of Schneemann's *œuvre* result from her lack of decorum.

30  Joan Semmel's words here and below were in conversation with the author, 28 August 1996, as are Carolee Schneemann's words below.

31  Laura Mulvey, 'Visual Pleasure in Narrative Cinema', *Screen* 16:3 (1975), 6–18; Luce Irigaray,

*This Sex Which Is Not One*, trans. Catherine Porter with Carolyn Burke (Ithaca, NY, Cornell University Press, 1985); *Ce sexe qui n'en est pas un* (Paris, Minuit, 1977).

32  I love Irigaray's writing and thinking, about both the specificities of the female body and their intimacy with women's language, so my words about her are neither attack nor blaming. An author cannot predict or control the effects or interpretations of her work. Associated by Anglo-American critics with *écriture féminine*, Irigaray came under fire for essentialism, elitism, and utopianism. However, her insistence on sexual difference may be seen as anti-essentialist and, quoting Irigaray, as 'resistance set up against the male imaginary, distortion' that '[gives] rise to discomfort', in hopes that sexual difference becomes visible, becomes heard in language. Irigaray, *This Sex Which Is Not One*, and *Speculum of the Other Woman*, trans. Gillian C. Gill (Ithaca, NY, Cornell University Press, 1985); *Speculum de l'autre femme* (Paris, Minuit, 1974), are influential examples of her *écriture féminine*. Above, I've quoted her words from the last page of *Speculum*, the English edition. See Naomi Schor, 'This Essentialism Which Is Not One: Coming to Grips with Irigaray', in Naomi Schor and Elizabeth Weed, eds, *The Essential Difference* (Bloomington, Indiana University Press, 1994), for an anti-essentialist interpretation of Irigaray, and Margaret Whitford, *Luce Irigaray: Philosophy in the Feminine* (London, Routledge, 1991), especially 'Feminism and Utopia' and 'Subjectivity and Language', for feminist critiques and placements of Irigaray.

33  Linda Nochlin, 'Pornography as a Decorative Art: Joyce Kozloff's *Patterns of Desire*', in Joyce Kozloff, *Patterns of Desire* (New York, Hudson Hills Press, 1990), 12.

# Beauty, the universal, the divine: Irigaray's re-valuings

> In other words, the issue is not one of elaborating a new theory of which woman would be the *subject* or the *object*, but of jamming the theoretical machinery itself, of suspending its pretension to the production of a truth and of a meaning that are excessively univocal.
>
> Luce Irigaray[1]

> This brings to mind the political stake – in the restricted or generalised sense – of this work. The fact that women's 'liberation' requires transforming the economic realm, and thus necessarily transforming culture and its operative agency, language. Without such an interpretation of a general grammar of culture, the feminine will never take place in history, except as a reservoir of matter and of speculation.
>
> Luce Irigaray[2]

The critical investigation or scrutiny of prime modernist concepts – such as those of the autonomy of the artwork, of its ability to speak universally, of its transcendent qualities, and of its beauty lying in its own truth – is usually undertaken in order to discuss what has been seen as opposite, excluded, or counter to those positions. For instance, the ability of high modernist art to speak universally to its audience can be thrown into relief by investigation of the whiteness and maleness of the majority of its practitioners, in order to reveal how practitioners who are black and/or women have had to compromise the articulation of their race and gender, or are seen as compromising modernism itself.[3] In other words, these investigations, crucial as they are as moments of resistance, nonetheless usually take on modernism within its own terms, and particularly through the device of the binary opposition – man/ woman, white/black, universal/particular, transcendent truth/relative truths, meaning in the object/meaning in the context. Rarely are those concepts of the meta-discourse themselves then re-thought, as the structure of the binary opposition, with its inbuilt and inevitable polarisation, does not make this very likely. What this essay will do is to explore how philosopher and psychoanalyst Luce Irigaray has re-thought and re-valued some of the concepts which are key to modernist thinking and prac-tice: beauty, the universal, and the transcendent. I will do this by taking as a starting-point notions highlighted in Irigaray's polemical essay 'How Can We Create Our Beauty?'[4] and reflected across other of her writings. I will then demonstrate how her rewriting of the concepts of universality, transcendence, and beauty can begin to provide a context for the discussion of recent artworks by women which resist categor-

isation in the critical impasse frequently found in the current negotiation of the modernist legacy.

### 'Things could be thought differently'[5]

Throughout Irigaray's writing are moments of what might be called 're-valuing'. By this I mean to indicate that Irigaray not only re-evaluates certain concepts, but rebuilds the terms with different values. Thus, where a concept such as, for instance, 'the universal' as it is generally used has been exposed as being partial, patriarchal, and applicable by and large only to men, Irigaray will explore a viable concept of 'the universal' for women; she will shift what it is that is meant when the word 'universal' is used, in order to demonstrate a concept of universality which is productive for women. Irigaray's body of writing is not anti-modernist, nor postmodernist, nor even pre-modernist, but non-modernist. She writes not from a position of simple opposition, but from a position of complex difference.

The enunciation of Irigaray's thinking happens in diverse ways, the re-valuing of terms being a major one. Her 'complex difference' is far removed from the often simplistic collapse into identity politics (as found most often in the USA);[6] it is the appropriate articulation of political and intellectual difference. Those of us brought up on writing which is modernist or (in reaction against modernism) postmodernist will be accustomed to a writer 'digging deep' through his or her practice, honing and owning a particular style and theme. Irigaray's writing does not do this; it is in turn polemical, rhetorical, ironical, theoretical, poetical, mystical, practical . . . sometimes within the same piece. It is not possible to point to a stylistically typical essay. Additionally, with the possible exception of some of her writings on language and linguistics, she does not espouse a formal academic format. This is a clear strategy on her part: 'It is surely not a matter of interpreting the operation of discourse while remaining within the same type of utterance as the one that guarantees discursive coherence.'[7] This means that while certain pieces of writing might offer particular analyses, poetics, and explorations, in order to grasp the underlying conceptual framework the reader has to read three-dimensionally, so to speak, across essays, layering thoughts, discussions, and writing structures. Through a series of hints – explicit, implicit, and embedded in the form of the writing – the reader arrives at an understanding of Irigarayan philosophy.

For the purposes of this essay I am going to take two major points as read: first, that concepts of beauty, truth, and transcendence within Western high-art practices have been predominantly produced by men; and second, that within this, since the early sixteenth century, one of the major carriers of meaning has been the image of woman. My premise, therefore, is that if one of our culture's major sources of illumination has been male concepts of beauty, then one of the shadows of this beauty consists of a beauty that is produced by, and productive for, women. Further, related to this shadow is another: that of women's development and determination of what constitutes their own beauty. This is not, therefore, simply an aspect of Freud's 'dark continent' of femininity – a metaphor which implies that the territory exists, and all it requires is for someone with the right pioneering or colonising spirit to venture in

and map it out with their predetermined cartographic languages in order for it to be legible thereafter. It is rather a matter of (as Irigaray stated in the title of one of her books) 'thinking the difference for a peaceful revolution' in the production of meaning throughout our culture.

### 'How Can We Create Our Beauty?'

'How Can We Create Our Beauty?' is in *Je, tu, nous: Toward a Culture of Difference*, a book of short polemical essays, each designed to focus on a particular aspect of Irigaray's thinking in order to introduce it to a wider audience and demonstrate its politics. I would like to take 'How Can We Create Our Beauty?' as the focus for a reading across Irigaray's work, which will piece together her discussion of the possibility of beauty which is determined by women. Throughout her work, Irigaray uses terminology which is familiar to us in the various fields of fine-art practice, but it is necessary to remember that she is not using these words in the specialist art-theoretical or art-historical manner (I have discussed her usage of, for instance, the terms 'gesture' and 'performance' elsewhere).[8] Also, when she writes specifically about art she is coming from the position of the non-specialist. Sometimes this can be a real problem, when the model of her thinking is informed primarily by the structures of the literary arts, or when her prime interest is in the psychoanalytic structures demonstrated by the artist, rather than an understanding of the artworks and how they function for an audience. This is the case with 'A Natal Lacuna', which centres on the artist Unica Zürn.[9] At other moments, one's initial frustration with what (to the specialist) can seem like a naive approach to the making of artworks is utterly ameliorated when one traces the development of Irigaray's terminology back through her other writings. By and large I would still maintain that her thinking is of most use to the visual artist when she is *not* explicitly discussing visual art; nonetheless, 'How Can We Create Our Beauty?' is a useful opening, as it does pull together and signal some of those non-visual art concepts.

Irigaray begins by positing her argument in words which are a challenge to many of us who are involved with contemporary art practices. Her terminology can appear naive for a number of reasons. Most of us making or working with art will have taken on board, for instance, Adorno's discussion about the impossibility of lyricism after Auschwitz; or the way an avant-gardist principle of 'épater les bourgeois' has disintegrated into postmodernist horror–chic; or a feminist–realist impulse to 'tell it like it is'; or possibly even the desire for catharsis which can only be achieved at the resolution of a certain order of narrative. Irigaray appears either to ignore or be unaware of the impact of each of these for contemporary art practice. She writes:

> Very often, when looking at women's works of art, I have been saddened by the sense of anguish they express, an anguish so strong it approaches horror. Having wanted to contemplate beauty created by women, I would find myself faced instead with distress, suffering, irritation, sometimes ugliness. The experience of art, which I expected to offer a moment of happiness and repose, of compensation for the fragmentary nature of daily life, of unity and communication or communion, would become yet another source of pain, a burden.[10]

Irigaray uses the rest of the essay to outline in four main points why she thinks women make images of pain, and how women could create beauty. First, she puts herself into the discussion by pointing out that she too deals with pain in her work, but states that she attempts to do so in what she calls 'a literary style' to cushion any potential sense of dereliction in the reader. At the same time she will look for a positive – something which women, 'who have a tendency to identify only with what they lack, their shortcomings', sometimes criticise her for. She says that showing the negative

> is positive and necessary given that it was meant to stay hidden. The portrayal of suffering is, then, for women an act of truthfulness. It's also akin to an individual and collective catharsis. . . . Daring to manifest publicly individual and collective pain has a therapeutic effect, bringing relief to the body and enabling them to accede to another time. This doesn't come as a matter of course, but it may be the case for some women.[11]

She likens the effect of this representation of anguish to the masked figures subjected to fate in Greek tragedy.

Irigaray's second point is that having children is a most wonderful creativity. However, within the male social order there is a particular obligation to do it; and further, a distinction is made between creation, which is reserved for men, and pro-creation, which is deemed of a lesser order. She suggests that 'there would seem to be confusion now between the beauty of the work [of childbirth] and its definition within a between-men civilization in which women no longer have a recognized right to engender spiritual values'.[12]

The third point is stated bluntly: 'As women, we have thus been enclosed in an order of forms inappropriate to us. In order to exist, we must break out of these forms.'[13] This may have one of three consequences:

(a) It may destroy us: 'Instead of being reborn, we annihilate ourselves.'
(b) It may show us what flesh, and therefore what colours, we have left. In a complex move elsewhere,[14] Irigaray proposes a close relation between flesh and colour; in 'How Can We Create Our Beauty?' she concentrates on colour: 'I think colour is what's left of life beyond forms, beyond truth or beliefs, beyond accepted joys and sorrows. Colour also expresses our sexuate nature, that irreducible dimension of our incarnation.'[15]
(c) The third possible consequence of breaking out of the inappropriate order of forms which encloses us is that women may rediscover their identity and forms, forms which are 'always incomplete, in perpetual growth, because a woman grows, blossoms and fertilizes (herself) within her own body'.[16]

The fourth and final main point of 'How Can We Create Our Beauty?' concerns the representation of a female divine. The between-men culture disallows women's expression of meaning. Just as a child is not an abstract or arbitrary sign, so too for women 'meaning remains concrete, close, related to what is natural, to perceptible forms'. In what is called pre-history, women participated in civil and religious life and were represented as women goddesses (not only mother-goddesses). Today, lack of divine representation leaves women in a state of dereliction, without means of

designating or expressing self, identifying and respecting mother–daughter genealogies.

From this essay, then, there are three salient points for discussion: (1) the general issue of flesh, body, female morphology and its representation; (2) the nature of female creativity, and in close relation, subjectivity; and (3) the representation of what Irigaray terms the 'female divine' and its inevitable adjunct, universality and transcendence. Running through these discussions, as they fold out into Irigaray's wider writings, are two others: (4) the necessity for productive acknowledgement of female genealogies (two-way interchange between mother and daughter, and its concomitant, exchange between women); and (5) in very close relation to this, a notion of fulfilment or 'becoming' for women. Without any of these, women's beauty is not possible: indeed, these in conjunction would be productive of and allow for the performativity of women's beauty. The Irigarayan discussion of beauty therefore, and my discussion here, is *not* about defining a new aesthetic, *nor* is it an essentialist notion of a female aesthetic which has been overshadowed by a male aesthetic, and which only requires a light to be shone on it in order to become visible. For Irigaray, beauty for women is a potential state of being which can only come about as a result of rethinking political and cultural discourse. Her discussion of beauty is about making possible an order of discourse which would in and of itself, and inevitably, be productive of beauty. It is a discussion which requires the reader to think differently: to reconceptualise what might be productive of beauty, and what might constitute the transcendental and the universal.

It should be becoming clear by now that anything approaching 'an Irigarayan aesthetic' will not be found in the reproduction of certain methodologies in the studio, or adherence to one or another 'style' of imagery. Irigaray is scathing of an aesthetic which has been left intact without reconsideration, and the thought that art might simply attempt to illustrate without in its discourses attempting to resolve the ethics of sexual difference:

> There is a danger that ethics should become a part of aesthetics and seen as secondary to the life of the people, pleasant but not essential to spiritual development. This avoids the need to go beyond contradictions and oppositions and achieve a truly sexualized thought.[17]

What I will move on to now is not therefore a discussion of what an Irigarayan aesthetic looks like, or how certain artists might be working within one, and even less, how certain artworks might illustrate Irigaray's thought. Rather, I want to search for the places within particular artworks (how they function, and practices which form them) which are performative of Irigarayan thinking – in that aspects of the works by the artists and by the philosopher can be seen to resonate – and which therefore will begin to be productive of Irigaray's concept of beauty. I have selected works produced in the 1990s, neither of which fits simply into the debates around modernism, and which sit at an uncomfortable tangent to the dominant strands of Anglo-American feminist art theory of the 1980s and 1990s. They are *Amazon* by Dorothy Cross (1992) and *Monument to the Low-Paid Women Workers* by Louise Walsh (1993).

## Changing language, changing concepts

The two artists, Cross and Walsh, are Irish. Before attending to their work, I would like to explore one specific aspect of the linguistic and conceptual context within which women in Ireland are working which has been neglected by critics. I am doing this also because it is a pertinent parallel to Irigaray's insistence on paying attention to difference, and to her re-valuing of concepts. What I would like to draw attention to is how the Irish use of English provides a conceptual construction of mothering which can be utilised by women artists in Ireland in a positive fashion. It provides a present possibility for developing an exploration of Irigarayan concepts of interchange between women, and of the universal being a mediation for them. It also leads to a necessary re-valuing of what might constitute essentialist representations in that context.

It is noticeable in the idiomatic use of English in Ireland that there is an interchangeable use of the nominative case rather than the personal possessive when referring to a particular mother. This would be recognised throughout the island, but is more prevalent geographically in the South (possibly accompanying the difference between northern and north-eastern accents and the southern and western accents). For instance, when a little girl got lost in a large shop, I heard the question asked 'where is the mother?' rather than 'where is her mother?' Likewise, talking about a woman going to a celebration, a comment was 'she took the mother with her', rather than 'she took her mother'. The closest that use of English in England gets to this is in the use of 'the wife' (as in 'don't tell the wife' or 'the wife's on the phone for you'); but this is specific to male usage, and indicates in varying degrees disparagement, fear, or loathing.[18] 'The wife' becomes a figure against whom men are pitted, and she is invoked in the search for male bonding. In contrast, the Irish use of the nominative mother – 'the mother' – is positive, precise, and particular, as it can be used interchangeably instead of the personal possessive – 'my mother', 'his or her mother'. This draws together three separate concepts: a definitive concept of a mother; the person of an individual woman; and the role which that woman has in a particular relationship. It is a use of the English language which allows for a shift in understanding of the concept 'mother'. This has significance for Irish women as it contributes in a subtle but strong fashion to the cultural construction of mothering, the body of the mother, and the mother herself. It provides for a concept of the mother where the abstract or universal can constantly be drawn across to the particular or personal, and vice versa, with a flexibility reflecting that found in the multiple, though differently structured, concepts of 'Mother Ireland'.[19]

For the Irish woman artist, this has the effect of allowing for a space where shifts and changes can be made within representation. Irigaray discusses the 'intersubjective' relation between a woman and her mother, and the importance of a cultural reflection of this:

> Woman, though, immediately becomes a subject with respect to another subject who is the same as she: her mother. She cannot reduce her mother to an object without reducing herself the same way, because they are the same gender . . . Woman has a direct intersubjective relationship with her mother. Hers is more an *inter-subject* economy than an economy of subject–object relations . . . Woman must be able to

express herself in words, images and symbols in this intersubjective relationship with her mother, then with other women, if she is to enter into a non-destructive relationship with men. This very special economy of woman's identity must be permitted, known and defined. It is essential to a real culture.[20]

Once you have within the language and its idiomatic usage a conceptual drawing together of a definitive notion of 'mother' and a personal relationship with an individual who is your mother, then I would argue that you have one possible space for the cultural expression (beyond the spoken word) of just such an inter-subject economy. Moreover, you have the space in the development of such a representational system for an imagery of the universal as mediation between women. This is an unusual conceptual space (as Irigaray points out, in general 'our discourse is incapable of rethinking a universal as mediation and not as truth resulting from arbitrary forms'),[21] not only where the English language is spoken, but within other European languages also. The concept does not occur in the Irish language (Irish Gaelic); while it would require a historian of the spoken language of Ireland to chart the shift precisely, one could speculate on the history of British suppression of Irish language and culture and the concomitant development of female characters as metaphors as pertinent factors in this development. Certainly feminism in Ireland has an ability to cross class and party-political barriers in a manner which is a revelation to British feminists; and crucially for this discussion, against the background of feminism, approaches to figuration and representation of women's bodies have developed among Irish women artists in a manner which is quite distinct from that seen in Britain, Europe or the USA. One indicator of this is the position of modernism. The terms of art-theoretical debate around modernism, as I indicated earlier, are still couched in the language of modernism or anti-modernism. Modernism however, with its discourse of the universal as ultimate truth, is the culture of the colonisers, not the colonised or the post-colonial; Ireland, of course, is a post-colonial state, and as such has a tangential relationship to modernist culture.[22] This, I would like to suggest, has further allowed for the development of a feminism and a related women's culture of representation and difference distinct from those developed in England and the USA.

The Irish linguistic construction of 'the mother' constantly returns the universal to the particular, allowing no idealising, insisting upon the possibility and power of the individual mother, giving space for criticism, development, change. This is the conceptual and representational space where many Irish women choose to work. It is against this background, I would argue, that the successes and failures of many Irish women artists should be measured, rather than against an inappropriate concept of essentialism. Anglophone feminist art criticism has found the work made in this space hard to acknowledge. In all the books on my shelves charting a broad range of feminist art practices there are just three books with any mention of work by Irish women.[23] I have on occasion heard non-Irish feminists dismiss Irish women's work as 'essentialist'. This is in itself an essentialising and racist judgement, as it ignores the specificities of Irish cultural history. In using the term 'essentialist' as if essentialism were universal not only in its structures but also in its effects and symptoms, such a judgement is often spoken from within a construction of 'Irishness' (sometimes

couched in 'positive', romantic terms) as already primitive, wild, spiritual and close to nature. Add retrograde notions of 'femininity' to this, and the colonialist trap for Irish women would be complete. But if Irish women are starting from a place of difference (differences of history, of culture, of politics, even — as I have demonstrated — subtle and crucial differences of language and concepts of womanliness), then Irish women artists will be productive of representations of 'woman' and women which will be a result of their exploration of appropriate strategies to deal with that position of difference. This will have little to do with embracing or maintaining a fundamentally essentialist position according to English or American criteria. (It is interesting that the attacks on Irigaray's 'essentialism' have come primarily from critics in the USA, where a need to counter identity politics may mean that some forms of difference — including European differences — are not recognised.)[24]

### Louise Walsh, *Monument to the Low-Paid Women Workers*

Putting up images — photographs, paintings, sculptures, etc., not advertisements — of mother–daughter couples in all public places today would show respect for the social order. The social order is not made up of mothers and sons, as patriarchal culture represents it.[25]

The point of these representations is to give girls a valid representation of their genealogy, an essential condition for the constitution of their identity.[26]

In the tradition of Western civic sculpture, the piece is made of cast bronze and stands in a busy city street. Unusually, the two sculpted figures (Figure 32) do not stand on a plinth, but occupy the same space as us, although they are slightly larger than life-size. Also unusually, they are female: a mature woman and her younger, adult daughter. The city is Belfast: in common with most nineteenth-century industrial Western cities its public sculptures show figures of historical men (leaders, soldiers, politicians) and allegorical women (virtues, personifications of colonialised countries, the

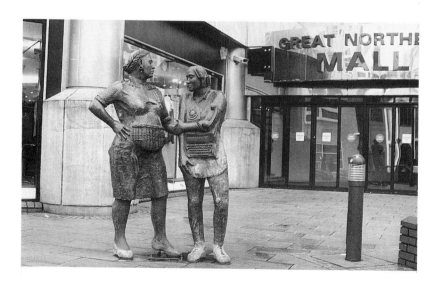

muses).[27] In one respect this sculpture is not unusual, as these figures are not representative of individual women. Instead it seeks to make visible a class or categorisation of women – the low-paid women workers of the title – and the contexts of their lives. Each figure is sculpted in a realistic fashion, augmented by objects which make up their lives – for instance, the older woman has a shopping-basket for a belly; the younger has a typewriter (Figure 33). Their bodies literally carry the traces of their

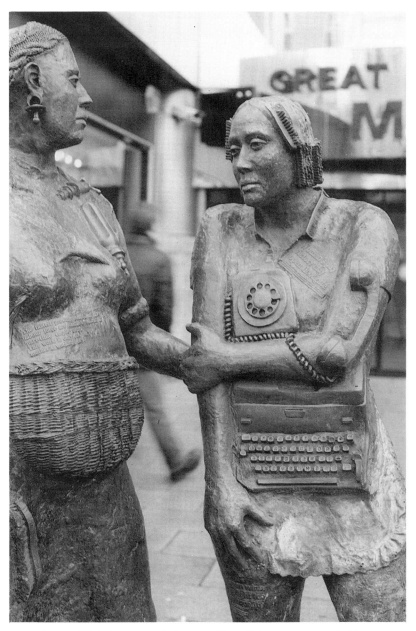

32, 33     Louise Walsh, *Monument to the Low-Paid Women Workers*, 1993, bronze, height 193cm

working lives: the accoutrements of low-paid and unpaid female labour such as scrubbing-brushes help form a shoulder here, a breast or an arm there. Additionally, inscribed upon them are the facts and statistics of work for these women – listings of the lowest-paid jobs, which are traditionally women's occupations; the rates of pay for particular jobs; and so on. But in order to read these, to know the circumstances of life for these women, you have to get close, become intimately acquainted with them, as the type is small. It becomes a wider political metaphor in a public place: only those who care enough to get close will ever know.

The sculpture was commissioned by Belfast City Council following a competition for a sculpture to commemorate the workers of a particular area of central Belfast. The intended site for the sculpture was a small square near the present site, tucked off the main road behind a couple of pubs. Upon the completion of the sculpture, the council (with its Unionist majority informed by Presbyterian moral-ity) withdrew the commission, not liking the politics of the piece, its aesthetics, or the negative coverage in the local press. The original site was around a corner from the area where some Belfast prostitute women work the streets. This had led the council to produce a sketch 'impression' of the piece as a clichéd representation of two prostitutes, and the local press to refer to the work as 'the two bimbos'. It was placed in its present position when a private company offered the site, which is owned by them. Ironically, it is far more visible now – on a main city-centre street, at the top of a short flight of steps leading to the main pedestrian access to the city bus station – than it would have been on the site offered by the council.

The two women are represented as being situated within a patriarchal eco-nomic system – the facts and figures inscribed on to them clearly indicate that – but they are not represented as victims. The older woman in particular is standing tall, physically solid, head held upright and a look of confidence – some might see it as challenge – on her handsome face. The daughter is slighter; her head and body turn a little towards her mother, as if seeking reassurance in her strength. The sculpture is not expressionistic in any way; the figures have not been given theatrical emotive ges-tures. Instead, the gestures are everyday ones, eloquent of a quiet dignity and a clear affectionate bond between the two women.

Among men in the Belfast art world, feelings about the work appear ambiva-lent: the work cannot easily be assimilated into the usual terms of the modern-ist/postmodernist debate. The fact that the work does not aspire to 'the universal' as it is understood within that debate (conceptually or formally) but primarily functions as a mediation of female experience leads to it sometimes being glossed over within the fairly macho environment of the Belfast art world. This is possibly compounded by the work's overt politics of gender, rather than the preferred political content for work in Belfast, the 'troubles'. However, it is also clear from anecdotal and verbal evi-dence that the sculpture is held in high esteem by women in Belfast across class and political or sectarian categories. In women's positive responses we can begin to see an empathy with Irigaray's own anecdotal telling of her reaction to seeing a sculpture of a mother and child which she at first took to be an image of Mary and Jesus, but then realised was Anne and Mary:

> Standing before this statue representing Mary and her mother, Anne, I felt once again at ease and joyous, in touch with my body, my emotions, and my history as a woman. I had before me an aesthetic and ethical figure that I need to be able to live without contempt for my incarnation, for that of my mother and other women.[28]

It was this experience that confirmed for Irigaray the importance of positive representations of mother-and-daughter couples and led her in different lectures/essays (as quoted at the beginning of this section) to urge for the placing of such works in public and domestic settings. Part of this is the adaptation of extant traditions of representation; for Irigaray, living in a Catholic country, this includes images of Mary and Anne. In the Republic of Ireland (some 95 per cent Catholic) representations of Mary are embedded in the broader culture to an extent that they are not in Northern Ireland, which is 38 per cent Catholic, and has its Protestant churches dominated by an iconoclastic Presbyterianism. However, in the North, Unionism (the mainly Protestant political movement) has been able on occasion to adapt concepts of Mother Ireland to its own purposes.[29] The strategy of adapting representational forms, while disrupting their existing structural function (as symbol or metaphor), is not new. In Belfast, a city utterly divided in its housing, schooling, employment, and national allegiances, and riven by decades of what can best be described as low-grade civil war, where the only thing the two sides seem to agree on is their need to control women's bodies and their anti-abortion stance, the public message to women has often appeared to be 'wait until after the revolution'. Public mediation between women has been restricted to the Peace Movement; one prominent Republican[30] woman told me that since the 1970s women could not be accepted as feminists in the North unless they supported the Peace Movement, thus relinquishing struggle for national or cultural identity. In such a context, Walsh's sculpture has enormous potency and potential as a mediating channel for Belfast women.

### Dorothy Cross, *Amazon*

> If women have no God, they are unable either to communicate or commune with one another. They need, we need, an infinite if they are to share *a little*. Otherwise sharing implies fusion–confusion, division, and dislocation within themselves, among themselves. If I am unable to form a relationship with some horizon of accomplishment for my gender, I am unable to share while protecting my becoming.
>
> Our theological tradition presents some difficulty as far as God in the feminine gender is concerned. There is no *woman* God, no female trinity: mother, daughter, spirit ... The most influential representation of God in our culture over the last two thousand years has been a male trinitary God and a virgin mother: a mother of the son of God whose alliance with the father is given little consideration.[31]

In the above passage, Irigaray sets out the necessity for a 'horizon of accomplishment' – a notion of the Divine – for women; the need for a form of mediation (or 'universal') as part of this; and the main reason why our nominally Christian culture does not provide this. Yet nowhere in her writings does Irigaray hint at any simplistic form of Goddess-worship for women. Instead, she explores some of the structures in, for

example, some of the early, pre-patriarchal, Greek mythologies such as the story of Demeter and Kore, and demonstrates how those structures provided the horizon of accomplishment. Clearly, developing a horizon for women of equivalent potential to that which men have within Christianity and its literary and visual representations is not something which can happen upon a whim; nor is it something which one could hope to find fully developed in any present artworks. Clearly also, many of the 'Goddess' images which have been made by women since the 1960s do not fulfil the function of 'horizon' as Irigaray has analysed the Divine to be. All too often such images have acted as mirrors, with a narcissistic overvaluing of the self-image. Irigaray distinguishes between such a mirroring and an act of contemplation:

> In a way quite different from the mucous membranes or the skin that serve as living porous fluid media to achieve communion as well as difference, the mirror is a frozen – and polemical – weapon to keep us apart. I give only my double up to love. I do not yield myself up as body, flesh, as immediate – and geological, genealogical – affects. The mirror signifies the constitution of a fabricated (female) other that I shall put forward as an instrument of seduction in my place. I seek to be seductive and to be content with images of which I theoretically remain the artisan, the artist. I have yet to unveil, unmask, or veil myself *for me* – to veil myself so as to achieve self-contemplation, for example, to let my gaze travel over myself so as to limit my exposure to the other and repossess my own gestures and garments, thus nestling back into my vision and contemplation of myself . . . The mirror, and indeed the gaze, are frequently used as weapons or tools that ward off touching and hold back fluidity, even the liquid embrace of the gaze.[32]

Hinting at the possibility of the Other who will enable a woman's becoming, providing the moment of productive contemplation, resisting the representation of self as instrument of seduction: these are aims to be found in a number of artworks by women. We have seen how Walsh's *Monument* is one work that would contribute to the representation of mediation between women and between generations of women. Dorothy Cross's sculpture *Amazon* (1992) (Figure 34) begins to hint at the possibility of a representation of the Divine for women in a different way.

*Amazon* is part of a series of works Cross made using cow-skins and in particular udders, stretching them across objects to make new, suggestive, entities. Udders have been stretched over an ironing-board, over a dressmaker's dummy, over a psychiatrist's couch, on a pillow, draped over a full-sized mannequin, and formed to mimic a floating mine; the teats have been placed over a Guinness bottle, on the toes of stiletto shoes, in a soup-ladle, spur-like on workman's boots. *Amazon* was formed from an old dressmaker's dummy. The cow-skin that was used for this piece came from a cow who had only one large teat on her udder, rather than the usual four. The skin was fitted tightly over the dressmaker's dummy, with the udder and its single teat formed into one vast breast across the chest of the dummy. Udders have multiple significations, primarily of the cow of which they are a part – 'cow' of course being also a common derogatory term for a woman. The cow is regarded in our culture as a placid, passive creature, used either for breeding or as a milk producer (dairy- and beef-farming are crucial to the Irish economy). The engorged udder of the milk-

producing cow can signify to us the earliest of our infant sucklings, and never-ending nurturing. It can signify at one and the same time the complexities of mothering and being mothered, and the derogatory and abusive ways in which mothers and potential mothers (i.e., women) are categorised. To use an udder in an artwork is to negotiate the abyss between abusive or derogatory representations and those which honour or respect. It is also to engage with the possibility of essentialism.

*Amazon* is a complex work to encounter. On the one hand, it would seem to be wide open to the charge of essentialism. Here, we have potential superimposition of womanliness, Irishness, the cow, the nurturer, and primitivism in a way which could be productive of highly retrogressive meaning. The placing of this work in a 'Bad Girls' context (as happened in London in 1994) – sexualised, glamorised, depoliticised – would encourage such a reading. Romantic–essentialist views of Irishness as wild, instinctive, subversive, and close to nature correspond to the construction of the 'Bad Girl'. This is not to suggest that *Amazon* is 'trapped' in its Irishness, but rather

34   Dorothy Cross, *Amazon*, 1992, dressmaker's dummy and cow-skin

that the 'Bad Girls' construction would not encourage any questioning of the racist stereotype. Another possible reading of *Amazon* is informed by psychoanalysis. Here, the phallic nature of the teat – it is in fact more or less penis-sized – is stressed. The height of the dummy, the size of the breast, the size and position of the teat/nipple, the actuality of the skin and the teat can be seen in this understanding as returning the viewer to infant anxieties and pleasures. It sexualises our relationship to our mothers and relates oral sexual pleasures directly to other initial oral pleasures. One can be unsure as to whether this is indeed (in the Lacanian framing) the phallic mother, or the bringer of sustenance and pleasure.

But *Amazon* also operates within the Irish language. Cross has said (in conversation) that she likes the fact that with a Dublin accent the words 'udder' and 'other' are indistinguishable. Intrinsic to *Amazon* is the Irish concept of the mother, as described, where the personal possessive and the nominative can shift from one to the other. In the gap provided by that shift, *Amazon* can begin dealing with the retrogressive ideologies and representations that patriarchal thought would have artists operate within. *Amazon* hints at the other *subject* on the 'horizon of possibilities' for women, which is of woman, but not of her. *Amazon*, for the woman viewer, will be 'of the same subjective identity as she is . . . a subject that cannot easily be reduced to an object'.[33] It offers one moment, one possibility even, for mediation between women within representation. In writing this, I am aware of the need to stress the knife-edge qualities of attempting this in a symbolic appropriate for women which is, according to Irigaray, at best still highly fragmentary, and remains on the horizon as a possibility. Where *Amazon* begins to achieve this can be located in the site of the bodily encounter between it and the viewer, when it signifies in ways that do not register when it is reduced to object status alone in a photographic reproduction. In its multiple readings it can be fluidly productive: 'The becoming of women is never over and done with, is always in gestation. A woman's subjectivity must accommodate the dimensions of mother and lover as well as the union between the two.'[34] Until we become women, we will not achieve beauty.

In concluding I would like to underline that what Irigaray offers us in her notion of beauty is not merely a tinkering with notions of aesthetics, or about gaining what Lucy Lippard once described as a bigger slice of a rotten pie,[35] nor is it another 'ism' to be added to the canon of what constitutes 'the beautiful'. It is instead a radical and ultimately deeply political reassessment of what 'the beautiful' might be for women.

### Notes

1   Luce Irigaray, 'The Power of Discourse', in her *This Sex Which Is Not One* (Ithaca, NY, Cornell University Press, 1985), p. 78.

2   Luce Irigaray, 'Questions', in *This Sex Which Is Not One*, p. 155.

3   One example of this would be Judy Chicago. While some women compromise their gender by denying that it has any relevance to their practices or their careers, Chicago initally compromised by encoding references to gender and personal experience in her work so successfully that colleagues and critics could not perceive them. Such work was shown regularly in

exhibitions of minimalist work. Upon changing strategy, and making these references explicit, the work was critically and curatorially eschewed by the discourses of the modernist avant-garde.

4  Luce Irigaray, 'How Can We Create Our Beauty?', in her *Je, tu, nous: Toward a Culture of Difference* (London, Routledge, 1993), pp. 107–11.

5  Luce Irigaray, 'Sexual Difference as Universal', in her *I Love to You: Sketch of a Possible Felicity in History* (London, Routledge, 1966), p. 43.

6  For one example of the negotiation of the identity politics of race in the USA see Anthony Appiah and Amy Guttman, *Color Consciousness: The Political Morality of Race* (Princeton, NJ, Princeton University Press, 1996).

7  Luce Irigaray, 'The Power of Discourse', in *This Sex Which Is Not One*, p. 78.

8  Hilary Robinson, 'Gesturing Towards the Mother: Louise Bourgeois' *Cells* and Related Works', *MoMA Occasional Papers No. 1* (Oxford, Museum of Modern Art, 1996).

9  Luce Irigaray, 'A Natal Lacuna', *Women's Art Magazine*, no. 58, 1994, pp. 11–13. See also my comments on this, 'Irigaray's Imaginings', *Women's Art Magazine*, no. 61, 1994, p. 20.

10  Irigaray, 'How Can We Create Our Beauty?', p. 107.

11  *Ibid.*, p. 108.

12  *Ibid.*, p. 109.

13  *Ibid.*

14  Irigaray, 'Flesh Colors', in her *Sexes and Genealogies* (New York, Columbia University Press, 1993), pp. 153–65.

15  Irigaray, 'How Can We Create Our Beauty?', p. 109.

16  *Ibid.*, p. 110.

17  Irigaray, 'The Universal as Mediation', in *Sexes and Genealogies*, p. 145.

18  There may be similar constructions to the Irish in local dialects in Britain, but the Irish is notable for its cross-class, cross-regional occurrence.

19  There is not the space here to explore the multiple configurations of 'Mother Ireland'. They differ structurally from the linguistic configuration I am exploring here in that they are primarily symbolic or metaphorical. The most substantial source on the subject is Belinda Loftus, *Mirrors: William III and Mother Ireland* (Dundrum, Picture Press, 1990).

20  Irigaray, 'A Chance to Live', in her *Thinking the Difference: For a Peaceful Revolution* (London, Athlone Press, 1994).

21  Irigaray, 'The Universal as Mediation', p. 128.

22  This has produced some interesting anomalies: two of literature's key modernists, Samuel Beckett and James Joyce, lived in self-imposed exile from their Irish home; and the absence of the modernist, masculinist avant-garde in Irish visual art left space for a woman painter raised in the Unionist Anglo-Irish ascendancy, Mainie Jellett, to become the major proponent of modernist painting in Ireland.

23  Lynda Nead, *The Female Nude* (London, Routledge, 1992), discusses work by Mary Duffy; Jo Anna Isaak, *Feminism and Contemporary Art: The Revolutionary Power of Women's Laughter* (London, Routledge, 1996), mentions work by Kathy Prendergast (pp. 165–71) and Dorothy Cross (p. 165); Mary Duffy, Anne Tallentire, and a Pauline Cummins/Louise Walsh collaboration are mentioned in Katy Deepwell (ed.), *New Feminist Art Criticism: Critical Strategies* (Manchester, Manchester University Press, 1995), pp. 114, 115–16, and 142–3, respectively.

24  See for example Christine Delphy, 'The Invention of French Feminism: An Essential Move', *Yale French Studies*, no. 87, 1995, pp. 190–221 for an analysis of 'New French Feminism' as a designation which has meaning only in Anglo-American academia, and none in France.

25   Irigaray, 'A Chance to Live', p. 12.

26   Irigaray, 'The Culture of Difference', in *Je, tu, nous: Toward a Culture of Difference*, p. 48.

27   See Marina Warner, *Monuments and Maidens* (London, Picador, 1985), particularly the first part, for a full discussion of the structural representation of historical men and ahistorical women.

28   Irigaray, 'Religious and Civil Myths', in *Je, tu, nous: Toward a Culture of Difference*, p. 25.

29   Loftus, *Mirrors*, p. 46.

30   A Republican in the contemporary Irish sense is a nationalist who seeks a united Ireland through violence if necessary, as differentiated from the constitutional nationalists who seek the same ends through democratic political means.

31   Irigaray, 'Divine Women', in *Sexes and Genealogies*, p. 62.

32   *Ibid.*, p. 65.

33   Irigary, 'Gesture in Psychoanalysis', in *Sexes and Genealogies*, p. 97, discussing little girls playing with dolls.

34   Irigaray, 'Divine Women', p. 63.

35   Lucy Lippard, 'The Women Artists' Movement – What Next?', in her *From the Center: Feminist Essays on Women's Art* (New York, E. P. Dutton, 1976), p. 141.

# Desiring daughters

The opening image of the videotape *The Influences of My Mother* (Sara Diamond, 1982) is a tight close-up on a dated, somewhat faded portrait of a young woman, perhaps in her mid-twenties. The date of the black-and-white photograph is uncertain, but its representational style suggests a studio photograph from around the 1940s. The frame highlights a pair of intelligent eyes, set in a gentle, expressive face.

The camera opens out to a medium shot, revealing the head-and-shoulders portrait in its entirety. A female off-camera voice addresses the viewer: 'It is usually the parent who constructs the identity of the child.' The camera continues opening to include in its frame a young woman seen standing at an adjoining wall, facing the portrait. There is an uncertain resemblance between this person and the figure in the portrait. The voice-over continues: 'In my case, it was to be the child who would construct the identity of the parent.'

The character on camera and in the voice-over is the videomaker Sara Diamond. The videotape is enactment and re-enactment of the processes by which she has imagined and reconstructed the identity of the mother who died while she was a girl in early adolescence. The figure Diamond presents is the paradoxical one of a daughter constructing her sense of identity through imaginary identification with, and through irrevocable separation from, a maternal parent whose identity she is also constructing.

The combination in the work of autobiography and fantasy, memory and desire, history and interpretation, artefact and invention further positions the document as one which blurs the boundaries of fact and fiction, personal and social. It is at once a desiring production and an enabling process, by means of which Diamond transforms her subjectivity. That this subjectivity is enabled by identificatory processes is made immediately evident. The opening scene continues with a shot of Diamond, her hair restyled, standing next to the photograph: two figures photographed at a similar age, dressed in similar tailored jacket and blouse, curly hair arranged in similar fashion, faces posed at a similar angle, the physical resemblance now certain.

The two figures, framed together in one image, look similar; but they are not one. And it is the passage from the acknowledgement of sameness to the recognition of difference, from the process of imaginary identification to the distancing of symbolisation, that is embodied within the narrative of the video and produced within its textual strategies.

At each stage of the video, which is organised in six chronological acts, the

relationship of mother and daughter undergoes a new definition, but each new 'identity' of the mother is anchored in the daughter's interpretation of her; in this way, the daughter constructs the identity of the mother. In these representations by the daughter, the mother is transformed, as the tape proceeds, from a figure whose principal attribute to the remembering daughter is that of an overwhelming power to a separate being who is herself a willing, active subject – a desiring subject. And the recognition of her as both woman and mother enables the daughter's constitution of herself as both subject and daughter – a desiring subject, a desiring daughter.

In *Measures of Distance* (1988), by the Palestinian artist Mona Hatoum, the maternal figure is also an absence; but in this instance absence is due to the daughter's exile from the war-torn country in which her mother remains resident. In this work, it is not death or time that marks the daughter's distance from the mother, but a complex range of psychic and social eventualities within a lived relation. Like Diamond's tape, which was produced in 1982, *Measures of Distance*, made six years later, represents in a yet more rigorous and complex fashion a renegotiation of the mother–daughter tie; and it too underscores the importance of the maternal figure to the question of female subjectivity and desire. Hatoum, however, specifies the centrality of language to this negotiation and further insists on the multiplicity of determinants of subjectivity – of gender, race, class, age, nation, circumstance.

Unlike Diamond, who must construct the figure of the mother within an imaginary set of relations drawn from memories and memorabilia, Hatoum constructs her videotape from materials provided by, and in collaboration with, the mother, and used with her consent. Yet this consent is a furtive one ('don't mention a thing about it to your father'), highlighting the mother–daughter bond as a trespass on patriarchal law.

Letters from mother to daughter, read in translation by Hatoum, form the principal narrative element of the sound-track. It is the words of the mother that are spoken, but through the mediation and translation of the daughter, who is both reader (of the mother's letters) and writer (of the videotext). It is the daughter who, even as she is also the subject of an address originating with the other figure, assembles the evidences by which our view of the figure is constructed. And the figure she presents is likewise a desiring subject, a desiring mother. It, too, is a desiring production.

Freud does not posit desiring daughters. Indeed, the paradox of female subjectivity and desire is its structural 'non-existence' within a symbolic order in which the phallus is the privileged signifier, not only as the representative of the principle of separation and individuation but as the symbol of desire, activity, potency. Not only is women's access to the phallic signifier highly problematic, but further a primary identification by the female subject with the mother is seen to militate against the separation and individuation that mark the distance from the maternal object, hence subjecthood and desire.

Within these parameters, the possibility on the daughter's part of a positive identification with the mother is confined to an identification with maternity and its promise of *jouissance*. In well-known accounts of this problematic, Julia Kristeva maintains that 'the consecrated (religious or secular) representation of femininity is

absorbed by motherhood';[1] Jessica Benjamin argues that the phallus maintains its monopoly on representing desire through the profound desexualisation of the mother;[2] Luce Irigaray insists that the culturally unsymbolised mother–daughter relation leaves women in a state of dereliction.[3] In short, women's identity is related to the positions made available in patriarchal ordering, that is, objecthood and motherhood.

Thus theoretical attention to the mother–daughter relation is necessarily imbricated with theoretical work on female subjectivity in that, as Brenda Longfellow has argued, 'the political urgency of both projects bears on the possibility of articulating a different economy of desire and subjectivity as symbolic resistance to the law of the father and the interminability of phallic mediation'.[4] Central to this engagement has been the attempt to extricate the female as subject of history from her designation as Woman and Other, and further to extricate the female as subject of desire from her capture as maternal object.

The mother–daughter relation is a crucial site for women precisely because it is the ground for a disinvestment of the Oedipalised symbolic order. As Rosi Braidotti has argued, the mother–daughter paradigm 'is an imaginary couple that enacts the politics of female subjectivity, the relationship to the other woman and consequently the structures of female homosexuality as well as the possibility of a woman-identified redefinition of the subject'.[5]

Yet the very complexity and difficulty of the relation to the maternal object within the context of the daughter's claim to a 'place' and a desire within patriarchal culture bespeak the force of the psychic and cultural imperatives that the female subject must negotiate. A voluminous body of women's narratives – in this instance considered from within feminist video production – have given voice in the 1970s and 1980s to the story of daughters uncomfortably bound to the psychic, symbolic and historical legacy of mothers.

Consider, for instance, the 1973 video-performance *Spring Sowing: Emergence*. In this real-time process tape by Jill Geiger, a supine woman is slowly cut out of her clothes as she, the clothes-cutter, and the camerawoman engage in casual conversation that counterpoints the dramatic scene being enacted. As Carol Zemel wrote of this work at the time:

> Slowly and deliberately, covering cloth was stripped away, so that when a naked and pensive woman rose from her cut-away shell, the psychic release was monumental. It was an assertive and liberating moment, at once poignant and ecstatic, as the now freed woman knelt, almost bowing, to her former being lying empty beside her.[6]

This 'emergence' and rebirth of the fully grown woman, the motherless daughter, 'born' anew with the aid and ministrations of her peers, might be seen as a metaphor for the repression, within a celebratory 'sisterhood', of the vexed question of the psychic and familial relation of mothers and daughters.

In this first surge of the feminist movement in the 1970s, this conflictual relation was perhaps partially displaced on to the search for another mother – the apt, not deficient, mother. The embrace of Goddess mythology and ancient matriarchally-centred forms of spirituality; the reclamation of lost female figures of history; the

rewriting and reinterpretation of myths, folk-tales, biblical stories, and so on; the denial of discord through the affirmative action of 'positive images' – all testify not only to the persistent historical erasure from the public sphere of women's voice and presence but also to the search, at the symbolic level of culture, for a 'positive' matri-lineage: one that would not only counter the cultural derogation of the female, but perhaps as well enable the daughter to circumvent the mother – to give her the mother she needs instead of the mother she has.

In this first generation of work, there was little sign of the vexation in the mother–daughter relation that would be explored, often with the aid of psycho-analytic tools, a decade or more later. This later work bespeaks a conflict between on the one hand 'feminine' mothers (ostensibly) inscribed within the father's law, and on the other feminist daughters in open revolt against it. Yet in this next generation of work, the effect of the lack of an alternative symbolic treasury is apparent.

Consider *Casting Off* (Jane Northey, 1983), which depicts a daughter seated in a rocking-chair, trying to reproduce the knitting skill of her mother and grandmother. But she cannot get it 'right' and abandons the gender-conformist project. Or *Ritual of a Wedding Dress* (Wendy Walker, 1984), in which a daughter unpacks her mother's wedding-dress from a trunk and tries it on; but the dress does not 'fit' (nor does the daughter's intervention undo the coherence and power of this intensive visual symbol). Or b.h. Yael's tellingly-titled *My Mother is a Dangerous Woman* (1987); here the daughter is a writer, blocked, who becomes preoccupied with the story of Demeter. This goddess of Greek mythology descended deep into Hades to pursue and rescue her abducted daughter Persephone. The twentieth-century mother proffers advice on the necessity and naturalness of female accommodation to male authority. That the 'good' towards which she would persuade the daughter is clearly tinged with masochism is, as Kristeva has argued,[7] fully consistent with the idealised feminine position. These tapes do not enact an extant sense of female subjectivity but rather articulate problems in attaining to it, problems located specifically around processes of identification at the site occupied by the mother.

Thus *The Influences of My Mother*, with its representation of the mother as woman, agent in history, desiring subject – as well as mother – signals a distinct change in the register by which the mother–daughter relation is articulated. It is a low-budget tape, made on small-format video equipment with minimal production values. Its performance elements are informal, self-conscious and frequently self-indulgent; the camerawork is sloppy, the image repertoire limited, the editing imprecise and the sequencing uneven. But despite the many technical flaws in the work, its textual strate-gies are conceptually sophisticated, mining an awareness of representation as con-struct, mapping a family narrative outside of patriarchal norms, organising its representational strategies in an admixture of conventional and innovative narrative codes and organising an alternative and feminine register of the gaze.

In considering *The Influences of my Mother* in relation to the other works men-tioned above, as well as to *Measures of Distance*, the shifts in perspective that these mother–daughter videotapes evidence point to a dynamic interplay between feminist art production, currents of feminist theory, and the conditions of possibility of

women's lives. All of these works underscore difficulties in the transaction of psychic and symbolic transformation for daughters seeking the possible terms of their desire. Yet the productions by Diamond and Hatoum suggest a reflection on the difficulties and possibilities of the mother–daughter relation notably different from the principal ways in which this relationship has been taken up as a problematic within psychoanalytic models of feminist criticism over the past decade or more. What is represented in these works is neither an idealisation of the mother, nor a merging with her, nor an evacuation of the maternal site, nor an entrapment in the feminine position of abjection and lack, nor a privileging of the pre-Oedipal extralinguistic maternal terrain, nor an *écriture féminine*. The tapes, and the processes they engage, are situated on the side of the symbolic and they navigate a retroaction, within language and culture, that reclaims and reinvests the maternal figure as object of desire *and* as desiring subject.

'How do you go about re-creating a once living woman through whom to see yourself?', Diamond asks in off-camera voice. From the start, Diamond makes evident that it is not the 'truth' of the mother that is at stake but her meaning, specifically her meaning to the daughter. The absence of the mother enables the daughter to project upon this figure her own memories, fantasies and wishes. At the same time, the identity of the mother is also retrieved from the empirical evidences of oral narrative, documents, photographs, testimony and the artefacts of personal and social history. But these, too, are partial and selective. Thus she is not only remembered but discovered and invented, not only the object of the daughter's search but the 'subject' thereby retrieved and produced (Figure 35).

In the first of six acts, the camera pans across a photograph of mother and daughter so as to exclude the mother: 'I pushed her away, but to say that it is as though she never existed *is* to acknowledge her presence. She was unknowable, mysterious, larger than life.' In the second act, the photograph from the opening scene is held in the daughter's hand, turned upside-down, the mother become a persecutory figure: 'I dreamed recurringly that she led me to the top of a volcano. The trip up was filled with wonder. At the top, she picked me up and threw me off the volcano.' In the third act, the mother is no longer the mother of personal memory but of social archetype, as expressed in popular music. Diamond, microphone in hand, croons along in pantomime to a sound-track of sentimental tunes on the theme of mother loss, or of the love, union and plenitude she symbolises.

By the fourth act, Diamond is a young adult and her growing physical resemblance to her mother stimulates a renewed interest in her person: 'I searched for a recognition of myself within *her* image. To reconstruct her would be to locate myself.' Here, through the daughter's research, the mother emerges as a subject of history: a communist, a labour organiser, an activist. The daughter begins to situate her mother's personal history within a broader account of social and political history. In the fifth act, the once-deprecated mother attains heroic status: 'My mother had loved me. She threw me *off* that volcano, not into it. She saved me!' In the final act, the psychic register shifts from the imaginary to the symbolic: here, the mother is neither the object of narcissistic need, feared or idealised, nor of a psychic merging precluding

35    Sara Diamond, still from *The Influences of My Mother*,
1982, videowork

separation, but the figure of a partial identification, reconstituted from within a social matrix.

The episodic structure of the tape, with its division into a series of 'acts', foregrounds the 'act' as the staging of a process as much as the separation of sequences, while the mode of direct address forgoes any attempt to render the place of enunciation transparent: rather, it foregrounds the construction of the video object, itself the construction of a subjectivity. Throughout the tape, the photographic image is employed as evidence of history, of desire and of loss (of that which it would represent), and these images are organised around the figure of the mother, who is both lost to the daughter and also a figure whose own subjectivity is 'lost' beneath the accumulations of her symbolic cultural meanings.

If the videotape is about a formation of identity, it is also about loss and mourning. Irigaray has drawn parallels between the state of melancholia described by Freud in 'Mourning and Melancholia' and the implications for the female child of the discovery of her mother's, and hence her own, 'castration': 'The little girl's separation from her mother, and from her sex, cannot be worked through by mourning', she writes.[8] Freud described the successful passage through mourning as one in which the mourner succeeds in psychically internalising the attributes of the lost object.[9] And

certainly Diamond enacts the stages that mark bereavement. Yet in Diamond's treatment of her history, it is not sufficient for her to incorporate the mother as she has known her. Rather, to complete her mourning, she must establish both a different parent and a different relation to her. This internally reconstructed parent provides a container that can hold Diamond's love and rage: a 'good enough' mother, in D. W. Winnicott's term, whom she can recognise as subject and through whom she can alter her sense of identity. Thus the 'mother' Diamond internalises and achieves a separation from is not the 'mother' whom she lost.

'To reconstruct her would be to locate myself', Diamond has said. But to 'locate' oneself does not speak of locating the self anew: rather, the implication is that it is a question of locating oneself at all. For Diamond, the locus of possibility of securing a sense of self, of identity, of place, is in relation to the mother. Yet she makes explicit that it is not only the mother as she is (or has been) that is uniquely of import but even what she has aspired to be. The mother's aspirations, however, are ultimately unknowable to the daughter. So again she invents the mother from the residual evidences of her life, and in so doing both makes the tools and employs them to locate herself in relation to the maternal parent rather than *no place*.

Yet what would sponsor this retroaction to reclaim and reinvest the mother? It is in the final act that Diamond makes it explicit that the social ground of feminism is the place from where she is looking in order to look back. In a direct address to the viewer, Diamond specifies the links between her own personal process of maternal reclamation and a larger collective feminist project. She further acknowledges this journey of the self as a process, in which the mother will 'change' as she changes.

In the classic Oedipal scenario, the female's assumption of the normative feminine position is predicated on a repudiation of the 'lack' of the mother-castrate and a turning towards the paternal figure in order to access, by indirect means, the resplendent phallus. The paternal representative is the agent of separation, the 'third term', effecting the severing of the dyad with the mother and with it the entry into language, symbol and culture. Yet the Oedipal moment, and the identifications that ensue from it, are themselves constituted retroactively. As Kaja Silverman notes:

> The moment isolated by Freud as inaugurating the division of the sexes must be understood as the product of intense cultural mediation, as an event which is experienced retrospectively by both male and female subjects . . . Both refer back their cultural status to their anatomical status after the former has been consolidated, and they do so at the suggestion of the society within which they find themselves.[10]

The process which Diamond re-enacts is likewise a retroaction, and is certainly situated within the conscious level of the secondary psychic processes. Yet it is an account of an experience and a negotiation in which her sense of identity is altered. As in the Freudian scenario, Diamond takes up a position of identification with the maternal figure; but she positions herself, and the viewer, not in terms of Oedipal desire and its privileging of the masculine, but in terms of female longing, along the axis of the maternal signifier. In Diamond's narrative, a separation from the mother is effected,

but it is not effected through a paternal intervention but rather from within a homo-sexual economy in which the mother is at once object of identification and agent of separation. The videotape invites speculation as to whether feminism – as a force within the social, political and cultural field – might constitute an alternative, non-patriarchal 'third term' sponsoring a retroaction which activates the negative Oedipus complex and inscribes the maternal, differently, within the symbolic.

As Kaja Silverman has pointed out, the libidinal investment in the mother, the negative Oedipus complex, is the muted parental term within unconscious fantasy, without the representational supports that work to sustain the daughter's unconscious desire for the father. The 'negativity of the negative Oedipus complex'[11] is that of a desire out of keeping with paternal law and phallic privilege. The recognition that unconscious desire is 'divided between at least two very different fantasmatic scenes', she argues, enables new discursive and relational strategies for activating the homo-sexual maternal fantasmatic scene, and with it both political and libidinal resources.

Silverman insists that the mother as unconscious Other *is* the Oedipal rather than the pre-Oedipal mother – that to suggest otherwise is to give female sexuality an essential content preceding language and symbolic structuration. As she elaborates, 'to situate the daughter's passion for the mother within the Oedipus complex . . . is to make it an effect of language and loss, and so to contextualize both it and the sexuality it implies firmly within the symbolic. It is also to bring it within desire, and hence psychic "reality".'[12] In situating unconscious desire for the mother within the symbolic, Silverman locates it on the side of language rather than outside of repre-sentation.

Certainly in these videotapes by Diamond and Hatoum, a maternal fantas-matic has been (re)activated. However, the mother–daughter compact which eventu-ates from this process is represented as, in effect, a renegotiation. The mother as desiring subject has been retrieved from a pre-given maternal position. For Diamond, the mother initially has meaning only in terms of the daughter's primary and narcis-sistic needs – in particular her need to feel loved rather than abandoned – but her 'meaning' acquires a social valence as the tape proceeds. Thus she is several mothers: a pre-Oedipal mother, feared and idealised within an oscillating imaginary; a mother of social archetype; a mother despised for being insufficiently feminine (like other mothers) by her gender-conformist daughter; a mother as subject and agent of history. In Hatoum's *Measures of Distance*, the mother is resituated in a primary posi-tion by the once father-favouring daughter; but this mother is at once pre-Oedipal and Oedipal, at once body, womanly and maternal, and voice, subject of language, speech, agency, desire. Here, the five-year gap between the visit in which the extraor-dinary photographs in the work were taken and the materials given symbolic form speaks volumes. What both works suggest is less a preoccupation with a clear divi-sion between the Oedipal and the pre-Oedipal than a staging of processes within the round-robin of the imaginary/symbolic, processes which break from a patriarchal symbolic subtended by a masculine imaginary.

As Margaret Whitford has succinctly summarised, 'If a female symbolic depends upon a female imaginary, it is also the case that a female imaginary depends

upon a female symbolic.'[13] The female imaginary, she argues, can be seen as the under-side, the 'scraps', of the dominant symbolic order, or it can be seen as something yet to be created. 'The female imaginary would be', she writes, 'not something lurking in the depths of women's unconscious, but a possible restructuring of the imaginary by the symbolic which would make a difference to women.'[14] Whitford underscores that the creation of a female imaginary is a collective process.

The Influences of My Mother and Measures of Distance suggest that feminism, with its challenge to the dominant symbolic order and its opening up of – and intervening presence within – the terrain of the symbolic, can sponsor such processes. But they further underscore the negotiation with the mother necessary to effect the break from a masculine symbolic, a transaction in which, in these works, the mother is able to assume the position of 'other' – as well as, and instead of, the 'same': both mother and subject. Diamond's tape stages processes by which a capture within the imaginary is worked through, distanced from and given symbolic form, while Hatoum works across the Oedipal divide, the irretrievable distance, to embrace the mother anew.

If The Influences of My Mother situates the mother–daughter relation within a dyadic economy which absents the father entirely, in Measures of Distance there is a tri-angulation of desires, the father pressing his presence at the edges of the scene, angry and anxious at his exclusion. The mother writes, 'It's as if you had trespassed on his property . . .'.

The governing image of this work is a series of still photographs of the mother, taken by Hatoum on a visit to her family in Lebanon five years before the tape was made (Figures 36–9). The photographs show the mother at her bath, in an extended sequence of documentation of a scene of unusual intimacy, sensual images of a naked, full-bodied mature woman. The image of the mother's body, however, is partially obscured through a second image which overlays it, that of neat delicate rows of handwriting in Arabic script from letters written by the mother to her daughter. Thus Hatoum at once represents the maternal body as the locus of desire and empha-sises, with the scriptface that literally fences the image, the barrier to this body pro-duced by language and mediation. The video pictures language as an inscription on/across the mother's body, but here the language of the fathers is used to give voice to the co-respondence between mother and daughter.

The letters are read in voice-over translation by the daughter, creating through language and voice a doubling akin to the doubling that Diamond has pro-duced visually. Yet the doubling of voice as Hatoum reads the mother's words, the doubling of language as the letters in Arabic are translated into spoken English, underscore that this union of elements also incurs losses. The incommensurabilities of translation are further emphasised by the second element of the sound-track, an untranslated recording of laughter-punctuated conversation between the pair. These shifts and doublings are matched by slippages and complexities in the categories and stereotypes where the place of the mother is defined, creating the calibrations for the videotape's many measures of distance.

The layering of sound and image creates a complex oscillation between its different elements. The images themselves shift and alter, at one moment in close-ups

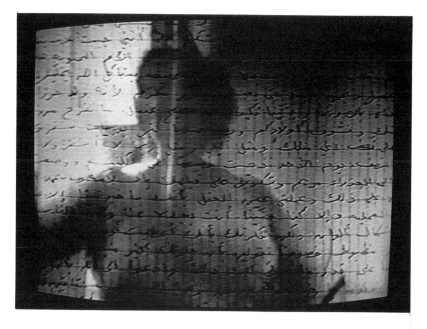

so tight as to abstract the body, then framed from a distance, a recognisable figure. Yet the images are never completely sharp, and this constant blurring of the image through movement, incomplete detail, framing too close or too distant for clarity, combines with video's imprecise visual field to create an image that appears *porous*, rendering visually the unfixity of the object that the tape suggests.

Hatoum's figuration of the mother can be seen as a critical stance at odds with the virtual proscription against the imaging of the female body that had assumed

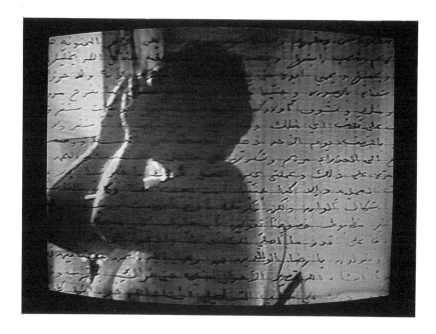

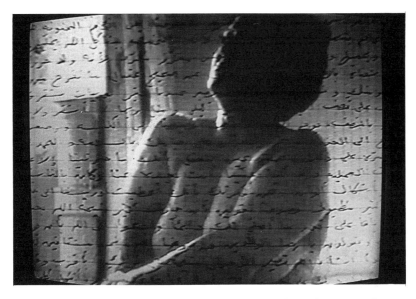

36–9    Mona Hatoum, stills from *Measures of Distance*, 1988, videowork, 15 min., colour

a powerful critical consensus in feminist work by the late 1970s and throughout the 1980s. Hatoum's representations of this female body, and specifically of this maternal body, are mediated to privilege a different modality of viewing: through the privileging of the female spectator, through the grid of language superimposed on the images, through the fluctuation of the image, through the layering of image, taped voices and spoken letters which together situate the narrative and the mother in a feminine scenario unbound from the father's gaze.

The intimacy of the photographs extends to the terms of address and the subject-matter throughout the tape. Each letter begins with a salutation to the daughter of touching warmth: 'My dear Mona, the apple of my eyes, how I miss you and long to feast my eyes on your beautiful face that brightens up my days . . .', reads one. Yet the videotape also makes evident that the intimacy and intensity of relation between mother and daughter is in part a new development. As the mother writes, 'I suppose he [Hatoum's father] is wondering why you're not communicating with him in the same way. After all, you've always been your father's daughter and I remember that, before you and I made those tapes and photographs together during your last visit, your letters were always mainly addressing him.' Hatoum, the 'father's daughter', has, like Diamond, become motivated to pursue a different knowledge of and relation to the mother, to locate a new evidence.

The mother embodies fully the feminine maternal aspect in her relation to her child, and the letters vibrate with love and longing for the absent daughter. But through the correspondence with her daughter, the mother begins to articulate for the first time ('You know, I have never talked in this way before') her own desire as a sexual subject. This desire is situated in relation to her marriage, and she urges the daughter to this end – one she equates with sexual pleasure. But her desire also finds expression in an erotics of intimacy that extends to include and embrace the daughter in their shared exploration of their experiences together and apart.

In this exploration, they are outside of the jurisdiction of the husband/father, who is threatened by this intimacy and his exclusion from it: 'We laughed at him when he told us off, but he was seriously angry. He still nags me about it, as if I had given you something which only belongs to him.' *As if.* The proprietorial arrangements of the patriarchal order are seriously undermined in this inscription of another locus and relation of desire. The authority of those cultural and familial limits is at once flaunted and observed through a conspiratorial secrecy, as if such a desire were transgressive, as if it could only be spoken from the margins of the Oedipal boundaries: as if, as in Diamond's video, the exclusion of the father was a necessary precondition for this articulation of a female subjectivity – a subjectivity of desiring mothers and desiring daughters.

The mother's desire – which in the videotape always begins, by virtue of its epistolary framing, with a loving and maternal enfolding – is seen to be expansive, flexible, extrovert. Significantly, as the daughter undertakes to explore a new relation to her mother, so does the mother expand the nature of her desire in relation to the daughter; thus both mother and daughter, as desiring subjects, each rework the inter-subjective self–other, mother–daughter relation. Though the mother declares, 'I actually enjoyed the [photo] session, because I felt we were like sisters, close together and with nothing to hide from each other', neither an improbable 'sibling' relationship with the maternal figure, nor a displacement of the father, nor a union with the mother, aptly characterises the position that Hatoum occupies. The shifting registers and unfixed positions articulate a relationship, a mother–daughter relationship, that occupies no visible place in the archives of the symbolic.

Through their correspondence, the two figures construct a separate and private space, one in which language and emotion are intertwined. This language is

neither univocal nor masterful: it is doubled and split, statement and ellipse. There are pauses in the reading and delays in the flow of sound; there are partial references to ongoing dialogues and topics taken up and left behind; there are relays of situations and circuitous movements of narratives. These registers, at once personal and social, are mapped directly on to the body of the mother. She is speaker and spoken, writer and written. Her words are mediated by the daughter – the person to whom the mother speaks, the person who in turn speaks the mother, the person who constructs the object of the mother-as-subject, the person who confronts and represents the gaps, openings, slippages and incommensurabilities at the very centre of an intimate relationship.

The major topic of the letters pertains to their (changing) relationship; but the relation between them is constantly pulled into, and shaped by, the social and political forces that have determined for each of them a situation of exile from the land of their birth: the mother from Palestine, the daughter from Lebanon. The shadow of war presses with increasing urgency in each letter and by the last has forced an end to the possibility of further communication for an indeterminate time. The letters are primarily focused within the close bonds of their relationship, yet the very circumstances which surround the writing underscore the multiplicity of factors that determine their lives and subjectivities.

In their correspondence, the mother maps on to the daughter's expressed sense of loss – of a 'gap' between her and her mother and an absence of childhood memory of the mother – the story of another loss, the exile from Palestine with its losses of family, of community, of identity:

> Yes of course I suppose this must have affected you as well, because being born in exile in a country which does not want you is no fun at all. And now that you and your sisters have left Lebanon, you are again living in another exile, in a culture that is totally different to your own. So when you talk about a feeling of fragmentation and not knowing where you really belong, well this has been the painful reality of all our people.

Like Diamond, Hatoum occupies a 'no place', yet here the return to the mother does not presage a solution to the problem of the losses and divisions of the subject. Rather, Hatoum makes explicit the ineradicable exile from the maternal body; and, further, she interweaves this psychosexual loss within other sets of losses, locating the particulars of identity within the specificities of cultural, linguistic, historical and generational boundaries.

At the same time, however, she articulates a realm of pleasure between mother and daughter, refusing – refuting – the order of dereliction and lack, and offering a symbolic construct of intimacy, laughter and love in libidinal, non-phallic intercourse. Loss may be the sponsor of desire, but in Hatoum's work, the daughter's claim on the maternal body (represented in the video's textual strategies as the very sign of the female) is also a claim for the maternal subject, woman and mother – mother and woman.

*The Influences of My Mother* and *Measures of Distance* are not only autobiographical representations but symbolic constructs that articulate a voice for the mother and

a dialogue with her. Yet it must be noted that, in a crucial sense, the principal protagonist in all of the tapes cited here is not the mother. What these narratives trace is not the story of the mother(s), nor even, despite the autobiographical emphases, of the daughter(s), but rather shifts in the ways in which the feminist subject might be said to 'see' and experience (and negotiate) this relation.

In these shifts of perspective can be found evidence of shifts in the currents of feminism itself: from an untheorised celebration of the female sign to an interrogation of femininity as it is constructed in representation and in familial and social relations; from a repression or displacement of the psychic dimension of the troubled mother–daughter relation to its considered exploration; from a preoccupation with 'difference' in relation to the masculine cultural text to an exploration of feminine desire in relation to the Other (as) woman.

Further, in their address of the mother–daughter relation, these videotapes, from different generations of feminist production, demonstrate that there is no stability of meaning in this term. In the very act of symbolising a cultural absence, replacing silence with speech, this relation is being modified, renewed and reinvented. What is at stake is the articulation of a relationship, a mother–daughter relationship, culturally unmapped in a symbolic order in which the term of the mother has been one possessed by the sons and fathers.

## Notes

This essay was first published in *Screen*, 34:2, summer 1993, pp. 109–23.

1   Julia Kristeva, 'Stabat mater', in Toril Moi (ed.), *The Kristeva Reader* (New York, Columbia University Press, 1986), p. 16.

2   Jessica Benjamin, *The Bonds of Love* (New York, Pantheon Books, 1988).

3   Luce Irigaray, *Speculum of the Other Woman*, trans. Gillian C. Gill (Ithaca, NY, Cornell University Press, 1985) and other writings.

4   Brenda Longfellow, 'Love Letters to the Mother: the Work of Chantal Akerman', *Canadian Journal of Political and Social Theory*, 19:1–2 (1989), p. 74.

5   Rosi Braidotti, 'The Politics of Ontological Difference', in Teresa Brennan (ed.), *Between Feminism and Psychoanalysis* (London and New York, Routledge, 1989), p. 96.

6   Carol Zemel, 'Women and Video', *Artscanada*, October 1973, p. 37.

7   Kristeva, 'Stabat mater'.

8   Irigaray, *Speculum*, p. 67.

9   Sigmund Freud, 'Mourning and Melancholia', in the Pelican Freud Library, Vol. 11: *On Metapsychology* (Harmondsworth, Penguin, 1984), pp. 245–69.

10   Kaja Silverman, *The Subject of Semiotics* (New York, Oxford University Press, 1983), p. 140.

11   Kaja Silverman, 'The Fantasy of the Maternal Voice', in *The Acoustic Mirror* (Bloomington, Indiana University Press, 1988), p. 124.

12   *Ibid.*, p. 123.

13   Margaret Whitford, 'Rereading Irigaray', in Brennan (ed.), *Between Feminism and Psychoanalysis*, p. 119.

14   *Ibid.*, p. 117.

# Select bibliography

**Selected articles offering similar case studies (other than those referred to in authors' notes)**

Ades, Dawn, 'Notes on Two Women Surrealist Painters: Eileen Agar and Ithell Colquhoun', *Oxford Art Journal*, April 1980, pp. 36–82.

Betterton, R., 'How do Women Look? The Female Nude in the Work of Suzanne Valadon', in R. Betterton (ed.), *Looking On: Images of Femininity in the Visual Arts and Media* (London, Pandora, 1987).

Callen, A., 'The Sexual Division of Labour in the Arts and Crafts Movement', *Oxford Art Journal*, Vol. 3, No. 1, April 1980, pp. 22–8.

Chadwick, W., 'Leonora Carrington: Evolution of Feminist Consciousness', *Women's Art Journal*, Vol. 7, No. 1, Spring/Summer 1986, pp. 37–42.

Chave, A., 'Minimalism and the Rhetoric of Power', in F. Frascina and J. Harris (eds), *Art in Modern Culture* (London, Phaidon and the Open University, 1992), pp. 264–81.

Cherry, Deborah, 'Picturing the Private Sphere', *Feminist Art News*, Women's Art History Issue, No. 5, 1982, pp. 8–11.

Cherry, Deborah and Beckett, Jane, 'Sorties: Ways out from behind the Veil of Representation', *Feminist Art News*, Women, Modernism and Modernity Issue, Vol. 3, No. 4, c. 1990, pp. 3–5.

Davies, Judy, 'The Futures Market: Marinetti and the Fascists of Milan', in Edward Timms and Peter Collier (eds), *Visions and Blueprints* (Manchester, Manchester University Press, 1988).

Duncan, Carol, 'The MoMA's Hot Mama's', *Feminist Art News*, Women, Modernism and Modernity Issue, Vol. 3, No. 4, c. 1990, pp. 15–19. Also a longer version in *Art Journal*, Summer 1989, pp. 171–8 and in C. Duncan, *Aesthetics and Power* (Cambridge, Cambridge University Press, 1993).

Duncan, Carol and Wallach, Alan, 'The Museum of Modern Art as Late Capitalist Ritual: An Iconographic Analysis', *Marxist Perspectives*, Vol. 1. No. 4, 1978, pp. 28–51.

Fer, Briony, 'What's in a Line? Gender and Modernity', *Oxford Art Journal*, Vol. 13, No. 1, 1990, pp. 77–88. (See also the chapter by B. Fer in B. Fer, D. Batchelor and P. Wood, *Realism, Rationalism, Surrealism: Art Between the Wars* (New Haven, Yale University Press and Open University, 1993).)

Giachero, Lia, 'Women in the Italian Avantgarde', *Women's Art Magazine*, No. 39, March/April 1991, p. 10.

Hansen, Dana Fris, 'Yayoi Kusama's Feminist', *Art and Text*, No. 49, September 1994, pp. 48–55.

Harris, A. Sutherland, 'Entering the Mainstream: Women Sculptors of the Twentieth Century: Part One: Barbara Hepworth and Louise Bourgeois', *Gallerie*, Vol. 2, Pt 2, Fall 1989, pp. 8–13.

Helland, Janice, 'Aztec Imagery in Frida Kahlo's Paintings: Indigenity and Political Comment', *Women's Art Journal*, Vol. 11, No. 2, Fall 1990/Winter 1991, pp. 3–7.

Irigaray, L., 'A Natal Lacuna', *Women's Art Magazine*, No. 58, May/June 1994, pp. 11–13.

Jaudon, Valerie and Kozloff, Joyce, 'Art Hysterical Notions of Progress and Culture', *Heresies*, No. 4, Winter 1978, pp. 38–42.

Kangas, Matthew, 'Mary Henry: American Constructivist', *Women's Art Journal*, Vol. 12, No. 2, Fall 1991/Winter 1992, pp. 20–3.

Katz, M. Barry, 'The Women of Futurism', *Women's Art Journal*, Fall 1986/Winter 1987, pp. 1–15.

Kelly, Mary, 'Reviewing Modernist Criticism', in B. Wallis (ed.), *Rethinking Representation: Art After Modernism* (New York, Godine and New Museum of Contemporary Art, 1984), pp. 87–103.

Lacy, Suzanne and Lippard, Lucy, 'Political Performance Art: A Discussion', *Heresies*, No. 17, 1984, pp. 22–5.

Lorde, Audrey, 'Age, Race, Class and Sex: Women Redefining Difference', in R. Ferguson, M. Gever, T. T. Minh-ha and C. West, *Out There: Marginalization and Contemporary Cultures* (New York, New Museum of Contemporary Art and Godine, 1990), pp. 281–8.

Lupton, Catherine, 'Mary Kelly', in J. Roberts, *Art Has No History: The Making and Unmaking of Art* (London, Verso, 1994).

Lynes, Barbara Buhler, 'The Language of Criticism: Georgia O'Keeffe', *Women's Art Magazine*, No. 51, March/April 1993, pp. 4–8.

Owens, Craig, 'The Discourse of Others: Feminists and Postmodernism', in Hal Foster (ed.), *Postmodern Culture* (London, Pluto, 1985).

Pollock, Griselda, 'Painting, Feminism and History', in A. Phillips and M. Barratt (eds), *Destabilising Theory* (Cambridge, Polity, 1992).

Risatti, Howard, 'The Sculpture of Alice Aycock', *Women's Art Journal*, Vol. 6, No. 1, Spring/Summer 1985, pp. 28–38.

Segal, Naomi, 'Sexual Politics and the Avantgarde: From Apollinaire to Woolf', in E. Timms and P. Collier (eds), *Visions and Blueprints* (Manchester, Manchester University Press, 1988), pp. 235–51.

Sykora, Katherina, 'Jeanne Mammen', *Women's Art Journal*, Vol. 9, No. 2, Fall 1988/Winter 1989.

Tickner, L., 'One for Sorrow: Two for Mirth: The Performance Work of Rose Finn-Kelcey', *Oxford Art Journal*, Vol. 3, No. 1, April 1980.

Tupitsyn, Margarita, 'Unveiling Feminism: Women's Art in the Soviet Union', *Arts Magazine* Vol. 65, December 1990, pp. 63–7.

Wayne, June, 'The Male Artist as Stereotypical Female', in Judy Loeb (ed.), *Feminist Collage: Educating Women in the Visual Arts* (New York, Columbia University Press/Teachers College Press, 1979).

Whiting, Cecile, 'Figuring Marisol's Femininities', *RACAR* (Canada), Vol. 18, No. 1/2, pp. 73–90.

Williams, Carol, 'A Working Chronology of Feminist Cultural Activities and Events in Vancouver, 1970–1990', in Stan Douglas (ed.), *Vancouver Anthology: The*

*Institutional Politics of Art* (Vancouver, Or Gallery and Talon Books, 1991), pp. 170–205.

## General books on feminism and modernism in the twentieth century

Ardis, Ann, L., *New Women, New Novels: Feminism and Early Modernism* (New Brunswick, New Jersey and London, Rutgers University Press, 1990).

Barta, I., Breu, Z., Hammer-Tugendhat, D., Jenni, U., Neirhaus, I. and Schobel, J., *Frauen, Bilder, Männer, Mythen: Kunsthistorische Beiträge (Kunsthistorikerinnin-Tagung)* (Berlin, Dietrich Reimer Verlag, 1987).

Battersby, Christine, *Gender and Genius* (London, Women's Press, 1989).

Baumgart, S., Birkle, G., Fend, M., Gotz, B., Klier, A. and Uppenkamp, B., *Denkräume: Zwischen Kunst und Wissenschaft (5. Kunsthistorikerinnin-Tagung)* (Berlin, Dietrich Reimer Verlag, 1993).

Broe, Mary Lynn *et al.* (eds), *The Gender of Modernism: A Critical Anthology* (Bloomington, Indiana University Press, 1990).

Broude, N. and Garrard, M., *The Expanding Discourse: Feminism and Art History* (New York, Icon/HarperCollins, 1992).

Broude, N. and Garrard, M. *Feminism and Art History: Questioning the Litany* (New York, Harper and Row, 1982).

Chadwick, W., *Women, Art and Society* (London, Thames and Hudson, 1989).

Dekoven, Marianne, *Rich and Strange: Gender, History, Modernism* (New York, Princeton University Press, 1991).

Elliott, Bridget and Wallace, Jo-Ann, *Women Artists and Writers: Modernist (Im)positionings* (London and New York, Routledge, 1994).

Gilbert, Sandra M. and Gubar, Susan, *The Female Imagination and the Modernist Aesthetic* (New York, Gordon and Breach, 1986).

Gilbert, S. M. and Gubar, S., *No Man's Land: The Place of the Woman Writer in the Twentieth Century (Vol. 1: The War of the Words)* (New Haven, Yale University Press, 1988).

Greer, Germaine, *The Obstacle Race: The Fortunes of Women Artists and their Work* (London, Secker and Warburg, 1979).

Griffin, Gabriele, *Difference in View: Women in Modernism* (Brighton, Taylor and Francis, 1994).

Guilbaut, S. (ed.), *Reconstructing Modernism: Art in New York, Paris and Montreal, 1945–1964* (Boston, Mass., MIT Press, 1990).

Hanscombe, Gillian E. and Smyers, Virginia L., *Writing for their Lives: The Modernist Women 1910–1940* (London, Women's Press, 1987).

Hyde, Sarah, *Exhibiting Gender* (Manchester, Manchester University Press, 1997).

Krauss, R., *The Optical Unconscious* (Boston, Mass., MIT Press, 1993).

Lindner, Ines; Schade, Sigrid; Wenk, Silke and Werner, Gabriele, *Blick Wechsel: Konstruktionen von Männlichkeit und Weiblichkeit um Kunst und Kunstgeschichte (4. Kunsthistorikerinnin-Tagung)* (Berlin, Dietrich Reimer Verlag, 1989).

Nochlin, L., *Women, Art and Power and Other Essays* (London, Thames and Hudson, 1989).

Parker, R., *The Subversive Stitch: Embroidery and the Making of the Feminine* (London, Pandora/RKP, 1984).

Parker, R. and Pollock, G., *Old Mistresses: Women, Art and Ideology* (London, Routledge, 1981).

Pollock, G., *Vision and Difference* (London, Routledge, 1988).

Sherman, Claire R. and Holcomb, Adele M. (eds), *Women as Interpreters of the Visual Arts, 1820–1979* (Westport, Conn., Greenwood Press, 1981).

Showalter, Elaine, *Sexual Anarchy: Gender and Culture at the Fin de Siècle* (New York, Viking, 1990).

Sutherland, Christine Mason and Rasporich, Beverly Matson, *Woman as Artist: Papers in Honour of Marsha Hanen* (Calgary, University of Calgary Press, 1993).

Tregebov, Rhea (ed.), *Work in Progress: Building Feminist Culture* (Toronto, Women's Press, 1987).

Wagner, Ann, *Three Artists (Three Women): Modernism and the Art of Hesse, Krasner and O'Keeffe* (Berkeley, Ahmanson Murphy Fine Arts Book, University of California Press, 1997).

Waller, S., *Women Artists in the Modern Era: A Documentary History* (Metuchen, New Jersey, Scarecrow, 1991).

Witzling, Mara S. (ed.), *Voicing Our Visions* (London, Women's Press, 1992).

Wolff, J., *Feminine Sentences: Essays on Women and Culture* (Cambridge, Polity, 1991).

Zegher, Catherine de (ed.), *Inside the Visible: An Elliptical Traverse of Twentieth Century Art in, of, and from the Feminine* (Boston, Mass., ICA/MIT Press/Kanaal Art Foundation, 1996).

## Theories of gender

Braidotti, Rosa, *Patterns of Dissonance: A Study of Women in Contemporary Philosophy* (Cambridge, Polity, 1991).

Butler, Judith, *Bodies that Matter: On the Discursive Limits of 'Sex'* (London, Routledge, 1993).

Butler, Judith, *Gender Trouble: Feminism and the Subversion of Identity* (London, Routledge, 1990).

Elam, Diane, *Feminism and Deconstruction: Ms en Abyme* (London, Routledge, 1994).

Grosz, Elizabeth, *Volatile Bodies: Towards a Corporeal Feminism* (Bloomington, Indiana University Press, 1994).

Hein, Hilde and Korsmeyer, Carolyn, *Aesthetics in Feminist Perspective* (Bloomington and Indianapolis, Indiana University Press/Hypatia Inc., 1993).

Hekman, Susan J., *Gender and Knowledge: Elements of a Postmodern Feminism* (Cambridge, Polity, 1992).

Kelly, J., *Women, History and Theory* (Chicago and London, University of Chicago Press, 1984).

Kroker, Arthur and Kroker, Marilouise, *The Hysterical Male: New Feminist Theory* (Basingstoke, Macmillan, 1991).

Lauretis, Teresa de, *Technologies of Gender* (Basingstoke, Macmillan, 1987).

Marshall, Barbara, *Engendering Modernity* (Cambridge, Polity, 1994).

Nicholson, L. (ed.), *Feminism/Postmodernism* (London, Routledge, 1991).

Riley, Denise, *Am I that Name? Feminism and the Category of 'Women' in History* (New York, Macmillan, 1988).

Scott, Joan Wallach, *Gender and the Politics of History* (New York, Columbia University Press, 1988).

Smith, Dorothy E., *The Everyday World as Problematic* (Boston, Mass., Northeastern University Press, 1987).

Walby, Sylvia, *Theorising Patriarchy* (Oxford, Basil Blackwell, 1990).

### Feminist studies of women artists in the twentieth century

Behr, Shulamith, *Women Expressionists* (Oxford, Phaidon, 1988).

Berkhauser, Jude, *Glasgow Girls: Women in Art and Design 1880–1920* (Edinburgh, Canongate, 1990).

Callen, A., *The Angel in the Studio: Women in the Arts and Crafts Movement* (London, Astragal, 1979).

Caws, Mary Ann, *Women of Bloomsbury* (New York, Routledge, 1991).

Caws, Mary Ann, Kuenzli, R. E. and Raaberg, G., *Surrealism and Women* (Cambridge, Mass., MIT Press, 1991).

Chadwick, Whitney, *Women Artists and the Surrealist Movement* (London, Thames and Hudson, 1985).

Dabrowski, Magdalena, *Liubov Popova* (New York, H. Abrams, 1991).

Deepwell, Katy, *Ten Decades: The Careers of Ten Women Artists Born 1897–1906* (Norwich, Norwich Gallery, Norfolk Institute of Art and Design, 1992).

*Domesticity and Dissent: The Role of Women Artists in Germany 1918–1938* (Leicester, Leicester Museum and Art Gallery, 1992).

Eiblmayr, Sylvia, *Die Frau als Bild: Der weibliche Körper in der Kunst des 20 Jahrhunderts* (Berlin, Dietrich Reimer, 1993).

Fisher, Andrea, *Let Us Now Praise Famous Women* (London, Pandora, 1987).

Gillespie, Diana, *The Sisters' Arts: The Writing and Painting of Virginia Woolf and Vanessa Bell* (New York, Syracuse University Press, 1988).

Helland, Janice, *The Studios of Frances and Margaret MacDonald* (Manchester, Manchester University Press, 1996).

Hooker, Denise, *Nina Hamnett: Queen of Bohemia* (London, Constable, 1986).

Jensen, Jona M., *One Foot on the Rockies: Women and Creativity in the Modern American West* (University of New Mexico Press, c. 1994).

Kaplan, Janet, *Unexpected Journeys: The Art and Life of Remedios Varo* (New York, Abbeville; London, Virago, 1988).

Lavin, Maud, *Cut with the Kitchen Knife: The Photomontages of Hannah Höch* (New Haven, Yale University Press, 1993).

Lavrientiev, A., *Vavara Stepanova: A Constructivist Life* (Boston, Mass., MIT Press, 1988).

Moutoussamy-Ashe, Jean, *Viewfinders: Black Women Photographers* (London, Writers and Readers, 1988).

Munro, Eleanor, *Originals: American Women Artists* (New York, Simon and Schuster, 1979).

Muyssen, C., *Profession ohne Tradition* (German-language catalogue) (Berlin, Martin Gropius-Bau, 1992).

Oldfield, S., *This Working Day World: Women's Lives and Culture(s) in Britain, 1914–1945* (Brighton, Taylor and Francis, 1994).

Perry, Gillian, *Paula Modersohn-Becker* (London, Women's Press, 1986).

Perry, Gillian, *Women Artists and the Parisian Avant-Garde* (Manchester, Manchester University Press, 1995).

Ryan-Smolin, Wanda, Mayes, Elizabeth and Rogers, Jenni (eds), *Irish Women Artists: From the Eighteenth Century to the Present Day* (Dublin, National Gallery of Ireland and the Douglas Hyde Gallery, 1987).

Schlieker, Andrea (ed.), *Leonora Carrington* (London, Serpentine Gallery, 1991).

Secrest, M., *Between Me and Life: A Biography of Romaine Brooks* (London, Doubleday, 1984).

Souhami, Diana, *Gluck: Her Biography* (London, Pandora, 1988).

*Dorothea Tanning* (London, Camden Arts Centre, 1993).

Tickner, Lisa, *The Spectacle of Women: Imagery of the Suffrage Campaign, 1907–1914* (London, Chatto and Windus, 1988).

Todd, Ellen Wiley, *The 'New Woman' Revised: Painting and Gender Politics on Fourteenth Street* (Berkeley, University of California Press, 1993).

Trenton, Patricia (ed.), *Independent Spirits: Women Painters of the American West, 1890–1945* (Berkeley, University of California Press, 1995).

Williams, Val, *The Other Observers: 1900 to the Present* (London, Virago, 1986).

Yablonskaya, M. N., *Women of Russia's New Age 1900–1935* (Oxford, Phaidon, 1990).

## Images of women/Theories of representation

Adams, P., *The Emptiness of the Image* (London, Routledge, 1995).

Betterton, R. (ed.), *Looking On: Images of Femininity* (London, Pandora, 1987).

Chester, G. and Dickey, L., *Feminism and Censorship* (London, Prism Press, 1988).

Duby, Georges and Perrot, Michèle, *Power and Beauty: Images of Women in Art* (Manchester, Manchester University Press, 1995).

Florence, Penny and Reynolds, Dee, *Feminist Subjects, Multi-Media* (Manchester, Manchester University Press, 1995).

Frueh, Joanna, *Erotic Faculties* (Berkeley, University of California Press, 1996).

Gammon, L. and Makinen, M., *Female Fetishism: A New Look* (London, Lawrence and Wishart, 1994).

Gammon, L. and Marshment, M. (eds), *The Female Gaze: Images of Women in Popular Culture* (London, Women's Press, 1988).

Kuhn, Annette, *The Power of the Image: Essays in Representation and Sexuality* (London, Routledge and Kegan Paul, 1985).

Lewis, Reina, *Gendering Orientalism: 'Race', Femininity and Representation* (London, Routledge, 1996).

Lovell, Terry, *Pictures of Reality: Aesthetics, Politics and Pleasure* (London, BFI, 1983).

Nead, Lynn, *The Female Nude: Art, Obscenity and Sexuality* (London, Routledge, 1992).

Nead, Lynn, *Myths of Sexuality* (London, Routledge, 1987).

Nochlin, L. and Hess, T., *Women as Sex Object* (New York, Newsweek, 1972; London, Allen Lane, 1973).

Schor, Naomi, *Reading in Detail: Aesthetics and the Feminine* (London, Methuen, 1987; London, Routledge, 1989).

Suleiman, S. Rubin, *The Female Body in Western Culture* (Cambridge, Mass., Harvard University Press, 1986).

Warner, M., *Monuments and Maidens: The Allegory of the Female Form* (London, Weidenfeld and Nicolson, 1985).

Williamson, J., *Decoding Advertisements* (London, Marion Boyars, 1978).

### Dictionaries and other useful general resources

Anderson, Janet, *Women in the Fine Arts: A Bibliography and Illustration Guide* (Jefferson, N.C., McFarland, 1991).

Bachmann, D. and Piland, S. (eds), *Women Artists: An Historical, Contemporary and Feminist Bibliography* (Metuchen, N.J., Scarecrow, 1978).

Chairmonte, Paula, *Women Artists in the US: A Selective Bibliography and Resource Guide* (Boston, Mass., G. K. Hall, 1990).

Dunford, P., *A Biographical Dictionary of Women Artists in Europe and America since 1850* (New York, Harvester and Wheatsheaf, 1990).

Fine, Elsa Honig, *Women and Art: A History of Women Painters and Sculptors from Renaissance to the Twentieth Century* (Montclair, N.J., Allanheld and Schram; London, Prior, 1978).

Frauen-Kunst-Geschichte-Forschungsgruppe-Marburg, *Feministiche Bibliografie zur Frauenforschung in der Kunstgeschichte* (A Feminist Bibliography of Women's Studies in Art History, 1970–1988) (Marburg, Pfaffenweiler/Centaurus Verlagsgesellschaft, 1993).

Gaze, D., *Dictionary of Women Artists* (London, Fitzroy Dearborn, 1997).

Harris, A. Sutherland and Nochlin, L., *Women Artists 1550–1950* (Los Angeles, Los Angeles County Museum of Art; New York, Alfred A. Knopf, 1976).

Heller, Jules and Nancy, *North American Women Artists of the Twentieth Century: A Biographical Dictionary* (Philadelphia, University of the Arts, 1995).

Newman, Marketa, *Biographical Dictionary of Saskatchewan Artists: Women Artists* (Saskatoon, Fifth House Publication, 1990).

Petersen, K. and Wilson, J. J., *Women Artists: Recognition and Reappraisal from the Middle Ages to the Twentieth Century* ([1976] London, Women's Press, 1978, 1985).

Petteys, C., *An International Dictionary of Women Artists born before 1900* (Boston, Mass., G. K. Hall, 1985).

Sellars, J., *Women's Works: Paintings, Drawings, Prints and Sculpture by Women Artists in the Permanent Collection* (Liverpool, National Museums and Galleries on Merseyside, 1988).

Slatkin, Wendy, *Women Artists in History: From Antiquity to the Twentieth Century* (Englewood Cliffs, N.J., Prentice Hall, 1985).

Tufts, E., *Our Hidden Heritage: Five Centuries of Women Artists* (London, Paddington Press, 1974).

*Women's Art Show 1550–1950* (Nottingham, Nottingham Castle Museum, 1982).

## Contemporary feminist art practice

Arbour, Marie Rose, *Art et féminisme* (Quebec, Musée d'Art Contemporain, Montreal and Ministère des Affaires Culturelles, 1982).

Baker, E. and Hess, T. (eds), *Art and Sexual Politics* (New York, Collier, 1971).

Barnett, P. *The Subversive Stitch* (exhibition catalogue, Manchester, Cornerhouse Art Gallery, 1986).

Betterton, Rosemary, *An Intimate Distance: Women Artists and the Body* (London, Routledge, 1996).

Brand, Peggy Z. and Korsmeyer, Carolyn, *Feminism and Tradition in Aesthetics* (University Park, Penn State Press, 1995).

Brettle, Jane and Rice, Sally, *Public Bodies/Private States: New Views on Photography, Representation and Gender* (Manchester, Manchester University Press, 1994).

Broude, N. and Garrard, M. *The Power of Feminist Art: Emergence, Impact and Triumph of the American Feminist Art Movement* (New York, Harry Abrams, 1994).

Burke, Janine, *Field of Vision: A Decade of Change. Women's Art in the 1970s* (St Leonards, N.S.W., Viking, 1990).

La Centrale (Galerie Powerhouse), *Instabili: La Question du sujet: The Question of Subject* (exhibition catalogue, celebrating fifteen years of women's exhibitions; Montreal, La Centrale, 1990).

Chicago, J., *Embroidering Our Heritage: The Dinner Party Needlework* (New York, Doubleday/Anchor, 1980).

Chicago, J., *Through the Flower: My Struggle as a Woman Artist* (Garden City, Anchor, 1986).

Deepwell, K. (ed.), *New Feminist Art Criticism: Critical Strategies* (Manchester, Manchester University Press, 1995).

Ecker, G. (ed.), *Feminist Aesthetics* (London, Women's Press, 1985).

Eiblmayr, Sylvia, Export, Valie and Prischl-Maier, Monika (ed.), *Kunst mit Eigen-Sinn: Aktuelle Kunst von Frauen, Texte und Dokumentation* (exhibition catalogue, Vienna/Munich, 1985).

Elinor, G., Richardson, S., Scott, S., Thomas, A. and Walker, K. (eds), *Women and Craft* (London, Women's Press, 1988).

Felshin, Nina, *But Is It Art?* (Seattle, Bay Press, 1996).

Frueh, J., Langer, C. and Raven, A., *Feminist Art Criticism: An Anthology* (New York, Icon/HarperCollins, 1991).

Frueh, J., Langer, C. and Raven, A., *Feminist Criticism: Art, Identity, Action* (New York, Icon/HarperCollins, 1996).

Grove, Nancy, *Magical Mixtures – Marisol Portrait Sculpture* (1991).

Hanley, Jo Ann and Wooster, Ann-Sargent, *The First Generation: Women and Video, 1970–1975* (New York, Independent Curators Incorporated, 1993).

hooks, bell, *Art on My Mind: Visual Politics* (New York, New Press, 1996).

Isaak, Jo-Anna, *Feminism and Contemporary Art: The Revolutionary Power of Women's Laughter* (London, Routledge, 1996).

Jacob, Mary Jane, *Shikego Kubota: Video Sculpture* (University of Washington Press, 1991).

Jones, Amelia (ed.), *Sexual Politics: Judy Chicago's The Dinner Party in Feminist Art History* (Berkeley, University of California Press, 1996).

Kavaler-Adler, Susan, *The Compulsion to Create: A Psychoanalytic Study of Women Artists* (London, Routledge, 1993).

*Mary Kelly* (New York, New Museum of Contemporary Art, 1990).

Kelly, Mary, *Post-Partum Document* (London, Routledge, 1983).

Kent, S. and Morreau, J., *Women's Images of Men* (London, Writers and Readers, 1985).

King-Hammond, Leslie, *Gumbo Ya Ya: Anthology of Contemporary African–American Women Artists* (New York, Midmarch Press, 1995).

*Künstlerinnen International, 1877–1977: Frauen in der Kunst* (exhibition catalogue, Berlin, Schloss Charlottenburg, 1977).

Lacy, Suzanne, *Mapping the Terrain: New Genre Public Art* (Seattle, Bay Press, 1995).

La Duke, Betty, *Women Artists: Multi-cultural Visions* (Lawrenceville, N.J., Red Sea Press, 1992).

Lippard, Lucy, *From the Center: Feminist Essays on Women's Art* (New York, E. P. Dutton, 1976).

Lippard, Lucy, *Get the Message? A Decade of Art for Social Change* (New York, E. P. Dutton, 1984).

Lippard, Lucy, *Overlay: Contemporary Art and the Art of Pre-history* (New York, Pantheon Press, 1983).

Lippard, Lucy, *The Pink Glass Swan: Selected Feminist Essays on Art* (New York, New Press, 1996).

Loeb, Judy (ed.), *Feminist Collage: Educating Women in the Visual Arts* (New York, Columbia University Teachers College Press, 1979).

Moore, Catriona (ed.), *Dissonance: Feminism and the Arts, 1970–1990* (St Leonards, N.S.W., Allen and Unwin, 1994).

Nemiroff, Diana, *Jana Sterback: States of Being/Corps à corps* (Ottawa, National Gallery of Canada, 1991).

Nemser, Cindy, *Art Talk: Conversations with Twelve Women Artists* (New York, Charles Scribner's Sons, 1975, 1995).

*Odyssey of Faith: Faith Ringgold: A Twenty-Five-Year Survey*, Fine Arts Museum of Long Island, April–June 1990 (essays by Eleanor Flomenhaft, Lowery S. Sims, Thalia Gouma-Peterson and Moira Roth).

Parker, R. and Pollock, G., *Framing Feminism: Art and the Women's Movement 1970–1985* (London, RKP/Pandora, 1987).

Piper, Adrian, *Out of Order, Out of Sight* (2 vols) (Boston, Mass., MIT Press, 1996).

Pollock, Griselda (ed.), *Generations and Geographies* (London, Routledge, 1996).

Robinson, Hilary (ed.), *Visibly Female* (London, Camden Press, 1987).

Rosen, R. and Brauer, C., *Making their Mark: Women Artists Move into the Mainstream, 1970–1985* (New York, Abbeville Press, 1989).

Roth, Moira, *The Amazing Decade: Women and Performance Art in America, 1970–1980* (Los Angeles, Astro Artz, 1983).

Saunders, L. (ed.), *Glancing Fires: An Investigation into Women's Creativity* (London, Women's Press, 1987).

Seblatnig, Heidemarie, *Einfach den Gefahren ins Auge Sehen: Kunstlerinnen im Gespräch* (Vienna, Cologne and Graz, Böhlau, 1988).

Shepherd, Elizabeth, *Secrets, Dialogues, Revelations: The Art of Betye and Alison Saar* (Seattle, University of Washington Press, 1994).

Siegel, Judy, *Mutiny and the Mainstream: Talk that Changed Art, 1975–1990* (New York, Midmarsh Press, 1992).

Spence, Jo, *Cultural Sniping: The Art of Transgression* (London, Routledge, 1995).

Spence, Jo, *Putting Myself in the Picture: A Personal and Political Autobiography* (London, Routledge, 1988).

Sulter, M. and Pollard, I. (eds), *Passions: Discourses on Black Women's Creativity* (Hebden Bridge, Urban Fox Press, 1990).

Tucker, Marcia, *Bad Girls* (Boston, Mass., MIT Press, 1995).

Wallis, Brian (ed.), *If You Lived Here: The City in Art, Theory and Social Activism* (Seattle, Bay Press, 1991).

Witzling, Mara, *Voicing Today's Visions* (London, Women's Press, 1994/95).

Wye, Deborah, *Louise Bourgeois* (New York, MoMA, 1982).

Zelevansky, Lynn, *Sense and Sensibility: Women Artists and Minimalism in the Nineties* (London, Thames and Hudson; New York, MoMA, 1995).

# Index

Note: Titles of works appear under the artist's entry. 'n.' after a page reference indicates the number of a note on that page.